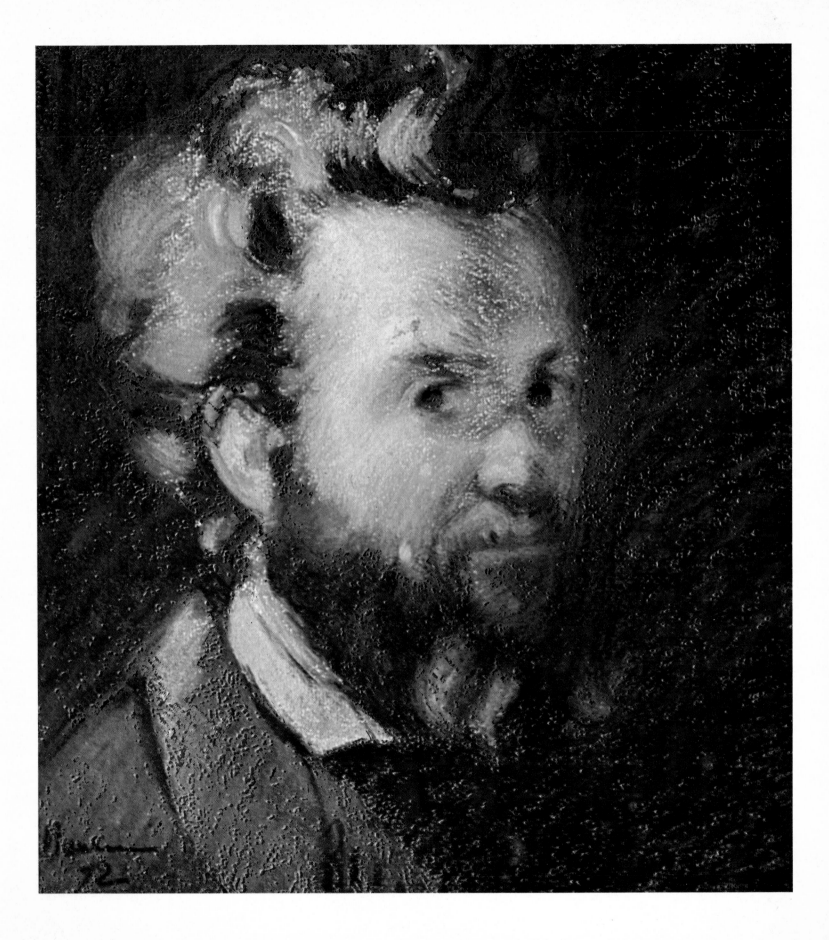

# ARMAND GUILLAUMIN

*by Christopher Gray*

*The Pequot Press, Inc., Chester, Connecticut, 1972*

# Contents

# List of Illustrations

Guillaumin was one of the original group of painters who exhibited in 1874, and who were collectively dubbed Impressionists by the critic Louis Leroy.* They exhibited together more or less regularly until 1886, and then began to break up. Some of them, e.g., the group around Degas, had never really accepted the Impressionist aesthetic as expressed by Monet and others. Some, among them Renoir, tended to return to their own interpretations of the principles of classic art. Others, like the neo-Impressionists Seurat and Signac, sought to put the developments of Impressionism on what they thought to be a sounder and more objective basis. Ultimately, only Monet and Guillaumin remained classical Impressionists. (I do not consider Sisley, who died in 1896.) Though their styles changed about 1886, they were both to consider themselves Impressionists for the remaining half of their active careers.

As the artistic development of Guillaumin parallels that of Monet, it will be necessary to explore, in the case of both artists, the nature of their development after 1885. I do not agree with those who think that both men began to lose their powers, and that their abilities declined, in middle age. This is a common explanation of the later styles of artists offered by critics. Two classic examples in the history of art are, of course, Titian and Rembrandt. Both men developed late styles which were considerable advances over their early ones, but incomprehensible to those who had seen in their early works the epitome of the expression of the aesthetic objectives of their times.

Christopher Gray

January 1970

* In *Charivari*, April 25, 1874, "L'Exposition des impressionnistes."

Christopher Gray presents here the life and works of Armand Guillaumin (1841-1927) painter, husband, father and man.

My husband found primary sources when possible and was able to talk to the artist's daughter, Marguerite, and to consult her family records over a period of years before her death in 1967. He made visits to all Guillaumin's principal painting sites where many of the people remembered the artist and reminisced.

At Guillaumin's request, most of his correspondence was burned at the time of his death. The Ballot letters from 1913 to 1923 survived however, and have been held in the Ballot family. With their kind permission, some of the letters have been reproduced in this work. (Guillaumin had little formal schooling. His letters in the Appendix are reproduced as he wrote them.)

Illustrations of Guillaumin's work cover the period from 1865 to 1923. They are presented to give a sampling of the artist's *oeuvre* throughout his life rather than to present a *catalogue raisonné*.

Various methods have been used for dating those works which were not dated by the artist—subject matter, known visits to various sites, and changing technique influence dating. The changes in signature from 1867 to 1895 have also been considered. The signatures on the drawings are all the same; it is possible that the artist signed all of them late in his career, but a careful study has been made of the signatures on the dated pictures (see plates 51-53).

Drawings, pastels, oils, lithographs and etchings are presented throughout the book, rather than in separate groups. (In some cases the drawings were preliminary to the oil painting or finished pastel.)

Two biographies appeared during the artist's life and were presumably checked, and perhaps altered, by him: Des Courières, Edouard, *Armand Guillaumin*, Paris, 1926, and Lecomte, Georges, *Guillaumin*, Paris, 1926.

Christopher Gray died in May 1970. This manuscript, prepared chronologically, was essentially complete at the time, though some editing was necessary. A few changes have been made in both the text and catalogue.

ALICE D. GRAY

January 1972

I was asked by Mrs. Alice Gray to make a dedication for this book by her late husband and, being well aware that other persons might have been better qualified to do so, my friendship for Mr. Gray made it difficult to refuse.

After his death Guillaumin suffered two injustices which for several years made him unable to attain the prestige of his colleagues of the Impressionist period, in spite of their consideration for his talent and personality. The first of these drawbacks was that in 1891 he had the luck to win what is called in France two "Gros Lots" (lotteries) for a total amount of 100,000 gold francs, which liberated him from the anxiety of having to sell his works through galleries. He traveled frequently, mainly to the South of France, in the Creuse, at Crozant; but also to Brittany where he achieved many of his works.

This "ill-omened" good luck did not help him very much. After his death most of his paintings were found amongst his friends. Therefore, the galleries did not have enough works in their hands to promote him through books and in the various other ways that it would have been necessary to make him better known in the world of arts; at least as well known as his colleagues and freinds of the Impressionist group.

The second drawback was that his son was also an artist and he painted and signed his works in the same style and manner as his father, which created confusion, destroying public confidence in his father's works for many years. Guillaumin's daughter, Marguerite, courageously opposed her brother in every possible way to establish the truth for the honour and reputation of her father. After this elaborate text written by Christopher Gray on Guillaumin, I do not intend to write anything technical about this artist's works, except to mention that from 1885 he was the pioneer of Fauvism. The important contribution of this book by Christopher Gray is that it enables us to judge Guillaumin as one of the important painters of his time.

Today Guillaumin's name is recognized as finally one of the successful artists of the 19th-20th Century.

My esteem for Christopher Gray was born during our first contact when he was working on his important book devoted to the sculptures and ceramics of Gauguin. I cannot forget the seriousness, the intellectual rigour and competence he showed while examining the works of Gauguin piece by piece from my collection. I also witnessed the untiring and endless research which he pursued in order to bring to light the true personality and work of Guillaumin. So I am happy to render homage to Christopher Gray, who in spite of his simplicity, discretion and reservation, revealed himself to be one of the most distinguished amongst those who try to enter into the mysteries of artistic creation.

Dr. Oscar Ghez
*President of Petit Palais*

Geneva, 1971.

Jean-Baptiste Armand Guillaumin was born the 16th of February, 1841, in Paris, at number 10, rue de Rivoli, which was at that time just opposite the Porte du Caroussel of the Louvre. His father, Jean-Joseph Guillaumin, was the son of a notary in Besson, a small village of about a thousand inhabitants, five or six miles from Moulins. Little is known of the early life of Guillaumin's father, except that he seems to have been trained as a tailor. Shortly after the death of Guillaumin's grandfather in 1839, we find his father in Paris, proprietor of a tailoring shop which specialized in hunting costumes for the *haute monde*, situated at number 10, rue de Rivoli, in the part of Paris where the elegant tailors' shops were. In 1845 Renoir's father set up a shop nearby. Jean-Joseph was married to Françoise-Félicité Legay, whose family were from Pontgibaud (Puy-de-Dôme) although she herself was born in Paris in 1817. Armand was the second child in the family; he had an older brother, Charles.

Shortly after Armand's birth his family moved back to the Département of Allier, settling at Moulins, where his younger brother, Maurice, was born in 1845, and his sister, Marie, in 1849.

When it was time for young Armand to go to school, shortly before the birth of his sister Marie, his family sent him to the Ecole communale at Moulins. We know that in school he formed a lasting friendship with Eugène Murer, later a successful pastry cook and hotelier, who became an enthusiastic financial supporter of the Impressionists in a small but important way. In addition to his friendship with Murer, two things stand out as resulting from Guillaumin's stay at Moulins. First, he developed a love for the landscape of the mountainous regions on the borders of the Massif Central. Second, he began his study of art. His first teacher, during his stay at Moulins, was an old artist of the region of the Bourbonnais, named Tudot. Tudot had no particular reputation, but from the time of his studies with him, Armand was primarily interested in painting.

In 1857, he was sent to Paris to work in the shop of his uncle Bernard, at number 10, Chaussée d'Antin. A maison de blanc called *Mille et Une Nuits*, the shop specialized in trousseaus, layettes, and lingerie for the *haute monde* (and perhaps the demimonde).

The Paris that Guillaumin returned to was far different from the Paris he had left some thirteen years before. The Empire under Napoleon III was expanding economically at a feverish rate. The depression, which had set off the Revolution of 1848, had begun in 1846 and had lasted until 1850, and was followed by a period of great growth in industry. Between 1850 and 1860 industrial horsepower increased from 67,000 to 178,000—more than twenty-six percent a year.[1] Under Napoleon III the north wing of the Louvre had been completed, the old houses of the Esplanade du Louvre had been cleared out, the rue de Rivoli rebuilt, and one of the first department stores, the Magazins du Louvre, had been built next to the Place du Palais Royal. Baron Haussmann, Préfet du Seine, had begun building the great boulevards. By 1860, eight new arrondissements were added to Paris, including Auteuil, Passy, Les Ternes, and Les Batignolles, and the population had increased by more than half.

The shop of Guillaumin's uncle stood next to the site on which the new opera house by Garnier was planned, and construction began by 1861. It was just off the new Boulevard des Italiens. Around the corner was the rue Lafitte with its art dealers, and nearby was the popular studio of the photographer Nadar. Durand-Ruel's Gallery remained on the rue Lafitte until 1924.

Though the sixteen-year-old Guillaumin lived in one of the most lively parts of a

---

1 See Clapham, J. H., *The Economic Development of France and Germany, 1815-1914.* 4th Edition (Cambridge, 1936) p. 240.

fast-growing city, he had little time to enjoy its sights. Clerks then worked more than twelve hours a day, for at least a six-day week, and the pay was low, not more than three francs a day. For the good of his nephew's soul, Guillaumin's uncle undoubtedly worked him hard, and deducted room and board from his salary. Guillaumin was not cut out to be a clerk in an elegant ladies' store. His rough personality, acquired from years at Moulins, and his masculine pride must have rebelled. Occasionally he was sent on errands which gave him a chance to see the new city, to gaze in the windows of the Marchands des tableaux on the rue Lafitte and even to play hookey by visiting the galleries of the Louvre.

Though Guillaumin could hardly have been a promising clerk, his uncle did permit him to enroll in the municipal art school on the rue des Petits Carreaux, only a fifteen-minute walk away. There he studied drawing under the sculptor Caillouet, a former winner of the Prix de Rome, whom Lecomte calls "if not the best sculptor in Paris, at least not the worst." At the Petits Carreaux Guillaumin confirmed his interest in a career as an artist, and won a bronze medal for his work.

But his fixed devotion to art caused friction with his uncle. At night Guillaumin made his bed under the counters at the store. As his free time was severely limited, he used to practice drawing surreptitiously by the light of a candle after he had gone to bed. His uncle caught him at work and angrily took his candle away.

He soon decided that he would have more freedom if he were to seek employment away from his uncle and his family. He found a job in another drygoods store on the rue Sentier, closer to the art school of the Petits Carreaux, but life there was no easier and he no longer dared dawdle on errands to look at the picture galleries.

In 1860, Guillaumin began working as a clerk in the Service des Titres for the Paris-Orléans railway, one of the great companies which had been formed in 1852 as part of Napoleon III's program of fostering rail expansion. Lecomte suggests that he may have formed a rosy picture of the life of a clerk from Balzac's *Employés* and the existence it depicted. If Guillaumin thought he would have more money, or free time, for his art, he was soon disillusioned—he earned barely enough to live. Probably, however, as an employee, he had a pass on the railroad which permitted him to take the train on Sundays to one of the little towns on the outskirts of Paris where he could draw the suburban scenery. At other times when he was free he would cross the Pont d'Austerlitz and sketch the workers on the Quai de Bercy.

Soon after he found employment with the Compagnie d'Orléans, Guillaumin began to study drawing again, this time at the Académie Suisse. In the summer he could draw from six in the morning until nine o'clock, and still have time to get to his job at ten. In the winter he would have time to attend the session from eight to ten in the evening. There he studied anatomy and perspective assiduously, and eventually even considered entering the concourse for the Prix de Rome. The Académie Suisse was a studio, located on the Quai des Orfèvres, where, by paying a minimal fee to cover the cost of the model and heating, one could be left alone to draw the model as one saw fit. With its freedom it was the training ground of a number of independent artists who found the discipline of the Beaux-Arts Studios not to their taste. In 1859 and 1860 Monet worked there briefly. From time to time the great Courbet would drop in to draw the model, and in 1861 he made a painting of Père Suisse himself.[2] More important for Guillaumin were three fellow students, all admirers of Courbet, whom he met at the Académie Suisse, and with whom he formed close friendships. The first was a young man of twenty-two from Aix (Guillaumin was only twenty)

2 Mack, Gerstle, *Courbet*, p. 27.

named Paul Cézanne, who had been sent to Paris by his father to study law, but who preferred art. Guillaumin also met Francisco Oller y Cestro, a native of Puerto Rico, who was a pupil of Courbet.[3] Oller was born in 1833, and eight years older than Guillaumin. Through Oller, both Cézanne and Guillaumin met Pissarro, the oldest of the group. A native of the West Indies, he was born in St. Thomas in 1830 and went to Paris in 1855. By the time Guillaumin met Pissarro he had already "arrived" in the eyes of the young artists, since he had had a painting accepted by the Salon in 1859. He had, however, been rejected in 1861.

The year 1862 was uneventful for Guillaumin, but several factors were at work setting in train the events that would lead to the formation of the Impressionist group. Monet, having returned from his year of military service in Algeria, had entered the studio of Gleyre. Toward the end of the year there Monet formed a close friendship with three members of the future Impressionist group: Bazille, Sisley, and Renoir. Their stay with Gleyre was short. In March, 1863, they left the studio there to work together in the Forest of Fontainebleau at Chailly.

As a result of protest on the part of the artists the Emperor, in 1863, graciously permitted a Salon des Refusés, but few people took it seriously. Most critics saw it as a complete vindication of the judgment of the jury, and the public seemed to have eyes only for Manet's *Bain*, later known as *Le Déjeuner sur l'Herbe*, which became the succès de scandale of the exhibition. Among those exhibiting with the Refusés were the group that were to be dubbed "the Impressionists," Pissarro, Cézanne, and Guillaumin.[4] In 1864 the Salon accepted paintings by both Pissarro and Renoir; in 1865, Pissarro, Monet, and Renoir were all represented there.

The earliest surviving works of Guillaumin date from 1865 (Fig. 1). He was then twenty-four, and had been drawing some ten years. One work is a quick sketch in soft pencil of a scene along the Seine, probably showing the forges at Ivry. This drawing has the appearance of a completely free and spontaneous preliminary sketch, but it is fairly large in scale, composed on a half-sheet of Ingres paper. It is utterly economical of means, creating the scene with a minimum of lines and apparently without any reworking. Nevertheless, it is fully established and well thought out. The buildings are largely massed on the left side of the drawing, creating a compositional tension which is resolved by the effectively uninterrupted recession of space on the right and the dynamic movement toward the right by the plume of smoke. The one element of the composition which does not seem to be adequately worked out is the placement of the ploughman and two horses in the left foreground, but the drawing of these three forms is remarkable in economy, revealing the artist's great potential as a draughtsman. Even though the drawing is slight, and does not explore the complexities of form in detail, it is significant that Guillaumin has already established a value pattern in the composition with a few quick hatchings. This pattern is carefully worked out as an integral part of the total composition, and contributes markedly to the effectiveness of the whole, as, for example, in the reenforcement of the dynamic balance of the composition through the opposing of the assertive black form on the middle right half of the drawing to the greyer forms of the building on the left.

The other work of 1865 is a scene of barges on the Seine, done in pastel (Fig. 2). Pastel was becoming popular through the works of Millet, who had begun to use it by this time.[5] Guillaumin's work, an elegant and simple composition, already shows a command of technique. All his life he used pastels in studying a scene. Later, his normal procedure was to commence with a charcoal sketch on a half-sheet of Ingres paper,

Fig. 1 *Landscape at Ivry*, 1865

3 Pissarro, *Letters to Lucien*, p. 263, n. 2.
4 Rewald, *History of Impressionism* (hereafter *HI*), p. 594.    5 Herbert, R. L., *Barbizon Revisited*, p. 151.

Fig. 2 *Barges on the Seine,* 1865

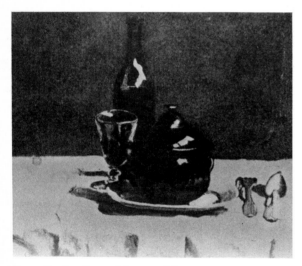

Fig. 3 *La Soupière* or *Marmite,* 1867

then elaborate the color scheme in pastel before undertaking the final painting. Throughout his career, however, he used it as well as oil for finished works of art.

By 1865, Guillaumin was a part of the ferment that was forming around the new directions in art championed by Manet. Cézanne had introduced Guillaumin to the circle of Zola, and he made the acquaintance of the habitués of Bazille's studio. Sometimes he attended the gatherings around Manet at the Café Gerbois, but in general the clerk at the Compagnie des Orléans preferred painting to discussion in the little free time he had.[6]

The first recorded painting by Guillaumin dates from 1867, though he had executed works as early as 1863—the year he exhibited in the Salon des Refusés.[7] Entitled *La Marmite* (Fig. 3), the picture shows a marmite on a plate. Just behind and to the left appears a wine glass, and behind it a wine bottle. To the right are placed a fork and a spoon. The whole arrangement is set on a table covered with a white tablecloth. The composition is austere; in placement of the table, there is a trace of the still life of Chardin. Though the arrangement is somewhat awkward, with an empty area on the left edge of the picture, shows Guillaumin's search to impose a formal order on his composition. The strictness of the order with the emphasis on the central axis, the static position of the fork and spoon, and above all the rhythm of the folds in the tablecloth, where it falls over the front of the table, recall such still lifes of Cézanne as the *Bread and Eggs* of 1865, and the *Black Clock* of 1869-71,[8] as well as the *Still Life* by Pissarro dated 1867 (Toledo Museum of Art).[9] In these three pictures heavy impasto, which seems to derive from Courbet, is evident.

Two drawings dated 1867 (Figs. 4, 5), show that Guillaumin was making use of his brief freedom to explore the environs of Paris and continuing to draw the scenes of workmen and draft horses in the region of the Quai de Bercy.

6 Lecomte, *Guillaumin,* p. 10.
7 Rewald, *HI,* p. 82.
8 Venturi, *Cézanne,* p. 69.
9 Reproduced in Rewald, *HI,* p. 156.

Ten years after his return to Paris, Guillaumin's determination to be a painter was becoming stronger every day, but he still lacked the means to devote himself fully to it. Many of the Impressionist group had some sort of financial resources. Manet, Degas, and Bazille were wealthy, Cézanne's father made him an allowance, and Pissarro's mother sent him a thousand francs a year—about the equivalent of $2,000 today. Sisley's family also helped support him, and even Monet could count on Bazille for help. Only Renoir, like Guillaumin, had no such resources. But Renoir had an extraordinary ability to keep himself in money by doing work in the decorative arts. He had been trained as a porcelain painter, and supported himself for a time painting blinds.

While out painting one day, Guillaumin met a Sunday painter who worked for the Département de Ponts et Chaussées of the city of Paris, and who advised him to apply for work there where he would have shorter working hours than those at the Paris-Orléans Railroad. Guillaumin naturally followed his suggestion and while waiting for his new appointment, decided to leave the railroad and see if he could support himself as a painter during the interim. He did not succeed, selling next to nothing, and decided to join Renoir and Pissarro, who was also now supplementing his income by painting blinds.

During this period Guillaumin painted a picture of Pissarro working on a blind in his studio (Fig. 6). What first strikes the observer here is the extraordinary similarity

Fig. 4 *Landscape sketch*, 1867

Fig. 5 *Horse*, 1867

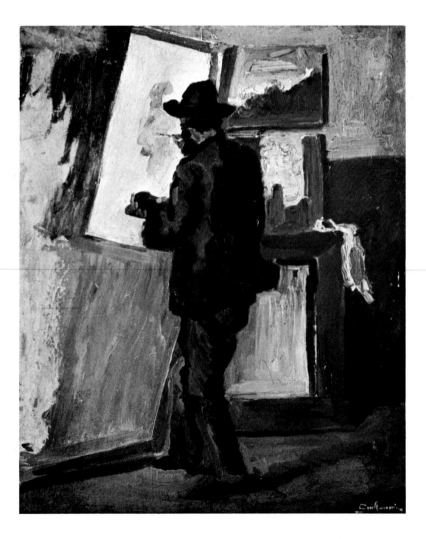

Fig. 6 *Pissarro painting a blind*, c. 1868

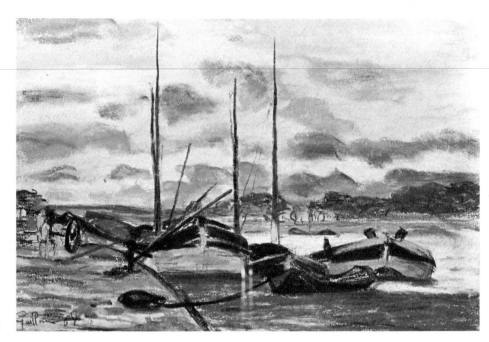

Fig. 7 *Péniches*, 1868

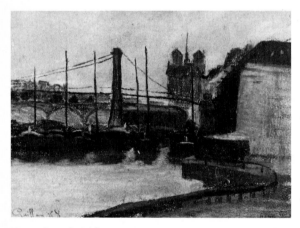

Fig. 8 *Quai de Béthune*, 1868

of Guillaumin's work to the portraits of Cézanne at this time.[10] The colors are somber, consisting largely of browns, greys, and ochres, relieved only by an accent of blue on one of the canvases hanging on the wall and touches of green on the blind Pissarro is painting. The paint is applied thickly and broadly, both drawing and modeling the form with the heavy strokes. Again, as in the drawing of 1865, the artist has shown a serious concern with composition, contrasting the orthogonals of the frames of the paintings on the wall at the right with the powerful diagonals set up by the picture frames on the left, seeking a final balance with the forceful push of the figure of Pissarro. Both the application of the paint and the composition still preserve a trace of clumsiness, yet one is struck by the power of this picture in which the artist breaks with tradition to explore new fields.

In addition, two pastels and a number of drawings, mostly scenes along the quais of Paris, were executed by Guillaumin in 1868. The pastels are scenes of barges, one in the open country (Fig. 7), the other at the Quai de Béthune (Fig. 8). In both the colors are muted with cool greys, greyish blues and black predominating. Although the *Quai de Béthune* seems somewhat overworked, allowing the pastel to become muddied, the scene of the barges is a masterly work which already shows indications of the skill that was to make Guillaumin one of the first and best of the pastellistes among the Impressionists.

One of the drawings is exceptional, for it is a study of trees in the open countryside (Fig. 9). Though it is a free and rapid sketch, it shows great proficiency in the handling of the complex forms of the tree in the foreground, and a competent establishment of space and setting.

By the end of 1868 Guillaumin seems to have got employment with the Ponts et Chaussées. At first he worked during the day, but he soon found that by volunteering for night duty (at a better wage), he would have to work only three nights a week.

10 See Venturi, *Cézanne*, pp. 72-78.

This gave him the free time he sought, though the work was neither easy nor pleasant—digging the night-soil out of the pits, where it had been dumped during the day, and carting it off. Later on he was to say that for twenty years he worked like a galley slave in order to have time for his painting.[11]

This new freedom made 1869 an active year for Guillaumin—with at least two paintings and more drawings. The first of the paintings, dated 1869 on the basis of a drawing of the same scene signed and dated that year, is entitled *Soleil couchant à Ivry* (Fig. 10). The picture is painted from a point across the bend of the Seine with the forges of Ivry silhouetted against the sunset sky, while a group of trees forms a dark mass on the right on the promontory within the bend of the river. Form by form, the painting follows the drawing except for the elaboration of the herbage in the foreground and the treatment of the sky and smoke rising from the stacks of the forges in the distance. The general color of the picture is set by the amber glow of the sky just after sunset, strong on the horizon, but grading into slatey blue toward the zenith. In many ways, except for the choice of setting, one is reminded of innumerable "Sunsets" of the Barbizon school, but there is one marked difference. The light forms in the picture which are not struck by sunlight, the sand in the foreground, and the white walls of the buildings in the distance, are tinged with violet, the color complementary to the orange of the sky. The law of simultaneous contrasts, enunciated by Chevreul, has been applied in this painting.

The other painting, done toward the end of the year, shows the same development. In *Chemin creux, effet de neige* (Fig. 11), signed and dated December 1869, we find a picture fully in the vein of Monet's *La Pie* (c. 1869, Collection of the Société Guerlain)[12] where the sunlight of the light on the snow contrasts with the shadows accented with clear touches of blue.[13] The broad brush strokes of the early phase of Impres-

Fig. 9 *Sketch*, 1868

11 Notes made by Guillaumin in margin of Dewhurst, Wynford, "Peinture impressionniste," *International Studio*, July 15, 1903, pp. 24-25.
12 Rouart, Denis, and Degand, Léon, *Claude Monet*. Translated by James Emmons (New York, 1958), p. 41.
13 The use of bluish shadows is often attributed to the application of Chevreul's law of simultaneous contrasts. Actually the effect is somewhat different from that law, and is explained by the fact that in sunlight, the shadows are lit by skylight rather than the direct rays of the sun. Skylight is considerably bluer than sunlight. In exact terms, skylight has a color temperature between 12,000 and 24,000 degrees Kelvin, while sunlight has a color temperature of only 5,400 degrees Kelvin. The higher the color temperature, the bluer the light. Kaye and Laby, Table of *Physical and Chemical Constants*, 7th ed. (New York, 1932), p. 74.

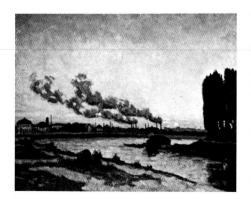

Fig. 10 *Soleil couchant à Ivry*, c. 1869

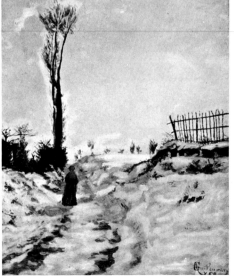

Fig. 11 *Chemin creux, effet de neige*, 1869

Fig. 12 *Bords de la Seine*, 1869

Fig. 13 *Bords de la Seine*, 1869

sionism are still to be seen, and the subdued colors of Guillaumin's early style are still dominant. Apparently the picture has suffered from a darkening in the sky by a glaze used to adjust the color. As the glaze probably was intended for a minor correction, the artist did not cover the whole of the sky too carefully. The darkening glaze has left an aureole of a lighter tone around the tree, which mars the effect. The picture was probably painted on the Route des Hautes-Bruyères, near Arceuil, and marks one of the first identifiable examples of Guillaumin's practice of taking the local train of his old employer, the Compagnie d'Orléans, to go to the suburbs to paint. During his career, Guillaumin painted near every local stop of what is now the Ligne de Sceaux and on the main Paris-Orléans line. It would be interesting to know whether he kept his "pass." Another bit of information is indicated by the painting itself. As it is dated December 6, 1869, it was done on a Thursday, showing that at least by end of 1869 he had free time to paint on weekdays.

A number of other drawings and pastel sketches testify to Guillaumin's active use of his new-found freedom. A number of scenes along the Paris quais are shown (Figs. 12, 13) but there are also some that indicate the artist's interest in getting out of the city on his sketching trips. On one occasion he went as far as the little village of Bièvres, more than ten miles by train from Paris (Fig. 14).

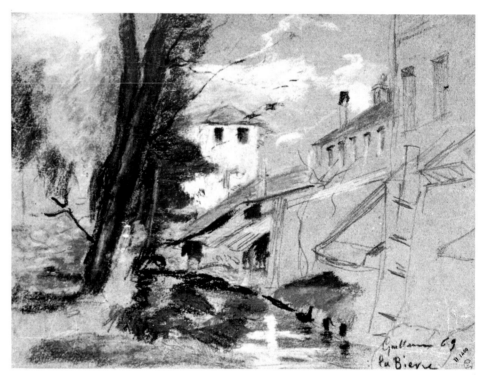

Fig. 14 *La Bièvre*, 1869

The year 1870 was critical for France and for the Impressionists. When the Franco-Prussian war broke out, Guillaumin was not drafted because his older brother was already in the army, and he served in the Garde nationale, stationed in Paris. He saw no action, and used to say ironically that he did his exercises climbing a pile of sand on the Quai de Bercy.

Naturally, he had little time to paint during the war and the Commune. The only works I have found dated 1870 are four drawings, two of his mother (Figs. 15, 16) and two of his father (Figs. 17, 18), the latter two inscribed "siège de Paris." One of the portraits of his father was done in the cellar of their home during the bombardment of Paris (Sept. 19, 1870 – Jan. 28, 1871), and is a finished drawing of considerable power, though there are certain anomalies that invite consideration. First, the placement of the figure somewhat left of center facing left, though perhaps only an error in placement by the artist, gives the figure a withdrawn aspect as it looks out of the picture, not at the observer. The execution of the features shows marked shifts of viewpoint. The axis of the nose and mouth and lower left chin is vertical, while the axis of the eyes is distinctly tipped. The left side of the figure's face is seen more nearly in profile, while the right side turns toward the three-quarters view. Plastic deformations of this nature are more or less instinctive in those who do not give a primary emphasis to

   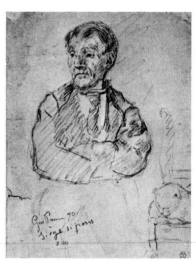

Fig. 15 *Drawing of artist's mother,* 1870   Fig. 16 *Drawing of artist's mother,* 1870   Fig. 17 *Drawing of artist's father,* 1870   Fig. 18 *Drawing of artist's father,* 1870

the idea of conceptual form, but they are remarkably close in their approach to the problem of form that was beginning to concern Cézanne.

The Commune, which followed the surrender of Paris, was a disaster for Guillaumin—most of his early works were destroyed in the upheaval. Lecomte[1] cites a wealth of portraits, still lifes and studies of the animals in the Jardin des Plantes that have disappeared, as well as Guillaumin's copies of paintings by Claude Lorrain, Rubens, and Ribera in the Louvre and Luxembourg. These copies are a serious loss for our

1 *Guillaumin* p. 27.

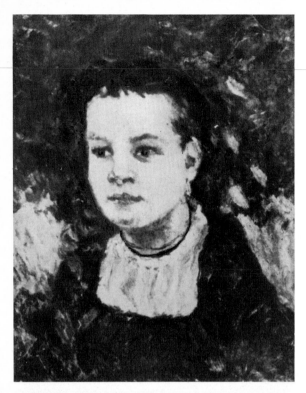

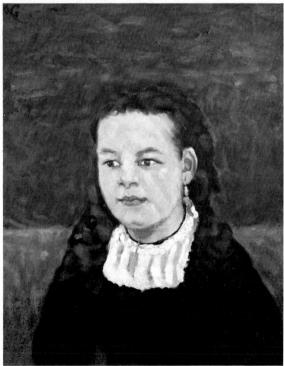

Fig. 19 A & B *Portrait of Mlle Marie-Joséphine Gareton,* 1871

knowledge of the artistic formation of Guillaumin. It is worth noting, however, that while Manet, the Realist precursor of the Impressionists, seems to have been most deeply influenced by Velásquez, Zurbarán, Goya, and Hals, all figure painters, Guillaumin, like Cézanne, copied painters more directly influenced by the great baroque tradition of Italy. His interest in Rubens suggests sympathy with the painting of Delacroix.

If 1870 had been a barren year, 1871 is marked by a resurgence of activity, even though the bloody suppression of the Commune was not achieved until the end of May. The first portrait that seems to have survived is that of a twelve-year-old girl (Fig. 19), Marie-Joséphine Gareton, who was born in Paris December 18, 1858, of parents from the Département of Creuse. Fifteen years later she was to become Guillaumin's wife.

In painting this portrait, Guillaumin first made a relatively complete oil sketch begun in 1870 in which a great change in technique appears. Instead of the thick heavy brushwork of such works as *Pissarro painting a blind* of 1867-68, the sketch is done in small touches and a more broken surface suggesting the developing style of Pissarro and Cézanne.[2] The finished portrait itself is quite different. It follows the sketch closely, but the head and shoulders of the girl occupy a relatively smaller proportion of the canvas, reducing the impact of the composition. Guillaumin has used subdued colors. The background is green, the dress is black, and the hair brown. Only in the face and in the lace collar are there light accents that bring life to the picture. The face itself, though more restricted in value range than in the sketch, is interesting; for, in spite of the unusual tightness of the drawing, there begins to appear a truly impressionist liveliness of color in the variety of greens, pinks, and blues that softly modulate the surface. On the whole the picture, particularly in the deadness of the background, fails to fulfill the promise of the sketch, but at the same time it gives promise of the richness of color to come in later works.

In addition to this oil portrait, there are other paintings, *Péniches sur la Seine à Bercy* (Fig. 20) and *La Seine à Paris, Quai de la Râpée,* both dated 1871. Here the sombre tonality of the earlier pastels of barges along the Seine is maintained. The cool greyness of the paintings express well the general appearance of the Seine, but there is little evidence of growth beyond the *Chemin creux, effet de neige* of 1869 (Fig. 11).

Another undated picture may well belong to 1871 on the evidence that it is signed with a signature that is unique and which has so far appeared only on pictures dated 1871: *A Guillaumin* with the A and the G intertwined in a monogram. Though various forms of this type of signature persist up to 1881, only in 1871 is it found with the cross bar of the A in the form of a flat V. This picture, *Place Valhubert* (Fig. 21), is a scene along the quais in front of the Gare d'Austerlitz, the old Paris station of the Paris-Orléans Railway, where Guillaumin worked for seven years. The picture is still sombre in color, reflecting the overcast winter weather, but the brushstroke is essentially changed from that of his earlier works and is similar to that of the sketch of Mlle Gareton.

The period after the war saw a tightening of the links between the artists who were to take part in the Impressionist movement. The death of Bazille had dealt a blow to his confrères of the studio of Gleyre, but other groups began to form. During 1872, Cézanne and Guillaumin worked with Pissarro at Pontoise. Pissarro wrote Antoine Guillemet: "Guillaumin has just spent several days at our house; he works at painting

2 See Venturi, *Cézanne...,* no. 128, portrait of Valabrègue.

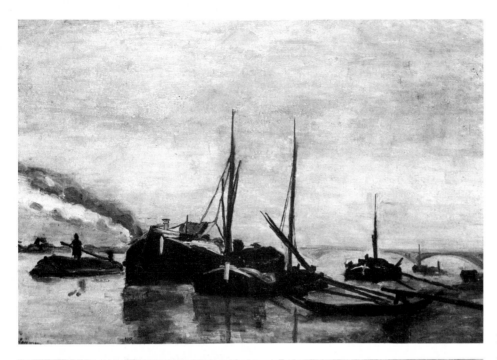

Fig. 20 *Péniches sur la Seine à Bercy*, 1871

Fig. 21 *Place Valhubert*, c. 1871

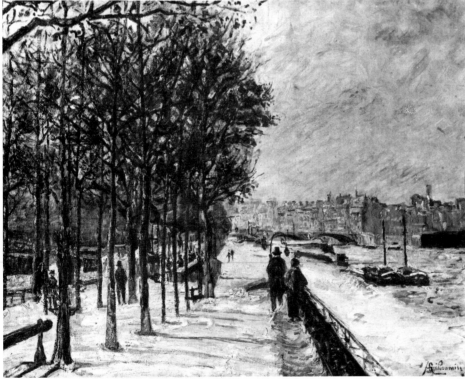

in the daytime and at his ditch-digging in the evening."[3]

Through Pissarro, Guillaumin and Cézanne met Dr. Paul Gachet, who had just bought himself a country house at Auvers, where Daubigny lived. Gachet had been

3 Rewald, *Cézanne*, pp. 93-94, from L. Vauxilles, "Un après-midi chez Claude Monet," *L'Art et les Artistes*, December 1905.

Fig. 22 *Nature morte*, 1872

Fig. 22A Cézanne's *Still life* done with Guillaumin at Auvers in 1872

Fig. 23 *Le Chemin des Hautes-Bruyères*, 1873

the physician of Pissarro's mother in the sixties and was now the company physician of the Compagnie de l'Ouest, one of the major rail systems that served Paris. He was also an amateur artist who painted and etched under the name of Van Ryssel ("from Lille," where Gachet was born). He was interested in the new movement in art and was beginning to form a collection of Impressionist works.

Guillaumin introduced his friends to Eugène Murer, once a fellow student in the Ecole communale at Moulins, who had come to Paris and established a successful café. Murer was interested in painting, and became interested in Guillaumin's friends as artists. The group had a standing invitation to come to his café on the Boulevard Voltaire, where he entertained them at dinner in the back room while they talked about art. Sometimes he gave a needy artist a hundred francs against the promise of paintings in return.

In addition to painting with Pissarro at Pontoise, both Cézanne and Guillaumin worked at the house of Dr. Gachet, where each painted a still life of objects Gachet owned. Guillaumin's *Nature morte* is signed and dated 1872 (Fig. 22). Both Cézanne and Guillaumin painted an arrangement of flowers and other objects on the same blue-flowered cloth and a dark background. Cézanne used the dark colors and heavy impasto of his earlier still lifes, but Guillaumin's picture is somewhat lighter and gayer in tone. Gachet bought both still lifes as well as Guillaumin's *Soleil couchant à Ivry* of 1869.

By far the most exciting picture of 1872 was a self-portrait in pastel. The picture has a certain effect of darkness because of the heavy green background, but the drawing is striking in its life, and the color has begun to scintillate with an atmosphere of light. To be effective, the technique of pastel demands that the colors not be overworked. The individual touches must be allowed to maintain their integrity, and the effects of blending must be achieved by an optical mixing in the eye. In short, the technique itself suggests the technique of Impressionism. But here it is the daring with which Guillaumin has brought together a range of hues to achieve a final synthesis that strikes the observer. The auburn hair alone is a blend of hues ranging to accents of vivid blues and greens. The coat collar, though giving the general effect of a dull green, shows touches of brilliant blue neutralized with orange. The shadowing of the face is done with an optical mixture of reds heavily neutralized with green. The description of the colors suggests garishness, however the balance and blending of the optical mixtures is so subtle that the effect is both delicate and luminous. (*See Frontice.*)

After his participation in the Salon des Refusés, there is no record of Guillaumin's having submitted any paintings to the Salon until 1872. That year he submitted a painting which was refused. He never sent another.[4]

During 1873, Guillaumin maintained his close relationship with Pissarro and Cézanne. Under the aegis of Dr. Gachet, Cézanne and Guillaumin undertook experiments in etching. Cézanne did not find the technique congenial, executing only three etchings, including one of Guillaumin and a copy of a Guillaumin landscape. Guillaumin, on the other hand, seems to have devoted himself wholeheartedly to etchings, completing eighteen or more.

The first plate, *Le Chemin des Hautes-Bruyères* (Fig. 23), was done in March, 1873 and was appropriately dedicated to Dr. Gachet. It is done with extreme freedom, and apparently with styli of different widths which give the etching somewhat the appearance of a drawing with a quill pen. The composition is simple, and there is little attempt at fine detail, but it is well thought out and the dark and light pattern is effective.

4 Alexandre, Arsène, *Preface to Exposition ... Guillaumin*, p. 9.

Guillaumin signed the work with the monogram AG at the bottom, right of center. The monogram is followed by the dedication, with which Guillaumin had some trouble as, of course, it had to be etched in reverse on the copper plate. In the upper left corner appears the black cat which he seems to have adopted as his symbol.

Gachet introduced him to Richard Lesclide who took a number of Guillaumin's plates of the views of Paris and its environs for his publication, *Paris à l'eau-forte* (première année 1873). On September 6, 1873, Guillaumin wrote to Gachet:

M. Richard Lesclide had told me that your etchings would appear this month, but I see no sign of them: have you finished them? If so, do send me proof. In return I shall give you those I made after you.

I still hope to go to Auvers but something always seems to prevent my doing so. However, I hope to see you before the end of September.

I have found a very obliging young man for pulling proof. He is a good worker and I shall recommend him to you if ever you need him. (*Legay, 1, rue des Grands-Degrès*).

What else can I tell you? Martin has visited me and seemed to be quite pleased with my new studies; he promised to think of me in terms of remuneration but I should like to have your opinion as well as that of Pissarro and Paul.[5]

The etchings of 1873 indicate that Guillaumin was working extensively in the environs of Paris: Bercy, Charonton, Hautes-Bruyères, Vitry, Bas Meudon, Charonne, La Platrière and Bicêtre. The mention in his letter of Martin, who was a small dealer willing to risk an investment in Impressionist paintings, suggests that, in a small way, Guillaumin was beginning to sell his works.

The year 1873 held some promise for Guillaumin, but for the Impressionists in general it was a continuing disaster. Even though Manet's *Le Bon Bock* was a great success at the Salon, only Berthe Morisot of the younger group succeeded in getting one work accepted, and that only a pastel. Indeed, among the Impressionists, only Manet and Berthe Morisot had been able to exhibit since the war of 1870. The others were consistently turned down, thus belying the promise of their gradual acceptance before the war.[6]

The indications are that the Impressionists were suffering from a number of after-effects of the war and the Commune. In the first place, the rapid repayment of the indemnity demanded by the Prussians (which was completed by the middle of 1872), had led to an economic reaction and a financial crisis in 1873 that was less than favorable to art. More serious was the nature of the political reaction. Even under Thiers, an Orléanist who only tolerated a conservative Republic, the government had put down the Commune with ferocity, but in 1873 Thiers had been overthrown by the Royalist forces, who placed the reactionary, Marshall McMahon, in power. Under McMahon, the National Assembly took the unprecedented step of reopening l'affaire Courbet. Under the Commune, Courbet had been director of the Commission of Fine Arts. In his trial by military court after the Commune, he had been condemned to six months in prison and a five-hundred-franc fine for his part in the Commune, but the court seems to have accepted his disavowal of responsibility for the destruction of the Vendôme Column. Then, in January 1873, twenty-three delegates to the National

5 Gachet, *Lettres impressionnistes*, pp. 65-67.
6 In 1872, Daubigny and Corot resigned from the jury in protest over this systematic exclusion. Monet had been accepted in 1865, 1866 and 1868. Renoir had been accepted in 1864, 1865, 1868, 1869 and 1870. Pissarro exhibited in the Salon in 1859, 1864, 1865, 1866, 1868, 1869 and 1870. Sisley had been accepted in 1866, 1868 and 1870. Now for two years all had been systematically excluded except the aristocrats Manet and Morisot.

Assembly proposed a measure condemning Courbet to pay personally for the restoration of the column, and the measure was duly adopted on May 30. This was estimated to be just under four-hundred thousand francs (approximately equivalent to $1,000,000 today).

In the meantime, under the leadership of Meissonier, the jury of the Salon had voted to reject all pictures submitted by Courbet, and they had discussed a permanent ban on his work. This vindictiveness, both on the part of the jury and of the National Assembly, shows their extraordinary horror at the very idea of Socialism.

At this time, the Impressionists were generally thought of as belonging to the Realist school, of which Courbet was the titular head, and they were generally identified as "communards," though perhaps only Pissarro had expressed sympathy with the Commune itself.[7] Barring the Impressionists from the Salon had become an article of faith of the reactionary politics of the era.

After two years, as the situation became more and more desperate, the Impressionists decided to band together to put on their own exhibition. On December 27, 1873, the founding charter of the Société anonyme des artistes, peintres, sculpteurs, graveurs, was signed by the initial members, Monet, Renoir, Sisley, Degas, Morisot, Pissarro, Béliard and Guillaumin.

7 Renoir, Jean, *Renoir, My Father* (Boston, 1962), p. 256.

The Exposition de la Société anonyme des artistes, peintres, sculpteurs, graveurs, etc., opened on April 15, 1874, in the old studio at 35, Boulevard des Capucines, which Nadar had just left for his new premises. Among the exhibitors, Pissarro had entered five paintings, Cézanne and Guillaumin had three each. Cézanne exhibited *La Maison du Pendu*, and *Une Olympia moderne: Sketch*, both of which belonged to Dr. Gachet, as well as an *Etude: paysage à Auvers*. Guillaumin exhibited *Le soir: Paysage*, *Temps pluvieux: Paysage*, and *Soleil couchant à Ivry* which also belonged to Dr. Gachet.

The furor created by this exhibition is too well known to require discussion here. Suffice it to say that in their diatribes, the critics were largely concerned with the more notorious Impressionists who had already attracted attention by their exhibitions at the Salon. Guillaumin, as an unknown newcomer, drew no comment either favorable or unfavorable.

Many of these artists were just getting started on their careers, and the critical and financial failure of the exposition of 1874 was a disappointment, but not a disaster. But to Pissarro, who had family commitments, and had already begun to establish a reputation in the official Salon, the rebuff of the exposition brought despair. In the summer of 1874, Guillaumin wrote him at Montfoucault, where he was staying with his friend Piette:

> Your letters are truly distressing, even more than your pictures which you say are so gloomy. What is it that always makes you doubt yourself? This is an affliction of which you should get rid. I know very well that times are hard and that it is difficult to look at things gaily, yet it is not on the eve of the day where all will turn better that you should give in to despair. Don't worry, it will not be long until you will occupy the place you deserve.... I do not at all understand the disdain with which you speak of your canvases; I can assure you that they are very fine and you are wrong to speak of them as badly as you do. That is an unfortunate frame of mind which can only lead to discouragement, and that, my dear Pissarro, is not right. The utmost anarchy reigns in the opposite camp and the day is near where our enemies will tumble.[1]

In a second letter he wrote:

> I am very anxious to see you and above all to talk to you. I feel that a few moments spent with you would cheer me up. To night . . . I saw one of your pictures which is a truly beautiful thing. You say that you are not doing anything worth while. I don't believe it after what I saw. I can understand that you are worrying and do not have all your heart in your work; that is probably what hinders your judgment of what you are doing. Try not to be disheartened. Better days are ahead . . .[2]

At this time Guillaumin was living with his mother at 2, Avenue Binet in Levallois-Perret. Cézanne must have been a fairly frequent visitor, for on at least one occasion his father, Pierre-Auguste Cézanne, dined with Mme Guillaumin when he had come to Paris. Since 1872, when Cézanne had had a son by his mistress, Hortense Fiquet, he had been living at 120, rue Vaugirard, a small two-story house. He seems to have shared his studio there at times with Guillaumin, for both give that address in the catalogue of the exposition of 1874.[3]

About this time Guillaumin rented Daubigny's old studio at 13, Quai d'Anjou, on the Ile Saint-Louis, which he in turn seems to have shared with Cézanne. Cézanne's

1 Rewald, *Pissarro*, pp. 29–30.
2 Ibid., p. 30.
3 Venturi, *Archives ...*, II, 255, 256.

financial difficulties in supporting, on his bachelor's allowance, Hortense and his young son Paul hardly permitted him to rent a studio of his own, where he could work without interruption from them. In this studio they entertained their artist friends, and sometimes sketched together on the quais and in the Parc d'Issy.

Though Guillaumin's job probably paid him no more than Cézanne's allowance, the security of it gave him a certain degree of independence, and he did not have to suffer the indignity of the sale that a number of the others had had to go through at the Hôtel Drouot in 1875 to raise money to live. In spite of this minimal security, Guillaumin complained that the harder he worked the less he seemed to make, and on occasion he had to borrow money from Gachet to pacify an insistent creditor. Of the twenty-two paintings acquired by his friend Murer, a number were doubtless exchanged for much-needed cash.

Guillaumin's letters to Gachet tell us of his difficulties and also of his part in the activities of the Impressionist group.[4] Cézanne and Guillaumin had abstained from joining the other Impressionists in their second exhibition at the Gallery Durand-Ruel in 1876. However, in August of the year before with Pissarro and his friend Béliard they joined a new organization, the Société de l'Union, formed by another friend of Pissarro, Alfred Meyer. The Union was intended to be a rival to the other Impressionists and in the winter of 1877 held an exhibition before that of the others had been organized. However, Guillaumin, Cézanne, and Pissarro had withdrawn from the Union and so took no part in this attempt at rivalry. Instead they all exhibited with the others in the third Impressionist Exhibition held in the spring.[5] Nevertheless, even though he had a difficult time, Guillaumin had achieved a modus vivendi that permitted him to devote the majority of his time to painting, at the cost of three nights' sleep during the week. He had a close circle of friends: Pissarro, Cézanne, Gachet, and Murer. (In 1875, Pissarro met Antonin Personnaz, a wealthy amateur of Bayonne, who began a magnificent collection of Guillaumin's paintings and who remained his friend and loyal supporter through the years.)

This time, instead of three paintings each, Cézanne sent thirteen oils and three watercolors, and Guillaumin sent twelve oils. The show took place, not in the baraque originally intended, but in an empty apartment at 6, rue Le Peletier, near Durand-Ruel's Gallery.

According to Georges Rivière, the first room contained some very beautiful paintings by Renoir, Monet, and Caillebotte. In the second hung Monet's *White Turkeys*, together with other paintings by Monet, Renoir, Pissarro, Sisley, Guillaumin, Cordey and Lamy which gave "à cette salle une gaïté inexprimable et quasi-musicale." Cézanne was shown in the Central Salon with the *Bal* of Renoir, a large landscape by Pissarro and the paintings by Berthe Morisot. Paintings by Monet, Pissarro, Sisley and Caillebotte were hung together in the Grand Salon, while in a small gallery at the back were the works of Degas and some watercolors by Berthe Morisot.

In a long review of the exposition by Rivière, which appeared in his short-lived periodical, *L'Impressionnist*,[6] he gave Guillaumin only a passing glance:

We ought to mention Messrs. Cordey, Guillaumin and Lamy ...

M. Guillaumin has exhibited some landscapes full of good qualities and certainly of good intentions.

4 Gachet, *Lettres impressionnistes*, pp. 71 ff.
5 Rewald, *History of Impressionism*, pp. 375, 390.
6 April 14, 1877, No. II, 1-7.

Because of the indefiniteness of the Catalogue titles and the omission of owners and dimensions, it is impossible to identify most of the paintings exhibited by Guillaumin, except for *Viaduc de Fleury* (Fig. 24) and *Femme couchée* (Fig. 25. *See also Color Plate Section*). The latter is a most extraordinary picture for the times, with its rich fragmentation of the flesh colors with touches of vivid greens, blues, violet and

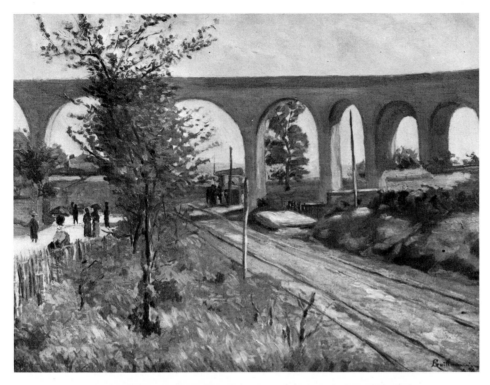

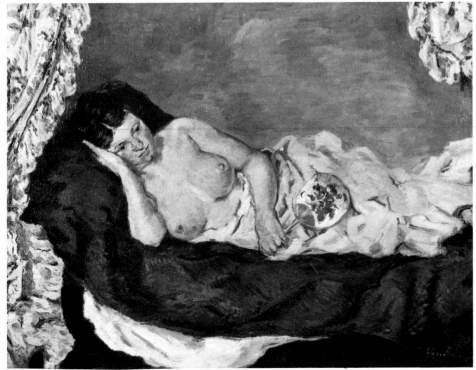

Fig. 24 *Viaduc de Fleury*, April 1874

Fig. 25 *Femme couchée*, c. 1876

red which recall the earlier works, in 1872, in pastel. As in the case of the pastels, Guillaumin has been able to achieve a synthesis of the extreme range of colors by optical fusion into a vital and luminous surface. Up to this time, he had concerned himself, as did most of the Impressionists, with colored surface, allowing color change and value change to suggest form. In *Femme couchée*, however, we find the appearance of another device, perhaps again influenced by pastel technique, that was to be used by Renoir, and more notably by van Gogh, the orientation of the brush-stroke to follow the surface contours of the form in a manner similar to that used by engravers to create the suggestion of plasticity.

The period of the late seventies was a very vital one. The first exposition of the Impressionists in 1874 had produced important results. It had brought together a group of painters who had all started out under the influence of the realism of Courbet, Corot, and Daubigny, but who were beginning to show a more penetrating interest in the phenomena of color and light as revealed "en plein air." The fact that they were now starting to break new paths in the development of art, had brought ridicule on them from the members of the official Salon and the critics. At this point they needed their group solidarity for two purposes, first to develop their new ideas in interaction with one another and second, to lessen the impact of the conservatives' adverse criticism of the individual by their mutual understanding and support of what they were trying to do. Even Louis Leroy's seizing upon the term "impressionist" to ridicule the exhibitors in the exposition of 1874 gave the group a certain sense of unity, and perhaps helped clarify their thinking about their common objectives.

The exhibition of 1874 produced a group of Impressionists all working together to explore the potential of their new approach. For a time, individual differences were less important than similarities. Each went from a simple preoccupation with the effects of light and "plein air," to a deeper and deeper study of the phenomenon of color, and a progressively more detailed breaking up of the surface of the canvas to try to reproduce the coloristic play of the natural world as they perceived it. Perhaps most characteristic of this period is the development of the microstructure of the painting in which the broad planes of color in the manner of Monet become refined into a myriad of individual colored touches. This effect begins to appear in the works of Monet about 1872, and reaches a high degree of development in the paintings of *Gare St.-Lazare* shown in the Exposition of 1877. In Pissarro's works of the period the tendency appears about 1874-75 in his landscapes at Pontoise. Cézanne follows it in his *Maison du Pendu*, shown in 1874. As has already been pointed out, this micro-structure appeared in the pastels of Guillaumin dating from 1872, but it is not until about 1876 that it appears in his oil painting. In them it is worked out with a boldness and skill that rival the experiments of the other Impressionists.

The developments of *Femme couchée* are also echoed in three landscapes Guillaumin executed in the Parc d'Issy and at Châtillon in 1875-77. *Vallée de la Châtillon sur Bagneux*, probably done about 1875 (Fig. 26), already shows a much looser brushstroke and a more detailed analysis of color than had been evident in the *Soleil couchant à Ivry* of 1872. Instead of broad opaque touches of color, in a manner reminiscent of Manet, the color is now resolved into a softly irridescent play of small areas, dryly brushed on in a complex of strokes. Though the individual colors are restrained, the modulation of hue creates a luminous richness to the autumn landscape. Probably next in the series is *Issy-les-Moulineaux: le parc* (Fig. 27), dated 1877 and inscribed: "A mon ami Personnaz." In this painting he has exploited the soft light of the region of Paris to create a picture of a delicate and shimmering tonality, in which the neutral tones are largely eliminated for areas of refined but relatively pure color. Yet, in spite of the

Fig. 26 *Vallée de la Châtillon sur Bagneux*, c. 1875

high key and the brilliant colors, he has succeeded in perfectly preserving the value pattern of the scene and has created a striking composition, which, though in a modern idiom, recalls those of his much-admired Claude Lorrain.

The third picture, *Paysage de la Plaine* (Fig. 28), while maintaining the high level of quality in composition and coloration of the previous work, shows a greater development to the structuring of form through the use of the brushstroke. The planes in the foreground of the gently sloping hillside are clearly differentiated by the direction of the stroke, the quality of the tree on the right margin is brought out, and the strong diagonal movement from lower right to upper left is balanced by the general movement created by the direction of the strokes in the sky.

As Cézanne was handling the brush in the same manner here,[7] we may assume that this development in Guillaumin is in part a result of their association at this time. Cézanne later defined one of his objectives as trying to make someting "solid" out of Impressionism. Guillaumin also sought during his whole career to create a sense of the underlying form in nature.

There are few events to record from his life in 1878. Théodore Duret mentioned him as a newcomer in *Les Peintres impressionnistes*, published in 1878, but made no comment on the quality of his painting. Guillaumin seems to have drawn away from Murer and Gachet, for there are no more letters in this period. Cézanne was in the south.

In painting, his *La Seine à Charonton* continues the advances that he had been making in previous years, but what is remarkable is the execution of a large number of portraits at this time. Des Courières records two pastels, *Portrait d'Ouvrière* and *Portrait de Femme*. In addition there is a very important *Self portrait* (Fig. 29), in which Guillaumin carries on the development of the microstructure of his painting in both subtlety of color analysis and in form orientation of the stroke. Another picture showing new tendencies is his *Portrait de Martinez* (Fig. 30), a friend of Pissarro who

7 See, for example, *Route tournant à Auvers*, Venturi, *Cézanne*, no. 178 (1875-77).

Fig. 27 *Issy-les-Moulineaux: le parc*, 1877

Fig. 28 *Paysage de la Plaine*, c. 1877

Fig. 30 *Pissarro's friend Martinez in Guillaumin's studio*, 1878

Fig. 29 *Self portrait*, 1878

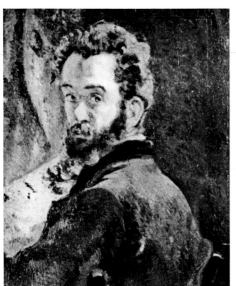

is shown in Guillaumin's studio. Not only is this work a fine portrait, but it also shows the development of a color harmony that Guillaumin was to favor in his later works, a balance achieved by the play of color around two poles, the complementaries red and green—the same color combination generally used by Delacroix. The painting tells us something about tastes at this time, for we find on the wall a Japanese porcelain bowl with a paper fan. Most of the Impressionists of this period were fascinated with all things Oriental; a fascination that was stimulated by the imposing exhibits of the Japanese Imperial Government at the Exposition of 1878. A number of Impressionists and post-Impressionists were strongly influenced by Far Eastern art. Guillaumin, though he appreciated the art of the Orient, seems to reflect none of their aesthetic principales in his own work. Like that of his friend Cézanne, his art remains firmly rooted in the Western tradition.

For some reason Guillaumin did not take part in the Impressionist exposition of 1879. Of the original group, only a few exhibited: Monet, Degas, and Pissarro. Sisley, Renoir, and Cézanne did not take part, for they had submitted works to the Salon that year. During the year, Guillaumin continued to paint landscapes around Paris and worked on scenes of the quais. Apparently, he was now supplementing his income by doing portraits, as was Renoir.

By 1880, he was prepared to enter the exposition in the spring with twenty-two entries. Of the old-line Impressionists, only he, Degas, and Pissarro took part. Cézanne, Monet, Renoir, and Sisley all abstained. Among Guillaumin's entries there were listed a number that had already been purchased by collectors; seven of his entries were portraits, of which three were in oil and four in pastel. The rest were scenes of Paris and its environs.

Again the critics largely ignored him. Apparently the only one to mention him was Zola. In the second of a series of articles, "Le naturalisme au Salon," in *Le Voltaire*, (June 19, 1880) he wrote:

> Messrs. Pissarro, Sisley, and Guillaumin are following M. Claude Monet . . . they have applied themselves to render spots of nature around Paris in true sunlight without recoiling from the most unexpected effects of coloration.

Extraordinary among the works of Guillaumin is a series of drawings and sketches of "cribleurs du sable," which were executed in and around 1880 (Figs. 31 ff.). At least six of these studies exist, ranging from charcoal drawings and pastels to an oil sketch on paper. It is remarkable that the same figure in an identical pose appears in all of them. Later in life he was to assert that he had always worked directly from life, but the nature of these drawings indicates that in this instance this was not the case. The earliest is probably the pastel with the single figure (Fig. 31), as it is the smallest, and is evidently supplied with a grid for enlargement on another sheet of paper. Possibly done at the same time, is another pastel on a half-sheet of grey Ingres paper (Fig. 32). In this latter work, the treatment of the folds of the trousers differs slightly from the first. The right elbow has been crooked more, and the left arm is straighter. In addition, the shirt is plain white instead of striped, and covers the arms nearly to the wrists instead of stopping at the elbow. Finally, in the hair, there is not the prominent forelock that marks the small sketch. However, when we pass to the other sketches of the series and note the same elements, it appears that all are closely related to the first in all these details.

Probably the next drawing is that in which Guillaumin introduces, in addition to two versions of the original figure on slightly different scales, a second figure of a cribleur (Fig. 33), from which the oil sketch on paper seems to have been worked out

Fig. 31 *Cribleur du sable*, 1880

Fig. 32 *Cribleur du sable*, 1880

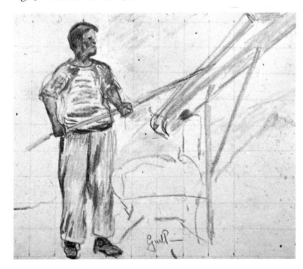

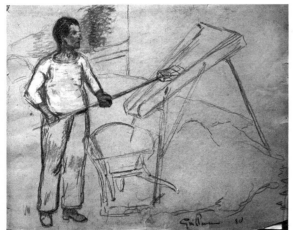

(Fig. 34). In a number of ways, but most particularly in the placements of the two wheelbarrows, this one is unsatisfactory.

Perhaps the final sketch in the series is the pastel variant in which Guillaumin has changed the location of the wheelbarrow of the original cribleur, and has turned the figure of the second slightly to the left (Fig. 35). As even this sketch is still spatially anomalous, it seems possible that he gave up the series at this point as a bad job.

In understanding this attempt on Guillaumin's part to construct a composed picture rather than a recording of nature, there are a number of factors to be considered. Both he and Cézanne had given serious thought to studying at the Beaux-Arts in the sixties. Cézanne, with his avowed interest in "doing over Poussin after nature," had executed many composed figure pieces in the last few years. In the first years of the 1880s, Pissarro also had turned to executing figure studies in an important way. Renoir was working largely with figure compositions. Finally, Guillaumin himself had been working more and more with the figure and had recently done a number of portraits. Since the late 1860s, he had been drawing scenes along the quais in which figures played an important part. It would seem almost inevitable that he should consider doing a picture in which the figures were the central element.

Yet this kind of picture was a contradiction. As did Cézanne, Guillaumin suffered from the lack of models. To be sure, he had the cribleurs of the Quai de Bercy, but they had their jobs to do, and could hardly be expected to return to a fixed pose whenever the artist might need them. He had essentially to reconstruct his scene according to academic principles, no matter how much the idea might have come from nature, but in doing so he betrayed the idea of Impressionism. It became no longer the concern with true color and light as the artist observed it but an attempt to create a plausible effect. For Cézanne, who had his theories of the modulation of color in relation to form, such a thing might be possible, but for Guillaumin who put his trust in the sensitive perception, such an approach must have appeared fruitless. In any case, though the artist was to continue to draw portraits and figures all his life, he never tried it again.

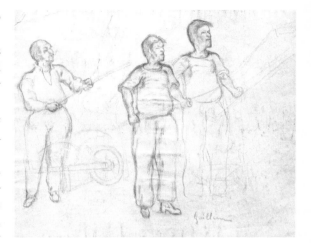

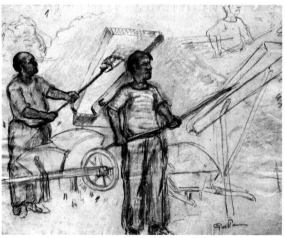

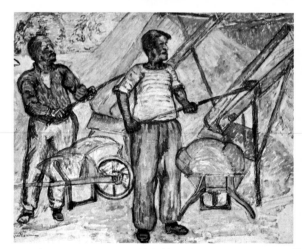

Fig. 33 *Cribleurs du sable*, 1880

Fig. 34 *Cribleurs du sable*, c. 1880

Fig. 35 *Cribleurs du sable*, c. 1880

## 4: 1881–1885 / Toward Recognition

The break that was becoming more apparent with each exposition between the group around Pissarro and that around Degas came into the open in 1881. When the possibility of a new show was being discussed in January the only two artists devoted to the common cause were Pissarro and Caillebotte. Again, Monet, Renoir, Sisley, and Cézanne abstained. Caillebotte had proposed that the exhibitors be limited to "Pissarro, Monet, Renoir, Sisley, Mme Morisot, Mlle Cassatt, Cézanne, Guillaumin; if you wish Gauguin, perhaps Cordey and myself."[1] However, the abstention of the four forced the hand of the group, and again Degas and his friends made up a major part of the exhibition.

Pissarro, with twenty-eight works, was the largest exhibitor, but Guillaumin, with sixteen, was next. Among his usual entries were included five portraits, of which four were pastels. One of the paintings, *Quai Sully*, had been bought by Paul Gauguin, a newcomer who had first exhibited with the Impressionists in 1879 at the invitation of Pissarro and Degas.

This year Joris-Karl Huysmans wrote a review of the Impressionist show. In his debut as a critic of Impressionism in the Exposition of 1880, he had little praise for anyone but Degas and his school. In 1881, he highly praised Pissarro, and the painting of Paul Gauguin, the *Nude Sewing*. Of Guillaumin, he had this to say:

> M. Guillaumin is also a colourist, and what is more, a fierce one. At first glance his canvases are sludges of combating tones and worn contours, an accumulation of vermilion and Prussian blue stripes; step back a little and at a second glance everything falls into place: the scheme becomes surer, the loud tones become calm, the clashing colors become reconciled and we are amazed at the unforeseen delicacy of certain parts of his paintings. His *Quai de la Râpée* is especially surprising from this point of view.[2]

In many ways the most interesting work executed in 1881 is the *Vue de l'Ile Saint-Louis* (Fig. 36), a still life in front of the open window of Guillaumin's studio on the Quai d'Anjou, showing the roofs of the city through the open window. The picture is composed of three definite areas in space, the still life in the foreground, the flowers in the flowerbox just outside the window, and the stretch of deep space beyond. The extreme force of the space recession is tempered by the emphasis on strong lines parallel to the picture frame and the change in size of object with distance. The large forms of the roof tops, diminished by perspective, fit in pattern scale with the flowers in the middle ground, which in turn relate to the forms on the table, creating an overall effect of surface pattern. Against this is played a secondary theme of movements in recession beginning with that of the table in the foreground, which is in part controlled by the placement of the two apples in the left foreground. General movement along the table top from right rear to left front is countered by the tendency toward the emphasis of the organization of the pitcher, plate, and fruit grouped on the right. While the directional axis of the pitcher neck, spout, and handle is allowed full play, the front edge of the platter under the pitcher has been raised slightly to create a quieter sweep than would the full form of the perspective oval. The tension of the forms on the foreground has been to a great extent resolved, but the artist has utilized a small residual movement of recession, which gives a suggestion of third-dimensional movement and, proceding from lower left to upper right, is played against the strong visual tension between the accent of the pitcher and the sunflowers in the middle ground on the left, which is reinforced by the spray of foliage reaching downward from the sunflowers

1 Rewald, *HI*, p. 477, from unpublished document.
2 " L'Exposition des Indépendants ", *L'Art moderne*, pp. 261-62.

Fig. 36 *Vue de l'Ile Saint-Louis*, c. 1881

toward the pitcher. Finally, the movement created by the tension between sunflowers and pitcher is countered and carried back into deep space by the receding diagonal of the roof behind the sunflowers.

As a result of this subtle composition, Guillaumin has created a picture that at once obeys the demands of a decorative organization of the surface while still preserving the suggestion of the amplitude of space. In working out, either logically or intuitively, a composition of this complexity, he has shown that his approach to painting was passing beyond the simple goals of realism to a recognition of the aesthetic value inherent in the structure of the painting itself. It is perhaps significant that in 1881, in a still life, a far more tractable subject, he achieves those aspects of composition that had eluded him in the *Cribleurs du sable* of the previous year.

The plans for the Impressionist exhibition of 1882 were hampered by dissentions within the group. Gauguin, partly because he was at this time a wealthy amateur, played a role in the organization of the exposition and he was adamant against Degas' camp, and Raffaëlli in particular. On December 14, 1881, he wrote Pissarro:

> In spite of all my good will I cannot continue to serve as a buffoon for M. Rafaelli and company. I beg you to accept my resignation. From now on I shall remain in my corner. I believe that Guillaumin feels the same way, but I do not wish in any way to influence his decision.[3]

If Guillaumin, as Gauguin implies, objected to the adherents of Degas, Monet and Renoir objected to Pissarro. On the 26th of February, Renoir wrote to Durand-Ruel:

> To exhibit with Pissarro, Gauguin, Guillaumin, is as if I were to exhibit with no matter what social group. A little more and Pissarro will invite the Russian Lavrof or another revolutionary. The public does not like that which smells of politics, and I do not want, at my age to be a revolutionary.[4]

Monet refused to exhibit without Renoir. Finally, the latter wrote to Durand-Ruel that he would accept:

> I... hope that these gentlemen will drop the ridiculous title "Indépendants." I would like to tell these gentlemen that I am not going to give up exhibiting at the Salon. This is not for pleasure, as I told you, it will dispel the revolutionary taint which frightens me... Since I exhibit with Guillaumin, I may as well exhibit with Carolus-Duran.[5]

Finally, a group of exhibitors was worked out including Caillebotte, Gauguin, Guillaumin, Monet, Morisot, Pissarro, Renoir, Sisley, and Vignon. It turned out to be the most comprehensive exhibition of those who were properly called Impressionists since the first exposition in 1874.

That the exposition took place at all was largely due to the insistence of Durand-Ruel. The reason for this was simple: he had suffered financial disaster and saw the exposition as one of the only chances of reestablishing himself. In 1880, Durand-Ruel had won a new adherent by the name of Feder, who was the director of the bank, L'Union générale, which was undergoing an extraordinary expansion during this period of economic boom. With Feder's financial help, Durand-Ruel had heavily invested in painting in anticipation of sales that might be stimulated by the period of affluence. Then, on January 11, 1882, the boom was ended by the failure of the Banque du Rhône

3 Rewald, *HI*, pp. 465-67, from unpublished document.
4 Venturi, *Archives* ..., I, 60-61.
5 Rewald, *HI*, pp. 468-69, from *Cataloque d'Autographes*, No. 61, Marc Loliel, Paris, 1936.

et de la Loire,[6] followed a week later by the failure of the Union générale and then the failure of the Crédit de France and the Crédit général français. All Feder's fortune was lost trying to stem the fall of his bank, and he even called upon Durand-Ruel for support.[7] The crash was the most serious economic crisis that the Third Republic was to undergo in the nineteenth century and its effects lasted until 1885.[8] Its influence on the lives of the Impressionists was considerable.

In the exposition of 1882, Guillaumin had twenty-six entries, of which half were pastels. Pissarro had thirty-six, Monet thirty-five, Sisley twenty-seven, and Renoir twenty-five. Again Huysmans gave Guillaumin hesitant praise:

> The chaos in which he has struggled for so long is slowly clearing. As far back as 1881, solid parts began to emerge in the stormy colors of his paintings; impressions of lively settings began to appear. His *Paysages de Châtillon* and the *Abreuvoir du quai des Célestins* are now almost balanced but M. Guillaumin's eye stays singularly agitated when considering the human face. His lavish rainbow colors appear once more in his portraits and brutally rend his canvases from top to bottom.[9]

Nor is Guillaumin the only one to suffer from this complaint: under the section devoted to Monet, Huysmans goes on:

> M. Monet has hesitated a long time, releasing short improvisations, hastily doing bits of landscapes, bitter salads of orange rinds, green onions and blue ribbons, all this resembling the flow of a river. This artist's eye was surely exasperated....[10]

During the rest of 1882, Guillaumin followed his usual routine. In 1883, no exhibition was planned. Instead, Durand-Ruel proposed a series of one-man shows of the work of Monet, Renoir, Pissarro, and Sisley. (Not until 1894 was he to consider a one-man show of Guillaumin's work.)

In January, 1883, Paul Gauguin quit his job as a banker to become a full-time painter. There are indications that he too was a victim of the crash of the Bourse in 1882.[11] In March, he stayed with Pissarro at Osay, where Guillaumin visited them. During the year, Guillaumin continued to paint on the Paris quais and in the environs of Issy, as well as venturing further out of the city.

In the spring of 1884, Pissarro moved further out of Paris to Eragny, and Gauguin was at Rouen, where he was more or less out of the group around Pissarro. However, Gauguin was anxious to maintain the solidarity of the Impressionist group, and wrote to Pissarro to be sure that Guillaumin was included in the monthly dinners.[12]

In May, Guillaumin decided to exhibit with the newly formed Groupe des artistes indépendants. The exposition opened on May 15. In addition to Guillaumin, Odilon Redon, Georges Seurat, and Paul Signac were among the exhibitors. Paul Signac was a young painter who, since 1880, had admired the works of Monet and Guillaumin. Unable to study with Monet, he had introduced himself to Guillaumin while the two of them were painting along the Paris quais. They formed a lasting friendship.

In June, the artists who had taken part in the exhibition of the Groupe des artistes indépendants rebelled against the loosely run committee, and, under the leadership of Odilon Redon, set up a new organization, the Société des artistes indépendants,

6 Perruchot, *Gaugin*, p. 85.
7 Venturi, *Archives ...*, II, 210-13.
8 Ibid., 247.
9 Huysmans, *L'Art Moderne*, Appendice, p. 289.
10 Ibid., pp. 291-92.
11 Perruchot, *Gaugin*, pp. 85 ff.
12 Rewald, *HI*, p. 493, from unpublished document.

which planned an exhibition for December of 1884. Again Guillaumin took part, as did Seurat, Signac, Redon, and Gauguin's friend Emile Schuffenecker. Apparently Gauguin had left for Denmark before the opening of the show. Guillaumin wrote Gauguin in Copenhagen reporting on the show, and stating that Schuffenecker wanted to buy one of his pictures that was already reserved. In January, Gauguin wrote back to Schuffenecker that he ought to choose another painting to buy from " cet pauvre artiste rempli du talent."[13]

During the spring of 1884, Guillaumin continued to paint in the environs of Paris, particularly at Epinay and Damiette. That summer, he introduced Signac to Pissarro in his studio. As Seurat was away, painting at Grandcamp, Signac undertook to explain the latter's theories to Pissarro who was much interested. Later on, in October, Guillaumin introduced Pissarro to Seurat at Durand-Ruel's.

In 1885 there was a retrospective exhibition of the works of Delacroix at the Ecole des Beaux-Arts. Monet had seen Delacroix at work in his studio in 1863. Delacroix's influence as a colorist seems to show its effects in the early work of the Impressionists, but the general search for a higher saturation of color in their canvases from 1885 on may stem in part from the effect of this restrospective.

By the summer of 1885, Gauguin had returned to France from Denmark, and re-established relations with Guillaumin. Now that Pissarro had moved to Eragny, Guillaumin's studio had become a center for the younger group that was forming around Pissarro. Cézanne had rented a studio in Paris at 15, Quai d'Anjou, next door to Guillaumin, who remained at number 13.[14] It was possibly at this time that Cézanne copied one of his old friend's scenes along the Paris quais.

13 *Lettres*, p. 44.
14 Perruchot, *Cézanne*, p. 230.

In the first half of the 1880s, new forces were gathering which were to change the future course of art. A younger group was beginning to form around Pissarro, who had originally more or less assumed the leadership of a small group including himself, Guillaumin, and Cézanne. By the 1880s, the other Impressionists were drawing further and further away from any participation in group activities, and the newcomers tended to join those who adhered to Pissarro. In the seventies Gauguin had met Pissarro, and by 1879, he was taking part in the expositions of the Impressionists, and cementing his relationships with Pissarro, Cézanne, and Guillaumin, all of whom he admired. As early as 1880, Paul Signac, later a neo-Impressionist, had admired the works of Monet, Renoir, Pissarro, and Guillaumin. By 1884, the neo-Impressionists, Seurat and Signac, had joined the group around Pissarro.

Pissarro held the role of chef d'école, but it would be false to assume that Guillaumin had no influence on the younger artists with whom he had, after 1884, a much closer contact than did Pissarro. Nor was the influence entirely one-sided. Guillaumin himself was open to the new ideas of the younger generation of artists, and during this period a decided change can be noted in his work.

In about 1883, Guillaumin started working at Damiette, outside Paris. Unfortunately, the pictures are seldom dated, but a number can be attributed to about 1885-87 on the basis of the unique signature he was using at that time. In these pictures Guillaumin begins to show certain deviations from the normal color balance of Impressionism—he seems, by this time, to have developed the predilection, which was to become his habit, for painting in the early morning and evening hours. In a normal Impressionist painting, executed toward the middle of a sunny day, the play of yellowish sunlight in the high-lights against the bluish skylight in the shadows tinges the whole picture with a dominant yellow-blue polarity. However, in those hours in which the sun is near the horizon, the quality of the sunlight is much more orange, and it gives the whole landscape an orange cast. This effect can easily be seen in any color photograph taken under these conditions without correcting filters. Nevertheless, in the same way the eye can adjust itself for the extreme yellowness of artificial light, it adjusts for the yellowing of the light both at dawn and dusk. The yellowness of early morning and late afternoon light is caused by the gradual elimination of the blue element in the light as the sun approaches the horizon. Yet, as in the case of artificial light, the observer is rarely aware of the yellowness, for subjectively "white" remains white. To achieve this result, there must be a relatively strong suppression of the complement of blue—yellow. Then the remaining colors of the spectrum, red and green, being complementary hues, will, when added, give the effect of white light. But, under these conditions, the light reflected from red or green objects will appear relatively more intense than under normal conditions.

The same polarization of color around an orange-red and a blue-green and a search for color rather than luminosity appears in Gauguin's works after his return to France in June, 1885. It should be remembered that Delacroix had made this polarity the basis of many of his pictures. Its appearance in the works of Guillaumin and Gauguin may have been stimulated by the renewed interest in Delacroix brought about by his retrospective in March and April of 1885, though Gauguin did not return to France until June of that year.

At the same time Guillaumin was developing the preference for painting in the early morning and late afternoon, another change became apparent in his work. The luminous pictures of the late seventies, in which he still followed the Impressionist search for light, were gradually replaced by paintings in which the search was directed more toward color.

In 1885 the Impressionist group dispersed. Cézanne left Paris for Aix; Monet had gone to Giverny. Pissarro, now at Eragny, was absorbed by neo-Impressionism; Renoir was turning more and more toward classical art. Gauguin, returning from Copenhagen, was searching to create a new approach to art that would soon be called Synthetism. Guillaumin's works were also marked by a number of changes, not apparently radical, but they are important as indicators of the new attitudes he was developing.

One of the most important Guillaumin pictures of this new phase is *Le chemin vers la vallée* of 1885 (Fig. 37). In this picture the greater density of color is immediately apparent, even though the total effect is still restrained: the range of color on the earth in the foreground is touched with brilliant emerald green and vermilion. Strong accents

Fig. 37 *Le chemin vers la vallée*, 1885

of color are used, but the picture has, nevertheless, a great sense of solidity and structure. The space in the foreground is created by the lines of the road receding from lower right toward the left, but the dominant movement is controlled by the opposing diagonals of the shadows of the trees. In the middle ground the movement of space is controlled by the counterplay of the diagonals of the mountain forms receding to a distant horizon. In the foreground the brushstroke is designed to give the effect of rough herbage and ground; but in the middle ground the brushstroke is used to define the planes of the receding hills, while in the sky, the general direction of the brushstroke is designed to create a countermovement to that of the middle ground, until the sense of direction of the movement of the sky is gently arrested at the top border of the picture by introducing a cross brushstroke. In addition to this careful structuring of the picture, which passes beyond the usual Impressionist approach, the elegance of the calligraphic line in the trees, together with the rhythms of their forms, also suggests a concern with the formal structure of the picture.

In Guillaumin's search for more powerful coloristic effects in the mid-eighties, he never allowed the light and dark values to be falsified, which perhaps explains why his works, in contrast to certain ones by Monet, generally carry well in black and white photographs. He controlled the form and composition to supply the framework on which he could paint with the most powerful color effects in his later life, without his pictures falling to pieces—he felt that composition ought to be second nature to an artist.

Like the other Impressionists, Guillaumin used smaller and smaller brushstrokes through the period of the eighties. Early in the eighties, there was less tendency for the brushstroke to follow the form as it had done in the period about 1875-78. From 1885 onward, however, he began to tighten up his drawing with a careful organization of the brushstroke again.

Typical of this development is a still life of 1885, *Vase de chrysanthèmes* (Fig. 38), where the structuring of the flowers with the brush is clearly apparent. The painting of the green drapery in the background follows the same tendency strongly, even suggesting some of the works of Renoir at this period. Yet, there is still an element in the draughtsmanship and the somewhat astringent color harmony that suggest the magnificent flower paintings of Vincent van Gogh.

In early 1886 Guillaumin was very active arranging an exhibition. As early as December 1885, Pissarro had written to Monet: "All of us, Degas, Caillebotte, Guillaumin, Berthe Morisot, Mlle Cassatt and two or three others would make an excellent nucleus for a show."[1] However, Pissarro, who had now adopted the technique of the neo-Impressionism of Seurat and Signac, insisted that these two new artists be included. Berthe Morisot and her husband, Eugène Manet, wanted to exclude them. Throughout March, Pissarro and Guillaumin, as two of the original Impressionists, discussed plans with the Manets—difficult because Manet's financial support was needed. In addition to Seurat and Signac, Guillaumin also proposed the inclusion of Odilon Redon, whom he had met at the organizing meeting of the Société des artistes indépendants. Finally the show was to open May 15th in Paris. Monet, Renoir, and Sisley refused to exhibit with the rest, leaving only Guillaumin, Morisot, and Gauguin to represent Impressionism. Guillaumin showed twenty-one paintings, Gauguin nineteen, and Pissarro's twenty entries indicated his adoption of the theories of Seurat.

Another complication was that Durand-Ruel was planning a showing of Impressionists in New York, to open in March. The painters for whom Durand-Ruel was

Fig. 38 *Vase de chrysanthèmes*, 1885

---

1 Pissarro, *Letters ...*, 64.

the regular dealer—Monet, Pissarro, Renoir, Degas, Sisley, and Morisot—made up the bulk of the exhibition; but Guillaumin was also represented, and Durand-Ruel included a few pre-pointillist paintings by Signac and Seurat.[2]

During the spring of 1886, Vincent van Gogh had arrived in Paris. Up to this time Vincent had undergone almost no influence from Impressionists. Later (summer, 1888, from Arles) he wrote to his sister about his first reactions to their work:

When one sees them for the first time one is bitterly bitterly disappointed, and thinks them slovenly, ugly, badly drawn, bad in color, everything that's miserable.

That was my own first impression too when I came to Paris, . . . And when there is an exhibition in Paris of Impressionists only, it is my belief that a lot of visitors come back from it bitterly disappointed.[3]

But Vincent's brother, Theo, as manager of Goupil's Paris branch, had begun to invest in Impressionist paintings. Portier, "broker" in paintings, introduced Guillaumin to the brothers van Gogh, who lived in the same building, in 1886, and Vincent soon developed a great admiration for Impressionism. As Pissarro spent most of his time at Eragny, and Gauguin was away in Brittany or in Panama, except for a few months in the winter of 1886-87, Guillaumin was the Impressionist who had the closest relations with Vincent during his two years in Paris.

In June, Gauguin, Guillaumin, Seurat, and Signac were planning to submit paintings to the exposition of the Indépendants, but in August, Pissarro wrote Signac:

I am not surprised that Guillaumin and Gauguin no longer follow you to the Independents. Gauguin, it seems, is much less embarrassed at this time . . . I hope that in succeeding he will be a little less sectarian . . . Nothing calms superheated natures like good business. As to my old friend Guillaumin, I am sorry about it for him. He sees intrigue in our struggle. That is absurd. We have no need of that.

At this time, Gauguin, who was never easy to get along with, was under great stress, and he acted as a disruptive influence on the group that had gathered around Pissarro. On June 16, Seurat wrote to Signac:

Degas had Portier say that he would be at the Rue Lafitte on the fifteenth at 6 o'clock in the evening. Under the influence of Gauguin, neither Pissarro nor I (and I regret it) replied. It is a rare lack of politeness. Pissarro is very irritated about it . . .

Guillaumin is slightly mad at me. Apparently to him I am working like Raffaëlli. The other evening he became angry with Fénéon (the article) because he had more to say to him about Dubois-Pillet, wished him in the *avant-garde* of Impressionism. Having misread, Guillaumin said to me: "Dubois-Pillet is no more in the *avant-garde* than you and than Signac."[4]

Further friction was caused by the fact that Signac had lent his studio to Gauguin while he was away without warning Seurat, who refused to let him in. Gauguin was furious, but, though both he and Guillaumin decided at the last moment not to show at the exposition of the Indépendants which opened August 20, Guillaumin seems to have been happy to join Pissarro, Seurat, and Signac in an exposition at Nantes which started October 10.[5]

By November, Gauguin was again worrying Pissarro, who wrote his son Lucien:

2 Venturi, *Archives ...*, II, 215-16.
3 Van Gogh, *Complete Letters*, W4 (Appendix), IV, 432.
4 Dorra, Rewald, *Seurat*, p. XLVII-XLIX.
5 Ibid., p. LI, note 20.

Lately I have been going with Signac, Seurat, and Dubois-Pillet to *La Nouvelle-Athènes*; entering one evening, we saw Guillaumin, Gauguin, and Zandomeneghi. Guillaumin refused to shake hands with Signac, so did Gauguin . . . Guillaumin came over to shake hands and asked whether I was going to dine with the Impressionists on Thursday.[6]

But Guillaumin, in taking Gauguin's side in the argument over Signac's studio, soon found himself deserted in turn by Gauguin, for in November, Pissarro had written his son: "Gauguin has become intimate with Degas once more, and goes to see him all the time . . . He has forgotten what he told me about the egotism and common side of Guillaumin."[7] Degas, the introverted aristocrat, had never been able to get along with a painter who was a republican and a ditchdigger. Gauguin, at the same time, was beginning to outgrow Impressionism, as was Guillaumin, but their paths lay in different directions.

6 *Letters* ..., pp. 82-83.
7 Ibid., pp. 81-82.

# 6: Art and Philosophy

By 1886 a vast change had taken place in the milieu that surrounded the Impressionists. They had begun their careers in the late eighteen sixties and early eighteen seventies when the aesthetic climate of France was dominated by the Realists; Courbet had been their inspiration, and Zola had been their supporter. By 1885 the situation had changed, and a new group soon to be known as the Symbolists represented the avant-garde in literature. Here we find Huysmans, who had been a disciple of Zola, and Mallarmé, both of whom were closely associated with the Impressionists.

In addition to the change in the literary people around the Impressionists, the group of painters was changing its outlook as well. Robert Rey, in *La Renaissance du sentiment classique dans la peinture française*, has shown how Renoir, Cézanne, Seurat, and Signac all returned to a classic conception of art. Pissarro, as explained before, had left the fold to follow the new ideas of Seurat and Signac. The return to classic art and the advent of neo-Impressionism were not the only tendencies that were tearing them apart.

Durand-Ruel said of Guillaumin's painting in the exposition of 1886 that he was doing Fauvist paintings before the term was invented. Guillaumin was not alone in being accused of Fauvism by Durand-Ruel, for in his *Memoirs* he wrote of Monet: "The paintings of Bordighera are characterized, in effect, by an exaggeration of the color. The impression received from nature is no more than a basis for daring the relation of pure hues. . . . His style verges on that of the Fauves of 1905."[1]

As early as 1880, Zola, who had been one of the few critics favorable toward the Impressionists, had begun to realize that the public was, to a large extent, unable to relate the works of the Impressionists to what they saw in nature:

> And what a stupefaction for the public when one places it in front of certain canvases painted in the open air, at particular hours: it stands open-mouthed before blue foliate, violet stretches of ground, red trees, running water with all the gaudiness of the colors of the prism. Nevertheless, the artist has been conscientious; he has, perhaps by reaction, exaggerated a little the new hues which his eye has established; but the observation is basically of an absolute truth.[2]

By 1885, Zola himself broke with the school of painters whom he felt were no longer following his ideals in art. This problem of what constitutes truth still plagues the criticism of the Impressionist school as it developed after 1885.

Sérullaz writes:

> Every great artist usually goes through a period of fulfillment during which a painter creates a personal idiom in which he can give rein to complete expression. . . . The greatest painters continue to develop by a process of renewal, whereas other—not devoid of genius moreover, and Corot and Monet are among them—take refuge in their style which, in spite of them, degenerates into a process, a formula, and sometimes, worst of all, into theory. . . . Monet's painting between 1889 and 1890 provides a typical example. . . . Up to his death in 1926, Monet . . . struggled to recreate his universe. Under the illusion that he was re-inventing the real which he had discovered so miraculously, he now . . . plunged into a fantasy of his own. . . . He finally painted compositions which were nothing more than abstractions.[3]

Sérullaz's criticism of the tendencies of Monet's late work essentially attacks the artist for no longer revealing nature as it appears to the Realist, but rather creating a

---

1 Venturi, *Archives ...*, I, 76. Cf. Bordighera (1884) in Potter Palmer Collection, The Art Institute, Chicago. Reproduced in color in Taillandier, *Monet*.

2 "Le Naturalisme au Salon: II," in *Le Voltaire*, June 19, 1880.

3 *The Impressionist Painters*, p. 75.

poetic interpretation of his own inward vision of his dream of nature. Perhaps that, too, has its value—a value that may surpass objective reality just as much as did the late works of Turner which were rejected on the same basis by Ruskin.

George Moore's appreciation of one of the pictures of the Damiette series is more just in his evaluation of what he called the "more vigorous painting of Guillaumin:"

There life is rendered in violent and colorful brutality. The ladies fishing in the park, with the violet of the skies and the green of the trees descending upon them, is a chef d'œuvre. Nature seems to be closing about them like a tomb; and that hillside —sunset flooding the skies with yellow and the earth with the blue shadow—is another piece of painting that will one day find a place in one of the public galleries; and the same can be said of the portrait of the woman on a background of chintz flowers.[4] (*See fig. 25 Color Plate Section.*)

Or again, Félix Fénéon:

M. Armand Guillaumin. Immense skies: superheated skies where clouds jostle each other in the battle of greens and purples, of mauves and of yellows; others, now in the twilight, where on the horizon rises the enormous amorphous mass of low clouds striated by oblique winds. Under these sumptuous skies are anchored, painted by brutal *empatements*, violet country-sides, alternating tilled field and pasturage: trees rustle on the slopes fleeing toward some houses surrounding kitchen gardens, towards some farmyards where the tongues of wagons stick up. Implanted in some leafy fields, some men and some women are fishing in the shade of a collection of fruiting shoots, the undulating reflections of the little river amplify themselves in ellipses which carry away the renascent water. Among some trees and flowers, under the canopy of the garden some plump-cheeked hearties read, sleep, rest their flesh in wicker armchairs. And this furious colorist, this beautiful painter of landscapes gorged with sap and panting, has restored to all his human figures a robust and placid animality.[5]

For Zola, who remained true to the Naturalist aesthetic, the objective truth of the scene was still the important criterion. He is almost apologetic in admitting that perhaps the artist has exaggerated a little. Moore and Fénéon, on the other hand, emphasized not the truth of the scene but its expressivity, and represented a new approach to criticism. Moore speaks of "life rendered in violent and colorful brutality. . . . Nature seems to be closing in like a tomb." Fénéon speaks of "the battle of greens and purples, of mauves and yellows," and "heavily sumptuous skies."

The group of artists that included Monet, Guillaumin, and later van Gogh, turned back to the Romantic attitude of Delacroix in contrast to those who were returning to Classicism. For the Romantics, the role of painting was to portray the subjective response of the human spirit to the stimulus of landscape, and nature was to become again a dictionary from which the artist chose his expressive elements, the means by which the artist expressed himself, but no longer the objective end in itself.

The evolution of this subjective attitude toward painting takes us to Charles Baudelaire, who felt that behind outward appearance there was a higher reality that was subjectively perceived in the mind.[6] Indeed, to the consciousness under the influence of drug states and in dreams it might be revealed more clearly than to the waking senses.

Baudelaire's attitude was taken up by his followers, the Symbolists. Mallarmé adhered to the idea of a higher reality and the subjective nature of the visual world. He wrote to Henri Cazalis:

4 *Confessions of a Young Man*, p. 55.
5 " Les Impressionnistes en 1886, " *Œuvres*, pp. 76-77.
6 Gray, Christopher, *Cubist Aesthetic Theories* (Baltimore, 1953), p. 9.

. . . describe not the object itself, but the effect it produces.[7]

[It is] aesthetically an error . . . to include on the subtle paper . . . anything else than, for example the horror of the forest, or the soft thunder scattered among the leaves; not the intrinsic and dense wood of the trees.[8]

Though Mallarmé was speaking of poetry, he was essentially considering the emotional subjective response to sensation as the objective of the artist, rather than an objective reality behind those sensations.

Villiers de l'Isle-Adam, who was four years older than Mallarmé, again emphasized the subjective nature of the experience of the phenomenal world—in *Axel* he maintained the superiority of the dream world of the mind to the world of everyday experience.

Joris-Karl Huysmans, born in 1848, started out as a Naturalist, a member of the group around Zola, but in the early eighteen-eighties, he broke with the Naturalists and turned toward Symbolism. In *A Rebours*, which appeared in 1884, the hero, Des Esseintes, tries to retreat from the objective world and create a whole inner world based on an artificially controlled stimulation of the senses.

What had really taken place here was a fundamental change in the attitude of the artist toward reality. The old concept of reality, which had been developed by Locke and Condillac, was based on the idea that the sense perception was the key to the ultimate objective reality. This attitude adopted by the Positivists in France, was that of the Naturalistic Movement that gave rise to early Impressionism.

As early as 1781, in *Critique of Pure Reason*, Immanuel Kant demonstrated the ultimate unknowability of the ultimate reality of the "thing-in-itself."[9] After Kant, the nature of the ultimate reality remained a problem for the German transcendental metaphysicians through the next century. Another step in the development of a new conception of reality was taken by Hegel, who, returning to the ideas of neo-Platonism, saw reality as the reflection of the ideas of the absolute mind. Since the mind of the artist was a part of the absolute mind, he could approach closer to the ultimate reality than could the phenomenal world of sense perception.[10]

While Hegel's philosophical system sought to give an objectivity to the ideas of the mind, Schopenhauer sought a different solution. In *The World as Will and Idea* he proposed the Will as the ultimate reality and the phenomenal world as an idea of the observer's mind. Following the ideas of Buddhism, Schopenhauer saw the dominance of desire in human life as essentially tragic, and the only surcease for the tyranny of desire was to be found in disinterested contemplation of the phenomenal world.

The genius is . . . the master of all the arts: it consists in the predominance of intuition and the contemplation over the will. . . . It isolates itself in a sort of higher sphere where life is only to be contemplated and beautified . . . genius despises practicality. . . . Thus it is understandable why genius has to be inimical to abstract science . . . it accepts all that imagination has to offer to art but rejects that other imagination called by Kant *imagination a priori* . . .[11]

The influence of Schopenhauer seems to have made itself felt through a change in intellectual climate rather than directly. Only in the case of Cézanne is there a record of the artist being interested in the philosopher,[12] but since the publication of Ribot's

7 Letter of October 1864, in *Propos sur la poésie*.
8 *Vers et prose*, premier divigation, p. 184-85.
9 Gray, op. cit., p. 33.
10 Hegel, G.F.W., *Philosophy of Fine Art* (London, 1905), p. 50.
11 Ribot, pp. 96-97.
12 Gasquet, Joachim, *Cézanne* (Paris, 1906), p. 102.

book on Schopenhauer, he seems to have attracted the interest of the critics and poets around the Impressionists.

The attitude of the Impressionists was changing in the middle eighteen-eighties, but few of them would have consciously admitted it. Neither Monet nor Guillaumin were given to such analyses, so the evidence of a change must be found in their work. To the end of their lives, they both maintained that they were painting what they saw. But what they saw had changed through a change of focus. They gradually turned away from a concern with the qualities of the efficient cause to the qualities of the response of the subject.

One is reminded of the incident of the *Talisman* of Sérusier. One day at Pont-Aven, painting an autumn landscape, he asked Gauguin to criticize it. "How do you see these trees?" asked Gauguin. "They are yellow," replied Sérusier. "Then put down yellow. That shadow is rather blue. So render it with pure ultra-marine. Those red leaves? Use vermilion."[13]

13 From *ABC de la peinture*, p. 42.

## 7: Artist, Benedict, Colleague

Although there was no sharp break in style in 1886, the new developments can be clearly seen in the gradual drifting apart of the aesthetic attitudes of Guillaumin and Pissarro, even though they remained close friends. On December 6, 1886, Pissarro wrote to his son:

> ... I saw Guillaumin. We went to look at my two last paintings which were bought by Durand. All he said was "there's no firmness in the foreground." It was evening, we were seeing the paintings by gaslight, which neutralized the orange tones. As Seurat says, what they look for is thick impasto; but at Clauzet's I saw a Guillaumin, also in the evening, and it looked made of tar, so much shellac was used at the base of this painting, which in my view is really old stuff; it must be admitted that he made an effort to tighten the design but then the harmonies are insignificant and lack logic, there is no drawing, there is a flurry of colors, but no modeling; it is one step from Jules Dupré—modernized ...[1]

Pissarro was probably reacting to Guillaumin's criticism of his pictures, but the statements show also the divergence of the paths of the two artists during the last two years. Pissarro, in becoming a convert to Seurat, sought to carry Impressionism to an even higher luminosity through the scientific application of the principles of optics, while Guillaumin was turning from light to color. He told Borgmeyer that he was interested in the works of Seurat and Signac, but thought their technique to be laborious.[2]

Guillaumin had no word of praise for Pissarro's work either. In February Pissarro, who had been asked to exhibit with *Les XX* in Brussels, wrote:

> ... I have no luck, the only one of my paintings which was liked in Brussels belongs to Durand, and he is not at all satisfied with it. This canvas had the knack of displeasing Guillaumin, too ... how luck favors me![3]

Not only was Pissarro disturbed by his friend's new style, but Monet's also shocked him deeply. At the end of the year, he wrote:

> ... at Pillet's ... There are two Monets, a *Cliff* and a *Landscape of Vétheuil*, I must say they are inferior, they are rank, and the execution recalls certain Gudins. ... Monet has too much talent not to recognize some day that we are right ...[4]

Sometime in 1886, with all the expositions, battles, and changes, Guillaumin found time to marry. His wife was Marie-Joséphine Gareton, whose portrait he had painted in 1871, when she was twelve years old, and he a young man of thirty. Marie was born December 18, 1858 in Paris, of a family originally from the Département of the Creuse in the western foothills of the Massif Central, in whose northern foothills Guillaumin himself had been brought up. She had received in 1884 a certificate of preparedness (*ordres des lettres*) to teach in a lycée or college for young women. On August 5, 1885, she was appointed *institutrice adjointe* at the lycée in Paris on rue Clausel, and on the twenty-eighth of that month she was first out of fifteen on the list of those "agrée des lycées de jeunes filles pour l'ordre des lettres." By October of the same year she was appointed "professeur de lettres 4ème classe" at the lycée for young girls at Le Havre. So far her progress had been rapid, and her career brilliant. But her new job took her out of Paris to Le Havre. On February 6, 1886, she received an honorable mention as Institutrice at the lycée at Le Havre, which opened up the possibility of a position in Paris, and on the twenty-ninth of September, she was named professor at the Lycée

---

1 *Letters* ..., p. 84.
2 Borgmeyer, C. L., " Armand Guillaumin, " *Fine Arts Journal*, Feb. 1914, p. 63.
3 *Letters*, p. 100.
4 Ibid., p. 90.

Fénelon, the oldest and "best" lycée in Paris for young women.[5] She and Guillaumin could now think of marriage without forfeiting his career as an artist.

His financial situation had improved somewhat. Both Portier and Nuñes were selling his pictures occasionally, Theo van Gogh was becoming interested in his work, and after eighteen years with Ponts et Chaussées, he had been appointed inspector on night duty, which meant no more ditch digging.[6]

The future Mme Guillaumin knew her husband-to-be very well. While she was twenty-seven, and Guillaumin forty-five, he had led an active outdoor life and looked considerably younger than his age. She also knew that his father had died in 1878, and that Guillaumin had continued to live in his mother's house until shortly before her death in 1883. He had been a confirmed bachelor, already somewhat crusty, and with a temper. She knew he was passionately devoted to art, about which she knew little; but he was also fond of music, especially Wagner and Mozart, and he read widely, having as favorites Verlaine, Baudelaire, Balzac, and Shakespeare. Altogether, despite his difficult career, he was a man of wide intellectual interest who, if necessary, could participate in any society. The one thing she feared was his temper. She made him promise always to control it with her if she consented to marry him, a promise he kept at enormous cost. Only on rare occasions did he not speak to his family for a week when he felt that they had tried him beyond endurance.

With their two incomes they were able to set up housekeeping at 19, rue Servandoni, near the church of Saint-Sulpice. In the beginning, Mme Gareton, Guillaumin's mother-in-law, stayed with them, and they got along with a single servant. Later, when the family began to grow, it was necessary to hire a nurse for the children while Mme Guillaumin continued to teach school.

Between 1887 and 1892, Guillaumin's last five years in Paris, the Impressionists and the Post-impressionists who gathered around them continued to see each other and to correspond intermittently. Guillaumin was no exception. In 1887, he saw little of Gauguin, who had left early in April for Panama and did not return until November. He occasionally saw Dubois-Pillet while sketching along the quais, and sent his regards to Signac and Seurat, but, as in the case of Pissarro, he had little sympathy for the neo-Impressionist technique. On the other hand, he saw a great deal of Vincent van Gogh. In the spring, Vincent organized a show of painters including Anquetin, Bernard, Koning, Gauguin, and himself. Guillaumin and Pissarro, as well as Seurat, went to see the approximately one hundred examples of Vincent's work. Later on, Vincent exhibited at the offices of the *Revue Indépendante*, where Fénéon used to hang pictures by avant-garde artists. Guillaumin may also have exhibited there,[7] and even though Gauguin refused and did not approve of Guillaumin's exhibiting with "beginners," Vincent had developed a great admiration for him. During the springs of 1887, he wrote to Bernard:

> I went to see Guillaumin, but in the evening, and I thought that perhaps you did not know his address, which is 13 Quai d'Anjou. I believe that Guillaumin as a human being has sounder ideas than the others, and if all were like him they would produce more good things, and would have less time and inclination to fight each other so furiously (*de se manger le nez*).[8]

Vincent was not above criticizing the older man, but his enthusiasm was so great that it could hardly be held against him. Once, when he was visiting Guillaumin in his

5 Her career is recorded in documents in the possession of her daughter Marguerite.
6 Rivière, Georges, "Armand Guillaumin," *L'Art vivant*, July 15, 1927.
7 Rewald, *Post-Impressionism*, p. 71, from unpublished documents.
8 *Complete Letters*, B 1 (Appendix), III, 474.

studio, he flew into a rage because he felt that Guillaumin's drawing was not correct. He acted out the movements of the laborers in a scene of the unloading of a barge. According to Coquiot, he started demonstrating various attitudes with an imaginary spade, or he would strip to the waist for a better display of anatomical detail.[9]

In October, Paul Alexis, under the pen name of Trublot, published an article on the collection of Guillaumin's friend, Murer, in the *Cri du Peuple* (21 October 1887). Among Murer's paintings were eight by Cézanne, twenty-five by Pissarro, sixteen by Renoir, twenty-eight by Sisley, ten by Monet, and twenty-two by Guillaumin.[10]

During the period 1885-87, Guillaumin had worked on a motif centering around the striking outline of a sandhopper on the quais in Paris. Of this series there is one drawing dated 1885, there is a pastel sketch, and finally, from 1887, there is a very carefully worked out pastel, which may be the final work of the series. Though there seem to be no detail studies, as was the case in the *Cribleurs du sable* of the early 1880s, the complexity and finish of the work developed over the later three-year period suggests that Guillaumin was concerned with the structure and composition of the painting in a way that again goes beyond a simple Impressionist approach.

Sometime in 1887, Guillaumin went to Agay on the Côte d'Azur near Saint-Raphaël, which was to become his favorite place to spend the late winter. He probably went during the winter school vacation, so that his wife could accompany him. Guillaumin had sometimes taken his vacations at the seashore—he spent some time in Jullouville in Brittany in 1873 and in Dieppe in 1881—but now that his financial position was improving he was able to indulge his taste for new sights and to travel more freely. I know of no painting of Agay during this period. In January 1888, Theo van Gogh put on a small exhibition of the works of Pissarro, Guillaumin, and Gauguin at the gallery Boussod and Valadon. Theo was becoming more interested in the works of the Impressionists, and turning the policy of the gallery toward investment in their works. Since Durand-Ruel was heavily in debt, and unwilling to make extensive purchases, a number of the Impressionists were looking for new dealers. Monet, whose new works Durand-Ruel did not like, signed a contract with Theo. Pissarro could not afford to break with Durand-Ruel, but, as the latter often refused to buy his paintings since his adoption of the Pointillist technique, he also relied on Theo for sales.

Early in 1888, before his departure in the middle of February, Vincent continued to visit Guillaumin's studio and discuss art. On October 3, 1888, he wrote Gauguin:

> After you left Paris, my brother and I stayed together for a time, which will forever remain unforgettable to me! The discussions covered a wider field—with Guillaumin, with the Pissarros, father and son, with Seurat, whose acquaintaince I had not made (I visited his studio only a few hours before my departure).[11]

Vincent's interest in the older artist did not cease with his departure—he was much interested in the pastels Guillaumin had been doing in the winter of 1887, of the sand barges along the Quai de Bercy. In fact it may well be that much of the progress Vincent made in 1887 and 1888 in the handling of the brushstroke in painting was influenced by Guillaumin's use of pastel.

Vincent was also anxious that Theo should buy Guillaumin's works. About March, he wrote Theo from Arles:

> As to the Guillaumin, surely it would be a good bargain if it's possible to buy it.

9 Coquiot, Gustave, *Vincent van Gogh* (Paris, 1923), pp. 136-37.
10 Pissarro, *Letters ...*, p. 121, note 2.
11 *Complete Letters*, No. 544a. The six excerpts which follow are from ibid., as indicated.

Only since they are talking about a new method of fixing pastels, it would perhaps be wise to ask him to fix it in that way if you do buy it. [No. 477]

And in May, again: "I have had a letter from Russell; he has bought a Guillaumin." [No. 480]. And shortly later: "Please will you tell Guillaumin that Russell wants to come and see him, and intends to buy another of his pictures." [No. 482]

From time to time, Theo asked Guillaumin and Pissarro to look at some of the work that Vincent was doing in Arles, and during the summer the latter wrote:

> Wasn't it rather pleasant this winter at Guillaumin's to find the landing and even the staircase, not to mention the studio, quite full of canvases? [No 504]

> It was very nice of Guillaumin to look, I am very much obliged to him, though on the whole I myself am dissatisfied with everything I do. [No. 505]

Again, apparently in response to a letter from Guillaumin in which he recounted his activities, possibly suggesting an exchange of pictures, he wrote:

> The same goes for Guillaumin [re exchange of pictures].

> I wish he [Russell] would buy a figure from Guillaumin. He says that he has had a very beautiful bust of his wife done by Rodin, and that on that occasion he lunched with Claude Monet, and saw the ten pictures of Antibes. I am sending him Geffrey's article. He criticizes the Monets very ably, begins by liking them very much, the attack on the problem, the enfolding tinted air, the color. After that he shows what there is to find fault with, the total lack of construction, for instance one of his trees will have far too much foliage for the thickness of the trunk, and so always and everywhere from the standpoint of the reality of things from the standpoint of lots of natural *laws*, he is exasperating enough. He ends by saying that this quality of attacking the difficulties is what everyone ought to have. [No. 514]

It is interesting to compare the understanding with which Guillaumin approached the work of Monet at this time in comparison with other artists. He criticized only some aspects of the form, while Pissarro and Fénéon failed entirely to comprehend Monet's work in 1888. On July 8, Pissarro wrote Lucien:

> . . . I saw the Monets, they are beautiful, but Fénéon is right, while good, they do not represent a highly developed art. For my part, I subscribe to what I have often heard Degas say, his art is that of a skillful but not profound decorator.

> Theo van Gogh seems dissatisfied by Fénéon's article: he told me that Monet had said that *it could have been anticipated* . . .[12]

In his review of the exposition of Monet's works at the gallery of Boussod and Valadon in the *Revue Indépendante* of March, 1888, Fénéon wrote of Monet's "brilliant vulgarité": "His reputation is growing but his talent does not seem to have gained anything since the Etretat series."[13]

In the fall of 1888, Guillaumin was in close touch with Gauguin and his group. Emile Bernard introduced him to the new critic of the Symbolist group, Albert Aurier, and Gauguin wrote from Brittany to Schuffenecker demanding why Guillaumin did not write. In December, Schuffenecker answered that he was seeing no one but Guillaumin. Gradually Guillaumin was growing away from the new avant-garde groups; his first child, Madeleine, was born in October, and he was wrapped up in his family. Nevertheless, Vincent still regarded Gauguin, Guillaumin, and Bernard among his and his brother's true friends in matters concerning art.[14]

12 *Letters* ..., pp. 126-27.
13 *Œuvres* ..., p. 129.
14 *Complete Letters*, No. 576 (III, 135).

With the birth of his daughter in October, the artist made innumerable sketches and pastels of his new family. He had done a number of portraits in the late seventies, but by the late eighties such work was almost entirely limited to sketches, pastels, and oils of his family. Actually the free sketches greatly outnumber the pastels and oils that can be considered finished works. Sometimes he became fascinated with a particular pose, sketching his wife for several years until he decided to embody his ideas in a finished picture. For example, as early as 1887, he made a drawing of her sitting at a table reading. In 1888, there is another study of her on the same sheet of paper with a sketch of her nursing Madeleine. Finally, in 1889, there is a finished pastel. Throughout the following years, Guillaumin picked up the same theme again and again, sometimes in pastel, sometimes in oil.

Guillaumin was invited to exhibit with Gauguin's group at the Café Volpini at the Exposition Universelle in March 1889, but since Pissarro and Seurat were not invited, he declined.[15] Gauguin regarded this as desertion,[16] and though they remained on more or less amicable terms, as artists they were separating.

In the spring, Guillaumin again went to Agay where the blue of the Mediterranean, the red of the rocky cliffs and the green of stone pines fascinated him.

In October, Gauguin, in Brittany, asked "Schuff" for news:

"Guillaumin a été en Auvergne. A-t-il rapporté de bonne études?"[17] Guillaumin had gone to visit his mother's family at Pontgibaud (Puy-de-Dôme). From this trip we have an important picture of a bridge over a ravine in the mountains near the small village of Peschadoire (Fig. 39).

15 Gauguin, *Lettres* ..., LXVII (note), p. 152.
16 Rewald, *Post-Imp.*, p. 279.
17 Gauguin, *Lettres* ..., XC, p. 171.

Fig. 39 *Pont dans les montagnes,* August 1889

Guillaumin, who had spent his youth in Moulins, had now been in Paris for thirty-two years, painting the gentle scenery of the Ile-de-France, and must have felt that the colorful mountains of Auvergne, covered with August heather, recalled those happy days. He was not by nature a city man. He loved the life of small villages in the midst of rugged landscapes. All his life as a painter he had sought color in the drab landscape of the environs of Paris. At Peschadoire nature was naturally colorful, and his picture is almost ecstatic with the effects of the brilliant pinks and green of the heather-covered mountains.

With the change in the nature of the landscape, Guillaumin also changed the quality of his brush work. He was always sensitive to the quality of surface texture, and adjusted his brush work to his subject. Here with the rugged terrain, he gave up the long grassy stroke he had been using in Paris for a shorter, more staccato touch appropriate to the rougher texture of the mountain flora and rugged outcroppings of rock.

Through 1889, Theo van Gogh continued his interest in the works of Guillaumin, and from time to time he was the subject of discussion between Theo and Vincent in letters. In September, Vincent wrote:

Let's keep looking out for portraits, especially by artists such as Guillaumin and the portrait of the girl by Guillaumin.[18]

These two works seem to have particularly impressed Vincent, for, toward the beginning of October, he wrote his sister:

Did you see the self-portrait by the painter Guillaumin and the portrait of a young woman by the same? They give an idea of what the painters are looking for. When Guillaumin exhibited his self-portrait, public and artists were greatly amused by it, and yet it is one of those rare things capable of holding their own beside the old Dutch painters, even Rembrandt and Hals. [W14, Appendix]

Of Guillaumin's landscapes, he wrote:

You must feel the whole of a country—isn't that what distinguishes a Cézanne from anything else? And Guillaumin, whom you cite, he has so much style and such a personal manner of drawing. [No. 613] What you say of Guillaumin is very true, he has found one true thing and contents himself with what he has found, without going off at random after divergent things, and in that way he will keep straight, and become stronger on those same simple subjects. [No. 611]

In 1890, Guillaumin again exhibited with the Indépendants, for the first time since 1884. Together with Seurat, Signac, Luce, and Vincent, he showed ten paintings, the maximum allowed. Theo wrote Vincent on March 19, the day of the opening, that Guillaumin was showing several things, "including some very good pieces." [T29, Appendix] Not long after, Gauguin wrote a long letter to Vincent, praising his work and commenting on Guillaumin:

Among those who work from nature, you are the *only one who thinks*. I have talked about it with your brother and there is one canvas that I should like to exchange with you for anything of mine you choose. The one I mean is a mountainous landscape; two very small travelers seem to be climbing in search of the unknown. There is in it an emotion like in Delacroix, with very suggestive colors. Here and there some red notes, like lights, and the whole in a violet harmony. It's beautiful and impressive. I've talked at length about it with Aurier, Bernard, and many others. All congratulate you. Only Guillaumin shrugs his shoulders when he hears it men-

---

18 *Complete Letters*, No. 604. The six excerpts which follow are from ibid., as indicated.

tioned. I do understand him, by the way, since all he sees is pigment with an eye devoid of thought. Towards my own canvases of the last few years he reacts the same way: he understands nothing.

Guillaumin may have shrugged his shoulders at Gauguin's ideas, but in May Vincent wrote to Theo:

So Gauguin and Guillaumin, both of them, want to exchange something for the landscape of the Alps. Well, there are two of them, only I think that the one done last, which I have just sent you, is done with more decision and is truer in expression. [No. 630]

Theo answered in the beginning of June, "Guillaumin has placed at your disposal a magnificent picture which he had at Tangui's, a Sunset. It will show to great advantage in your studio." [T37, Appendix] In the meantime, Vincent had come to Auvers to be under the care of Dr. Gachet, at whose house he saw for the first time a number of Guillaumin's early works including the *Femme couchée*, which particularly impressed him. That Gachet had no proper frame for it irritated Vincent to such a degree that he accused him of not appreciating the work. When the delivery of the frame which Gachet ordered was delayed, Vincent flew into a violent anger.[19]

Toward the middle of July, Vincent made his last trip to Paris to see his brother but he missed seeing Guillaumin.

I am very sorry not to have seen Guillaumin again, but I am glad he has seen my canvases.

If I had waited, I should probably have stayed talking with him so long that I would have missed my train.[20]

By July 29, Vincent was dead. Guillaumin, again visiting his mother's family in Pontgibaud, could not attend the funeral.

Guillaumin was working in the mountains at Pontcharra and up the Isère almost to the border of Savoie (Fig. 40). Those pictures which are known from this trip are marked by the return to a more liquid paint and a more uniform application. This changing of technique suggests that he was looking for new solutions to aesthetic problems.

In January 1891, Guillaumin and Gauguin were invited to exhibit with *Les XX* in Brussels. That year, Gauguin sent his "scandalous" wood relief, *Soyez amoureuses et vous serez heureuses*, which received excoriating reviews in the press. Guillaumin's works, in contrast, received little attention.

On January 21, the death of Theo van Gogh robbed Guillaumin of a friend and supporter, leaving him without a regular dealer. Marcel Joyant succeeded Theo as director of the gallery. Gradually, Guillaumin was losing his friends. In February, an article by Albert Aurier on Paul Gauguin led to the estrangement of Bernard and Pissarro, and a parting of the ways with Guillaumin.[21] Dubois-Pillet, who used to meet Guillaumin along the quais, had died, and on March 29 Seurat died. Cézanne, long withdrawn from the struggle of the avant-garde, withdrew to the south of France, having given up his studio on the Quai d'Anjou next to Guillaumin in 1890. In April, Gauguin set out for the South Seas with only one brief return before his death.

Yet the round of exhibitions continued. In March, 1891, the exposition of the Indépendants opened with ten paintings by Guillaumin. His friend Signac, who was on the hanging committee, had arranged memorial exhibitions of the works of Dubois-Pillet

19 Bazin, Germain, *Van Gogh et les peintres d'Auvers ...*, Musée de l'Orangerie (Paris, 1954), Preface.
20 *Complete Letters*, No. 649.
21 Aurier, Albert, "Le Symbolisme en peinture: Paul Gauguin," *Mercure de France*, March, 1891, p. 165.

Fig. 40 *Paysage à Pontcharra*, c. 1890

and van Gogh, but new names were appearing: Bernard, Bonnard, Willumsen, and others further removed from Impressionism. Symbolism was now the rage among the avant-garde, both painters and critics, and the reaction against Impressionism was under way. In an article on the exhibition, Octave Mirbeau praised highly the works of Vincent, damning the others with faint praise: "I recognize the limited realism of Armand Guillaumin, devoid of ideas, but well executed, as the saying goes, honest and robust qualities of craftsmanship."[22]

In the spring of 1891, Guillaumin did his final group of paintings of *Cribleur du sable* (Fig. 41). The technique became very tight—not only was the brushwork quite restrained, but the color treatment, with its predominance of green and yellow, indicated a concern with color effects rather than the direct recording of the perception of color of an Impressionist already noted for the "Fauve"-like color of his earlier works.

During the summer, he went to Cleçy-sur-Orne in the département of Orne in Calvados. He returned at the beginning of August and wrote his friend Murer:

Fig. 41 *Cribleur du sable*, 1891

I have waited until today expecting to go to see you any day but I had, and still have, quite a few landscapes to finish; I should like to take advantage of the good weather; on returning I had quite a bit of work for *la Ville*; finally, I am looking for a studio and all this has prevented my calling on you.

When will I manage to do so?

I have brought back with me 15 or 16 canvases; if you come on a Wednesday between 2 and 3 p.m. you will find me.

On other days you will find the door shut.

When do you leave for Algeria?

22 " Vincent van Gogh, " *Echo de Paris*, March 31, 1891. Reprinted in Mirbeau, *Des Artistes*, vol. I (Paris, 1922).

For a few days I am going to lose myself in paintings.

If there should be any change in my plans I shall let you know.[23]

Guillaumin found time to go the Ile de Ré in February 1892. In the spring and summer he painted around Paris. In August he wrote Murer again:

Portier and I hope to have lunch with you next Thursday and shall be joined by an amateur who wishes very much to see your collection.

If this is not convenient for you, please write me.

I have worked very hard this year; the largest part of my canvases is presently at Goupil's, Bd. Montmartre.

In September he seems to have gone on his vacation to Crozant, a small village on the Creuse, not far from Fresselines, where Monet had stayed for three months in the spring of 1889. Later he went to Saint-Palais, near Royan on the north shore of the mouth of the Gironde.

In October he was back in Paris, but the rendezvous he had planned with Murer seems not to have taken place, for he wrote:

Portier has asked me to offer you his apologies. His poor health and the bad weather make it impossible for him to go out and particularly to risk a trip. The same applies to M. Personnaz who had intended to accompany us but has a very sensitive throat.

Thus, all three of us beg to be excused; we shall call upon you as soon as the weather improves.

I believe that you have received an invitation for the exhibition at Goupil's . . .

Guillaumin was busy in Paris for the rest of the fall. November 29 he wrote again to Murer:

Have you left yet? I had thought to see you in Paris before your departure, not so much in order to remind you of your debt but rather to propose an exchange: I should like to get from you the canvas in your dressing room which measures about 10, a quarry in the Parc d'Issy with Paris in the background. I would give you a more modern painting of the same dimensions and a drawing, if you wish to accept this exchange.

I shall know when I return Friday, in which case I shall depart the 4th or 5th of December . . .

Murer did not like the idea of the exchange, and apparently suggested that Guillaumin was trying to get the better of the bargain, for the next letter is curt:

Dear Eugene,                                                        Agay, 16 December 1892

I had not intended to gain anything, I am quite well off; there was no question of satisfying the whim of an amateur but rather I had in mind to give pleasure to some one whom I like and respect very much. Let us not talk about it any more. There remains nothing for me but to wish you success in your enterprises. So long.

Guillaumin

To summarize Guillaumin's art during the late eighties and early nineties, he had continued to work in the countryside in the environs of Paris, Damiette, the Valley of the Chevreuse, and Breuillet. He seems always to have worked in the southwest sector where he had started in his first expeditions, seldom encroaching on the western sector where Monet worked. He also began his visits to the Creuse, Saint-Palais, and Agay.

23 Gachet, *Lettres* ..., pp. 75-76.  The three excerpts which follow are from ibid., pp. 76-78.

As well as painting landscapes outside of Paris, Guillaumin was still working along the quais of the Seine. In his countryside landscapes, he developed further his red-green polarity; in his works along the quais, the predominance of the yellow sand, and the fact that his sketching had to be done nearer the middle of the day while the works were active, led him to change his usual (early morning and late evening) color organization. He was also sketching and painting his family regularly.

As he approached the age of fifty, Guillaumin was settled into a routine of life with his wife and his children (in August of 1891, his second child was born, a son, Armand). His job with the city must have been stultifying, as his friends gradually disappeared from the scene. But then the unexpected happened: in 1891, one of the bonds he held paid a special premium of 100,000 gold francs. There is little information about this important event.[24] Considering that the annual wage of a skilled worker was seldom over 1,750 francs a year, the interest on this sum alone, 5,000 francs, gave him security. In addition, Mme Guillaumin still held her excellent position as a professor in a lycée, and Guillaumin himself could count on a moderate but steady income from his paintings. Even if he gave up his job with the city forthwith, his future was assured. But he had worked for twenty-two years for the city of Paris, and would be able to retire on a pension in one more year, so he kept on working and retired in 1892.

24 Lecomte, p. 23: " ... la bonne fortune d'un lot important à l'un des tirages du Crédit Foncier lui permit de se liberer totalement. " Gauguin, *Lettres* ..., p. 44, No. 2: " Une obligation de Crédit Foncier lui rapporta une prime de cent mille francs. " See also Rewald, *HI*, p. 566.

## 8: 1886-1902 / Maturity and Independence

Guillaumin's life for the next twenty years is largely written in his paintings. By the age of fifty-two, he had passed through the years of struggle to establish Impressionism. He had been closely associated with the younger men who had launched post-Impressionism: Gauguin, van Gogh, Seurat, and Signac. With their followers he had little contact and little sympathy. As Monet, Pissarro, Renoir, and Cézanne had withdrawn to go their own ways, it was Guillaumin's turn to withdraw and develop his own ideas.

His last years before his retirement had not been happy. One cannot help feeling a certain sterility in his art of that period. He reacted badly to contemporary criticism, and he felt himself out of touch with the younger generation. In a period in which idealism again held sway, he found his intuitive poetic vision stultified. Almost as soon as he left Paris, his own personal genius flowered. No longer did he have to think of pleasing patrons. Condescending critics no longer had to be thanked for throwing him a crust. Dealers could no longer tyrannize him.

After his retirement and his maturation as an artist, he gradually slipped into a new routine of life. In the later winter and early spring, he painted at Agay. Early summer he spent at Crozant. Some time in the later summer or early fall, he would spend a month at Saint-Palais-sur-Mer, and then return to Crozant until winter, when he went to Paris to show his new works. The Côte d'Azur, the Côte d'Argent, and the Valley of the Creuse, all fascinated him.

Agay is a little seacoast town, hardly more than a stop on the Marseilles-Nice railroad, seven miles east of Saint-Raphaël and in the heart of the Esterel. It had been the Portus Agathonis of Antoninus, but in Guillaumin's time it was little more than a railroad stop and a haven for fishing boats caught in a storm. There was one hotel, the Grand Hôtel d'Agay, across from the railroad station, which had full pension for seven and one half francs a day; and a couple of villas where one could live even more cheaply.

Though the temperature in winter ran in the middle fifties, it was a welcome escape from Paris. Agay was just such a small town as Guillaumin always preferred, and in the off-season he could be sure of not being disturbed by sightseers. Yet it was on the main Paris-Menton line, he could easily get up to Paris to see his family, and they could join him on vacations. But even more than the seclusion of Agay and its convenience, it was probably the site itself that really attracted him, so that he spent the late winter there year after year.

Agay is bold, almost brash in its coloration. The rocky land is striking with rugged forms, and even the pines that dominate the landscape are marked by a clarity of outline that is not found in the more feathery trees of the region of Paris. The strong reds of the rocks, the Mediterranean blue of the sea and the sky, the clear green of the foliage, as well as the boldness of the landscape, have an epic quality far removed from the more lyrical landscape of the Ile-de-France. The myriad nuances blending to create an almost nacreous glow of light softened by the hazy atmosphere, give way to a landscape in which forms and colors are strikingly assertive. The problem of the Impressionist is not to learn to perceive the suggestion of color, but to learn to orchestrate the more insistent colors of the Esterel. While the changes of light produce ever-varying effects on the landscape of the region of Paris, the colors of the landscape around Agay transcend the vagaries of atmosphere to create a less time-dependent effect. The moods may change, but the personality remains the same.

At Agay, Guillaumin continued his custom of painting in the early morning and the late afternoon when the slanting light revealed most sharply the rugged forms of the landscape, and the yellowing rays of the sun darkened the blue of the sea, turned the rocks of the Esterel crimson, and made the new growth of the stone pines almost irridescent in their greenness.

Early in the period of his stays at Agay, Guillaumin settled on his favorite scenes which he painted again and again: the view of the port of Agay from Cap Dramont with Cap Long in the foreground, the Rastel d'Agay in the background, the view of the Dramont itself from Pointe de la Beaumette, *La mer à la Beaumette*, *Les Roches rouges*, *Les Iles Besse*, *La Maleraigue au temps du mistral* (Figs. 42, 43, 44), and studies of the gnarled and windswept stone pines.

There is a certain sameness to these repeated subjects that tends toward monotony in Guillaumin's works at Agay. Though the powerful statements are admirable in themselves, the same scenes, at the same time of year with the same insistent colors, stultifies variety. On the other hand, the landscape at Agay, with its lack of subtlety, encouraged Guillaumin in his development out of the Impressionism that Monet was developing in his series of Rouen Cathedral. Here at Agay, the strong forms, colors, and light of the Esterel acted on Guillaumin in much the same manner that Gauguin's visit to Martinique led him to Synthetism. Color nuanced to the degree of creating the effect of a mirage could not convey the impact of the colors of Agay any more than they could those of Martinique. One can see in Guillaumin's work as it developed at Agay the same idea that Gauguin expressed by saying that a pound of green is greener than an ounce. The minutely broken areas of color began to fuse and Guillaumin began to simplify his forms and colors in a manner which, though highly individual, led in the direction of Synthetism.

The end of this process does not appear as the immediate and conscious result of an intellectual perception as it did in the case of Gauguin, but rather, in the case of Guillaumin, it appears to be an intuitive response that matures over the next twenty years.

Saint-Palais-sur-Mer is a small seacoast resort not far from Royan on the north shore of the mouth of the Gironde, situated on the Conche de Saint-Palais on a strip of rocky coast that extends from Royan to la Grande Côte, a few miles beyond Saint-Palais. Though it is like Agay in that the coast is rocky, in other ways it is very different. The rocks are greyish limestone darkened at low tide by the blackish green of seaweed. The forms are eroded, but they have neither the tumultuous shapes nor the brilliant colors of the volcanic porphyry of Agay. Instead of the brilliant blue of the Mediterranean, the sea has the pale grey-green of the water of estuaries, and the sky is tempered to a grey-blue by the mists that sweep across the Atlantic to gather on the seacoast. The vegetation in August no longer shows the brilliant greens of spring, and the effect of the pines and other trees is again that of blackish green forms that are eternally bent into huddling shapes, retreating under the impetus of the unrelenting sweep of the west wind rolling off the sea.

Yet, like the drab coast near Le Havre which Monet loved to paint, the coast near Saint-Palais has its charms. Guillaumin, in his interest in form, particularly liked to paint the changing light and weather effects on *Les Perrières* with *Les Rochers Platins* and the *Pont du Diable* (Figs. 45, 46, 47), which arose with fantastic rock formations sticking out into the sea just beyond the Conche of Saint-Palais. Here, in contrast to the bold colors of Agay, his seascapes take on a pearly irridescence recalling his work around Paris in the late seventies.

His real *pays d'élection*, however, was the region immediately centering on the small village of Crozant in the Valley of the Creuse (Fig. 48). Even today, Crozant has a population of only a thousand, while in Guillaumin's time, before the popularization of "le camping," it was only a small unvisited village in the western foothills of the Massif Central, isolated, but only eight kilometers from the main Paris-Bordeaux line and a few hours from Paris.

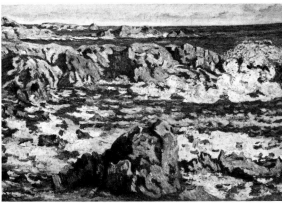

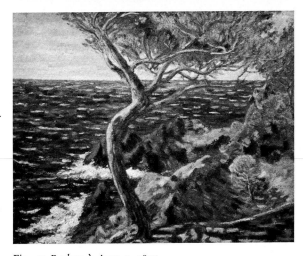

Fig. 42 *Rochers à Agay*, c. 1893

Fig. 43 *La mer à la Beaumette*, c. 1895

Fig. 44 *La Maleraigue au temps du mistral*, 1901

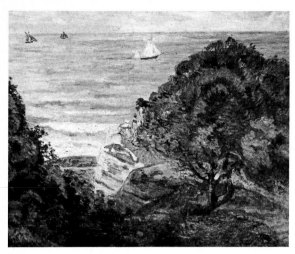

Fig. 45 *Saint-Palais: la mer*, 1893

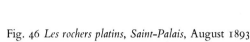

Fig. 46 *Les rochers platins, Saint-Palais*, August 1893

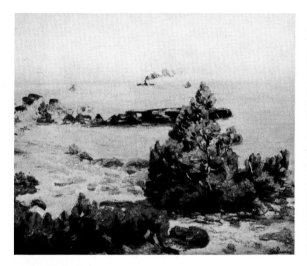

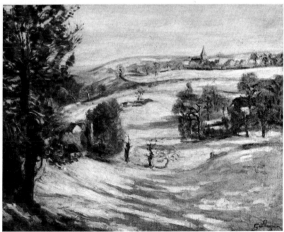

Fig. 47 *Saint-Palais: Pointe de la Perrière*, c. 1893

Fig. 48 *Neige à Crozant*, c. 1898

In the whole of the Valley of the Creuse, Crozant is unique, for it lies in the center of a stretch of the river that passes through an intrusive flow of ferriferous granite which ages to a soft brownish-pink. It extends from the Moulin Génetin to the Moulin Barat. All Guillaumin's Crozant paintings were done within this area. While the rest of the valley of the Creuse is colorful, nowhere does it achieve the same richness that it does in the region of Crozant, which lies on a high promontory formed by the confluence of two rivers, the Creuse itself, and the Sédelle. Both, at this point of their course, were swiftly flowing streams with an alternation of quiet pools and rapids, mill ponds, and water tumbling over mill dams.

While Agay is dominated by the powerful colors of the Esterel and the Mediterranean, the Saint-Palais by the play of sunlight and mist over the soft colors of sea and landscape, Crozant has a landscape of infinitely varying moods. The vivid autumnal colors linger late in the year to be replaced by the soft colors of winter, set sharply against the landscape in an atmosphere washed clean by the cold air flowing down from the mountains. Spring brings the colorful new growth, relieved against the ground made silvery by hoar frost, delicate yet vivid colors, at times softened by the morning mists. In the late spring and summer the hillsides glow with the yellow of the flowering genista and the

fields and hedgerows are dotted with the crimson of foxglove. Late summer and autumn cover the mountainsides with the crimson-purple blooms of the heather.

In Guillaumin's day, the region around Crozant was given over to the raising of sheep, and the landscape was far more open than it is today. Old stands of trees wooded ravines alternated with open, close-cropped pasturage, dotted with the low shrubs of genista and heather and the vivid green of bracken, none of which the sheep would eat.

Like the other Impressionists—Monet especially—Guillaumin had always been fascinated by the play of light on water. At Crozant he found two streams in which water took on all moods, from the calm pool of Les Telles on the Creuse, to the racing water of the Moulin Bouchardon on the Sédelle. There were, in all, six mills in the region of Crozant, and he painted all of them. I have not seen a painting of the Moulin Barat, but M. Serret assures me that Guillaumin painted it. On the Creuse itself, he loved to paint the cliffs of the gorge reaching down to the water. Rocky formations such as *La Fileuse*, and the *Rocher de l'Echo*, he did again and again; almost every year he painted the strange form of the heather-covered *Puy Bariou* rising in the middle of the Valley of the Creuse.

The genius of Guillaumin was his own very personal vision of color. He had a fine ability to compose; he had a strong sense of structure; but these aspects of the painting were not the essential ones to him, and in them he would never break new paths. They were only the skeleton to carry the sensuous flesh of his paintings, his pure rejoicing in color.

In a period which proclaimed "pas le couleur, rien que la nuance," Guillaumin's color was decried as "fauve." In an era that sought the suggestive and the mysterious, Guillaumin practiced the bold statement. If Monet's late works have the illusory quality of dreams, and, in spite of their color, an almost elegiac quality of mood, Guillaumin's paintings are rejoicing paeans to the beauty of nature. While Monet sought the drab to bathe it in a redeeming atmosphere of color, as for example, in his pictures of Gare Saint-Lazare and his series of London, Guillaumin, on the other hand, loved to paint the brilliant colors of Agay, the autumn foliage at Crozant, the heather in bloom, the genista, the flowering apple trees in the spring at Damiette. In this he recalls the rejoicing of Vincent in the bold colors of the Midi. His paintings are executed directly. There is little evidence of repainting, and little sign of hesitation. As he was recording his direct response to the scene before him, he never worked on a canvas except in front of the motif. Monet sometimes completed canvases in the studio, but according to his daughter and his own statement, Guillaumin did not do this. Further evidence is found in the number of his unfinished paintings. As the light changed, and the seasons changed, he was limited in the actual time he could work on each canvas. This method of work implies certain limitations. The fact which both the Realists and the idealistically inclined Symbolists failed to realize is the uniqueness of the Impressionist response. Sérullaz quotes Charles Péguy's criticism of Monet with approval:

> Granted that a celebrated painter painted these waterlilies twenty-seven and thirty-five times, when did he paint them best? Which versions were most successful? One's logical impulse would be to say the *last*, because he knew more. . . . But I, on the contrary, say the *first*, because he knew less . . .[1]

Both Péguy and Sérullaz make the error of assuming that what Monet was trying to paint had a constant element that could be painted better or worse, perhaps a certain true essence of waterlily. On the contrary, Monet's painting was an attempt to create an objective equivalent of an aesthetic event which was produced in the observer by

1 *The Impressionist Painters*, p. 76.

his sensations. Both the ephemeral and changing sensations, modified by time, light, atmosphere, and the changing mood, experience and knowledge of the observer, which are again dynamic factors, are combined in the aesthetic event. As the painting is the result of the interrelation of two dynamic processes, no two paintings have the same "subject," and are incommensurate. Certain factors may go to vitiate the effect of the picture, but one can not presume that either the "first" or the "last" is better. With some understanding of what the Impressionist is trying to do, it will appear clearly that the, quality of the Impressionist picture will not be determined entirely by the skill of the painter nor by the nature of the external event, but rather by the quality of the artist's response.

As the production of an Impressionist picture is strictly time dependent, it approaches music more closely in some ways than it does classical painting. Like a musician's performance, it can not be reworked piecemeal. If the constellation of circumstances is not propitious, the performance will be inferior. Consequently, if we were to consider, for example, the more than a score of paintings that Guillaumin made of the Rocher de l'Echo near Crozant (Fig. 49), it is obvious that a number of the paintings are less successful than others, but they should no more be weighed in determining the aesthetic value of Guillaumin's work, than should the occasional poor performance of a master musician be used as a basis for judging his aesthetic value.

Though Guillaumin himself stated that he discovered Crozant in 1893, there is a painting of the tiny village of La Querlière, signed and dated in the artist's hand the eighth of August, 1892 (Fig. 50). This work is extraordinarily revealing of his sensitivity to his new environment, for, in comparing it to the works of a similar nature which he had just been executing in the environs of Paris, it is immediately apparent that the picture of La Querlière is far richer and more luminous in color. The composition develops in three major zones. The foreground, dark, with its rich greens and

Fig. 49 *Rocher de l'Echo*, c. 1912

Fig. 50 *La Querlière*, August 8, 1892

muted reds, gives place to a middle ground where a warm golden light bathes the path and the trees with strong accents of yellow, while the distant trees of the background hold their place through the use of light blues and muted violets. Not only is the picture rich in the perception of color which it reveals, but color also fills an important function in its plastic realization, through the differentiation of various spatial elements of the complex composition.

In September, 1892, Guillaumin was at Saint-Palais painting the rocks of *La Perrière*. His movements in 1892 are difficult to trace. The date on the painting *La Querlière* shows that he was in Crozant August 8, but a letter to Murer has him in Paris August 28. According to the date on *Les barques de pêche à Saint-Palais* (Fig. 51) he was at Saint-Palais in September. He must have had (or taken) a very extended vacation leave, since letters to Murer dated November 29 and December 16 indicate that he did not retire from his job at Ponts et Chaussées until December 4 or 5.

Fig. 51 *Les barques de pêche à Saint-Palais*, September 1892

In 1893, Guillaumin went to Agay in the late winter, but came back to Paris for the birth of his daughter Marguerite in February. During the spring and summer he painted in the environs of Paris, at Charonton, Boigneville, Saint-Evroult, and Saint-Chéron.

At Saint-Chéron (Fig. 52), he painted a view of a farm in which the saturated color of the landscape of La Querlière appears in a scene in the softer atmosphere of spring in the Ile-de-France. With the stronger color there is less tendency to search for extreme color variations within any specific area. One thinks of some of the color affects of Vincent at Arles, but perhaps the softer light of Paris and the predominant pink-blue polarity lacks the telling qualities of Vincent's more austere coloration.

During August and September, he took his family to Saint-Palais. There under the influence of the soft misty sea atmosphere and the delicate coloration of the land and sea, he produced a view from the Pointe de la Perrière (cf. Fig. 47) in which the robust color of his work at Saint-Chéron and Crozant gives way to a delicacy of tint that recalls his works of the late seventies. The soft greens of the stone pines is interpainted with red in a manner reminiscent of Delacroix. The acquamarine of the sea is enriched with violet shadows, while the greyish sky is composed of a network of strokes of very pale purple and green. In both cases, the modulation of the color is not in terms of complements, or primary hues, but of hues adjacent to the normal color. Rather than a doctrinaire application of the color theories of the compositions of light, he seems to have been searching for an enriching harmony of tone. Gauguin and van Gogh also were less concerned with optical theory than with color harmony. To Cézanne the role of the optical theory of color was as a modulator of space, though in the late eighties the same modulation of the color of the sky is found in his works.

Fig. 52 *Prairie à Saint-Chéron*, 1893

Another characteristic that should be pointed out is that Guillaumin's brush work still plays an important part in preserving the structure of forms, and even here, with the soft misty light of the sea, he carefully preserves the structures of the forms in his painting.

He spent the fall through December, 1893, at Crozant.

In January-February of 1894, Guillaumin had a one-man show at Durand-Ruel's. It included sixty-four oils dating from the seventies to 1893. Only ten of the sixty-four paintings were unsold. Besides the oils there were forty-one pastels. The Introduction to the catalogue was written by Arsène Alexandre. In addition to the usual biographical and eulogistic material, he described how the painter worked:

> At least it will be of interest to read about some of the working methods heretofore unpublished. The painter himself is helping us in showing them to us through his exhibition.

Here he is, then, before the selected subject which he prefers to be simple and large. He will proceed to simplify and enlarge its elements and keep or investigate only those which made their first impression on him. He will have to put to work seemingly quite opposed but indispensible resources: great patience and great rapidity.

However, the problem is not insoluable and M Guillaumin has achieved this in the following fashion: a very patient succession of fast operations.

With natural verve, aided by acquired assurance, he begins to establish the general outline construction of his landscapes on a large sheet of white paper. He may have to re-do several of these large sketches until each plan may seem to him to have its own color and the whole its balance before adding the slightest touch of color. If he works with figures, a worker or a peasant who would never pose, and whom he would never ask to do so, he may do a sketch as often as ten times, with imperceptible differences, until he finds the motion completely satisfactory. This is the first series of operations.

The second one begins only if the first promises the hoped-for results. If the subject holds no further interest for him after this try, he resolutely abandons it. Otherwise, he hastily sketches in his design with rough indications of pastel which furnish him with the first effect of the wanted coloration. This pastel is then sometimes taken up again, sometimes more or less pushed as is done with the different stages of an engraving; but at each stage it is complete in itself. At this point one might say that the artist has half finished the painting.

In his paintings we find the same method. They are executed in the same vigorous manner, before nature, after the preparatory pastels. One has to understand the surety which allows the painter all the methods he has used on the same subject.

However, he will leave this subject only with regret and will feel that he has to improve on the unity of lines and the various blendings of colors at different times.[2]

After his exposition at Durand-Ruel's, Guillaumin probably remained in and around Paris until September, painting at Saint-Val and Boigneville. He went briefly to Saint-Palais, and then was in Crozant from September until February.

In 1895, Guillaumin was very active painting at Agay, where he stayed from February until the end of April. There he painted *La Maleraigue*, *Agay: la baie*, and *La Mer et Pins*, *Les Roches rouges*, the *Vallée d'Agay*, and the favorite view of the *Rastel d'Agay* from Cap Long (Figs. 53-58).

Typical of the works at Agay this year is a view of *La Maleraigue* (Fig. 58), painted near sunset. The rocky promontory jutting out into the sea is framed by the sea and sky. In the sky the clouds are bathed with the red and orange of a sunset played against the darkening blue of the sky itself. The sea, turning dark with the setting sun, picks up myriad reflections of lighter blue and occasionally a touch of light green. Dark shadows of the ripples are accented with deep blue. Against this is set the darkening red of the rocks, relieved by the almost black forms of the stone pines. The picture, in spite of its brilliant colors, reveals the austere, even threatening aspect of the Esterel coast. The harsh forms are emphasized by the brush work which accentuates the sharp planes of the rocks. Even the sky, in contrast to the placid sea, has a stormy quality emphasized by restless activity of the brush.

In May, Guillaumin was back in the environs of Paris, painting at Miregaudin. In July and August, instead of making the usual visit to Saint-Palais, the family went again to Pontgibaud, and further into Dauphine to Pontcharra. The fall saw them returning

Fig. 53 *Agay*, 1895

Fig. 54 *Vallée d'Agay*, 1895

2 *Exposition Armand Guillaumin*, Preface, pp. 11-13.

Fig. 55 *Le Lac, Agay*, 1895 (Durand-Ruel)

Fig. 56 *Agay*, 1895

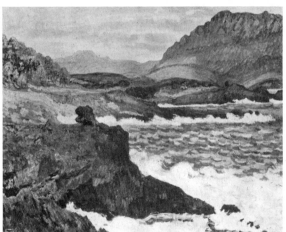

Fig. 57 *Agay: la baie*, May 1895

Fig. 58 *Agay: Pointe de la Maleraigue*, May-June, 1895

to Crozant. This year he rented a house, Les Granges, instead of staying again at the Hôtel Lépinat (now Hôtel Goulinat). This was to be his home for the next eighteen years, though when he was in Crozant alone he still spent his evenings at the Hôtel Lépinat. La mère Lépinat was a widow who had a large house on the church square in Crozant. She enjoyed the company of the artists who were beginning to frequent Crozant, eventually took in boarders, and finally turned the house into a hotel by adding a café. Guillaumin, as one of her oldest guests, continued to take his meals there when he was alone. A table was always reserved for him by the side of the fire in the kitchen.

In 1895, a new dealer appeared on the Paris scene, Ambroise Vollard. In that year, Vollard held an important exhibition of the works of Cézanne in December, which aroused considerable critical comment. On December 4, Pissarro indignantly wrote his son Lucien: "Would you believe that Heymann has the cheek to repeat the absurdity that Cézanne was always influenced by Guillaumin?"[3] Though Heymann exaggerated, he was not the only one to note the relation of certain elements of the style of Cézanne to that of others, for Arsène Alexandre wrote: "The interesting thing about the exposition is the influence he exerted on the artists who are now well known, Pissarro, Guillaumin, and later Gauguin, van Gogh, and others."[4] Of those mentioned by Alexandre, it was his old friend Guillaumin who best understood Cézanne's search for structure. Though they had remained friends, they saw little of one another after Cézanne had given up his studio on the Quai d'Anjou to return to the seclusion of Aix and become a recluse. He had often invited Guillaumin to visit him at Aix, and when, after many refusals, Guillaumin did pay him a visit, Cézanne was not very cordial. When Guillaumin reproached him, Cézanne answered that he had invited him, but that was to be polite. He ought to have known better than to accept the invitation. Again, walking on the quai side with Signac, the two artists saw Cézanne approaching, but, on the latter recognizing his old acquaintances, he urgently signaled that he did not wish to speak to them.[5]

Fig. 59 *Ravin de la Sédelle à la Folie*, June 1896

Fig. 60 *La Querlière*, September 1911

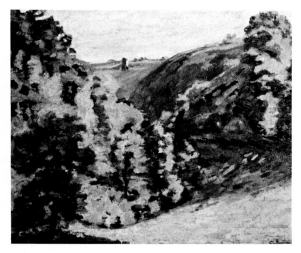

In 1896, Guillaumin went to Agay in the late winter, as usual, but he was back in Paris for the birth of his son André in March. At the end of school, the family was again settled at Les Granges, where Guillaumin remained for most of the year.

As he becomes older, it becomes harder and harder to establish the dates of his paintings. His color variations are slight, while his use of pigment and brush seem to obey no orderly progression. But even though only a few are dated, one can still see broad developments in his style.

In general, after 1893, Guillaumin's color became more subtle in its variation, though his love of the brilliant shades of spring and autumn on the Creuse often disguised the fact. Over the period his brushstroke varied little. Though he tended to relate the brushstroke to the form, it became shorter and drier.

Another factor that makes dating of pictures more difficult is that Guillaumin became more sensitive to times of day, the season of the year, and the weather.

The magnitude of the problem can be seen by a comparison of two pictures, *Le Ravin de la Sédelle à la Folie* (Fig. 59), dated June 1896, and *La Querlière* (Fig. 60), dated September 1911. Though there was a span of fifteen years between the two pictures, brushstroke, density of pigment, and use of colors are all essentially identical. Obviously, without external evidence, dates for pictures in this period can be only tentatively assigned. The two experts who have had the most experience with the works of Guillaumin, M Serret and Mlle Guillaumin, often differ by more than ten years in their dating of these pictures. (*See color plate Section.*)

Another side of the problem of dating is that not only do pictures that differ in date by as much as fifteen years show no change in style, but also pictures done the same year show great difference. For example, *La Maleraigue* (cf. Fig. 44), executed at Agay in 1901, shows a tempered color harmony and a short dry brushstroke entirely different from the *Portrait of Madeleine* (Fig. 61), signed and dated 1901. In the latter picture, Guillaumin adopted the long slashing brushstroke, used to create form, typical of such

3 *Letters* ..., p. 277.
4 "Claude Lantier," *Le Figaro*, December 9, 1895.
5 Rewald, *Cézanne*, p. 149.

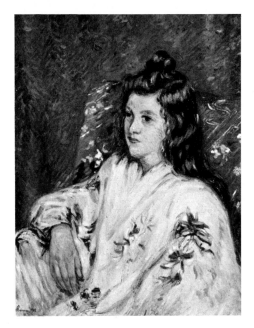 

works of the middle eighties as the *Vase avec chrysanthèmes* (cf. Fig. 38). To add still further confusion, his landscape, *Boigneville-les-Carneaux* (Fig. 62), also dated 1901, shows yet a third style. In this case the brushstrokes seem to blend together into more gently varying areas of color, while the color itself recalls the extreme freedom of the works of 1892–93.

At the beginning of September 1896, Pissarro wrote his son Lucien that Vollard was going to install a lithographic press in his gallery on the rue Lafitte. Pissarro had experimented with lithography as early as 1874,[6] but now he was stimulated to take it up again. In 1896–97 Vollard published two *Albums des Peintres-Graveurs*, but they were hardly more than a collection of prints by those contemporary artists he could persuade to contribute. Both contained works by Guillaumin as well as Pissarro. Guillaumin had, of course, experimented with graphic techniques in 1873 when he had done a series of etchings with Pissarro, Gachet, and Cézanne. Though he had not continued his graphic work, Vollard persuaded him to try lithography. Guillaumin approached the use of the lithographic crayon in much the same spirit in which he approached pastel, though the limitations of the technique restricted his range of colors. Indeed, he actually executed a number of his lithographs after pastels: a portrait of his daughter *Madeleine* (Fig. 63), a portrait of his son Armand eating soup (*La Soupe*, Fig. 64), and a portrait of his new-born son André in his crib (Fig. 65). Only in two cases were the lithographs done after paintings: *Les meules* (Fig. 66) and *Les Roches au bord de la mer* (Fig. 67). The last case is interesting, for a proof sheet with annotations is known, as well as the final print.

In the beginning of the uneventful year of 1897 he was at Agay, and later on a few miles up the coast at Le Trayas. Late spring and fall he spent again at Crozant.

In 1898 the climax of the Dreyfus case came with Zola's publication of *J'Accuse* on January 13. As the Dreyfus affair had been dividing all France, it split the old Impressionists. Monet and Pissarro were Dreyfusards; Cézanne and Degas were anti-Drey-

6 Duret, Théodore, *Manet and the French Impressionists* (London, 1910), p. 51.

Fig. 63 *Madeleine*, 1896

Fig. 64 *La Soupe*, 1896

Fig. 65 *Portrait of André*, 1896

Fig. 66 *Les meules* or *Haystacks in Winter*, 1896

Fig. 67 *Les Roches au bord de la mer*, 1896

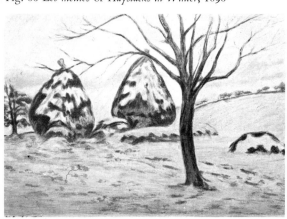

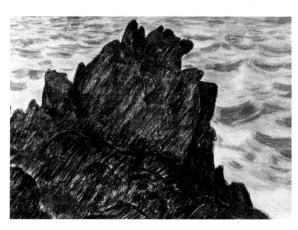

fusards. Guillaumin was apparently neither pro nor con. On the day of the publication of *J'Accuse*, Pissarro wrote to Lucien: "I heard Guillaumin say that if Dreyfus had been shot at once, people would have been spared all this commotion!"[7] That he wrote about Guillaumin's expression of exasperation to his son indicates that as a Jew Pissarro could not ignore the statement, but it did not seem to cause continued bad feeling between the two old friends. Pissarro included his name in the list of friends to be invited to the opening of his show at Durand-Ruel's on May 28.

In 1899 life went on as usual, but in 1900 Guillaumin went to Saint-Sauves in February. May and June were spent in the environs of Paris; in the fall, his family persuaded him to go not only to Saint-Palais, but to visit Saint-Servan and Dinard (Figs. 68, 69) on the coast of Brittany as well. In 1901 he went to Agay (Fig. 70) and then to Pontcharra in July (Fig. 71), and in 1902 he again visited Moret in the spring and spent August and September in Brittany at Carolles.

These ten years of his life, since retirement, had been idyllic. He sold paintings easily, he had matured as a late Impressionist, he painted the scenes he liked best, and he had a devoted family.

7 *Letters* ..., p. 318.

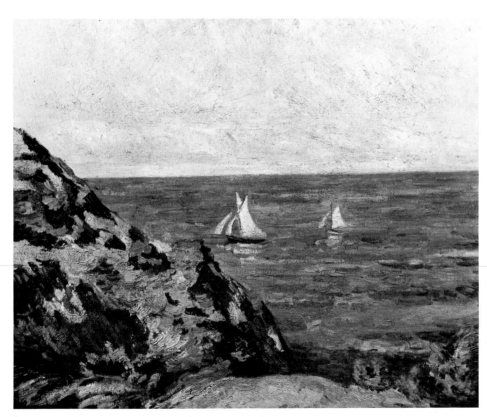

Fig. 68 *Dinard*, September 1900

Fig. 69 *Saint-Servan*, September 1900

Fig. 70 *Agay: marine*, c. 1901

Fig. 71 *Rue de Villard Benoit, Pontcharra*, July 1901

Guillaumin was fascinated by Holland, where he spent nine months, from September 1903 to the end of June 1904 (Fig. 72). It was his first time away from France. He went from one city to another around the Zuyder Zee. He wrote:

> How poorly painters have understood the Netherlands! Having had in mind the works of Dutch artists I expected to find a somber, cold and sad country. It was a joy for me to discover fresh tones. How can anyone see Holland as a dark country immersed in fog? By the way, the natives are quite unbearable . . . the children threw pebbles at me . . . I have never seen a place where it is more difficult to work "after nature."[1]

Fig. 72 *Moulins en Hollande*, c. 1904

He might have added that he was a sixty-three year old man, traveling outside France for the first time, and the change of diet, particularly the lack of his accustomed wine, had upset his stomach, so that he had to return to Crozant to get himself back in shape. That winter he spent in Rouen, where in a different setting he returned to his first artistic love, painting the barge activities along the Seine. By summer he was back at Crozant in his customary routine.

He spent the early part of 1905 at Agay and Le Trayas. In the late summer he again went to Saint-Palais, but in the autumn he went to Villeneuve-sur-Yonne. As usual, he spent the end of the year at Crozant, where he stayed through February before leaving for his annual visit to Agay in March.

In 1906, Guillaumin received a signal honor: he was made president of the section of painting in the new Salon d'Automne. Le Salon d'Automne had been started in 1903 by Francis Jourdain and Robert Rey to provide a more or less autonomous salon for the exhibition of paintings by the avant-garde.[2] The first year Renoir had been president; Guillaumin held the position from 1906 through 1908.

1 Des Courières, *Guillaumin*, pp. 45-46.
2 On Guillaumin's relationship to this Salon, see Jourdain and Rey, *Le Salon d'Automne* (Paris, 1926).

In 1906, under Guillaumin's presidency, it was decided to hold an important retrospective exposition of the works of Paul Gauguin, who had died three years earlier in the Marquesas. Concurrently there was a retrospective show of Courbet, who had exercised an important influence on the work of the young Impressionists in the second half of the sixties. In 1907, the retrospective of Cézanne's work in 1904 having been a success, it was decided to put on an even larger one (he had recently died, and he had been the friend of Guillaumin's youth). The special events of the Salon d'Automne of 1908 were retrospectives of the works of Monticelli and of Rodolf Bresdin. The catalogue had a preface by Odilon Redon. During the period of Guillaumin's presidency of the painting section, the Société du Salon d'Automne had increased from one hundred and fifty to two hundred and seventy-five members, and its position as an important force in the artistic world had been assured.

Guillaumin's activity with the Salon d'Automne did not particularly interfere with his painting. In May, 1907, he visited Le Trayas. At the urging of his family he went to Le Val André in the fall. Madeleine was now nineteen years old, Margot (Marguerite) was fourteen, and they wished to spend part of their vacations where there were more people. Guillaumin found the landscape dull, and the region too full of people. According to Margot, his bad humor spoiled the holiday for the whole family.

From 1908 to 1910, the routine was varied only by a visit to Pornic in Brittany in 1908 and a spring in Poitiers in 1910.

The spring months of 1911 on the Côte d'Azur were changed by going to Le Brusc, near Toulon, before the usual visit to Agay and Le Trayas. The coast at Le Brusc was very different from that of Guillaumin's favorite places in the Esterel. At Le Brusc the rocks had neither the color nor the wild shapes of those at Agay and Le Trayas (Figs. 73, 74). As a result, his choice of subjects was different. His attention was largely drawn to the gnarled stone pines and the sea; for, though it lacked the color of Agay,

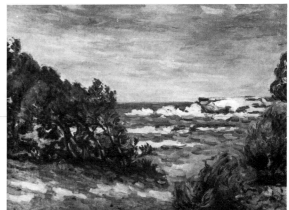

Fig. 74 *Pointe des Embiers*, 1911

Fig. 73 *Le Brusc: le pin parasol*, March 1911

the region was more exposed to the western winds and the sea and trees were much affected. By April he was at Crozant where, contrary to his usual practice, he stayed through August.

Guillaumin was proposed by his admirers for La Légion d'honneur in 1911. When he received the necessary papers to fill out, he did not take them seriously, and, not knowing what to do with them, he simply put them aside. Finally, at the urging of his friends, he filled them out and on December 7 he was made a Chevalier. Not only was he receiving official recognition, he was now beginning to receive critical notice by those interested in the development of modern art. In 1910-12, Sérusier was discussing the role of Guillaumin with his students: "Guillaumin est très intéressant. Comme Cézanne et Gauguin il doit son initiation à Pissarro. Il est resté plus impressionniste que ses camarades, mais il est de leur famille."[3]

In 1913, he was seventy-two years old, and it was fifty years since he first exhibited in the Salon des Refusés. He was still to have a decade of active painting ahead, but life was changing. He made his last trip to Pontcharra that year. He had given up going to Saint-Palais four years ago. He had done his last work in the environs of Paris. Only the Côte d'Azur and Crozant still attracted him. His family had grown up: André, the youngest, was seventeen and preparing for the bachot.

Crozant was now "home." Though the natives were extremely distrustful of outsiders, they had finally got accustomed to the rough artist who seemed to have become one of them. Guillaumin was himself a man of the Massif Central, yet he had a knowledge of the wider world and was, in spite of his gruffness, often a help to visitors who tended to suffer from the natives' extreme xenophobia, often expressed by their custom of barring their doors and setting their dogs on anyone with an unfamiliar face. Nevertheless, Guillaumin remained a man apart. Though he was known as an upright man, the curé reproached him for not setting his flock a good example by attending church.

His fondness for this region led him to accept an appointment to the departmental committee for the preservation of picturesque sites. He said that he could believe that other places in the world might be *as* beautiful as the Valley of the Creuse, but that he could not believe that any were *more* beautiful, and he expressed the hope that the Valley around Crozant could be preserved in somewhat the same manner as the American national parks.

Evenings he would join in the convivial amusements of his friends at the café. Sometimes Alluaud[4] would play the piano, and sometimes Guillaumin himself would perform with marionettes. As an artist, however, he was a solitary. He would not tolerate being watched while he painted. Des Courières records the following incident:

> One day a prying individual had succeeded in surprising Guillaumin on a site and said to him: "I am a painter myself, Sir, would you permit me to watch you working?"
>
> "Well, one of the two of us will have to leave," answered Guillaumin, "and I find it preferable that you be the one . . ."[5]

The old schoolmaster of Crozant since 1911, M Alamasset, now the honorary director of the school, relates another incident. A Dutch painter asked Guillaumin

---

3 *L'ABC de la peinture*, p. 162.

4 Eugène Alluaud was the son of the founder of one of the oldest porcelain manufactures at Limoges, but he preferred art to the porcelain business. He painted around Limoges from 1907 to 1910, then spent more and more time at Crozant where he built himself a house, from which Guillaumin often painted the Creuse and Puy Bariou. He exhibited landscapes of the Creuse at the Salon des Indépendants and at the Brussels exposition of 1910.

5 *Guillaumin*, p. 49.

to look at his painting and give him advice. Guillaumin's gruff reply was that if he painted that way himself, he would never take up a brush again.

He was extremely regular in his habits. On good days, he would be up before dawn and set out for his site with the son of his housekeeper as porter, carrying two canvases. According to the porter, who still lives in Crozant, he would work in the morning from 4:00 to 8:00 and in the afternoon from 4:00 to 6:00, always on a different site in the afternoon from that in the morning.

He also led a regular life otherwise. When his family was away, he always turned up precisely on the hour at the Hôtel Lépinat for his meals. The old man was solidly healthy and had a hearty appetitie—Mme Guillaumin was known to complain of his capacity for disposing of a whole leg of lamb at a single sitting. Sometimes his friends were annoyed at his meticulous regularity. M Alamasset recalls that Guillaumin invited a number of friends at Crozant to see his paintings before he sent them off. Lépinat, having to bring in his cows beforeheand, arrived just after the others had left. Guillaumin told him he was too late, and would not let him in, even though they were intimate friends.

As his life centered on Crozant, Limoges became the metropolis around which his activities centered. At that period, Limoges had become wealthy through the flourishing porcelain industry. Such men as Alluaud, Bernadaud, D'Albis, Haviland, and others knew and loved the region around Crozant and bought paintings by Guillaumin. Unfortunately, those who are still alive who knew him at Crozant were some forty years his junior. Though they regarded him as their friend, he appeared as a rather rough-hewn old man who liked to keep to himself. The younger generation that gathered around his children all called him "Père Guillaumin," though his wife was always "Madame Guillaumin."

Just before World War I, Guillaumin began painting a few selected sites even more frequently than before. During the last ten years of his work at Crozant, such subjects as the Barrage à Génetin, the Rocher de l'Echo, Pont Charraud, and Puy Bariou were regularly painted several times a year. This constant repetition of themes in his last years may be the cataloguer's despair, but it is not monotonous. Like Monet, in his watergarden at Giverney, Guillaumin developed a profound awareness of the change in nature with time. It may be of interest to note that the ideas of Bergson on time and change, expressed in *Evolution créatrice*, were also influencing the ideas of the Cubists at this time. To use the "pathetic fallacy," nature had many moods that were constantly changing. It was never the same twice, and each mood was worth painting. Mme Jo Teillet, daughter of the painter Smith from Bordeaux, who knew Guillaumin well, says that he disliked the summer landscape—he called it "un tas d'épinards."

Guillaumin's portrayal of the landscape at Crozant during the last ten years had been powerful, choosing its most colorful aspects; in this next decade, he became famous for his painting of Crozant under the more delicate aspect of "la gelée blanche." In these paintings, he caught the fey aspect of the early morning light scintillating over the sere landscape of winter and early spring. While an almost brutal power is shown in some of the landscapes of the first twenty years of painting the region around Crozant, he developed an almost pure lyricism in his last ten years. True, it is not the "impressionism" of the Impressionists of 1875-85, for which the critics were still looking, but the landscapes are some of the finest nature poetry ever painted.

## 10: 1913–1918 / Good Grey Artist and Friend

Guillaumin gives us some insight into his personal and family life as an old man through his correspondence with a young woman artist, Clémentine Ballot, née Leroi, who became a close friend of his family in 1913. She was born in 1879, and in 1913 was the mother of a ten-year-old son, André.[1] She had been interested in art as a child, and was largely self-taught until her marriage to Jules-Gabriel Ballot in 1902. Ballot was a broker in over-the-counter securities, born of a family native to the Creuse. He was interested in art, permitted his wife to enroll in a course under Fernand Desmoulins, and introduced her to the region. At Gargilesse, Mme Ballot executed a number of neo-Impressionist works under the influence of Léon Detroy. As early as 1907 she had made her debut at the Salon des Femmes Peintres et Sculpteurs, and in 1908 she was accepted in the Salon of the Société nationale des Beaux-Arts. In the autumn of 1912, she met Armand Guillaumin, and the two remained fast friends until the end of his life. For seven years, 1912 to 1918, they painted the same sites along the Creuse: Génetin, the Moulin Bouchardon, Pont Charraud, Les Ruines and Le Rocher de l'Echo.

As with all correspondence between friends, we suffer from the disadvantage that letters were only written during periods of separation, so we do not know much about their activities together at Crozant. The records of their paintings show that they often painted side by side on the same sites, a notable exception to Guillaumin's insistence on having no one watch him at work. Both Mlle Marguerite Guillaumin and Maître André Ballot recount stories about how the old artist would get up before dawn in the winter, put on his heaviest clothing, put layers of newspaper under his coat to keep out the wind, and set out for the Hôtel Lépinat to arouse Mme Ballot to go with him to paint a "gelée blanche" at Pont Charraud.

Another bond between them was their common concern for their families during the period of World War I when the two of them (and sometimes their families), spent much of the time at Crozant to avoid the rigors and dangers of Paris. On August 17, 1914, he wrote her about the terrible events that were taking place and the effects on their two families.[2] (The letters mentioned in this chapter and the following one will be found in the Appendix.)

On the seventh of September he again wrote from Paris, because his wife had to return to teaching, that Armand, Jr., called Chabral, had been wounded in the foot during the Battle of the Marne. He expected to return to Crozant that fall.

During the war years, Guillaumin spent the long winters in Crozant without his escape to the Côte d'Azur, and during bad weather painted still lifes. He had done some still lifes at the beginning of his career, and now, as he turned again to them, he reworked a number of his very early ones. For example, the *Still life with Marmite* of 1914 (Fig. 75) is identical in motif to the one of 1867, even to the arrangement of the fork and spoon. In 1914, he made subtle changes to improve the composition. The somewhat too static balance of the earlier work is gone.

On March 28, 1916, he wrote Mme Ballot a long letter saying that he had remained in Paris after the date of his planned departure on February 18, as he had had no news of his son Chabral for nearly a month. During the height of the battle of Verdun, on March 19, he heard that his son had been taken prisoner, but apparently not wounded.

After the twenty-five day wait, Guillaumin felt the need to get back to Crozant, to rest, to work, and to straighten out his thoughts. He wrote:

---

1 Gauthier, *Clémentine Ballot.*

2 Germany declared war on France on August 3. The first heavy French losses were in the battle of the frontiers in Lorraine, August 14-25.

Unfortunately the weather was not favorable. I arrived the 20th in a storm and every day has been the same except last Saturday, when it was a beautiful day . . .

The Alluauds were here Saturday ·and Sunday but left yesterday because of the rain. . . . I am the only painter here, and that annoys me royally. Point was supposed to come, but he has put off his departure . . .[3]

On August 2 he wrote:

The weather has been magnificent since our arrival. I profit from it to work. I get up at four-thirty, and go to bed at nine. There have been some amazing effects of fog. The mornings are exquisite. . . . The Madelines will be here on the eighth.

During the winter of 1916, Mme Ballot and Guillaumin were again painting together at Génetin and Le Rocher de l'Echo. The correspondence resumes in April 1917, after she left Crozant, and continues until her return in the autumn. April 26 he wrote asking her to send him two kilos of *blanc de Meudon* if she could find it. This was a powdered chalk which he used with glue to make a thin absorbent priming on his canvases.

During the middle years of the war, Guillaumin's painting became more and more delicate. The general tonality of the pictures tends to be lighter, there are more effects of misty atmosphere, and the delicacy of the paint-layer itself almost approaches that of watercolor at times. There are a number he presented to Mme Ballot, Mlle Yvonne Coste, and other friends, that seem to be unfinished. The effects depend to a considerable extent on the areas of white ground that appear through and around the brush work. After the war, in the few years of activity remaining to him, this mood seems to have passed. One almost has the impression that the horror of the destruction had sapped his rugged vitality, reducing his strong voice to a whisper. Nevertheless, these pictures have their own special charm.

Guillaumin arrived in Crozant about the 7th of February, 1918, and started immediately on a "gelée blanche" of Pont Charraud which he dated February 10.

A "gelée blanche" which Guillaumin calls "fairly good" is undoubtedly the view of Pont Charraud in the Musée municipale at Limoges. It is a joyful picture of one of his favorite scenes now dominated by the pinks of the rocks and the winter foliage set off against the green stems of the genista. The yellows of the yellowed bracken and the dried-out fields give a warm golden glow to the middle ground. In the distance one field is beginning to turn green, while the slanting light of the early morning turns the distant hills a pale crimson violet. Though Guillaumin railed at the dealers for constantly demanding "gelées blanches," he himself delighted in them even when the early morning cold of mid-winter nearly paralysed the 77-year-old fingers. Their luminosity fitted in well with the gradual clearing and lightening of his palette which had been going on since the nineties, but which became more and more apparent after 1910.

As usual, the composition, though not obtrusive, is well thought out. The general movement of the composition is set by the flow of the foreground space from front right to back left, contained by the rocks on the left foreground, and the bank on the right middle ground. The center of interest in the pink tree on the right middle ground is balanced by the houses of Pont Charraud in the left middle distance. The strong recessional diagonal having reached the left side of the picture, the movement is countered by the rolling forms of the rising hill carrying the eye toward the right in the

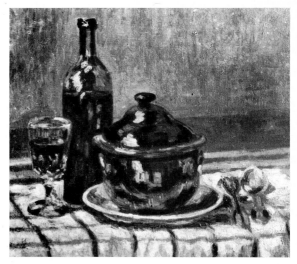

Fig. 75 *Still life with marmite*, c. 1914

3 Armand Point, born in Algeria in 1860/61, was a pupil of Herst and was influenced by the pre-Raphaelites and Botticelli. He came to Paris in 1888, won an Honorable Mention in 1889, and the traveling prize of the Société nationale in 1893.

far distance where the sharp silhouette of the bank and dark tree on the right in the middle ground seize the attention and carry the eye forward. To further balance the movement of the space in the picture, and to increase the sense of depth, the brushstrokes of the sky are slanted toward the right as they move from the horizon toward the zenith.

During the rest of 1918, Guillaumin spent most of his time at Crozant. Mme Ballot was also there from the spring on, so the correspondence is meager through that year. On the twelfth of June, he was in Paris briefly during the bombardment of "Big Bertha," but he soon returned to Crozant, which was full of people escaping Paris, until the war finally ended.

After the war Guillaumin resumed his former travel routine. At age seventy-eight in 1919 he spent the late winter at Agay, where he stayed from February to June, with a trip to Cap Martin, and a visit to Paris in the spring. By June he returned to Crozant where he stayed until winter, and then returned to Paris.

Guillaumin spent some time using his considerable influence, as one of the original organizers of the Indépendants and past president of the section of painting of the Salon d'Automne, to further the career of Mme Ballot. Early in June, he wrote his friend Personnaz to try to arrange an exhibition at Biarritz. The same month, when he had to go to Limoges to see about a toothache, he talked to his dealer there, Dalpayrat, about the possibility of an exposition. At the same time (letter of July 1) he was pressuring his dealer in Paris, Georges Petit, to consider her works. During this time he got wind of a plan among his friends to have him promoted to the rank of officer in the Légion d'honneur. He wrote July 8 to her:

> I had wanted to write to Seguin to thank him for his kind thought in connection with me, but then I thought that he might have written you confidentially without authorizing you to tell me about it. Please drop me a line by return mail and tell me whether I may write him. At any rate I should be very grateful if you told him about my present letter in order to gain time.
>
> I should like to ask him to drop the proposition he made regarding me; I have done nothing to qualify for it. A recompensation is acceptable only if one has deserved it and such is not my case.
>
> During the fortnight I passed in Paris, I refused a general's services in this matter—the brother of an amateur well known to you. He might have reason to find it bad. . . . However, all this matters little. Please let me know whether I may write him about this question and I hope it will be in time to save him unnecessary steps.
>
> Thank you very much, my dear. Yours, Guillaumin.
>
> The address is R. Jouvenet.

By July 28, Crozant was beginning to fill up with tourists that were coming in greater numbers every year, and the landscape was beginning to lose its color.

> This year the heather is even less colorful than last year. I still do not work much but I believe that the weather is going to turn nice again, but oh god what colors! . . . I have to really tax my ingenuity to obtain the effect.

Guillaumin stayed on at Crozant until the usual trip to Paris in the winter. In 1919, his wife did not have to leave in October, for, after thirty-five years of teaching, she had passed the age of sixty and was ready to retire. In mid-December, Guillaumin left for the Côte d'Azur. This time he and his wife went to Rocquebrune where they rented a villa, "Les coccinelles." Early in January he wrote:

> The first eight days of my stay here were no good, I had no courage. At this moment I feel pretty well. The weather is beautiful, rather warm. This nice weather is restoring some of my self-assurance.
>
> I have used these days to look at themes. I have found some; they are very different from Agay and Le Trayas, quite Japanese in fact. The difficulty is that one is almost always next to a house on the street. There are many carriages on the road and one could frighten the horses with a parasol. Well, I shall try my best . . .
>
> Don't forget to tell me the name of the president of the 'Nationale' who will be chosen and give me his address so that I may congratulate him properly and thus prepare him for the favor I intend to ask him in due time on your behalf.

On January 10, he wrote that he had sent a letter of felicitation to the new president, Bartholomé, and that he had begun to work,

. . . but without enthusiasm, one is too much on the street to be able to work. There are only very steep inclines on which one can neither stand nor sit. I have, however, started two water colors but you have no idea how gray everything is. It is quite the opposite of Agay or Le Trayas but to make up for it is much warmer.

Late in January, Guillaumin again wrote her about her candidacy for admission to the Nationale, remarking on one of her backers: "I like Lebasque very much though he listens too much to the dealers in my opinion."[1] Again he writes of his painting:

The weather is nice, but there is often a strong wind which bothers me. I am working a little but I am not enthusiastic, it is too gray. Father Corot has rendered the atmosphere of this country very well but this fails to delight me. I like Crozant, our pleasant times in that lovely country.

As an afterthought he wrote:

I forgot to tell you that had I held my last letter for another two days I could have added that I received a very friendly note from the new president. This gives me great hopes for my request. Do not fail to tell me when the time comes because I should be very happy to be of some help to you.

On February 29, Guillaumin was depressed about the death of their mutual friend, the painter Paul Madeline,[2] one of the intimate group of Crozant painters. He himself was feeling his age:

I am getting lazier and lazier; I feel myself aging and it is becoming increasingly difficult for me to work. I tire very rapidly; everything is becoming indifferent to me.

In spite of his depression, his letter is still full of concern for the career of Mme Ballot. He accuses her of having shown people too many of her paintings at one time, and boring them with the quantity. But he goes on to say of her candidacy:

. . . I hope that the friendly influence of Seguin and Lebasque have surmounted this obstacle. . . . When are you sending to the 'Nationale'? Don't fail to inform me about this and, above all, indicate when the jury is going to start working because it is not good to write too soon. . . .

My little Margot is well. . . . Dancing is no sinecure when one wants to do what she has in mind. . . . If the country here were richer in themes and a bit less rugged I would stay a little longer to keep her company, but I just cannot do it. I am too tired. Imagine that at one time I climbed 500 steps every day to go to work.

It is unseasonably warm. The hills are covered by houses as from Paris to St.-Germain.

The next week he wrote that the moment had arrived, and he had written to Bartholomé—"since people honor me by believing that you are my pupil, I want this to be of some service." He was packing up to leave Rocquebrune for Paris. By the 14th, he had received a reply from Bartholomé who, though he was sick with bronchitis, promised to pass along a good word to his replacement. He had been planning to leave on the 15th for Paris, but there were no places on the train, so he could not get to Paris until Friday. He hoped to spend the month of April in Crozant

1 Henri Lebasque, landscapist, had a difficult beginning. He was on the committee of the Société des Indépendants, and later was affiliated with the Société nationale. In 1900 he won a bronze medal.

2 Paul Madeline worked at Crozant, and had become a friend of both Mme Ballot and Guillaumin. He had been a pupil of E. Chalym, a landscape painter. He became a member of the Société des artistes français in 1897. He won Honorable Mention in the exhibitions of 1897, and in the Exhibition Universelle of 1900. He became a sociétaire of the Société nationale des Beaux-Arts in 1910.

recovering from his stay at Rocquebrune, so his visit to Paris would have to be cut short.

Early in April, he left for Crozant, but was not able to work before the end of the month. On the 21st, he explained what had happened:

> It has been quite a while since I have given you my news or asked you for yours, ... even if I had been able to write. On Maundy Thursday, the day before our departure, I ran after a bus which was not moving at that point and I fell flat on my face. Among other things I cracked my thumb joint and as I did not immediately take care of myself, I have been obliged to wait this long to write to my good friends. As regards painting ... I have done nothing so far partly because of my thumb and partly because the first two or three mornings it rained and stormed. I had hurried my return hoping to finish some of the landscapes I left last year when I was so happy to be able to work next to you. ... The season is at least three weeks in advance of last year's and prevents me from finishing these landscapes.[3]

> At the moment, I am not in a good mood, I see nature as she is. I do not have an idealistic approach and besides it is very cold; you could almost expect snow. Also, I should like to caution you so you won't be unadvised as you were before.

> The news of the Salon gives me great pleasure and believe me that I deeply regret not being able to see your works in that milieu. I am sure that they can hold their own next to all those great masters! You thank me. You are too kind and I can only wish that I may be able to be of some help to you. At any rate I am happy that you are satisfied. Do not fail to let me know when to write to the association. I hope that will all go very easily. Yes, I share your opinion about Point. He is evidently an artist but why always look back? And since all their compositions turn upon each other, why not take their subjects from modern life? Why all these muses and antique gods? Mythological scenes have been painted in all their aspects and 99% of the public ignores them. Long live Chardin and the painters of the 18th century! Without them we should know nothing of that lovely era. It is very sad that he has been injured for life but maybe time will bring some surcease.

> I have no news, good news.

> If you see Lebasque and some others of our friends please remember me to them. My wife sends her best regards. When are you coming? Fondly, Guillaumin.

On May 8 he again wrote his felicitations on the favorable response of the jury to her works, and said that he was still not satisfied with how his painting was progressing:

> I am not very happy. First of all, I have done absolutely nothing in April. ... I thought I would catch up with myself from now to the end of the year and here it is summer already. The country will be overrun by stupid tourists and troublesome painters. ...

On July 25, he again complained of the summer landscape:

> The weather is not good and consequently the painting does not progress. I usually do not work much at this time but during the whole of July I have not done a single canvas, one or two water colors are, after all, not enough. Everything seems ugly to me except some morning views; furthermore, the country is full of tourists which is not amusing at all. ... The colors are pretty bad and what with the changing weather, I have lost quite a few ready palettes—sad thing!

3 Guillaumin now had the habit of waiting for the next season to finish pictures that he had been unable to finish during the first season because of a change, either in the weather or in the development of the motif with the change of season.

He also mentioned his disappointment that she had not been made a sociétaire of the Nationale, but expressed hopes for the future.

In August, he again found it necessary to express his reluctance about the Légion d'honneur:

Croizant-Creuse August 29, 1920

My dear Goldorp:

You too want me to become an officer! This seems like a real epidemic—you are the sixth of my good friends whom I implore not to give way to these proceedings. My dear friend, I do not want to be nominated for officer. I have done nothing to deserve it. I have a great respect for the Légion d'honneur and find that these distinctions are given out too frequently. I don't want to augment the number of those thus honored who do not merit it. This being agreed upon, I thank you for your kind thought. It has been quite a while since I last saw you. Since last year I have passed twice two months in Paris; half of that period in bed, the other half to get ready to go south for the winter. The summer has arrived here and I am hardly working at all at this moment.

I shall return to Paris at the end of September and I shall not fail to go to see you but will first make an appointment.

My wife thanks you and wishes to be remembered to you. . . .

Guillaumin.

After his usual stay in Paris, Guillaumin and his wife left for Menton just before Christmas. Again, just before leaving, he had had an accident. On December 23 he wrote: ". . . Sunday evening at 8 o'clock, I stepped off the Autobus at rue Vaugirard opposite our street and fell, without, however, hurting myself much. . . . With the help of a passer-by, I was able to get up on the sidewalk. I was generally upset but a little rest will rectify this."

By January 3, he was getting back his strength.

The quiet of the little corner where we are staying is very good for me and I am gradually getting to be my own self again. The shock I suffered when I fell is now practically only a memory and a few days hence I shall go back to work because so far I have done nothing. . . .

My impressions are very gentle. The general coloration of the countryside is somewhat somber, almost sad; the lines of the mountains are very beautiful and graceful but too crowded . . .

On January 11, he wrote:

I have started to work. I had a painting session this morning and two sessions of water color in the evening. It pains me to see this country so different from Crozant, Agay or Trayas. It is very fine, very gray. It makes you think of the Italian Corots. I find that he has rendered that country very well. I shall try in my own manner to do as he did.

On February 16th:

I have found Point's news of interest. I agree with him about the South, except Agay and Trayas, the rest is fairly neutral. Particularly here, there is absolutely nothing to do in cloudy weather. When the sun is shining, everything takes on a bluish tinge and it is very difficult to find a theme and consider it apart from the whole. I have not done a whole lot until now and probably shall not while here. [And, as an afterthought] I am 80 years old since this morning.

The letters of March 9 and 17 are full of plans for a new siege of the Nationale on her behalf. Again he was planning to write all his old friends: Bartholomé, Paulin, Lebasque, Aman-Jean, Masseau, Morand, J. E. Blanche. By the middle of April, Guillaumin was in Crozant, and complaining of the uncertainty of the spring weather which kept him from working. On May 20, he announced:

I wrote to the President (not of the RF), to Paulin and Charles Guerin who answered by return mail that he would do everything possible for the lady I recommended to him without giving him her name. Excuse this oversight which I repaired immediately.

This time the "démarches" that Guillaumin and his friends made in favor of Mme Ballot were successful—she was made an associate of the Société Nationale. The next letter, written from Crozant on June 17, began with the salutation, "chère amie et confrère," and announced that he expected to be in Paris the coming Monday, the 21st.

. . . I have started to work but without enthusiasm. I painted some in the morning and somewhat less at night. Everything is gray—ugly. There are no colors, everything is neutral. The material to work with is ugly and the presence of Smitt lends no joy to the country. I have tried to make him put in a word on your behalf but without success. Well, it does not matter. A few days ago we had a great sorrow. You doubtless remember Dr. Pautet.[4] He was a new friend, but a good and true man. He was staying at Gurthure with his wife and son. Three days after his arrival he drowned and his body was found only yesterday. We are leaving tonight for Limoges because we think that services may be held tomorrow; in any case our visit will please Mme Pautet. This is a tragedy.

Crozant, September 23, 1921

I have not worked too much since my return—I have been too lazy. The weather has been very changeable. There have been only infrequent interesting effects, very little fog and not nice. I have done three canvases de 30 in the mornings. In the evenings I made a study for the moonrise which has provided me with three or four water colors but all this does not half satisfy me.

Crozant, November 22, 1921

Dear Madam and good friend:

. . . It is rather annoying but the older I get the more I am convinced that one cannot lead the life of an inveterate worker and have a social life also. This obligation, full of failings, renders me very indulgent.

Since your flight back to Paris the weather has been fairly nice. I have been working a little but you may doubt that. The fall has been a complete failure. The snow and frost have burnt the foliage and the whole country is chocolate color; you know I dislike that color. Despite this, I have managed to do something. I have saved almost all the landscapes from last year and have added two or three new ones. I should be pleased were you to think them good.  G.

Do not make the date of my return known to anyone.

During this year, Guillaumin was still active but was feeling the effects of age. Apparently writing was becoming more and more difficult—his last letter shows an irregularity of pressure on the quill pen with which he habitually wrote. From now on the letters in his own hand cease, and the correspondence continues in the hand of Mme Guil-

---

4 Resident of Limoges, who had a collection of Guillaumin's paintings.

laumin. Ironically, in the same year that Guillaumin began to feel his powers weakening, he began to receive the reasoned acclaim that had been so long denied him.

Louis Vauxcelles wrote:

> To number Sisley and Guillaumin among second-rate Impressionist painters—under the easy pretext of Sisley's using nuances to fragility and Guillaumin being robust to an almost excessive brutality—seems unjust . . .
>
> Are Sisley and Guillaumin "less" than Claude Monet? In the historic sense of creation—perhaps; in the deeper sense of quality—hardly . . .
>
> He [Guillaumin] is being accused of brutality; he often has a strong authoritarian tendency. But art ceases to be subtle where the subject commands. . . . He has no mannerism about him, never having lied. . . . The painting being fashioned by the hand of a workman, with precise values . . . can defy time. . . . This applies to Guillaumin's paintings as pictures of true colors.[5]

In the same year André Fontainas praised Guillaumin as one of the initiators of modern art,

> an observant constructor of brilliant sites of a specific quality. . . . The work of Messrs. Guillaumin, Signac, Maurice Denis, Bonnard, Vuillard, Roussel, Vallotton, Valtat—the masters, innovators, precursors—is definitive. . . . M. Guillaumin, resolved to discover the unknown aspects of light at the risk of loosing part of the harmony in order to gain in truth, is not afraid to disturb the balance of the atmosphere of his dazzling sunlight bursting upon rivers in the middle of the day, on trees denuded of their foliage or adorned with arabesques, or yet on piled-up ice floes blinding in the winter sun. . . . He possesses a disconcerting subtlety so true that one comes to dread this strange outburst as a display of virtuosity until an attentif examination persuades the onlooker and fills him with admiration.[6]

Though Guillaumin, by the summer of 1922, found writing too much of a burden, he still continued to paint. But his view, *Agay: le matin*, done in February, is marked by a greater broadness in the brushstroke and a lack of refinement in touch suggesting that the eighty-one-year-old painter's hand was no longer capable of the precise control that it had had in his younger years. Yet the signature is still firm, elegant and precise.

In July, he was back in Crozant painting his favorite scene of Les Telles on the Creuse with Puy Bariou in the distance. Again the touch is broader, while the signature remains precise. The sensitiveness of the color is remarkable. Though there is no longer any of the broken touches of Impressionism, the epic brilliance with which the foreground colors flash forth is still undiminished, and the subtlety with which the softer colors of the sky and the distant mountains set off the foreground remains the same. Only in November does the hand hesitate, and the color begin to lose its bold harmony.

In 1923, after the spring at Agay, Guillaumin returned to Crozant where Edouard des Courières probably made the visit he describes in his biography.[7] He was full of admiration for the vitality and hardiness of the elderly artist, and praised his recent works. It was probably in the late fall of that year that Guillaumin commenced his last painting. In its unfinished state it appears to be the beginning of a "gelée blanche" of his favorite subject, La Creuse with Puy Bariou in the distance. The main forms of the landscape are boldly brushed in; the dark trunks of the trees in the middle ground are laid in; the nacreous color of the snow in the foreground is indicated in bold free

---

5 *L'Art française de la révolution à nos jours* (Paris, 1922), pp. 168, 172.
6 *Histoire de la peinture* ..., pp. 300, 315.
7 *Armand Guillaumin*, pp. 38 ff.

strokes; and the violets of the distant hills are established. In the sky, the orange line of the dawning light on the horizon is laid in, and the greenish tinge nearer the zenith is indicated in a patch in the upper right corner of the canvas. There are a few masses of foliage, and that is all. (*See color plate section.*) There is no indication of why the artist never painted again. He continued with a few drawings and pastels, but the career which had lasted for sixty productive years, from the Salon of 1863 to the end of 1913, was over.

After a spring spent in Le Trayas in a rented villa, "La Vertige," Guillaumin returned to Crozant just once more, in 1924, before he left the place that had been his spiritual home for more than thirty years. But things were not the same. Many of his old friends had died. The man who had served diligently for years on the Commission départementale des sites pittoresques, advocating that the region of the Creuse be made into a national park, saw his ultimate defeat, and the coming end of the Creuse as he knew it, in the rise of the waters backed up behind the dam at Eguzon. The wild Creuse with its play of pools and rapids was to become a placid lake, and many of his favorite sites were to be innundated.

Though Guillaumin was finished with his career as a painter, he was not forgotten. In 1924, Des Courières published a monograph on the aging artist. He first points out that, strictly speaking, only Monet, Guillaumin, Pissarro, Sisley, and Berthe Morisot are entitled to be called Impressionists and that

without wishing to speak ill of great names like the beautifully sonorous Pissarro, Sisley the born landscapist with an infinitely delicate touch, Berthe Morisot, the rare genius among women, we have to recognize that in the domain of painting Guillaumin occupies a higher sphere.[8]

Guillaumin was given marked recognition in 1926: a retrospective exhibition at the Salon d'Automne, where he had been president of the section of painting twenty years before. The exhibition included one hundred twelve works from all periods of his career. In the preface, Robert Rey wrote:

Guillaumin remains the same objective and unchanged painter throughout his life, so much so that if one were to choose the most typical, the most indicative and telling picture, an "impressionistic" picture—one would have to take a Guillaumin.[9]

The same year another monograph appeared, written this time by Georges Lecomte. On the sixth of December, Monet died at Giverney.

In the spring of 1927, in his eighty-sixth year, Guillaumin, the last Impressionist, died peacefully at the Château de Crignon at Orly.

A year later, Henri Focillon wrote:

Guillaumin's landscapes of the Creuse are of the richest colors, those of Normandy possess the bright, dazzling quality of the Esterel. His breadth of style, the aplomb with which he handles his canvases put him next to Monet.[10]

8 Ibid., p. 56.
9 Ibid., p. 16-17.
10 *La Peinture* ..., pp. 219-20.

*Agay, 1914, from left to right: Mme Clémentine Ballot's porter, Mme Clémentine Ballot, Armand Guillaumin, Armand Guillaumin's porter.*

*Crozant, 1917, from left to right:*
*M Féron, Armand Guillaumin, Mme Clémentine Ballot.*

*Crozant, 1917, Mme Clémentine Ballot and Armand Guillaumin.*

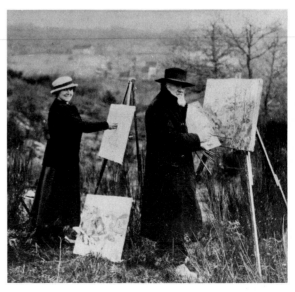

Chère Madame,

Nous avons été tous très touchés de votre bonne lettre et dans ces terribles événements c'est encore un petit bonheur de voir que les amis ne vous oublient pas. Mon fils est à Lille, il était encore le 2 août à Verdun mais l'agression de ces coquins en Belgique a fait déplacer son régiment. Vous pensez que nous sommes très inquiets car assurement il va être de la grande bataille qui va se livrer ces jours-ci, et qui est peut être commencée à l'heure actuelle 400 km de front (?) et plusieurs millions d'hommes qui vont se battre pour la folie d'un empereur, surtout de son fils. Que de misère! que de vies vont s'éteindre dans ces jours-ci. Nous aurons la victoire finale, tout l'indique et avec toutes les nations dont les armées sont avec nous, le courage, et l'envie de se debarasser de ces allemands, [illegible] et assassins il faudrait une male chance extraordinaire pour que nous soyons vaincus.

Mon gendre est à Grenoble et notre fille a pu quitter Nancy et venir nous rejoindre ici après une période de 10 jours qui ont été bien dure pour elle.

Nous sommes sans nouvelles d'Armand, sa dernière lettre était du 5 ou 6 Août. Je ne sais plus. Je ne puis rien faire comme vous pouvez le penser. Et cependant cela me ferait du bien de travailler. J'oublierais un peu, mais je ne puis. Quel cauchemar!

Alors vous voilà séparés. C'est bien dur mais au moins, pour le moment M Ballot n'est pas en danger et d'ici quinze jours, les Allemands seront repoussés chez eux.

J'ai lu dans un journal que le trafic des Ch. de fer allait reprendre. Vous pouvez peut-être revenir à Paris où M Ballot vous rejoindre.

Les lettres mettent encore 4-6 jours pour parvenir, mais elles arrivent. Les Journaux reviennent aussi entre autres le petit parisien. Tout va pour nous aussi bien que possible et ces brigands au lieu de nous avaler d'un bon [illegible] sont immobilisés depuis 12 jours. Les russes sont sur leur dos. Les Anglais vont débarquer sur leurs côtes du nord. Enfin madame il faut faire comme tout le monde montrer du courage même quand l'anxiété vous dévore.

Ici nous vous envoyons tous ainsi qu'à Madame Leroy nos meilleurs amitiés.

Guillaumin

Dimanche 18 Xbre (Octobre?) 1914 [Paris]

Chère madame

Par le temps plutôt triste qui nous rend si triste c'est une joie de recevoir des lettres des amis que l'on aime. Aussi votre lettre nous a fait à tous grand plaisir vous êtes donc toute excusée de votre retard. Ne soyez pas trop contrite. J'ai vu Madeline et je me propose d'aller le voir demain avec le regret de ne pouvoir lui venir en aide car d'après ce qu'il m'a laissé entrevoir il est un peu inquiet peut être beaucoup sur la vie en ce moment, je regrette de ne pouvoir lui venir en aide, c'est dans ces moments là qu'il serait bon d'avoir de la bonne galette prête pour être mangée entre amis, mais hélas personne n'en a pas même les stés (?) que vous doivent.

Oui nous avons quittés Crozant les lycées ouvrent le 20 et il fallait que ma femme soit à son poste nous sommes tous revenus un peu longuement Partis à 8ʰ moins le 1/4 de la maison nous sommes arrivés en gâre à 11ʰ. Comme vous le voyez ça a été un peu long mais pas embêtant; beaucoup moins embêtant que la lâcheté d'esprit des gens du Crozant de la suffisance de certain général d'opéra comique etc. etc.

Je voulais retourner cet automne à Crozant; toute reflexion faite je resterai ici. J'ai commencé à travailler depuis deux jours et si je peux continuer cela vaudra mieux que d'être loin des miens. Je serais inquiet de leur sort et les longues soirées de Crozant

me paraîtraient plus noirs et plus tristes. Je repenserais à celles de l'année dernière, j'aurais trop de chagrin.

Mon fils n'est pas allé où il pensait et sauf changement depuis 8 jours, il doit être au camp de La Contine sur la limite de la Creuse et de la Corrèze, il y aura peut être froid mais du moins il sera à l'abri de tout danger immédiat. De même pour mon gendre qui est toujours à Grenoble du reste je suis tranquille mais j'ai toujours une grande anxiété pour mon pays, et pour ceux qui le défends (?) Je suis heureux que vous n'ayez pas d'inquiétude à l'égard de M Ballot c'est bien assez d'être séparés.

En somme ça va bien pour nous, et j'espère que vous reviendrez bientôt [*illegible*] ce bon vieux Paris, ça n'est pas très dangereux (?) les taubes et on leur fait la chasse, il n'y en a pas eu aujourd'hui il est 9ʰ 1/2 ils ne viendront pas.

Enfin chère madame travaillez si vous le pouvez car c'est toujours un moment d'oubli.

Il est 3ʰ je ferme pour aller voir Avenue de l'Opéra le communiqué de 3ʰ. La vie se passe à attendre 3ʰ et le matin les journaux entre temps aux bons amis.

Mais tous nous vous envoyons à vous, à madame Leroy (agayou esta [?]) et aux petits amis nos mellieurs pensées.              Guillaumin

Avez vous des nouvelles de Albert Joseph?

                                        Paris 29 Juin 1915
Chère madame et amie.

Vous êtes vraiment trop bonne et votre carte me fait grand plaisir, beaucoup plus même j'espère que maintenant vous êtes tranquille mais absolument sur la santé de vos deux enfants. Si oui il ne me reste plus qu'à vous souhaiter de bonnes séances de travails dans ce beau pays. Ne vous laissez pas prendre par les devoirs mondains n'ami connu (?) soient-ils. Je vous demande pardon de ces conseils, mais vous êtes un artiste (la peinture avant tout). A Crozant mai-juin ont été deux mois épouvantables, je n'ai rien fait ou à peu près et je ne defendrais pas ce que j'ai fait ces deux mois ci. une chose que j'ai faite [*illegible*] sans le vouloir c'est de rompre ou à peu près les rélations avec les Smitt. Je vous dirai que je n'aime pas les querelles, ni les discussions, mais par suite d'une altercation injustifié. Avec Marguerite, nous en sommes arrivés à grand peine à nous dire bonjour-bon soir. Pour moi je suis délivré d'avoir à lui donné mon avis sur ses produits, ça m'était trop dur ou de lui mentir ou de lui être désagréable. Madame ce qu'il fait est au dessous de tous je pense que le grand mécontentement qu'il a de lui le rend fou.

Je viens de recevoir une lettre de mon Chabral. Il va bien toujours plein de courage, d'[*illegible*] et avec prudence, ce que je lui recommande.

En terminant ce mot je vais aller chez G. Petit où tire la tombola, mon Dieu pourvu que je ne gagne pas mon portrait par Bonnat ou par madame M. L. mais non celle-ci ne fait que des fleurs je ne ferais pas son affaire, je ne suis qu'un vieux chardon.

Alluaud est à Rouen il doit faire des dessins chez les anglais, Mad. Alluaud est à Vittel, elle est allée chercher sa belle-soeur qui était infirmière et a attrappée la fièvre scarlatine.

Moi je pars vendredi pour Rouen et Elbeuf. Je serai de retour à Paris le lundi VI et nous partirons le 15 pour Crozant, nous vous y attendrons avec impatience. Donc venez, venez vite. Présentez nos amicaux souvenirs à Madame Leroy. Donnez de bon baisers à Roger et André: Et à vous aussi de nous tous.              Guillaumin.

Bien chère madame amie,

Il tonne, il vente, il pleut, c'est le vrai moment d'écrire à ses amis. Au milieu de toute l'angoisse que nous avons eue du 24 février au 19 mars, et dans l'émotion de la nouvelle de ce jour là, je comprends que vous avez été doublée et cependant je croyais vous avoir écrit ou Marguerite: enfin quoi-qu'il ne soit vous me pardonnerez.

Je devais partir pour Crozant le vendredi, 18 février. Une lettre de l'ami Montague me disant que son fils apprenti aviateur venait en permission et désiderait me voir, m'a fait remettre mon départ au lundi 20 mais. La bataille a commencé le 20 et alors j'ai voulu attendre des nouvelles de mon Chabral nous n'en avons eue que le 13 ou 14 datées du 24 février et jusqu'au 19 mars nous n'avons rien eu. Vous pensez dans quelle angoisse nous étions, et chacun cachait sa pensée à l'autre. Enfin le 19 à 4h je reçois la visite d'une dame dont le mari est infirmier à la C$^{ie}$ ou bataillon de mon fils et qui m'annonce que Chabral était prisonnier mais ne paraissait pas blessé. Ma femme et ma fille m'apportait un peu après la même nouvelle venue par un de ses camarades. Nous étions rassurés et presque contents mais pas tout à fait. Enfin le 16 ma femme a reçue une carte ouverte datée du 2 mars. Il nous disait qu'il était en bonne santé, pas trop mal mais nous demandait des colis de victuailles pour compléter le pas mal.

Quant à moi chère Madame j'ai pris le 19 février de partir le lundi 20 je ne pouvais plus tenir à Paris, après la tension d'esprit de 25 jours sans nouvelles. L'annonce de sa capture m'avait coupé bras et jambes. J'avais vraiment un grand besoin de repos, de travailler pour me changer les idées, mais malheureusement le temps n'est pas favorable; je suis arrivé 20 par un orage, et tous les jours ça a été de même, sauf samedi dernier où il a fait une journée admirable. Tous les jours il a plu, vous ne perdez rien à ne pas être là.

J'ai reçu votre dernière carte renvoyée de Paris, et je croyais que vous étiez en route pour le retour, d'après la lettre que Madame Lépinat reçoit aujourd'hui je vois qu'il n'en est rien. Tant pis, enfin il me semble que vous voila tranquille sur le sort de vos enfants. J'en suis bien heureux pour eux et surtout pour vous que je voyais si tourmentée. Vous pouvez travailler plus facilement n'étant pas tourmentée par la santé des enfants. Les Alluaud étaient ici Samedi et dimanche ils sont partis hier par la pluie, nous avons parlé de vous et désirez votre retour ici; quand viendrez vous? Je suis tout seul ici de l'espèce peintre et je m'embête royalement. Point devait venir, mais il a reculé son départ. Mais c'est vous que je voudrais voir avec Madame Leroy et vos enfants, ici tout le monde est laid et pense bas [*illegible*] vous à Paris avant la clôture des deux expositions triannuelles. Et le Paysage vous le verriez et me dire ce que vous en pensez.

Chère madame ami je vous embrasse bien amicalement et respecteusement (comme ces mots sont long) et les petits amis aussi.

Revenez nous bien vite. Votre vieil ami.                                      Guillaumin

Ci joint l'adresse, si vous pouvez, écrivez-lui en ne disant rien des choses de la guerre ni des allemands. Envoi aux prisonniers de guerre.

Guillaumin Armand
10$^e$ Cie Matricule 61202
Kriegsgefangenenlager
Meschede. DEUTSCHLAND.

Quels mots! et on est prié d'écrire lisiblement!

Crozant 28 Mars 1916
2 h. soir.

Très chère madame amie.
Il tonne, il vente, il pleut, c'est le vrai
moment d'écrire à ses amis.
Au milieu de toute l'angoisse que nous
amène du 24 février au 19 mars, et dans
l'émotion de la nouvelle de ce jour-là, je
comprends que vous avez été oubliée et
cependant je croyais vous avoir écrit ou
à Marguerite: enfin quoiqu'il en soit vous
me pardonnez.
Je devais partir pour le ... le vendredi
18 février. une lettre de l'ami Montagne
me disant que son fils apprenti aviateur
venait en ..., et désirait me voir
m'a fait remettre mon départ au lundi 21
mais la bataille a commencé le 20
et alors j'ai voulu attendre des nouvelles
de mon Chabrel nous n'en avons eu
que le 13 ou 14 datée du 24 février
et jusqu'au 19 mars nous n'avons
rien eu vous pensez dans quelle angoisse
nous étions et chacun cachait sa peine

à l'autre. Enfin le 19 à 4 h je reçus la visite
d'une dame dont le mari est infirmier à la
... ou bataillon de mon fils et qui m'annonce
que Chabrel était prisonnier, mais ne
paraissait pas blessé. ma femme et ma
fille m'apportèrent un peu après la même
nouvelle ... par un de ses camarades.
nous étions rassurés et presque contents
mais pas tout à fait. enfin le 16 ma
femme a reçu une carte ouverte datée
du 2 mars, il nous disait qu'il était en
bonne santé, pas trop mal mais nous
demandait des colis de victuailles pour
compléter le pas mal.
quant à moi chère madame j'ai
pris le 19 février de partir le lundi
20. je ne pouvais plus tenir à Paris, après
la tension d'esprit de 24 jours sans
nouvelles, l'annonce de sa capture m'avait
coupé bras et jambes j'avais vraiment un
grand besoin de repos, de travailler pour
me changer les idées, mais malheureusement
le temps n'est pas formable; je suis arrivé

20 par un orage, et tous les jours ça a
été de même sauf samedi dernier où il
a fait une journée admirable. tous les
jours il a plu, vous me plaignez de
paraître là.
j'ai reçu votre dernière carte ...
de ... et je voyais que vous étiez ...
inquiète pour le retour, d'après la lettre
que madame ... écrit aujourd'hui
je vois qu'il n'en est rien. tant pis, enfin
il me semble que vous n'êtes tranquille
sur le sort de vos enfants j'en suis bien
heureux pour eux et surtout pour vous
que je voyais si tourmentée. vous pouvez
travailler plus facilement n'étant pas
tourmentée par la santé des enfants.
les Allemands étaient ici samedi et dimanche
ils sont partis hier par la pluie, nous
avons parlé de vous et dit votre
retour ici; quand viendrez vous?
Je suis tout seul ici de l'espèce humaine
et je m'embête royalement. Point
d'... venir, mais ... votre départ.
mais c'est vous que je voudrais voir

avec madame ... et vos enfants ...
tout le monde est ... et pense tout.
suis reçu à Paris avant la date des
deux expositions biennale; et le Paysage
vous le verrez et me direz ce que vous en
pensez.
Chère madame amie je vous embrasse
bien amicalement et respectueusement
(comme mes mots sont longs) et les petites amies
aussi.
revenez nous bien vite.
votre vieil ami
Guillaume
ci joint l'adresse si vous pouvez m'en glisser ... ne
disant rien des choses de la guerre, ni des Allemands
envoi des aux prisonniers de guerre
Guillaumin Armand
10e cie 11 matricule 61202.
Kriegsgefangenenlager.
Meschede. Deutschland
quels mots! et on est prié d'écrire lisiblement

Chère Madame et amie très chère. Je reçois ce matin votre lettre datée 2 mars, c'est un erreur car le cachet de la poste de Montana [?] est du 3.IV.-16. Puis vous me dites que vous apprenez de chez vous que Chabral est prisonnier depuis une mois. Alors je ne comprends plus. Quant à moi je vous ai écrit avant mon départ qui était le 20 mars (jour du marronier) sauf erreur et en tous cas je vous ai écrit vers le 30 mars ou les premiers jours de ce mois. Madame Lépinat vous a écrit le même jour que moi. Dans ma lettre je vous donnais l'adresse du garçon en vous avertissant de ne rien mettre à propos des faits de la guerre, ni d'injure. Enfin vous voyez ça de la. C'était surtout une précaution à l'égard des petits amis, s'ils avaient voulu écrire à Chabral. Vous savez votre lettre a été ouverte par l'autorité militaire. Ce qui n'a pas d'importance. On peut bien ouvrir la mienne on n'y verra que l'expression de mes meilleurs pensées pour vous et à mon âge, hélas! ça n'est pas très compromettant. Tant pis pour moi d'ailleurs. [*illegible*] en effet chère Madame me voilà un peu tranquille du sort de mon fils, et sauf les accidents, les maladies je suis à peu près sûr de le revoir entier, mais quand?

Ce qui ne m'empêche pas d'être tourmenté sur le sort de la patrie, sur celui de tous les combattants jeunes ou vieux qui se font tuer l'ambition folle d'une partie d'une grande nation qui se prétend la plus civilisée. Enfin espérons que nous verrons bientôt la fin de cette horrible chose. Point devait venir, mais il est encore à Marlotte qu'il ne peut se décider à quitter. Je suis donc seul et je pense souvent à vous. Voyons quand viendrez vous, vous me dites que Madame Leroy viendra en mai vous retrouver, ou à Montana, mais alors vous allez donc y rester l'été, mais vous allez y périr d'ennui, à cette époque l'an est bon ici vous vous y porterez bien les petits amis aussi, vous travaillerez et nous serons tous heureux et contents.

Marguerite a du vous écrire, il est vrai qu'elle a été très grippé, mais c'est égal. Elle vous a écrit. En regardant l'enveloppe de votre lettre j'ai un remord n'aurai je pas mis hôtel du Lac au lieu de du Parc mais il n'y a peut-être pas de lac ni d'hôtel de ce nom en tous cas on vous aurait donné la lettre. Tant mieux que vos gentils enfants se trouvent bien de leur séjour là-bas, vous payez assez cher par l'ennui de ne pas pouvoir y travailler. Donnez moi vite une autre lettre pour me dire que vous avez reçu la mienne. Embrassez les petits amis pour moi, je vous dirai bien respectueusement que je vous en fait autant, mais si ma lettre est ouverte que dira-t-on. Bien votre ami.

Guillaumin

Envoi aux prisonniers de guerre
  Guillaumin Armand
  10ᵉ Compagnie Matricule 61202
  Kriegsgefangenenlager
  Meschede, Deutschland
Ecrire sans abréviations très lisiblement.

Très chère madame et très amie. Il me faut implorer mon pardon car je suis coupable, très coupable, pas indifférent, ça non; mais je suis un grand paresseux. Nous sommes ici depuis le 20 juillet, et tous les jours je vais écrire à madame Ballot. Mais j'allais le faire aujourd'hui vrai de vrai, je le jure sur l'honneur. Je commence les nouvelles. Nous allons tous bien. André a fait la route de Paris à Crozant à byciclette en 2 jours et demi. Marguerite est à Rouen toujours heureuse de danser. J'espère que ce petit succès la guérira un peu si non tout à fait de sa maladie réelle, et des imaginaires

qu'elle se figure avoir. J'espère qu'elle passera une petite partie des vacances avec nous. Vous ne nous donnez pas de nouvelles de M Ballot. J'espère qu'il va bien malgré le très long séjour qu'il fait loin de vous. La maman va un peu bien, mais pas trop, elle est obligée à faire attention à bien des choses.

Le temps est magnifique depuis notre arrivée ici, j'en profite pour travailler. Je me lève le matin à 4ʰ 1/2 et je bûche jusqu'à neuf heures. Il y a eu des effets de brouillards épatants. Les matinées sont exquises. Venez donc avant le mois de 7bre. Vos enfants vont bien. L'air de Crozant est aussi bon que celui du pays où vous êtes. Mais oui venez vous travaillerez. Vous verrez le général. Je le rencontre partout où je plante mon chevalet. Je crois qu'il veut me faire connaissance.

Mon Chabral va bien, il nous a envoyé 2 photo, une en habit de travail, l'autre en uniforme : il a très bon air, et n'a pas la souffrance printe sur la figure, il espère revenir bientôt. Nous aussi. Oui, que les petits amis lui écrivent, ça lui fera bien plaisir.

Madame Lépinat voudrait pouvoir disposer d'un certain jambon fumé, elle a peur qu'il ne se gâte, elle vous a écrit il y a un mois à ce sujet, et elle n'a pas de réponse.

Les Madeline seront ici le 8. Faites comme eux, amenez vous, vous êtes restée assez longtemps à entendre le rang des vaches que vous n'avez peut être pas entendue.

Oui venez vite, vous trouverez des gens qui vous aiment bien et très heureux de vous voir. On vous recevra bien, mais sans la fanfare vu les circonstances.

Très chère madame ma femme vous envoie ses meilleures pensées, moi aussi, et nous vous embrassons tous du fond du coeur. Votre très vieil ami.

Guillaumin

[P.S. from Mme Guillaumin]

Sûrement, chère Madame, vous seriez mieux ici qu'à Montana, et nous aurions tant de plaisir à vous y voir tous. J'y trouve pour moi le repos physique, mais hélas! le repos moral est encore loin : je ne le goûterai que quand je verrai mes malheureux enfants, mon pauvre Chabral surtout! heureux et tranquille. Et puis la pensée du sang qui coule tous les jours, peut-elle laisser du repos! Enfin du moins, nous apercevrons le but du sacrifice, et ce n'est plus à nous à être inquiétés.

Dites à madame Leroy que je pense toujours à elle avec une affectueuse sympathie, je fais toutes mes amitiés aux deux jeunes amis ainsi qu'à leur aimable maman.

M. Guillaumin

Crozant 26 Avril 1917

Très chère madame amie.

D'après votre bonne petite lettre je pensais vous voir à Crozant ces jours-ci à mon retour d'un petit voyage à Paris. Je pensais tellement vous retrouver ici. Hier au soir que dans les 2 jours que j'ai passé à Paris je ne me suis pas inquiet de vous. J'avais vu César le lundi, je savais que vous lui aviez demandé des toiles, etc., et j'avais conclu de son discours que vous étiez à Crozant : hélas! il n'en est rien. Et quand aurai-je le grand plaisir de vous voir? Je souhaite que le retard de votre arrivée ici n'est pas dû à la santé ni de Monsieur Ballot ni à celle d'un des petits amis. Il non, n'est-ce pas! et vous allez tous bien. Je voudrais un être sûr, si vous ne venez pas encore envoyez moi un petit mot. Tout petit, mais rassurant.

Vous me permettez chère madame d'attirer votre attention sur la question bagages. Il ne faut pas qu'une malle ou autre colis dépasse 60 K. et pour la pesée collection 100 en tout. Les bagages non personnels ne sont pas reçus. Il faut les expédier par grand vitesse. Ne manquez pas de retenir vos places; autant que possible; ne partez pas un Samedi.

Je vais vous charger d'une commission. C'est pour imprimer les toiles. J'ai de la gélatine mais pas de *blanc de Meudon*. Ayez l'obligeance d'en apporter 2 kilos si vous en trouvez. Il y en a ordinairement chez les Mds. [Marchands] de couleurs en bâtiments, droguistes comme il y en a dans tous les quartiers. J'ai tout ce qu'il faut pour le reste. En vous attendant j'embrasse les petits amis, Madame Leroy et vous pour le sûr. Venez - venez. Bien à vous respectueusement.

Guillaumin

Samedi 5 Mai 1917

Très chère Madame amie.

J'ai reçu votre lettre jeudi et avec une grande joie, et j'étais très inquiet sur vous tous. Je craignais que M Ballot qui était reparti sans être bien guéri ne soit à nouveau repris, un des enfants malade ou vous, ou Me. Leroy, il n'en est rien tout mieux! Figurez vous que Mercredi nous parlions de nos craintes avec Me. Lépinat et je lui disais: si vous ou moi n'avons pas de lettre j'envoie une dépêche et j'avais écris à ma femme de téléphoner chez vous. Enfin tout est bien, vous êtes heureuse, M Ballot aussi, je souhaite très fort que ce bonheur dure très longtemps. M Ballot a vraiment payé sa dette. Tout le déplaisir sera pour vos amis de Crozant qui ne vous verrons pas.

Depuis une huitaine de jours le temps est assez favorable, j'ai un peu travaillé, et hier-soir, il y a eu de l'orage et voilà le temps au gris, il y a beaucoup d'arbres en fleur mais c'est curieux je n'en vois pas qui fasse cet motif; puis je n'ai pas l'esprit assez joyeux pour en tirer parti. L'enthousiasme au travail someille toujours. Ici il n'y a pas grand chose de nouveau. Les Alluaud ne sont pas venus depuis un moment, la femme de Cal Jurot [?] mets au monde son huitième enfant, enfin si ça les amuse.

Avec tout ça quand viendrez vous? Peut être pas avant l'automne c'est long et cet été viendrez vous? Je sais bien que l'hôtel est embêtant quand il est plein de touristes.

Etes vous allée voir l'exposition Van Dongen chez Barbazanges, Fbg St. Honoré 109? C'est tout à fait de l'affiche de beaux tons et tout cela donne une impression pénible, gênante bien souvent. La peinture n'est pas faite pour être pénible à regarder.

Les femmes de van Dongen ont l'air sales d'esprit et cependant il y en a qui sont d'une belle couleur.

Chère madame donnez-moi quelque fois de vos nouvelles de tous les vôtres. Ce sera une charité car je vous assure que je m'ennui royalement dans ce moment. J'embrasse Mad. Leroy, mes petits amis et leur aimable maman. Une bonne poignée de main à M. Ballot.

                                                                                Guillaumin

                                                          Crozant 15 Juin 1917

Très chère madame et plus amie encore.

J'avais reçu avec plaisir votre conte de forges, elle m'annonçait une lettre, et cette bonne nouvelle était confirmé dans une lettre à Mad. Lépinat. C'est pour cela que je ne vous ai pas écrit de suite, je ne vous en veux pas, et pourquoi? En le jour où vous et les vôtres n'aurez plus d'amitié pour moi je serai fâché, mais je crois et espère que nous n'en sommes pas en route.

Vous avez dû en effet avoir bien à vous allez vous reposer. Je dois vous dire pour vous consoler de ne pas être à Crozant, que ce n'est pas beau en ce moment, non il n'y a pas eu de printemps. En 15 jours nous avons passé de l'hiver au printemps et à l'été, mais le vent du mois d'août en quelques jours tout le paysage a été fumé comme en août. Il n'y a que les matins de cinq heures à 8ʰ où l'on peut un peu travailler, et encore il n'y a pas de beaux effets.

Je suis de votre avis, il n'y a pas de pays plus beau (p[our] peinture) que celui-ci. Il y a plusieurs années je cherchais pour faire plaisir aux monstres du Bd. de la Madeleine, angle Richepance, je n'ai rien trouvé. Il n'y a que le bord de la mer qui puisse rivaliser avec ceci pour vous dire que je n'ai rien fait que j'aime. Ma foi rien. Les temps ne me favorisait pas puis tous ces événements, tous ces mescomptes (?) m'ont déprimés comme vous pouvez vous le figurer. Je me remonte un peu à la pensée qu'en 7ᵇʳᵉ j'aurai peut être la chance de revoir mon Chabral. Oui, il aura 18 mois de captivité accomplie et on pourra peut être le faire comprendre dans une série d'internés en Suisse.

Vous pensez si j'espère. Je pourrais aller le voir, puis c'est une demie délivrance le calme ici. Oui mais que les gens sont bas et déprimants, ils accepteraient la paix allemande, sans comprendre où ça menerait le pays.

Nous voilà à la moitié de l'année, l'automne sera bientôt venu. Mais est-ce qu'on ne va pas bientôt lâcher M Ballot. Je lis tous les jours le retour des vieilles classes, alors! Je ne voudrais pas fâcher M Ballot en le vieillissant mais tout de même il n'est pas dans les jeunes classes. Il va revenir je pense. Moi aussi et tous ici nous pensons à vous. Nous parlons de vous bien souvent avec Madame Lépinat, avec les Alluaud qui étaient ici il y a quinze jours. C'est un thème de conversation qui m'est toujours

agréable. Que l'automne arrive vite, sales porcs de Russes — sans leur bassesse la guerre était finie et nous aurions tous été heureux de nous revoir, ce sont des gens méprisables. Madame amie pour terminer de façon plus plaisante, embrassez pour moi, Mad. Leroy, les petits amis, Monsieur Ballot. Ça ne vous fera pas de peine et je vous embrasse amicalement et respectueusement, ces mots sont bien longs à écrire. Bien votre ami.

<div align="right">Guillaumin</div>

Je n'ai reçu votre lettre que hier.

<div align="right">Crozant 2 Août 1917</div>

Chère madame amie

Merci pour tous les vôtres et pour vous de votre bon souvenir. Ici, également nous pensons à vous, nous sommes tous désireux de vous voir, et peinés d'attendre jusqu'à l'automne. En ce moment vous auriez auprès de vous quelques amis, ils n'y seront plus à cette époque, mais leur ennui sera pour moi un plaisir de [*illegible*] et je me fais une grande joie en pensant que cet automne nous pouvons retravailler ensemble sans être gênés par les touristes qui sont en grand nombre en ce moment. Hier il en est arrivé tout un chargement y compris les Morand et Madlle Lalique. Mais tous serons partis à la fin de 7<sup>bre</sup> et nous serons alors tous réunis, car je pense bien qu'à cette époque. M Ballot sera enfin libéré. Je ne sais quel temps vous avez à Forges. Ici la campagne est bien laide, je peux travailler un peu le matin jusqu'à 8<sup>h</sup> après tout le paysage est dur. Vert uniforme. Enfin vous ne perdez rien. Mais nous perdons le plaisir de vous voir. Les Alluaud vont venir s'installer ici pour un mois. Ils auraient bien voulu que vous soyez là, ils vous envoient un bon souvenir.

Nous avons reçu ces jours-ci une lettre de Chabral, il nous charge de bonnes pensées pour vous et les petits amis. Nous espérons qu'avant la fin de l'année nous le verrons.

André est rentré de voyage et a commencé son travail de laboratoire. Il ne veut pas prendre de vacances en ce moment. Ça me fait plaisir quoique ça me prive.

Marcel Lépinat est en plain dans la bataille. Il écrit à sa femme des lettres navrantes qui l'inquiètent beaucoup, sans remédier à rien. Ce sont de tristes temps que ceux dans lesquels nous vivons.

Très chère madame amie tous les trois nous vous envoyons toutes nos meilleures pensées. En vous embrassant tous Madame Leroy, les petits amis, et vous bien sûr.

Votre confrère et ami

<div align="right">Guillaumin</div>

<div align="right">18 Octobre 1917</div>

Chère Madame amie

Je pars demain matin pour Crozant avec le regret de ne pas partir avec vous et celui de ne pas vous avoir vue avant mon départ. Aujourdhui je me suis mis en route pour vous dire au revoir mais à cinq heures j'étais rue Scribe et je n'ai pas eu le courage de monter jusque chez vous. Rue Scribe je voulais voir mon cousin Bernard pour le tourmenter au sujet de Monsieur Ballot. Je ne l'ai pas trouvé; son bureau pour le Ministère de commerce étant transféré Avenue des Champs-Elysées. Je lui ai laissé un mot, et je ne le lâcherai pas que je n'aie une réponse favorable.

Notre André part demain matin pour Menton rejoindre son dépôt (?). C'est une bien dure épreuve pour nous tous. Enfin! à la grâce de Dieu il y a des jours où on voudrait croire à la providence.

Je souhaite, nous souhaitons tous que tout soit bien pour vous et les vôtres. Donnez nous des nouvelles.

Nous vous embrassons tous bien amicalement.

<div align="right">Guillaumin</div>

Crozant 28 Février 1918

Chère madame amie

Je reçois aujourd'hui seulement votre bonne et amicale lettre, je suis très flatté que le temps passé sans vous voir vous paraisse aussi long qu'à moi: je discutais ce matin avec Made. Lépinat sur le nombre de jours depuis mon arrivée. Elle me parlait de quatre semaines, moi d'un peu plus longtemps et calandrier sous les yeux il y aura juste trois semaines demain. Je regarde aussi qu'il faudra attendre au moins vingt jours pour vous voir, c'est bien long! et il n'y a rien à faire. Il faut attendre. Je suis très heureux des nouvelles de la santé d'André et j'espère que le séjour ici lui sera favorable, à condition que pendant ce temps-là, il ne travaillera pas, ou presque. Il y a des périodes où il faut laisser sa cervelle en friche (?), puis j'espère que le temps sera plus aimable que depuis quelques jours, depuis trois jours nous avons une tempête violente, il n'y a pas moyen de tenir un peintre dehors: cependant je ne dois pas me plaindre depuis mon séjour ici j'ai fait quatre paysages, une gelée blanche assez bien, une autre à laquelle il faudrait une bonne séance, deux paysages même motif temps gris, et un soleil assez bien. C'est bien suffisant en somme. Je souhaite et suis sûr que vous aurez du succès aux femmes peintres. Jusqu'ici qu'elle époque l'exposition est-elle ouverte, je voudrais pouvoir être à Paris dans cette période, mais si elle se trouve dans la période de Pâques je ne pourrai guère aller la voir. Il ne me restera qu'à vous souhaiter bonne chance.

Je savais par ma femme que vous aviez écrit ou que vous deviez le faire et vous pensez comme je vous suis reconnaissant de vos bonnes pensées pour mon Chabral. Nous avons reçu de lui une carte du 20 janvier commençant par ces mots: Hélas non la bonne nouvelle n'est pas encore pour cette fois. Vous pensez si j'ai eu le coeur serré, je lui ai repondu de suite pour le reconforter quoique bien navré moi-même.

Je me fais un grand bonheur de voir arriver pâques qui vous amenera tous pour longtemps. Je pense et soyez certaine que mes pensées vont souvent vers vous.

Marguerite a dû vous informer de ses débuts à la C$^{ie}$ Pe. Ce n'est pas grand chose mais elle a dû être bien heureuse. Et M Ballot? comment se trouve-t-il? Il doit commencer à se remettre de toutes ses fatigues, il a bien payé son écot. Faites lui mes amitiés ainsi qu'à Madame Leroy. Pour finir je vous embrasse tous de bon coeur, Votre vieil ami.

Guillaumin

Crozant 1er juillet 1919

Bien chère madame et amie.

Je ne vous oublie pas croyez-le. Je retarde tous les jours d'en jour pour vous écrire, mais c'est que moi-même j'espère une réponse de mon ami Personnaz. Je lui ai écrit dans les premiers jours de juin, ou plutôt dans les derniers de mai, au sujet de votre exposition de Biarritz. J'attends encore! Je vais lui écrire aujourd'hui, de votre côté avez vous fait quelque chose à ce sujet, je pense qu'en tous cas vous avez envoyée vos deux tableaux. Dites-moi ce qu'il en est. Depuis que je suis ici je n'ai rien fait, ou à peu près. La 1re quinzaine de juin a été très chaude, beaucoup trop, je me suis bien occupé à travailler, mais le mal de dents m'a empoigné fortment, et après quelques jours je suis allé à Limoges pour me faire soigner. J'y suis resté quatre jours, [*illegible*] il a tranquille j'espère pour un succès ou deux. Pendant ces quelques jours j'ai vu Dalpayrat, je lui ai naturellement parlé de vous et il serait très content de vous faire une exposition. Il faut que vous la fassiez cet automne, quand vous viendrez à Crozant vous pourriez apporter une douzaine de vos paysages sans cadres. Il vous en prêtera ou en empruntera comme il a toujours fait pour moi. Ce que je vous dis là est très

sérieux il faut absolument que vous fassiez cette exposition ce qui ne vous empêcherait pas d'en faire une autre à Paris un peu plus tard.

L'affaire avec G.P. [Georges Petit] n'a pas eue de suite. Ces messieurs ont trouvé que je n'avais pas assez d'éléments pour faire une grande affaire: au fond je n'en suis pas fâché.

Marguerite m'a écrit qu'elle avait eue le plaisir de déjeuner avec vous et qu'elle devait vous rendre visite accompagnée de l'ami Chabert, puisque celui-ci vous aura plus car c'est un bon ami, comme vous. Margot m'a dit aussi que Roger avait fait de très grands progrès sur le piano. Ce sera un grand musicien qui fera honneur à sa maman. Je voudrais bien que vous me donniez des nouvelles de M Ballot, d'André, de Mad. Leroy. Notre André a passé deux jours ici il est sous-lieutenant à l'intendance et est très heureux. Nous attendons Chabral lequel doit passer quelques jours à Paris je lui ai conseillé d'aller sans cérémonie vous demander à dejeuner en l'assurant que vous seriez contente. Avez-vous des nouvelles de Madeline, de Point? La saison n'est pas trop bonne pour nous.

Chère Madame, ma femme se joint à moi pour vous embrasser tous de bon coeur.
Votre vieil ami.

<div align="right">Guillaumin</div>

<div align="right">Crozant 8 juillet 1919</div>

Chère Madame amie

Je voulais hier écrire à Seguin pour le remercier de la bonne pensée qu'il a eu à mon égard, mais peutêtre ne vous avait-il fait qu'une confidence sans vous autoriser à m'en faire part. Répondez-moi donc je vous prie par retour un simple mot m'indiquant si je puis lui écrire. En tous cas je vous serais infiniment reconnaissant de lui faire part de ce mot: pour gagner du temps.

Je le prie (?) donc de le prier de ne plus donner suite à la proposition qui me concerne; je n'ai rien fait qui puisse me faire accepter ce grade. Une récompense ne se comprend que lorqu'on est sûr de l'avoir méritée et ce n'est pas mon cas.

Pendant la quinzaine que j'ai passé à Paris j'ai refusé à un Général, frère d'un amateur que vous connaissez, les offres de service qu'il me faisait à ce sujet. Il aurait raison de la trouver mauvaise, mais tout cela n'est rien, je vous prie de me dire si je puis écrire à ce sujet, j'espère qu'il serai temps pour lui éviter des démarches inutiles.

Chère Madame je vous remercie et vous embrasse respectueusement.

<div align="right">Guillaumin</div>

L'adresse est bien R. Jouvenet.

<div align="right">28 juillet 1919</div>

Chère madame amie

J'attendais pour vous écrire d'avoir une lettre de l'ami Personnaz mais je ne reçois toujours rien: ça me navre, car ou il est malade, ou il est fâché de mon insistance, ou encore son amitié pour moi n'existe plus. Je relis votre lettre datée (Samedi) sans autre indication vous me dites que vous envoyez vos tableaux fin juillet: est-ce fait? Peutêtre que je recevrai un mot quand votre envoi sera arrivé, alors je lui écrirai, car je n'oserai le faire avant d'être averti par lui. Dites-moi ce que vous en pensez.

Vous ne m'avez rien dit du résultat de la visite de Chabert ni même si elle a eue lieu. Du reste pour une amie petite ou grande vous êtes joliment réservé sur ce qui vous concerne vous et les vôtres, car c'est par une tierce personne que j'ai appris le succès du petit ami André, cependant cela méritait d'être raconté. Je vous en veux

très fort. Je crois que vous vouliez pour le récompenser aller avec lui en Allemagne, dans le Harts je crois. André me charge de vous prier d'aller à Landau, où il est. C'est sur le chemin ou dans la même région, vous lui feriez grand plaisir et à nous aussi. Combien de temps resterez vous dans ce voyage? Et quand vous verra-t-on à Crozant? Le dit Crozant commence à se remplir, les nabis arrivent comme disait Yuste-mad. Faucher est arrivée. Elle a louée à Chanyotin! Il paraît qu'elle reconnait qu'elle a mal gouverné l'an passé. C'est égal je ne tiens pas à faire sa connaissance. J'ai revu aussi un M. et une Madame un peu forte. Ils m'ont dit que vous me les aviez présentés je veux bien le croire mais je ne me souviens d'eux que vaguement. Cette dame m'a dit qu'elle avait vue Rue Montparnasse une boutique Maurice Point M$^d$ de tableaux avec Armand Point dedans. Qu'est ce que ça veut dire? Je voudrais les nouvelles de Madeline meilleures, mais peut-être que depuis votre lettre elles sont bonnes; je voulais vous demander si vous le rappelez à quelle époque vous et moi faisons les brouillards au chemin des chevalliers je veux me remettre à ceux que j'ai laissés en train; cette année les bruyères sont encore moins fleuris que l'an passé. Je ne travaille toujours pas beaucoup et cependant je crois que le temps va revenir au beau, mais dieu de dieu quelles couleurs! Je suis obligé de combien des trucs pour obtenir un effet, ce méchant César ne m'envoie rien. Si vous le voyez secouez-le un peu.

Que fait M Ballot est-il toujours dans les faurrures, viendra-t-il avec vous? Oui je pense.

Je n'ai plus rien à vous dire, si cependant je voudrais des nouvelles de Madame Leroy cette fois c'est tout. Ma femme vous embrasse tous et moi aussi. Votre très vieil ami.

Guillaumin

écrire: Mr. A.G., Attaché d'intendance, à la 47$^e$ OI Sect. P. 192.
et si vous allez à Landau, le demendez à la Sous-Intendance.

Les Coccinelles - Roquebrune
Alpes Maritimes
[c. Jan. 1, 1920]

Chère Madame amie.

J'ai quitté Paris il y a bientôt 15 jours je n'étais pas en trop bon état et au moment où je montais en voiture j'apprends que vous aviez de l'angine; j'ai été bien tourmenté et le suis encore puisque je n'ai pas de nouvelles de vous. C'est un regret que j'exprime et non une reproche que je fais car j'ai été bien négligent: mon excuse est que les premiers huit jours que j'ai passés ici je n'étais pas bien du tout, je n'avois pas de courage. Cependant je suis assez bien en ce moment il fait un temps magnifique très chaud ce beau temps me remit d'aplomb de plus en plus.

J'ai employé ces jours à regarder les motifs. J'en ai trouvé quelques-uns. Ils sont très différents d'Agay et du Trayas tout à fait japonais. La difficulté c'est que l'on est presque toujours sur le bord d'une route à côté d'une maison. Sur la route il y a beaucoup de voitures attelées et avec le parasol on peut faire peur aux chevaux. Enfin je tâcherai de m'arranger. Je n'ai pas encore reçu mon bagage que Guichard devait m'envoyer. N'oubliez pas que le président de la Nationale sera nommé de me le dire et de me donner son adresse pour que je puisse le féliciter de manière à préparer la demande que je ferai à temps à votre sujet. Avez-vous des nouvelles de Madeline? Travaillez vous, êtes vous contente? Je ne suis pas en train d'écrire. Embrassez M Ballot pour moi. De même les jeunes amis qui sont devenus mes grands amis. N'oubliez pas madame Leroy et moi je vous embrasse de tout coeur pour terminer. Votre vieil ami.

Guillaumin

Les Coccinelles - Rochebrune A. M.
[early January 1920]

Chère amie

Nous sommes très inquiets! Nous attendons avec impatience et tous les jours le facteur pensont (?) avoir un mot de l'un ou de l'autre puis rien du tout. Vous êtes quatres et vous ne pouvez l'un ou l'autre nous écrire un petit mot pour nous rassurer. Faites-le vite si vous ne l'avez pas encore fait. Nos nouvelles à nous sont bonnes, nous avons eu la chance d'avoir du beau temps pendant la première quinzaine de notre séjour ici et je suis 15; je voudrais être sûr qu'il en est de même pour vous. Et j'aime à croire que M Ballot et les deux jeunes amis vont bien.

Chère Madame et amie si vous voyez votre ami M. Séguin je vous prie après lui avoir fait mes compliments de m'excuser si je ne suis pas allé le voir dites lui que j'ai passé la dernière semaine de mon séjour à Paris sans sortir puisque j'ai gardé le lit jusqu'au Lundi 15. Ne manquez pas de me dire si Bartholomé est nommé et son adresse. Donnez moi vite de vos nouvelles de tous les vôtres ma femme et moi nous vous embrassons bien amicalement. Votre vieil ami.

Guillaumin

Samedi 10 janvier 1920 [Roquebrune]

Très chère dame et amie

Je suis en retard. Je vous dirai pourquoi tout à l'heure. J'espère que vous êtes remise de votre inquiétude vis à vis de vos trois malades. Vous avez mal terminé l'année et je souhaite que la commencement de celle-ci soit plus doux pour vous et les vôtres. Aviez vous fait de projet de venir par ici pour les vacances du jour de l'an c'était une idée un peu chouette. La cause de mon retard est que dès la réception de votre lettre, j'ai envoyé à Bartholomé un mot de félicitations et je pensais qu'il me repondrais, ce qui est bête car on n'est pas obligé de repondre dans ce cas. Enfin j'ai attendu jusqu'à aujourdhui. Ma femme me faisait tous les jours la reproche de ne pas vous écrire.

Avez vous M. Séguin et avez vous eu la bonté de m'excuser si je n'ai pas pu aller le voir? Margot va bien et est assez contente du moins elle l'était jusqu'à ce jour, mais ce matin elle est venue avec mal au genou. Elle a grand peur de ne plus danser. Du moins pour un peu de temps. J'ai commencé à travailler, mais sans emballement, on est trop dans la rue pour travailler. Il n'y a que des pentes très raides où on ne peut se tenir debout ni assis. J'ai néanmoins commencé deux pastels, mais vous n'avez pas idée comme tout est gris de ce côté c'est tout l'opposé d'Agay ou du Trayas mais en revanche il fait beaucoup plus chaud.

Chabral va bien. Il joue (?) en tournée avec Chabert. Quant à André il va bien aussi et a passé les vacances du jour de l'an avec nous.

Avez vous des nouvelles de Madeline? Connaissiez vous les July? Madame July était grosse, elle vient de mourir presque subitement d'une congestion pulmonaire. July nous a envoyé un petit mot reçu hier. Ma femme et mois nous en sommes très peinés car c'était une délicieuse créature et la peine de July nous fait un peu peur. J'espère que Madame Leroy va toujours mieux et que de ce côté vous êtes tranquille. Je pense que vous ne me garderez pas rancune de mon retard. La cause doit m'excuser un petit peu, votre amitié fera le reste.

Ma femme et moi nous vous envoyons nos meilleures pensées et nous vous embrassons tous de bon coeur. Votre vieil ami.

Guillaumin

Roquebrune A. M.
[late January 1920]

Chère madame bien amie.

J'ai appris, nous avons appris avec grand plaisir que tous vos malades étaient hors d'affaires et que vous étiez tranquille et que vous pouviez vous reposer. Vous avez eu un bien dur moment à passer, mais vous êtes vaillante. Mais vous n'avez pas pu travailler, faire des natures mortes!

Très heureux de votre soirée chez Séguin, mais il était question je crois d'un mariage, avez vous réussie dans votre diplomatie? En ce qui me concerne je suis tranquille sur mon compte du moment que vous étiez là j'ai dû être bien défendu.

J'aime beaucoup Lebasque quoique à mon avis il écoute un peu trop les marchands. Si M. Séguin a un pastel daté de 1884 ce n'est pas à Epinay s/Orge ni ma femme et une de mes filles, nous ne nous sommes maris qu'en 1886. C'est la mère de ma femme et elle, elle doit être debout de dos avec un manteau indiatre.

Il fait beau, avec souvent un grand vent qui est bien gênant. Je travaille un peu mais je ne suis pas emballé, c'est trop gris. Le père Corot a bien rendu l'atmosphère de ce pays. Mais ça ne m'enchante pas. J'ai pris à Crozant, à nos bonnes séances dans ce beau pays.

Margot va bien. Elle veut toujours vous écrire, mais les répétitions, leçons et les représentations lui laissent peu de temps elle vous remercie de votre bon souvenir et va vous écrire.

Je vais oublier de vous dire que si j'avais tardé de vous envoyer ma dernière lettre de deux jours j'aurais pu vous dire que j'avais reçu un mot très amical de nouveau président. Ce mot me donne bon espoir pour ma requête, ne manquez pas de m'avertir quand il en sera temps car je serais très heureux de pouvoir vous être bon à quelque chose.

Vous rappelez vous, que vous ou moi, nous avions promis à l'homme de Génetin de lui donner cinq fr. pour son bois. Je suis parti sans le faire. L'avez-vous fait? Si non comme je vais écrire à Crozant je le ferai faire il ne faut pas que les artistes manquent à leur parole.

Il faut que Madame Leroy continue à bien aller, on ne l'aimera que davantage et vous aussi prenez loin de vous.

J'ai reçu une lettre de Kite (?) il est eu à Pâques je n'ai pas encore pu lui répondre mais je vais le faire.

Pas de nouvelles des Madelines, ni de Point. Ma fois tant pis c'est à peine si je prends le temps d'écrire à ceux que j'aime.

Ma femme et moi nous vous enoyons à tous de bons baisers.     Guillaumin

Dimanche 29 février 1920
[Roquebrune]

Très chère Madame bien amie.

Je relis votre dernière lettre et je m'aperçois que voilà presque un mois que je dois vous répondre. Ne me méprisez pas, ne croyez pas que je vous oublie, il n'y a pas de danger. Je pense toujours de vous, à vous tous, et vous aime toujours autant. Mais je deviens de plus en plus un grand paresseux, je me vois vieillir, j'ai une peine de plus en plus grande à travailler. Je me fatigue très vite. Tout me devient indifférent — non pas vous — j'ai lu dans un journal que le salon des dames peintres était ouvert. Cela me fait grand plaisir, et j'espère que vous devez y figurer en bonne place, celle qui vous est dûe d'ailleurs.

Je voudrais bien savoir si l'intervue avec G. Petit a eu lieu, ce qu'il en est résulté. Je pense qu'il a dû être content, et vous aussi à propos de cette visite. Je ne sais si vous avez fait part d'une observation faite par Chabert; c'est que vous lui aviez trop montré, il était grisé. Evidamment il y a là un [*illegible*]. J'en ai fait moi-même l'expérience et je suis en colère après moi de ne pas vous avoir prévenue.

Mais j'espère que l'influence amicale de Séguin, celle de Lebasque aura surmonté cette faute. J'ai votre lettre sous les yeux et je dis, quand G. P. sera venu je vous ferai part du résultat de la visite, comme vous ne m'avez pas fait part de rien du tout. Je conclue qu'il n'est pas venu, ou que vous attendiez pour ne le dire une lettre de moi.

Et Aman-Jean, est-il venu? Quand envoyez-vous à la Nationale? Ne manquez pas de m'avertir, et surtout indiquez-moi à quelle époque commenceront les opérations du jury, car il n'est pas bon d'écrire trop tôt, mais il n'est pas meilleur de le faire trop tard. Mais peutêtre que tout cela sera pendant la période du 15 mars au 1er avril. Alors je serai à Paris. Il parait que qui je suis 5 (?) serait à Monte Carlo, Margot assure avoir aperçu la dame gracieuse de cet horrible peintre qui fait partie de la société moderne dont Alluaud est un des maintiens.

Ma femme voyant que je vous écris me fait voir que la dernière lettre de vous est lui adressée, mais ça ne fait rien. Nous avons appris la mort de Madame Lacotte un peu plus tard. Celle de ce pauvre Madeline, ça c'est triste bien plus que la précédente, comment ça va-t-il tourner par là, avec le triste état de santé de sa mère.

Bien heureux des nouvelles de Mad. Leroy et j'espère que vous tous allez bien.

Ma petit Margot va bien. Contente de nous avoir, et fâchée de nous voir partir. Ah ça n'est pas une sinécure que la danse, quand on veut faire ce qu'elle veut faire. Cela me fait peine (?). Si le pays était plus riche en motif et un peu moins rude, je resterai encore un peu pour lui tenir compagnie, mais je ne puis le faire plus. Je suis trop fatigué. Pensez que pendant une période je grimpais tous les jours 500 marches pour aller travailler.

Il fait très chaud, trop pour la saison. Les pentes sont couvertes de maisons comme de Paris à St. Germain.

Pensez à nous, comme nous à vous, puis pour terminer nous vous embrassons très fort comme nous vous aimions.

Guillaumin

Roquebrune 6 Mars 1920

Chère Madame amie.

J'ai reçu hier soir votre lettre du Lundi 1er Mars; je commence la journée par vous répondre, et j'écris par le même courrier au Président, et j'espère que vous serez satisfaite et moi aussi car puisqu'on me fait l'honneur et le plaisir de vous croire mon élève je voudrais que cela serve à quelque chose. Vous avez dû avoir une lettre de moi ces jours-ci. J'attendais pour écrire à B. le moment favorable ça y est. Merci pour les nouvelles de chez G. Petit mais vous ne me dites pas s'il est venu vous voir et ce qu'il en est résulté: avez-vous reçu les autres visites que vous attendiez? Cela me ferait plaisir de le savoir. Pour l'instant je ne fais plus rien. Je vais commencer mes emballages. Je ne sais comment ça va aller. Pour le moment on ne prend que les c. postaux de comestibles comme bagages, on ne prend que les effets ou que du linge, enfin je tâcherai de revenir voir les amis dont vous êtes pour sûr. Nous vous embrassons tous bien. Votre vieil ami.

Guillaumin

Roquebrune 6 Mars 1920.

Chère madame amie.

*[handwritten letter, largely illegible]*

Roquebrune 14 Mars 1920

Chère Madame amie.

En même temps que votre lettre j'en reçois une de B. qui m'écrit de son lit où il est retenu par une bronchite, mais il me dit qu'il a donné le mot à celui qui le remplace au jury. D'après votre mot je pense qu'il a été très bien remplacé et que vous êtes bien heureuse. Je vous assure qu'ici nous le sommes. Ma femme, Margot et moi autant que vous et les vôtres. Pour mon compte je voudrais croire que j'y suis pour quelque chose, car j'estime que votre réception vous est bien dûe, et que c'est une qui devraient vous remercier de votre envoi (?). Je pensais partir demain, mais il n'y a pas de place avant jeudi. Je ne serai à Paris que vendredi prochain: ce qui va bien raccourcir mon séjour à Paris. car je m'en profiter du mois d'Avril à Crozant et me rattraper un peu de mon séjour ici. Que ferez-vous ce printemps? et Monsieur Ballot? Tout devient compliqué.

Nous vous embrassons tous et souhaitons que vous soyez vite guérie. Vous n'êtes pas toujours prudente pour votre gorge.

Bien à vous,

Guillaumin

Très chère Madame et amie;

Il y a longtemps que je vous ai donné de mes nouvelles et demandé des vôtres, si j'avais pu écrire. Le jeudi saint, veille de nôtre départ en courant pour attraper une autobus, qui lui ne bougeait pas, je suis tombé tout de mon long dans la rue: en autre chose je me suis cracké (*sic*) le doit sur la jointure, comme je ne me suis pas soigné de suite, j'ai été obligé d'attendre jusqu'à ce jour pour écrire à mes bons amis. Quant à la peinture! Je n'ai encore rien fait d'abord à cause de mon doigt, puis à part deux ou trois matinées, il a plu, fait des grands tempêtes je n'ai rien fait. J'avais précipité mon retour ici dans l'espérance de pouvoir reprendre quelques paysages laisées en route l'heureuse année où j'avais le plaisir de travailler à côté de vous, à côté des baraques à Breton et de la carrière à [*illegible*]. Même que vous avez eue si froid. La saison qui est en avance d'au moins trois semaines m'a empêché de terminer ces paysages.

Pour le moment je ne suis pas en train, je vois la nature telle qu'elle est. Je n'ai pas ma idéal, puis il fait très froid, on disait qu'il va tomber de la neige, aussi je vous dirai de bien faire attention, de ne pas faire d'imprudence comma ça vous est arrivé ici.

Les nouvelles que vous me donnez du salon me font grand plaisir, et soyez sûre que je regrette bien fort de ne pouvoir prendre plaisir d'aller voir vos oeuvres dans ce milieu. Je suis persuadé qu'elles doivent merveilleusement se tenir à côté de tous ces grands maîtres! Vous me remerciez. Vous êtes trop aimable de le dire et je voudrais croire que je puis être de quelque chose dans votre satisfaction, en tous cas soyez sûre que je suis très heureux que vous soyez satisfaite: ne manquez pas de me dire quand il en sera temps d'écrire pour le sociétariat. J'espère que ça ira tout seul. Oui je suis de votre avis pour Point. C'est évidemment un artiste, mais pourquoi toujours regarder en arrière, et comme toutes leurs compositions tournant les unes sur les autres, pourquoi ne pas prendre les sujets dans la vie moderne, pourquoi les muses, les dieux antiques. La mythologie où on a beau dire tous ces personnages ont été retournés peints sur toutes leurs faces, et quatre-vingt-dix-neuf personnes sur cent les ignorent. Vive Chardin et les peintres du 18e. Sans eux nous ne saurions rien de cette belle époque. Maintenant c'est bien regrettable qu'il soit blessé pour la vie, mais peut-être qu'avec le temps il y aura un amélioration.

Je dis pas de nouvelles, bonnes nouvelles.

Je vous prie si vous voyez Lebasque et d'autres amis de leurs, faire mes amitiés.

Ma femme vous embrasse bien, moi pour sûr j'en fais autant.

Quand viendrez vous?

Vôtre bien affectionné ami

Guillaumin

Crozant 8 Mai 1920

Très chère madame amie.

C'est avec grand plaisir que j'ai lu votre lettre, et vous pouvez croire que j'ai écrit de suite à Bartholomé, à Paulin et à F. Masscour (?): J'espère que ces trois bonnes volontés pèseront dans la balance et que vous serez nommée; je serais très heureux si je pouvais croire que je serai quelque chose dans la réalisation de ce désir et à mon avis ils devraient être fier de vous compter parmi eux.

Des nouvelles que vous nous donnez de vous et des vôtres nous rassurent sur votre compte et celui de Madame Leroy. Nous souhaitons que son séjour à Fontainebleau lui soit profitable et la remette complètement. Quant à nous ça va, les enfants vont bien nous avons reçu une lettre de Margot hier, elle est très contente, mais très fatiguée.

Ce n'est pas une profession de tout repose que la sienne; enfin puisqu'elle l'aime et le fait avec plaisir tous est pour le mieux. Elle ira sûrement vous voir à son passage à Paris.

Je reprends ma lettre interrompue par la visite de Mlle Coste et Marguerite Baudot elles vous souhaitent le bonjour et vous envoient leurs amitiés. En ce qui me regarde je ne suis pas très content. D'abord je n'ai absolument rien fait en Avril. A cause de la pluie et de mes doigts car j'en ai eu deux de malades. Mais je vous en ai déjà parlé. Je commence au dessus du jardin deux toiles de 25 le matin, mais il est impossible d'avoir deux heures de suite. Et pendant ces intérromptions la végétation pousse et tout change. Vous connaissez ces ennuis. Le soir c'est la même chose j'ai un paysage au soleil un autre par temps que je ne puis terminer ni l'un ni l'autre. Enfin d'ici la fin de l'année je pourrai me rattraper mais voici l'été. Le pays sera plein de touristes embêtants de peintres plus ou moins gênants. A ce propos je n'entends pas parler de l'illustre Tartarin (?) de Bordeaux mais hélas nous l'aurons sur le dos cet été et l'automne. C'est triste. Ce que l'est aussi c'est que vous ne viendrez qu'en Septembre. C'est loin Septembre et vous ne me dites pas si vous resterez l'automne j'espère qui oui.

Je n'ai pas de nouvelles de Firay (?), je crois qu'il n'ait des ennuis. Si je n'étais pas si paresseux je lui écrirais malgré que ce soit moi qui lui ait écrit le dernier. Voilà très chère amie ce que j'ai à vous dire, pour aujourd'hui. Tenez moi au courant de tout ce qui vous arrive au sujet du salon et ne craignez pas d'avoir recours à moi. Je suis toujours bien aisé de penser que je puis vous servir à quelque chose. Les amitiés de ma femme et les miennes à tous ceux qui sont avec vous et nous vous embrassons bien.

<div align="right">
A vous

Guillaumin
</div>

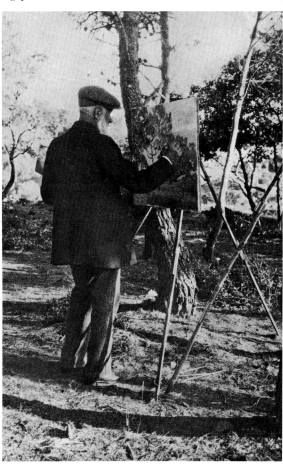

*Agay, 1914, Armand Guillaumin.*

<div align="right">
Crozant 14 Mai 1920
</div>

Très chère Madame amie.

Excusez cette moitié de feuille, mais avec les deux lettres qui y sont jointes la feuille entière serait trop lourd. Puis je n'ai rien d'intéressant à vous dire, si non que nous pensons toujours à vous, que l'on vous aime toujours et que le mois de Septembre tarde à venir. Nous voici à la moitié de Mai et il fait mauvais à part quelques jours de chaleur intense il fait plutôt mauvais. Je suis bien ennuyé de ne pas travailler. Les arbres poussent et le paysage se ferme. Les Alluaud sont ici je leurs ai fait vos amitiés ainsi qu'à Madame Lépinat et je vous fais le retour pour eux. Il y a également tous les Lacotte sauf le fils. Ils viendront tous vers la mi Août pour un mois. Vous aurez comme moi d'ailleurs le plaisir d'être rasie gratis.

Vous voyez pour la Nationale ce que vous pouvez espérer. Paulin m'a aussi repondu. Il n'est pas de comité, mais il me promit de parler pour vous aux amis qu'il a et il le fera, et j'espère que j'aurai le plaisir de faire quelque chose pour vous. Vous pourrez ne plus vous laisser embêter par Tartarin. L'avez-vous rencontré, j'espère que non, ici on n'entend pas parler de lui. Mon André a eu le très grand plaisir de passer deux heures avec vous chez les Lamotte, je l'envie! Ecrivez moi, embrassez M Ballot, Mad. Leroy et les deux jeunes amis. Moi très respectuesement je vous embrasse.

<div align="right">
Guillaumin
</div>

Crozant 25 juillet 1920

Chère madame amie

Je vous ai pardoné votre longtemps à me repondre, et si je ne vous pas écrit plutôt c'est que je pensais que vous me donneriez des nouvelles d'André, de son examen. Il a réussi tant mieux, et vous lui ferez bien nos compliments collectifs. Nous espérons qu'il viendra à Crozant au mois de Septembre. En attendant laissez-le se reposer auprès de Madame Leroy. Nous sommes très heureux que vous n'avez un pas d'inquiétude au sujet de votre mère.

J'ai reproché à Margot son silence, ou plutôt sa paresse à vous écrire car elle doit toujours le faire, excusez-la un peu. Elle est très occupée, la matin répétition; dans la journée leçons particulières. Le soir casino, tous les jours, vous voyez qu'il ne lui reste pas beaucoup de temps pour écrire à ses amis car elle ne vous oublie pas. Chabral et sa femme sont à Paris et André est parti vendredi rejoindre trois camarades pour faire des excursions dans les Alpes. Madeleine est toujours dans ce vilain pays du Nord.

Nous ici nous allons bien, mais le temps, et par suite, la peinture ne va pas. Je ne travaille pas beaucoup à l'ordinaire à cette époque, mais de tout juillet je n'ai pas fait une toile, un ou deux pastels c'est tout de même trop peu. De reste en ce moment tout me parait laid, sauf quelques vues matinées, puis le pays est plein de touristes ce n'est pas drôle du tout. Les Smitt sont arrivés vendredi soir [illegible] j'ai vu madame, elle m'a paru bien fatiguée, quant à lui sa vanitè lui fait refleurir le teint. Il est tout rouge. Je ne lui ai pas parlé de notre échec pour la Nationale et ne lui en parlerai pas, car je me doute de ce qu'il me dirait. A ce propos je vous avais demandé des détails vous ne m'avez rien dit, pourquoi? Smitt a bien dû user son éloquence pour bien vous convaincre qu'il avait tout fait pour votre succès. Je ne lui en parlerai pas le premier. De tout cela il resulte que vous n'avez pas peint depuis l'automne dernier. Ça doit vous décourager un peu. Prenez encore un peu patience dans un mois vous serez tous ici, vous pourrez travailler mais si un mois est vite passé en vous attendant il est, du moins, sera vite passé si vous ne devez rester que ce mois. Si vous me faites le plaisir de m'écrire avant votre arrivée, parlez-moi de vos projets. Que fait Monsieur Ballot. Il est heureux je pense puisqu'il n'a pas d'histoire mais dites-moi qu'il va bien et est content des femmes (?).

Voulez-vous si l'occasion se présente me rappeler au souvenir de votre ami Séguin. Des couleurs sont bien mauvaises et avec ces temps changeants j'ai perdu beaucoup de palettes preparées - triste!

Embrassez pour moi M Ballot, les jeunes amis et que tous vous le rendent, à donc un mois.

Votre très vieil ami

Guillaumin

Crozant - Creuse 29 Août 1920

Mon cher Goldorp.

Vous aussi, vous voulez que je sois officier! Mais c'est une épidémie et vous voilà parmi mes bons amis le sixième que je prie et supplie de ne pas céder à ce bon mouvement. Non cher ami je ne veux pas être nommé officier. Je n'ai rien fait pour cela. J'ai un grand respect pour la Légion d'honneur, et je trouve qu'on en donne trop. Je ne veux pas augmenter le nombre des décorés qui ne le méritent pas. Ceci accepté je vous remercie bien d'avoir eu cette pensée. Il y a en effet bien longtemps que je n'ai eu le plaisir de vous voir. Depuis l'année dernière j'ai passé en deux fois deux mois

à Paris dont la moitié au lit la second à me préparer l'hiver à partir pour le midi. L'été a venue ici où pour le moment je ne travaille guère.

Je rentrerai à Paris à la fin de 9bre. Je ne manquerai pas d'aller vous voir, mais je vous demanderai votre jour.

Ma femme vous remercie et à son tour vous envoie un bon souvenir. Moi un gros tas de bonnes pensées.

Guillaumin

Jeudi 23 Xbre 1920 [Paris]

Très chère madame et amie.

Nous sommes arrivés mardi à bon part (?) avec deux heures de retard, par un temps splendide. Nous avons vu en passant Margot nous l'avons embrassés très fort pour nous et pour vous, elle était très contente de cela, elle est fatiguée, elle travaille beaucoup, mais est heureuse de son sort. Elle est venue déjeuner et dîner avec nous, elle vous remercie bien d'avoir parlé pour elle à vos amis. Elle va vous écrire. Il faut que je vous dise que Dimanche soir à 8h. en descendant d'autobus rue de Vaugirard en face notre rue je suis tombé mais sans me faire grand mal, le danger était un autobus aux nos

derrière (?). J'ai pu avec l'aide d'un passant me remonter sur le trottoir. J'en ai un grand ébranlement général mais un peu de repos ça sera fini il me reste juste assez de place pour vous envoyer à tous nos meilleures pensées nos bien sincères amitiés pour M Ballot vos petits enfants Mad. Leroy et vous à la fois pour la bonne-bouche.

Votre vieil ami

Guillaumin

Menton 3 Jer [Janvier] 1921

Très chère Madame et amie.

J'attendais tous ces jours-ci une bonne lettre de vous. Et je me figurais que vous étiez peut-être malade ou M Ballot ou quelqu'un des vôtres. J'espère que cela n'est pas, et que vous êtes en train de faire de belles natures mortes si toutefois vos devoirs de femme du monde vous en laissent le temps. Non n'est-ce pas, et c'est moi seul qui sois coupable. Oh! de paresse seulement car je ne vous oublie pas.

Hier en parlant de vous avec ma femme, il m'est venu à l'esprit que dans le mot que je vous ai écrit je vous disais que je vous écrirais·d'ici quelques jours; je ne l'ai pas fait ce qui explique et excuse votre silence. Vous voyez je suis coupable, très coupable même envers vous, mais ne me gardez pas rancune. Répondez moi de suite du moins le plus vite qu'il sera possible.

Nous ça va bien, ma femme est heureuse de se trouver dans ce pays qu'elle aime. Moi aussi d'ailleurs malgré que je l'aime moins. Cependant le calme du coin où nous sommes me fait beaucoup de bien, et je me retrouve petit à petit dans mon état habituel. Le grand ébranlement que j'ai eu par ma chute est à peu près à l'état de souvenir, et d'ici quelques jours je vais me mettre à travailler car je n'ai encore rien fait. J'ai reçu seulement mes outils qu'hier. Puis il ne faisait pas beau même un peu froid, ensuite nous avions André avec nous pour les fêtes. Naturellement nous nous sommes promenés ensemble et hier il a pris le train à 12ʰ et est arrivé à Paris.

Mes impressions sont très douces. La coloration générale du pays est toujours un peu sombre, presque triste, les lignes de montagnes sont très belles et gracieuses mais trop peuplées de maisons et de [*illegible*] le grand (?) boche domine trop. Les motifs sont très difficiles à couper, je pourrais même dire impossibles aussi je me bornerai aux pins au Cap Martin qui sont à la portée de la main. Et c'est ce qui est le plus intéressant ici. Le petit hôtel où nous sommes est dans le genre Lépinat, nous y sommes très bien. (vous savez que l'hôtel Lépinat est vendu).

Marguerite me charge de toutes sortes de bonnes pensées pour vous et les vôtres et de vous embrasser pour elle ce que je fais d'un peu loin, mais je me rattraperai en venant à Paris, mais c'est encore loin.

Vous occupez-vous de votre exposition avec GP. il faut faire une exposition d'une trentaine de toiles il le faut absolument, sans vous occuper des autres salons, ni des bons amis que vous savez. Je pense que vous avez du Dalpayrat et que vous vous êtes entendus. Il ne faut pas manquer de faire l'exposition à Limoges.

Je n'ai plus rien à vous dire. Ma femme et moi nous vous envoyons tous les voeux qu'un véritable amitié peut dicter pour vous et tous les vôtres.

Votre vieil ami

Guillaumin

Rives d'or Hôtel
Cap Martin Roquebrune
par Menton, A. M.

Menton 11 j'er 1921

Chère Madame chère amie

Vous avez du recevoir ma lettre en même temps que je recevais la votre: je pense que je vous souhaitais ainsi qu'à M. Ballot une bonne année et la reste et que ces voeux étaient aussi pour mes jeunes amies si je ne l'ai pas fait je la fais maintenant. J'ai reçu un mot de Dalpayrat qui me dit qu'à son grandissime regret il n'a pas pu aller vous voir. Il me charge de vous exprimer tous ses regrets. Je le fais et les partage. J'aurais bien aimé qu'il se rende compte de votre travail et du progrès très grand que vous avez fait. Savez-vous s'il s'est mis en rapport avec Aman-Jean? Il était très désireux de lui être agréable. Si vous avez besoin de mes services de ce côté dites-le moi, je ferai le nécessaire. Et vous chère confrère! vous êtes-vous décidée à parler au représentant de la maison G. P. vous auriez bien tort de négliger de le faire. Il faut à toute force que vous fassiez une exposition qui fera bien imagée des gens et vous mettra en valeur ce que vous méritez bien. Les jaloux et les méchants seront térassés. Ce qui sera bien fait.

Nous avons eu de vos nouvelles par la jeune et aimable dame Inglissé qui a eu le plaisir de vous recontrer chez les Salmons; c'est une charmante dame et je pense qu'elle vous aura plu.

Puisque vous savez la naissance d'un autre Guillaumin je me dispenserai de vous l'apprendre. Il faut seulement lui souhaiter un brillant avenir.

J'ai fait part à Marguerite de vos voeux je l'ai embrassée pour vous, elle a promis de vous écrire, mais ces temps derniers elle a été accablée de travail, répétitions, représentations, leçons, elle vous demande un peu de crédit et se propose de vous écrire.

J'ai commencé de travailler, j'ai fait une séance peinture le matin, deux séances pastel le soir, j'ai de la peine à voir ce pays si peu ressemblant à Crozant et à Agay ou au Troyat. C'est très fin, très gris, cela fait songer aux Corots d'Italie, je trouve qu'il a bien rendu ce pays. Je tâcherai de faire comme lui à ma manière. J'ai eu de la périostite, j'ai bien souffert, mais j'ai trouvé un bon dentiste qui a remis les choses en place. Je vais me mettre sérieusement au travail. Pendant que je vous écris ma femme tricote à côté de moi et tous les deux nous vous envoyons nos bonnes pensées en vous embrassant tous.

<div style="text-align:center">

Votre vieil ami
Guillaumin

</div>

Un bon souvenir à M. Séguin

16 Février 1921

Chère Madame et amie

J'étais fort en colère après moi d'avoir tardé à vous repondre, mais comme ce retard m'a valu une seconde lettre, que de plus j'ai pu lire la lettre que vous avez écrite à Margot, je me pardonne facilement. Mais pourquoi me parlez vous d'ennui en lisant ce que vous appelez bavardage, il me fait grand plaisir au contraire.

Les nouvelles de Point m'ont intéressés je suis de son avis pour le midi, sauf pour Agay le Troyat, tout le reste est bien neutre. Ici surtout, il n'y a absolument rien à faire par le temps gris, par le soleil tout est bleuâtre neutre très difficile à trouver un motif à le détacher de la masse. Je n'ai pas fait grand chose jusqu'à présent et je ne rapportrai pas grand chose de mon séjour dans ce pays.

Je suis fâché pour Aman-Jean de son état, quoique au point de vue exposition il n'y ait pas à espérer beaucoup pour la vente; et Jacques Blut qui vient [illegible]. une n'aura peut-être qu'un succès d'estime c'est quelque chose pour sûr, mais un peu de galette ni nuisirit pas.

Merci de tout ce que vous me dites à propos de l'exposition chez Danthon. Je voudrais qu'il y est beaucoup de gens de votre avis et le mériter (?). Je ne sais si A. Doyot a fait l'article et si le No. est paru. Je viens de le demander à Danthon. Vous êtes vraiment une bonne amie et tout ce que vous faites pour ma Margot me touche, je peux dire nous touche profondément et nous sommes tous les trois de votre avis. Il faut qu'elle reste quelque temps à Paris pour que M. S. puisse s'occuper d'elle. Rappelez-moi au souvenir de M et Madame Séguin. J'ai écrit à Alluaud qui a enfin repondu à ma troisième lettre. Son amitié est un peu fragile, enfin chacun donne ce qu'il peut. J'ai vu les Morand, mais ils sont au coeur de la ville à deux k. de nous, mais il y a un tramway, on se voit de temps en loin d'ailleurs il y a une station devant chez nous et à 50 mètres de chez eux. Je suis de votre avis pour Ferson (?) et je crois qu'il n'ira pas beaucoup plus loin.

Causons de vous. Je suis content que vous ayez eue la visite de ce monsieur et je comprends qu'il se soit intéressé à vos oeuvres. Mais si vous trouvez que les conditions qu'il vous fait sont très avantageuses, je me permettrai de ne pas être tout à fait de votre avis. Sauf pour la salle qu'il vous donne pour le reste ça me parait plutôt défectueux! Vous parlez du mois de X^{bre} 1923 ou peut-être 1922 ça me paraît bien loin. Etes-vous sûre avec lui pour cet arrangement et ne pouviez vous pas dans l'intervalle faire une démonstration quelque part. Vous feriez peut-être bien de tâter le terrain de ce côté ou de la faire tâter par S. ou Lebasque. Le temps passe vite et il faut vous faire voir. Etes-vous satisfaite des femmes peintres? Et j'espère que vous avez été bien traitée par elles. Si vous avez des coupures qui vous concernent envoyez-les moi. Je vous les renverrai si vous y tenez. Avez-vous trouvé une bonne et un logement pour Chabral et sa moitié? Ne les oubliez pas je vous en prie.

Nous n'avons pas de nouvelles de Lacotte depuis longtemps ni directes ni indirectes, quant aux pastels je les avais tout à fait oubliés et Guichardoz (?) aurait pu les garder sans risque, soyez tranquilles vous et M Ballot nous règlerons cette affaire au mieux de vous intérêts ceci progrès (?).

Mes chers amis ma femme et moi nous vous envoyons à tous y compris Mad. Leroy nos meilleures amitiés en vous embrassant tous.

Votre vieil ami,

Guillaumin

J'ai 80 ans depuis ce matin.

9 Mars 1921

Bien chère madame très amie.

J'aurais dû vous répondre de suite mais si vous m'avez écrit étant au lit c'est à peu près pour une raison analogue que je suis en retard. Ma femme et moi nous nous battons avec le rhume, qui se termine pour moi en pharyngite. La fatigue m'a rendu paresseux. Cependant j'ai fait un violent effort et j'ai écrit de suite à Paulin et je n'ai pas besoin de vous dire que je vous ai très fortement recommendée. Ce qui m'a été facile car à votre égard je pense de vos peintures tout le bien que j'en dis. J'ai également écrit à Fin Masseau et celui-là sera avec nous. Hier j'ai passé quelques instants avec les Morand, nous avons parlé de vous, et de lui-même il m'a assuré qu'il ferait pour vous faire nommer associé tout ce qu'il pourrait.

Je n'ai pas écrit à Bartholomé parce que j'ai pensé qu'il valait mieux le faire au moment de vote pour nommer les associés: si vous êtes d'un avis contraire, je lui écrirai mais peut-être qu'il n'est plus temps. Mais je crois que pour la réception de votre envoi vous n'avez rien à craindre.

C'est bien regrettable qu'Aman-Jean soit encore malade, mais il pourrait peut-être vous recommander à ses amis, ça pourrait tout de même vous être utile.

Hélas ce gros cachalot de Smith expose à la Société nouvelle fondée par Madeline, par Alluaud etc. j'ai été invité une fois: jamais plus et vous jamais, jamais, mais il ne faut pas oublier Smith il est si aimable et son épouse si gracieuse! Enfin il ne faut pas trop s'en faire pour ces amitiés là.

Où avez-vous pris chère amie, que nous étions logés dans le grand quartier de Menton? C'est un erreur; d'abord nous sommes sur le territoire de Roquebrune! nous sommes à côté du dépôt des trains, à quelques mètres d'une usine à gaz et autour fabriques. J'avais fait tout un plan stratégique pour travailler d'une façon regulière. J'avais vu les motifs que je comptais faire tout autrement qu'ils étaient. Les effets d'éclairage n'y étaient plus. Tout me paraissait noir, puis il est venu des tempêtes, de vilain temps gris et très froid. Mon petit accident du départ qui m'a fait perdre beaucoup de jours ma sacré mâchoire et enfin pour finir ce rhume qui n'en finit pas, fait que je n'ai pas beaucoup travaillé.

La père Lacotte qui a vu ce que j'ai fait a trouvé le tout à son gout! est à moi en pas, vous me le direz quand je serai de retour.

Savez-vous si l'article d'Armand Doyot a paru? J'ai demandé à Danthon mais il ne m'a pas repondu là-dessus.

Il y eu comme vous le savez beaucoup d'article remplis d'erreurs plus ou moins nombreuses.

Si vous découvrez quelqu'un à qui je pourrais à un moment ou un autre écrire dites-le moi je serai heureux de le faire pour votre bonne faites donc refraîchir la tête à Valérie.

Soignez-vous bien pour ne pas donner la plus petite inquiétude à vos amis. Nous vous embrassons tous comme nous vous aimons très fort.

<div align="right">Votre vieil ami<br>Guillaumin</div>

17 Mars 1921

Très chère Madame et amie

Je venais de recevoir une lettre de l'ami Paulin, qui me disait qu'il était sûr la réception de deux de vos paysages mais que pour la troisième il n'était pas sûr, qu'il allait s'informer quand je reçois votre lettre. Me voilà tranquille. Du reste j'aurais trouvé singulier que vous fassiez refusée pour une partie de votre envoi, il est vrai qu'avec la protection du commis voyageur que nous connaissons il faut s'attendre à tout. Il faudra que vous me preveniez à temps pour le vote des associés. Du reste avant de quitter Paris j'irai voir le grand montrer de la Nationale et je pense que vous pourrez compter sur l'appui de M Morand. Il me l'a du moins fait comprendre.

J'espère que votre première sortie avait été bonne et suivie d'autres aussi bonnes et que sûrtout vous n'avez pas fait d'imprudence ce que vous est, permettez moi de vous le dire, assez habituel.

Je commence mes préparatifs de retour. Je ne peint plus ça me fait six toiles, c'est bien assez. Le pays me déplait de plus en plus à force d'être éclairi il n'y a ni ombre ni lumière, tout est gris, blanc et noir.

Avez vous eu la livraison l'art et les artistes? Je pense que A. D. n'aura pas fait ce qu'il avait dit. ça m'est égal.

Nous partirons le 29. Si vous m'écrivez d'ici-bas vous me ferez plaisir.

Faites pour ma femme et moi nos amitiés pour tous le vôtres et nous vous embrassons comme de vrais amis.

<div align="right">Guillaumin</div>

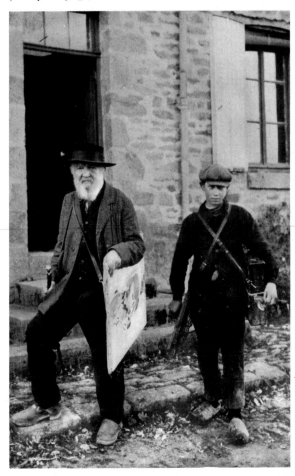

*Crozant, 1915, Armand Guillaumin and Maurice Moreau (at 11 years of age).*

Chère Madame très amie.

Je ne sais si c'est un malentendu mais je pensais recevoir l'adresse des membres du comité que je connais, je crois me rappeler que nous avions marqués ceux auxquels je devais écrire. Envoyez-moi ces adresses le plus tôt que possible pour me permittre d'écrire à temps. J'attends votre lettre avec une grande impatience.

Avez vous été chez Paulin; il ne faut pas manquer de la voir, il est très influent et pourrait peut-être conquérir à votre cause J. E. Blanche qui est un vilain être, en tous cas il se pourrait qu'il l'empêche de vous nuire.

Depuis que je suis ici il y aura 25 jours demain j'ai un peu travaillé la première semaine j'ai mis en train un pastel au Pont Charrant, mais je l'ai abandonné. Ça n'allait pas, alors j'ai commencé à la peinture le même motif. Le pluie m'a interrompue et j'ai repris aujourd'hui, c'est le motif que vous avez chez vous dans le cabinet de Monsieur Ballot. Je ne sais si j'arriverai à le finir, tout change dans l'espace d'une nuit. D'ailleurs vous connaissez cet ennui. Avez vous reçu une invitation pour l'exposition Franz Burty (Haviland) j'ai déchiré la carte. Je ne sais plus où. Si vous y allez faites moi part de votre impression, dites-moi aussi si les critiques vous ont bien assistés. avez-vous les coupures des journaux: en tous cas ne vous laissez pas attrister par toutes les méchancetés des bons camarades. Faites pour le mieux ce que vous avez à faire, le reste viendra en son temps.

Ici dimanche dernier nous avons vus les Alluaud. Ils sont venus hier, mais ils sont allés à la pêche, pendant ce temps la peinture se repose. Enfin chacun arrange sa vie à sa guise, mais il me semble qu'on ne cultive pas les lauriats en s'amusant d'abord et travaillant ensuite. Ceci entre nous je ne voudrais pas médire d'un ami.

Travaillez ferme en attendant que vous soyez aux Andelys, ou ici, moi je me tâte pour y aller. La vie d'hôtel ne me tente guère, les déplacements non plus. Cela serait compenser par vos présences.

J'espère que les nouvelles de Madame Leroy sont bonnes, je les voudrais très très bonnes croyez moi.

Ma femme et moi nous vous embrassons tous du fond du coeur.

Votre vieil ami,

Guillaumin

Chère Madame et amie.

Nous avons été très heureux de vous savoir rentrés chez vous tous en bon état et de savoir de bonnes nouvelles de Madame Leroy en effet cette promenade en auto avec vous a dû être un grand plaisir pour elle. Depuis votre départ j'ai écrit au Président (pas de la RF) à Paulin et à Charles Guérin qui m'a repondu par retour qu'il ferait le possible pour la dame que je lui recommandais *et dont je ne lui donnais pas le nom.* Excusez cet oubli que j'ai réparé de suite. Si vous voyez encore quelqu'un à qui je puisse écrire dites-le moi et si cela ne réussit pas abandonnez cette société et faites une exposition à vous seule. Vous avez assez de belles toiles pour cela.

Ici le temps est toujours le même des brumes noires, plus ou moins, elles se résolvent très souvent en pluie, hélas! En somme voilà un mois bientôt que je suis là et le peu que j'ai commencé est à refaire. Je suis navré et je passe en désespoir de cause la moitié de temps à dormir. J'aimerais mieux à peindre.

Frank Haviland (Franz Burty) expose à la Galérie Weil mais j'ignore ou perche (?) cette galérie mais ça doit être facile à savoir. Tous les Lacotte sont partis hier, désespérés

du temps. Ils n'ont pu trouver à louer pour cet été. Je n'en suis pas très fâché. Voilà toutes les nouvelles.

Toutes nos amitiés à tous et nous vous embrassons de coeur.

Guillaumin

Crozant 17 juin 1921

Chère Madame et confrère.

Je ne veux pas quitter Crozant et arriver à Paris. Vous seriez peut-être surprise — plus ou moins désagréablement si je venais vous rendre visite sans vous prévenir. Je serai à Paris Mardi prochain 21 et je vous prie de me faire savoir quand je pourrai vous voir: j'espère que Margot a dû avoir ce plaisir mais avec sa toutou (?) guerie il se pourrait que non. Elle veut attendre d'avoir repris ses leçons pour voir M. Séguin,

mais elle ne va pas auditionner de suite. Je ne comprends pas ses intentions. Peut-être serez vous plus heureuse quand elle vous verra.

Je veux aussi revoir le salon et voir vos tableaux que je n'ai pas très bien vus. J'ai reçu quelques jours avant le vote des associés une lettre de Fin M. m'affirmant en très bons termes de son intention de faire tout ce qu'il pourrait pour vous être agréable et à moi aussi; comme le résultat a comblé nos voeux je l'ai remercie, (on ne sait pas) j'ai écrit à Paulin, Guérin-Bartholomé, enfin à tous. Travaillez-vous? Moi un peu, mais je ne suis pas ardent. La nature n'est pas belle en ce moment, un peu le matin, en ce moment je termine une toile de 25 vallée de la Sédelle, de 6ʰ30 a 8ʰ1/2. Le soir à Génetin une petite toile de 4.

Tout cela sera terminé dimanche ou lundi, et mardi nous prendrons le train pour être à Paris à 7ʰ.

J'espère que nous vous trouverons tous en bonne santé et que vous avez de bonnes nouvelles de Madame Leroy.

Très chère madame et amie nous vous embrassons tous bien fort.

<div align="right">Guillaumin</div>

<div align="right">Crozant 10 Août 1921</div>

Bien chère Madame et amie.

Nous avons lu avec plaisir votre bonne lettre et je me demande en quoi nous avons mérités toutes les bonnes choses que vous nous dites. Enfin passons, mais je pense tout de même que c'est nous qui vous devons quelque chose. J'aurais bien voulu être avec vous le jour du vernissage. Albert me dit que vos paysages font très bien, cela me fait un grand plaisir et me fait encore plus regretter d'être parti, mais je ne pouvais pas agir autrement. Puisque vous avez le courage de travailler, ce dont je vous fais compliment profitez en, ces toiles vous serviront pour le jour chez G.P. ou [illegible] s'occuper de vous, et l'on ne vous reprochera plus de me rassembler ce qui est absurde d'ailleurs. En ce qui me concerne j'ai commencé à travailler mais sans enthousiasme. Je fais une petite séance le matin, une autre plus petite le soir tout est gris, c'est laid. Il n'y a que des tons neutres. La matière est laide et ce n'est pas la présence de Smitt qui donna (?) de la joie au paysage. J'ai essayé de le faire parler à votre propos sans réussir ça n'a pas d'importance. Nous avons eu ces jours-ci un très grand chagrin vous vous rappelez sans doute le docteur Pautet. C'était un nouvel ami, mais bien bon et vrai. Il était à Gurthury avec sa femme et son fils. Trois jours après son arrivée il s'est noyé et son corps n'a été retrouvé que hier. Nous partons ce soir pour Limoges, car nous pensons que le service sera peut-être demain en tous cas notre visite sera agréable à Madame Pautet. C'est un grand malheur.

Vous devez avoir appris que Alluaud a été décoré. Cela me fait plaisir. Puisqu'il le désirait en tous cas je pense que ça n'est pas comme encouragement au travail.

Vous ne me parlez pas de vos enfants. Pourquoi? André est-il parti pour Londres à la première occasion. Dites-nous ce qu'il fait. Nous voici au tiers d'août et 7ᵇʳᵉ sera bientôt arrivé. Et nous aurons le grand bonheur de vous voir. D'ici-là la pluie aura enfraîchie le temps et nous aurons de belles brumes, et de beaux effets. Mais viendrez vous? Les motifs des Anelys (?) vous retiendront peut-être. Enfin vous serez la bienvenue.

Nous vous embrassons tous les quatres bien affectueusement.

<div align="right">Votre vieil ami,</div>

<div align="right">Guillaumin</div>

Crozant 23 7bre 1921

Chère madame et amie.

Je ne mérite pas du tout de si grands et amers reproches: votre avant derrière lettre est de dimanche dernier. Sauf erreur de ma part et comme toutes vos (?) lettres elle n'est pas datée. Je vous tenais un peu rigueur parceque nous étions en grand colère après vous, vous deviez venir pour le 1er 7bre puis ça a été pour le 12 ou environs, enfin bientôt c'est vague. Maintenant c'est pour le 4 8bre c'est long. Rassurez vous chers amis nous ne sommes malades ni les uns ni les autres et nous sommes heureux à la pensée de vous voir tous en bonne santé. Nous pensons que Marguerite sera ici le 27 c'est à dire mardi prochain, elle compte rester avec nous trois ou quatre jours, elle aura une grande déception de ne pas vous voir mais il faut qu'elle soit le 4 à Nancy. Alors! regrets sur toute la ligne.

Je n'ai pas beaucoup travaillé depuis mon retour ici, j'ai eu beaucoup de paresse à vaincre. Le temps a été très variable. Il n'y a eu que de rares effets intéressants peu de brouillard et pas beaux. J'ai fait trois toiles de 30 le matin. Le soir j'ai entrepris des études pour un lever de lune que je voulais faire. Ça m'a fait faire trois ou quatre pastels mais tout cela ne me satisfait qu'à moitié. Tâchez donc d'avancer votre retour ici. Les affaires sont-elles si urgentes. M Ballot pourra vous amener et retourner à ses affaires: qui sera avec vous Roger peut-être car André restera en Angleterre. Vous ne me dites rien de cela c'est pourtant intéressant et jusqu'à quand resterez vous? Nous, nous resterons jusqu'à la fin de 9bre mais peut-être ferons nous un petit voyage à Paris car notre Madeleine avait l'intention de venir se marier ici et se reposer un peu mais je sais que le programme sera modifié.

Je suis étonné et confus de vos renseignements (?) à propos du tableau acquit par la ville, et j'ai beau chercher dans ma conscience je ne trouve pas à moins d'en avoir parlé à Lapauze. Peut-être en effet: en tous, par moi ou un autre, je suis très heureux et ma femme également.

J'aurai encore bien de reproches à vous faire mais je ne veux être trop dur. Venez vite le plus vite possible vous nous ferez grand plaisir. Donnez de bons souvenirs à tous là-bas et nous vous embrassons en toute amitié.

Votre vieil ami,

Guillaumin

Yvonne [friend of Madeleine, music student] est là, elle vous envoie un bon baiser par mon entremise ce que je fais très volontier.

Crozant 22 9bre 1921

Bien chère Madame et amie.

Si j'attendais pour vous écrire quelques jours de plus j'aurais aussitôt fait de vous porter ma lettre, ce qui d'ailleurs n'aurait rien de désagréable pour moi: ceci pour vous dire que nous quittons ce pays enchanteur, surtout quand vous y êtes, lundi prochain 28 de ce mois, et je ferai tout pour vous rendre visite le plustôt possible: j'espère que je vous trouverai tous en bonne santé, et que vous me montrerez ce que vous avez fait depuis votre retour à Paris; vous aviez l'intention de faire quelques natures mortes, j'espère que oui et que vous n'avez pas été contrariée par les devoirs du monde. C'est bien ennuyeux, mais plus j'avance en âge plus je m'assure qu'on ne peut mener la vie d'invétéré travailleur et la vie mondaine. Cette obligation, qui explique bien des défaillances, me fait très indulgent pour beaucoup.

Depuis votre fuite à Paris le temps a été assez beau. J'ai un peu travaillé, mais vous devez vous en douter. L'automne a fait comme le reste, et a été tout à fait manqué.

La neige et la gelée ont brûlé les feuilles, tout le paysage est couleur chocolat, et vous savez que je n'aime pas cette couleur. J'ai tout de même fait quelque chose. J'ai sauvé presque tous les paysages en train de l'an passé et en ai fait deux ou trois de neufs. Je les trouverai bons, si vous êtes de cet avis.

Ici rien de nouveau. Les Alluaud ne sont pas revenus, les Smitt sont partis lundi dernier, mais ils ne sont pas intéressants. Alexandre Jurnot (?) s'est tué en tombant de voiture. Le père Mignat a été renoncé par Mlle B et ma femme qui convenaient de conduire Margot à [*illegible*] mais il ne sera quitté pour une balafre à l'oeil.

Embrassez pour moi tous les vôtres pour moi qu'ils vous le rendent et croyez à ma grande et profonde amitié.

<div align="right">Guillaumin</div>

N'ébruittez pas le date de mon retour.

<div align="right">La Falaise - Agay Var. 31er Jer 1922</div>

Très chère Madame et amie.

Mais pas une amie bien sage: vous ne parlez de l'état de vos reins qui ne sont pas malades. Mais c'était pour votre poitrine que vous deviez voir le médecin, vous n'avez rien fait et ma femme ne vous félicite pas, et moi je me permets d'en faire autant.

Ne manquez pas d'aller chez G. P. parce que vous risqueriez de le mettre contre vous, et il faut éviter de se faire des ennemis surtout parmi les marchands.

Alors vous voilà heureuse et vous allez entrer dans la gloire avec un grand G. Ces dames peintres ont fort bien agi et je leur ferais mes compliments. Que vous rapporte cette place de première? Quels droits vous donne-t-elle? J'espère en tous cas que vous n'aurez plus à passer devant un jury si bien disposé soit-il: et votre ruban violet. Mais oui, il sera très décoratif et ornera fort bien cette poitrine que vous vous entêtée à ne pas soigner. De notre côté la santé va bien. Mais c'est le temps, et par suite le travail qui ne va pas. Tous les jours de la tempête par abord ou tribord des pluie comme un déluge je n'ai pu rien terminer de ce que j'ai mis en train en arrivant. Le temps passe et la lumière tourne, tout est à recommencer. Mais ce n'est pas la peine de vous en parler, vous êtes au courant de cet ennui. Hier la pluie a commencé à tomber à 9h jusqu'à aujourd'hui à 4h et ce n'était pas drôle!

Vous dites je vais me remettre à peindre. C'est le vrai remède à la bonne santé. Que voulez-vous dire? La bonne santé est donc une maladie enfin, oui, travailler ça vous fera oublier bien des choses. Mais pas vos amis. Marguerite nous a parlé de votre dîner. Elle a été très contente du menu et surtout de toute votre amabilité.

Etes-vous allée aux indépendants, et avez-vous vu des envois vraiment intéressants? A part la discussion Signac-Picabia sans avoir vu je donne raison à Signac. Quel besoin de violence!

Chabral a eu une bonne idée s'il a pu vous faire rire un moment.

Ma femme vous envoie ses amitiés, elle vous embrasse ainsi que M. Ballot, j'en fais autant et ferme ma lettre.

<div align="right">Votre très vieil ami,</div>
<div align="right">Guillaumin</div>

<div align="right">Agay. 26 février 1922</div>

Chère amie.

Je relis votre dernière lettre et je m'aperçois qu'elle n'est pas datée, de sorte que je ne sais de combien de jours je suis en retard et je souhaite que vous n'ayez pas gardé le souvenir de cette date.

J'espère que depuis cette date vous vous êtes toujours bien portée et que vous avez pu faire les tableaux de nature morte que vous vous proposiez de faire. Dans la prochaine lettre que vous vous proposerez pour sur de m'écrire le plus tôt que vous pouverez, je vous prie de me dire si vous avez revu G. B. et s'il s'est décidé à vous prendre quelque chose. Etes vous allée au petit palais? Et avez vous vu votre paysage? J'aimerais que vous me disiez tout cela au lieu de perdre votre papier et votre temps à me donner des remerciements dont je n'ai que faire. Il est bien naturel que je m'occupe d'une artiste qui est mon élève comme tout le monde le prétend.

Le mois de Février a été assez beau et nous venons d'avoir quinze jours d'un temps admirable qui me faisait souvenir du temps où nous étions aux Dunes, et vous au Rastel. Je travaille aux mêmes endroits et je refais avec joie les mêmes motifs sans avoir un grand chemin à faire d'ailleurs je crois bien que ne saurais le faire il y a 4 km aller et retour. Ce qui fait 8 si on va travailler au même endroit matin et soir. Enfin je profite du temps que la Providence veut bien m'accorder, mais je m'applique à bien faire et peut-être que la qualité sera mieux que la quantité. Plus qu'un mois, c'est vite passé surtout ici où les jours passent avec une rapidité extraordinaire ceci pour me faire pardonner.

Ma femme et moi nous vous embrassons amicalement.

<div align="center">Votre vieil ami,

Guillaumin</div>

Veuillez vous me rappeler au souvenir de M. Séguin, de Karbouski, et autres amis.

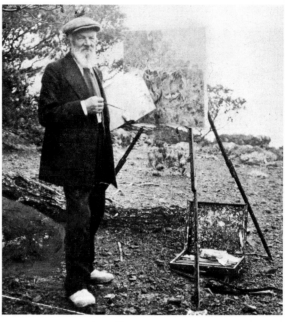

*Agay, 1914, Armand Guillaumin.*

<div align="center">Agay Var. 15 ju 1922
la Falaise</div>

Chère amie

J'attendais, nous attendions impatiemment ce matin dans l'espérance d'avoir de vos nouvelles: mais après une bonne heure d'attente notre bonne nous dit que c'est aujourd'hui dimanche, et que nous pouvons remettre à demain le grand plaisir de recevoir une lettre de vous; nous vous en prions fortement: dites nous bien vite si cette guerre de grippe vous a laissée tranquille. Vous le savez vous avez été bien imprudente en ne vous soignant pas sérieusement tout de suite si par malheur vous ne pouviez écrire faites le faire par M Ballot ou un des jeunes amis. Nous allons bien maintenant. Ma femme avait inaugurée la saison par une fluxion d'origine douteuse, mais tout est mis en ordre. Nous avons très beau temps. Un grand soleil. Froid et avec tout cela un grand mistral que vous connaissez et que il y a déjà longtemps vous avez approuvé comme il le mérite très désagréable pour le travail aussi aujourd'hui j'ai été obligé de renoncer je ne pouvais tenir où j'étais à cause du vent qui soufflait en [*illegible*] rafales. Vous devriez venir par ici vous vous débarrasseriez de votre sale grippe. Quant à moi je vais bien et mon état général s'améliore tous les jours et j'espère que je vais pouvoir travailler avec suite.

Avez vous des nouvelles de vos affaires picturales? Avez vous téléphoné à G. B. si oui où en êtes vous? et du côté des dames peintres se passe-t-il quelque chose? Voilà bien des questions. Si vous ne sortez pas encore, cela vous fera passer un bon moment à me répondre. Je vous prie de donner un bon souvenir à Karbouski je pense à lui avec plaisir.

Nous vous embrassons bien fort tous les quatre.

<div align="center">Votre vieil ami.

Guillaumin</div>

[In Mme Guillaumin's hand]

Crozant Creuse 15 Sept. [1922]

Cher Monsieur.

Je recevrai avec plaisir Madame Ciolkocoska (?) puisqu'elle viendra de votre part. Je suis toujours à la maison de 10 h. à midi, quand je rentre du paysage. Cette dame peut donc choisir son jour, et m'avertir si elle désire une autre heure.

Avec mes sentiments les meilleurs.

Armand Guillaumin

*About 1918-1920, portait of Monsieur and Madame Armand Guillaumin.*

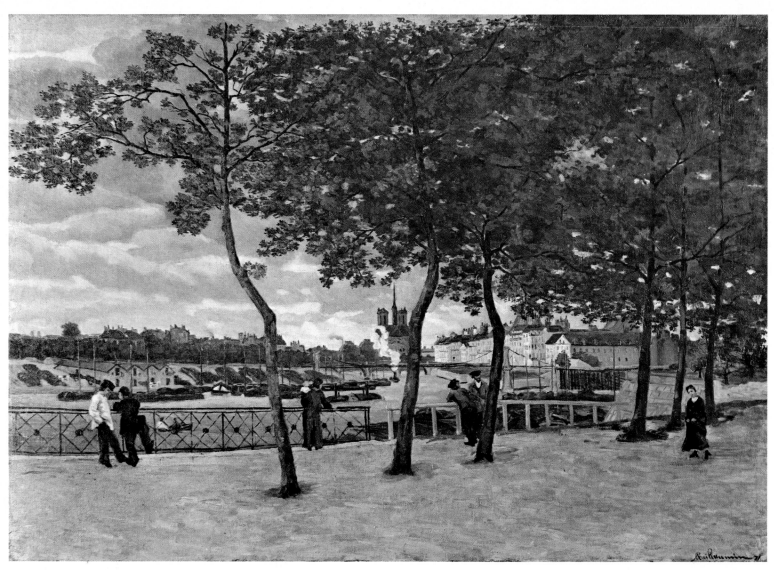

Pl. 1 *La Seine à Paris (Quai de la Râpée)*, 1871

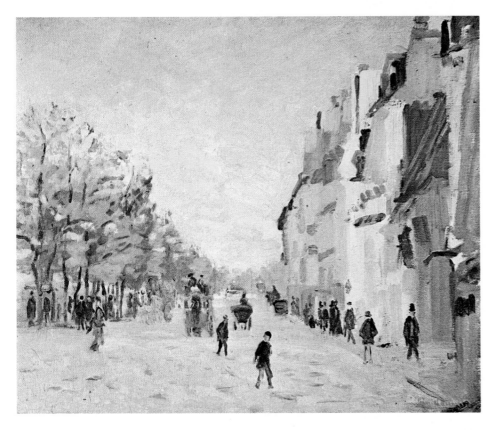

Pl. 2 *Quai de Bercy - effet de neige,* c. 1874

Pl. 3 *La péniche,* 1874

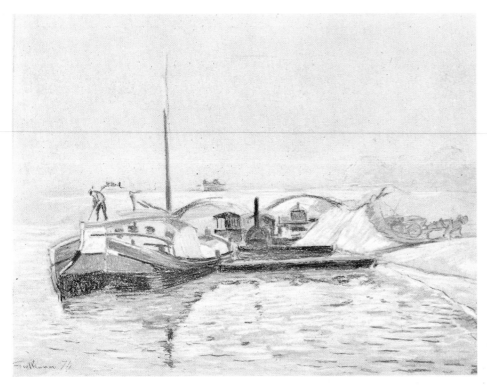

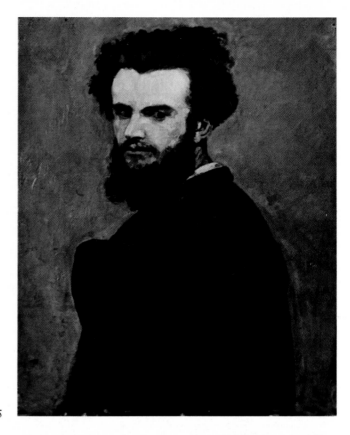

Pl. 4 *Self portrait*, c. 1875

Pl. 5 *Femme couchée*, c. 1876

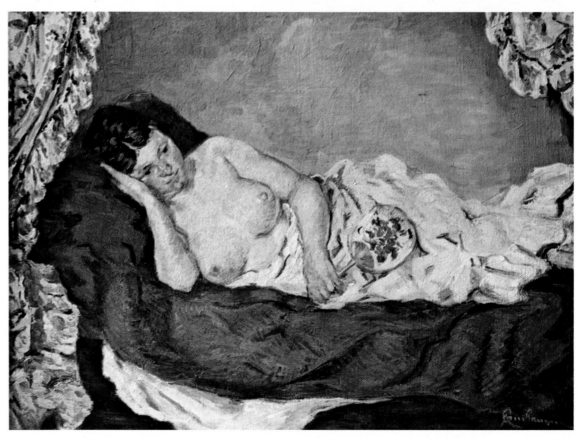

Pl. 6 *Le Pont des Arts*, c. 1878

Pl. 7 *Les Quais de la Seine*, 1879

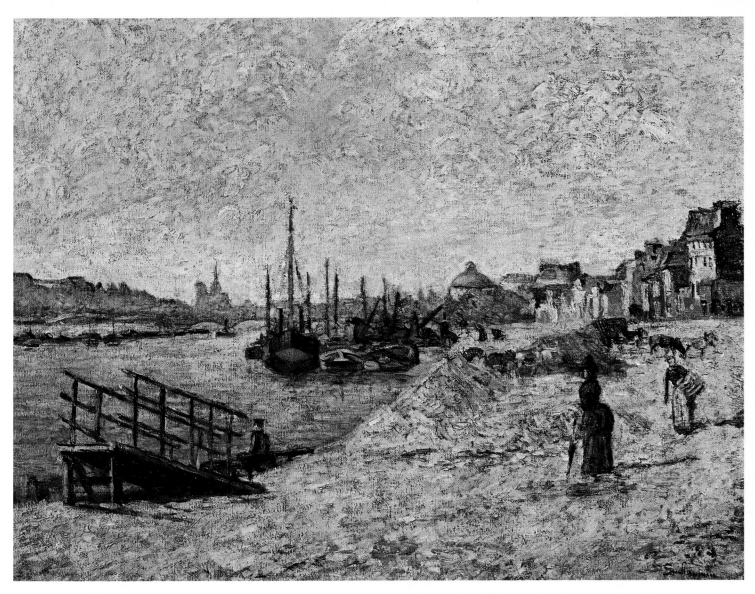

Pl. 8 *Quai de Bercy*, c. 1881

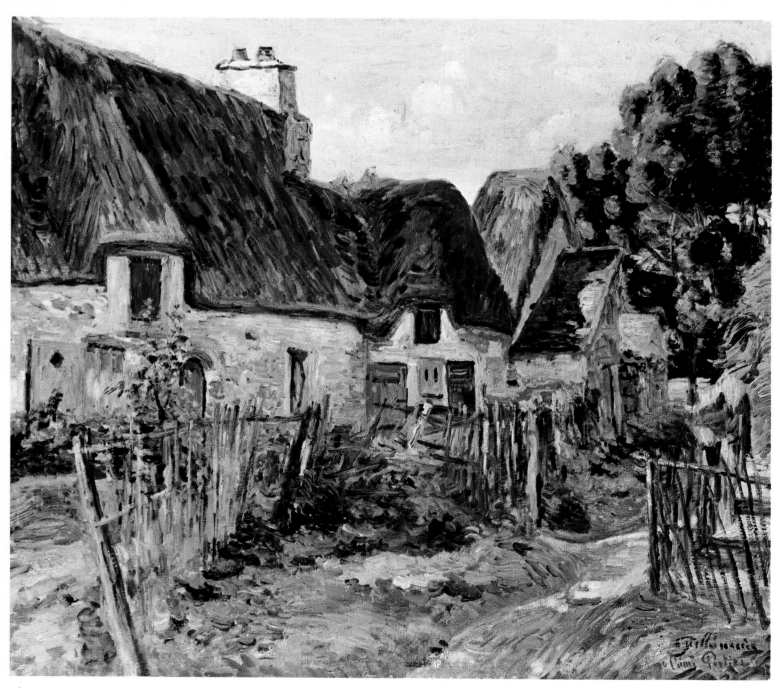

Pl. 9 *Chaumières*, c. 1882

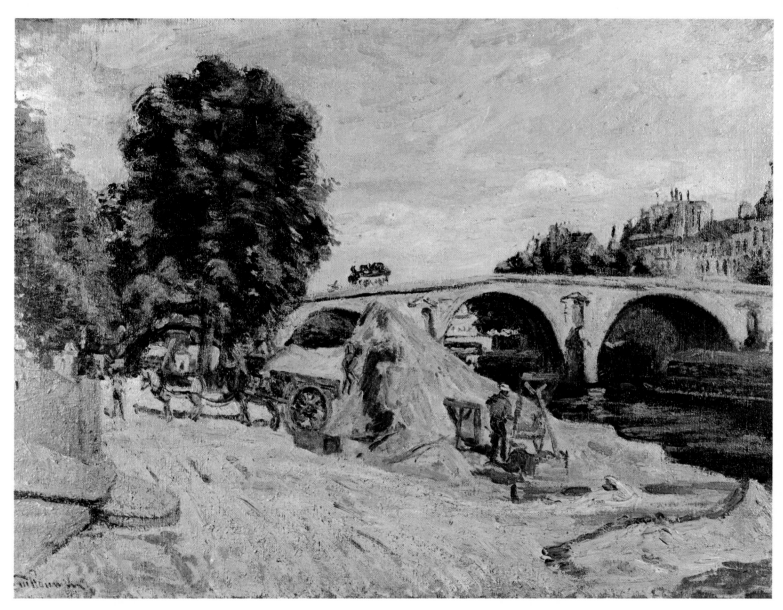

Pl. 10 *Pont-Marie from the Quai d'Anjou,* 1883

Pl. 11 *Après la pluie*, c. 1885

Pl. 12 *Cottage at Damiette*, c. 1883-1885

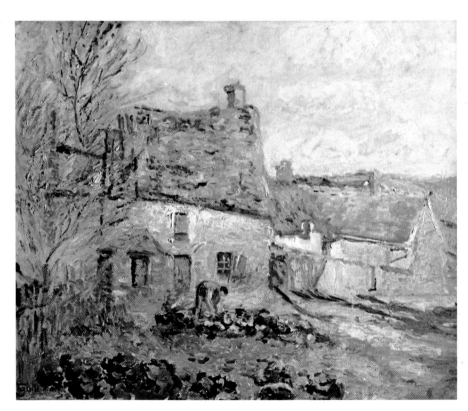

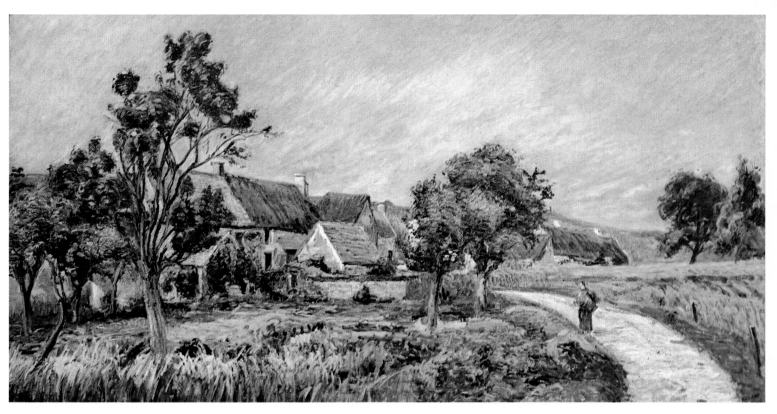

Pl. 13 *Crépuscule à Damiette*, 1885

Pl. 14 *Les pêcheurs*, 1885

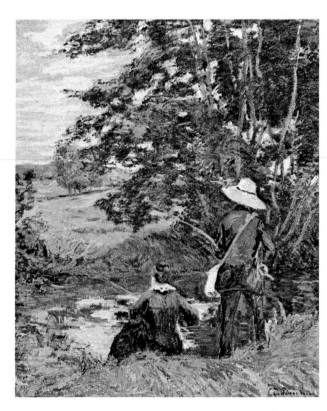

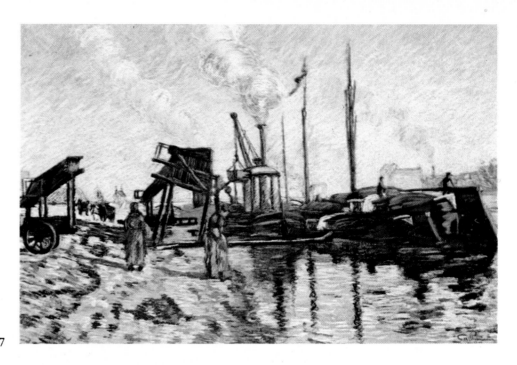

Pl. 15 *Sand Hopper, Quai de Bercy*, December 1887

Pl. 16 *Paysage*, c. 1889

Pl. 17 *Pommiers en fleur*, c. 1889

Pl. 18 *Quai de Bercy*, April 1891

Pl. 19 *Portrait of Mme Guillaumin*, 1892

Pl. 20
*Ferme et arbres
à Saint-Chéron,*
March 1893

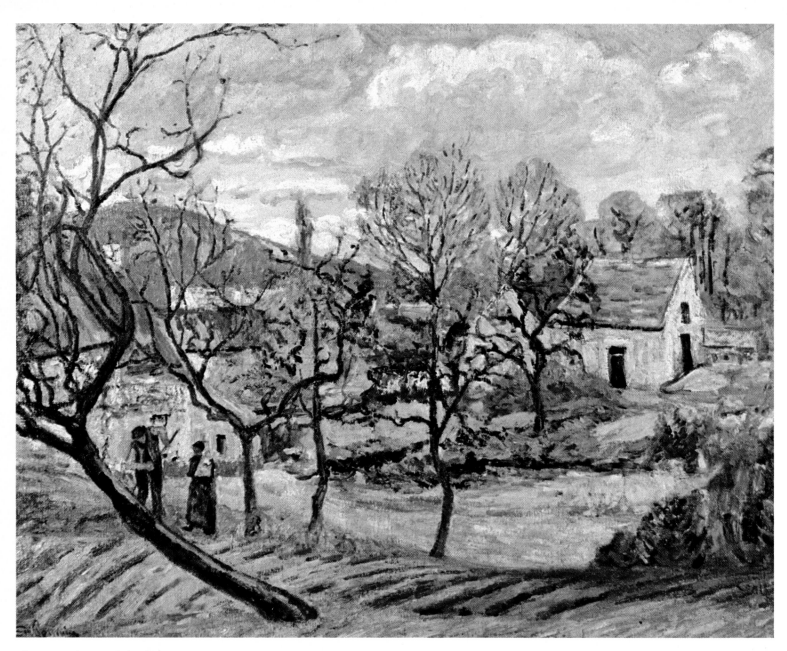

Pl. 21 *Landscape of the Creuse*, c. 1893

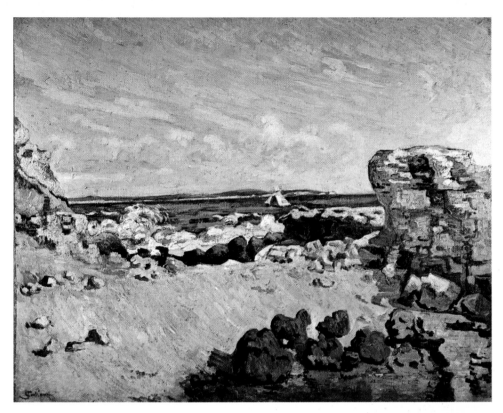

Pl. 22 *Saint-Palais*, c. 1894

Pl. 23 *Mme Guillaumin écrivant*, 1894

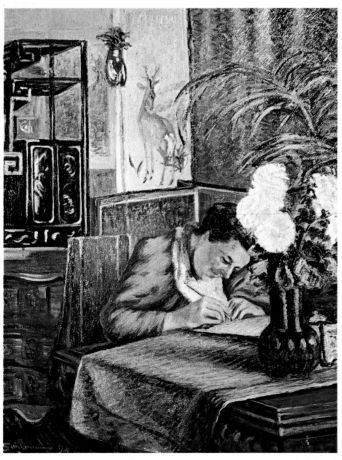

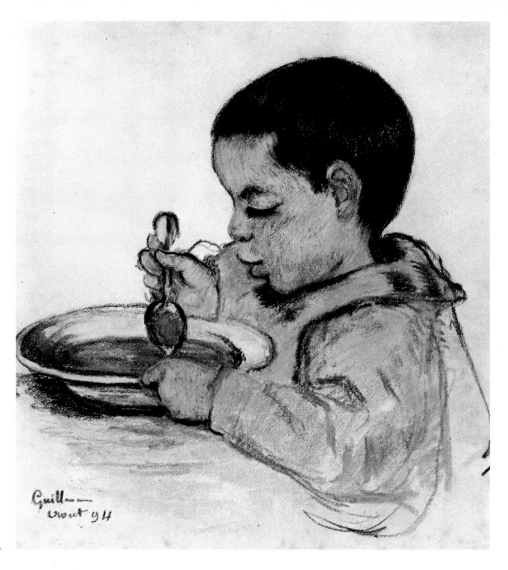

Pl. 24 *Enfant mangeant la soupe*, August 1894

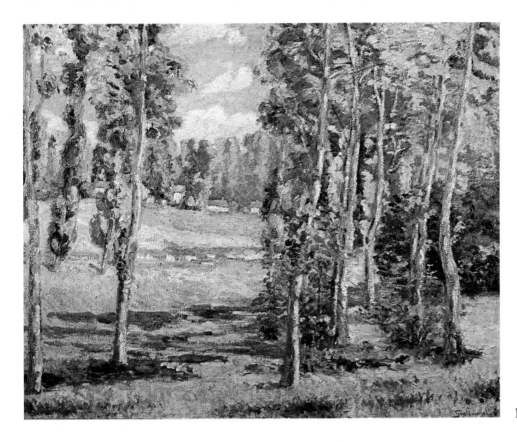

Pl. 25 *Prairie à Pontcharra*, August 1895

Pl. 26 *Le pâturage des Granges*, c. 1896

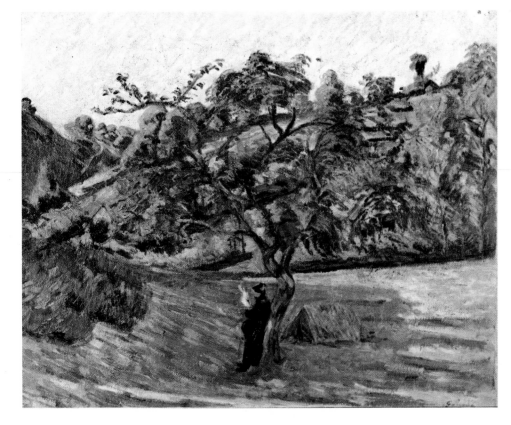

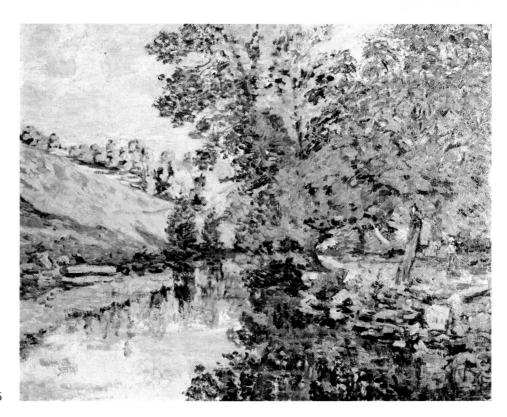

Pl. 27 *Ecluse des Bouchardonnes, c.* 1896

Pl. 28 *Route de Crozant: petit brouillard et gelée blanche,*
November 1899

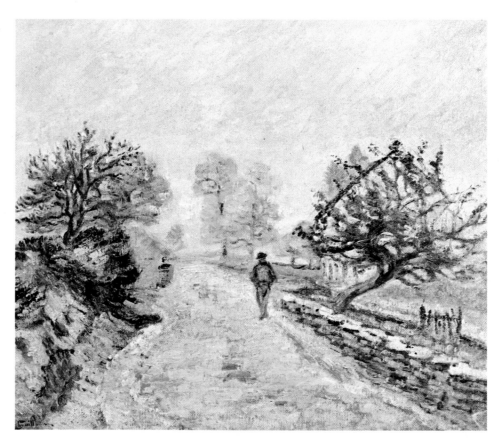

Pl. 29 *Jouy - les chaumières*, 1900

Pl. 30 *Barrage de Génetin*, c. 1900

Pl. 31 *Saint-Sauves sous la neige*, 1900

Pl. 32 *Agay*, May 1901

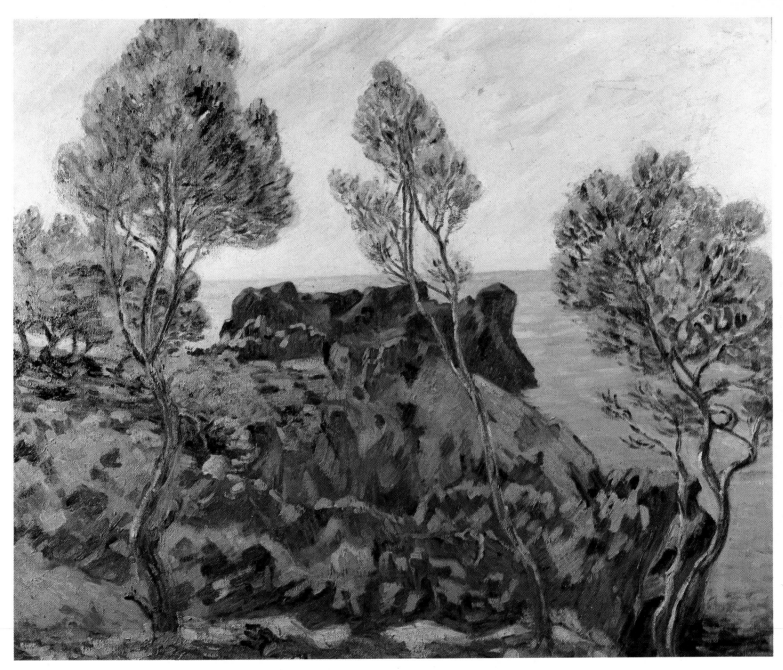

Pl. 33 *Agay - les roches rouges,* c. 1901

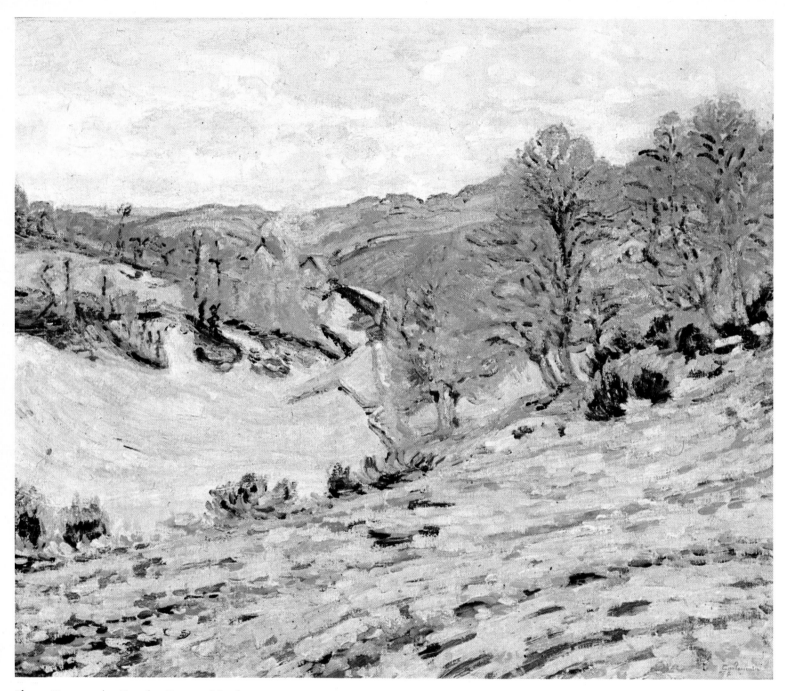

Pl. 34 *Crozant: les Grandes Gouttes,* March 1902

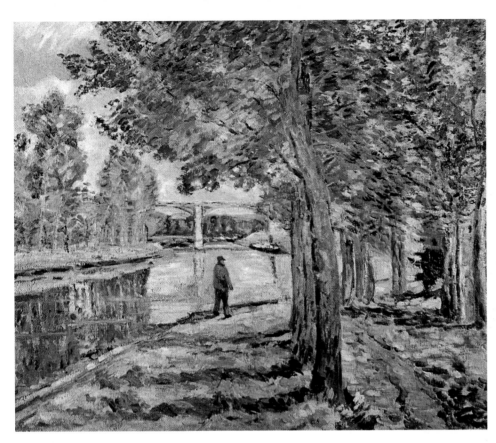

Pl. 35 *Moret*, c. 1902

Pl. 36 *Moulin de la Folie*, c. 1902

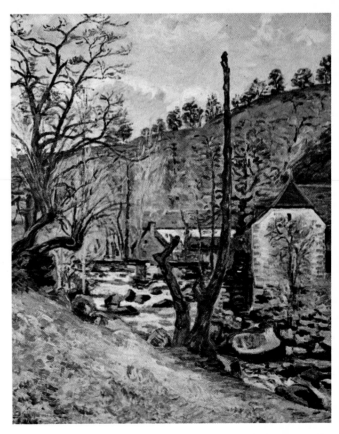

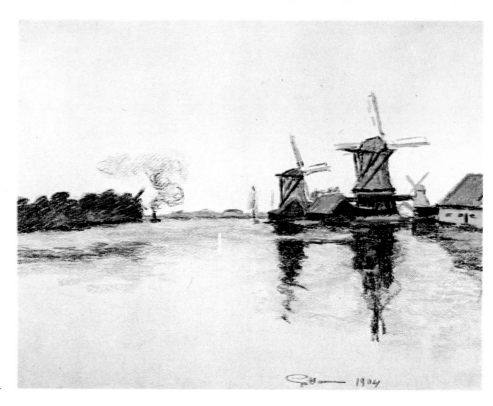

Pl. 37 *View of Holland*, 1904

Pl. 38 *Vallée de la Sédelle et les ruines*, c. 1905

Pl. 39 *Mlle Guillaumin lisant,* 1907

Pl. 40 *Chemin creux: gelée blanche,* 1909

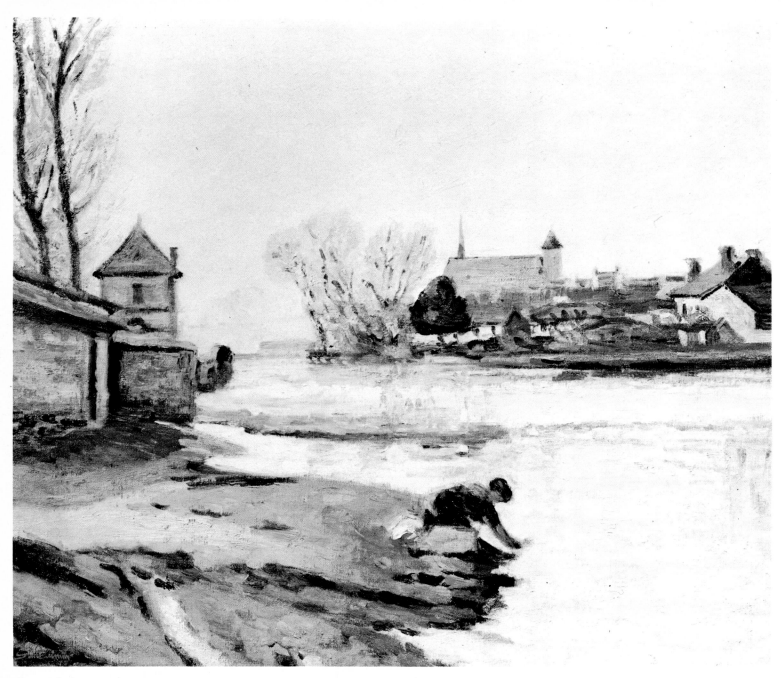

Pl. 41 *L'Abreuvoir à Poitiers,* 1910

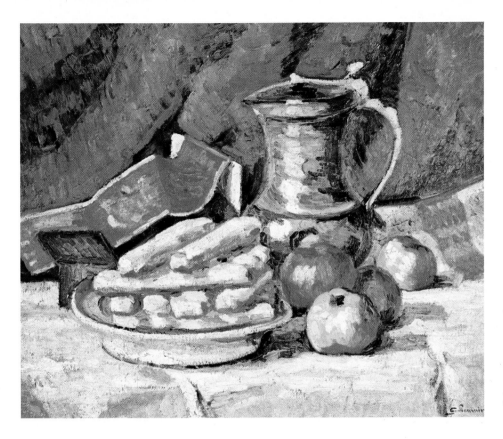

Pl. 42 *Still life with pewter pitcher, apples and biscuits champagnes*, c. 1911

Pl. 43 *Le Moulin Bouchardon*, October 1913

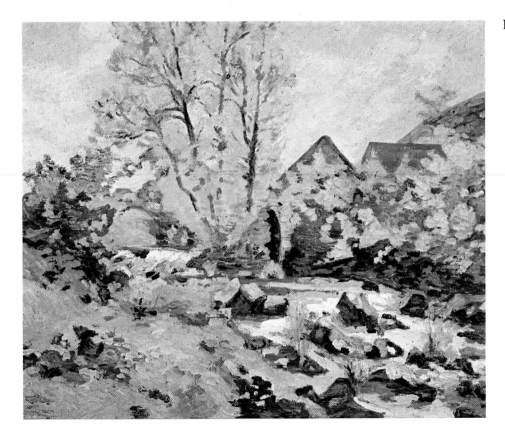

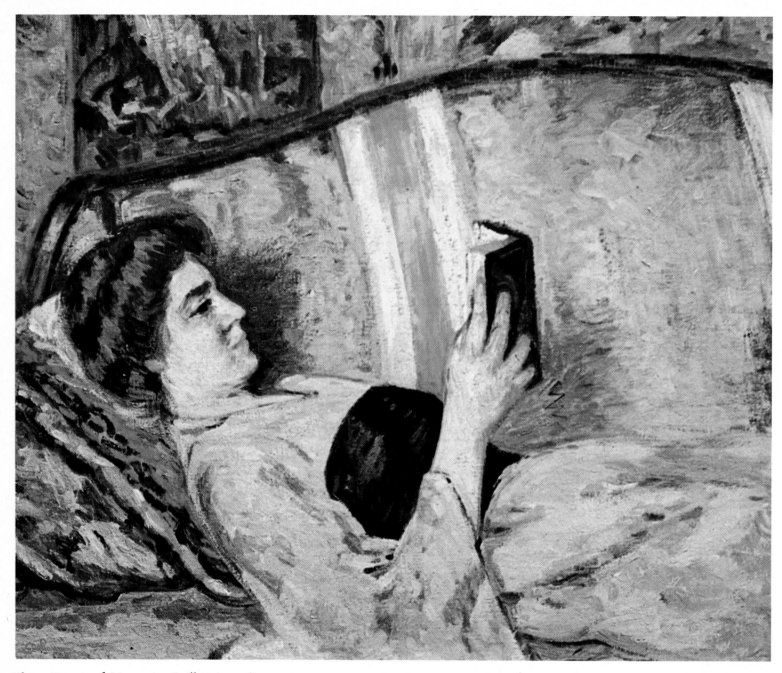

Pl. 44 *Portrait of Marguerite Guillaumin reading*, c. 1914

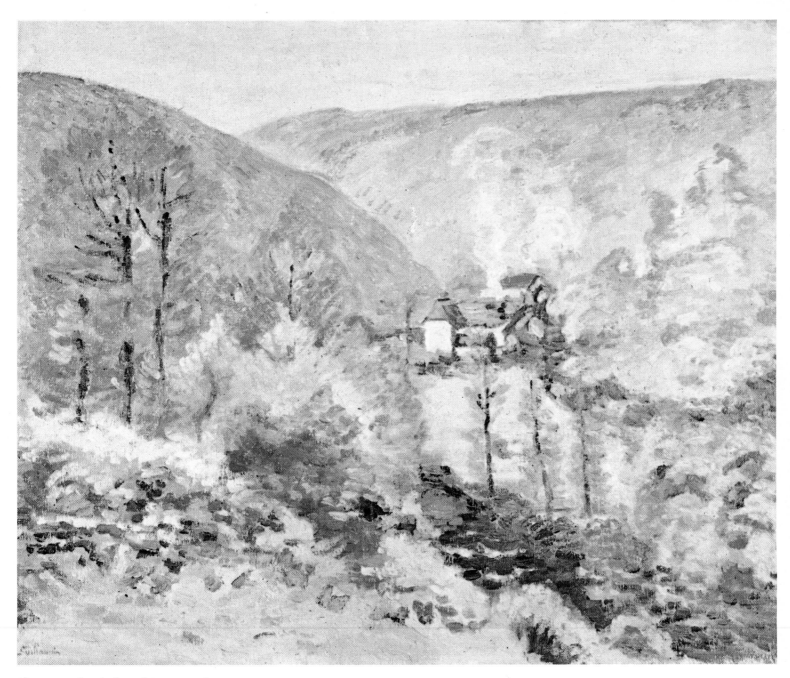

Pl. 45 *Moulin de la Folie*, November 1916

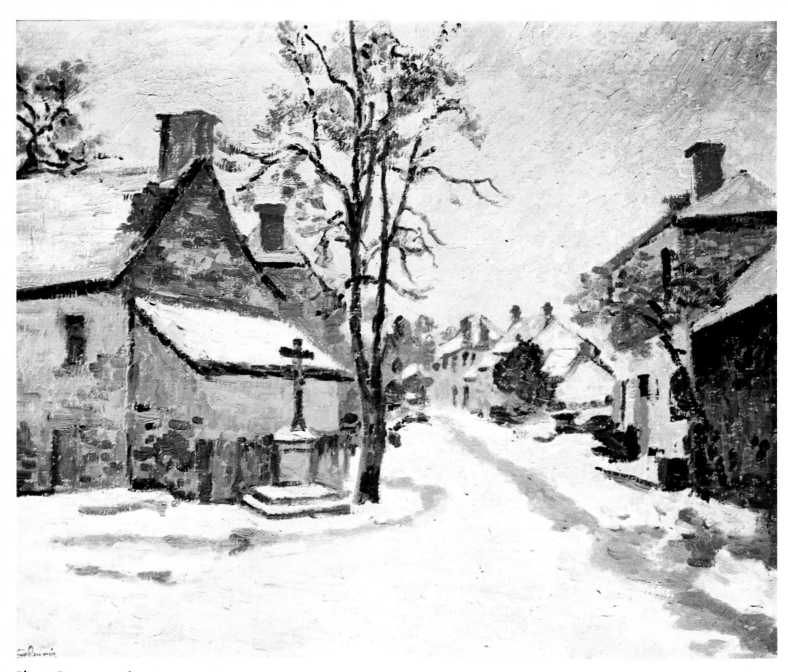

Pl. 46 *Crozant sous la neige,* c. 1916

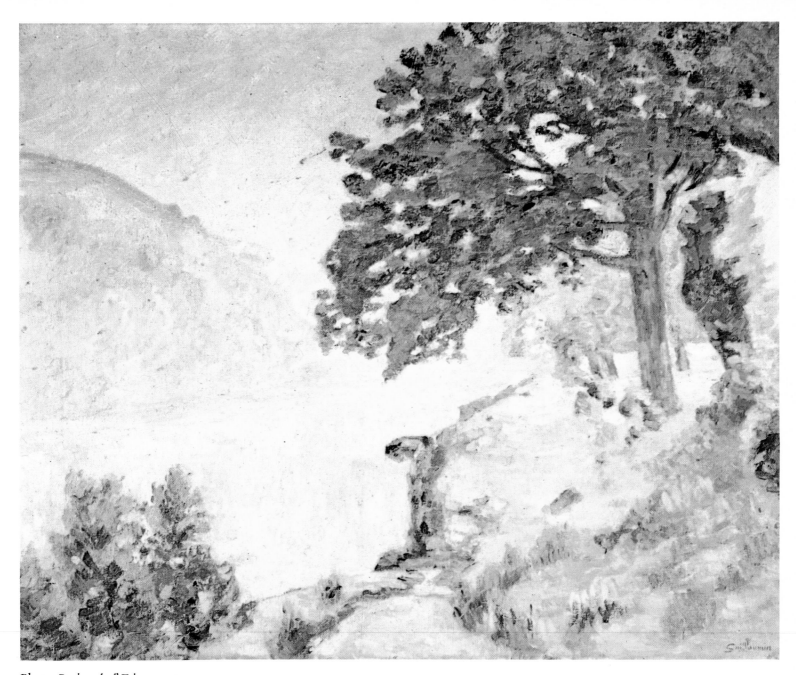

Pl. 47 *Rocher de l'Echo, c.* 1917

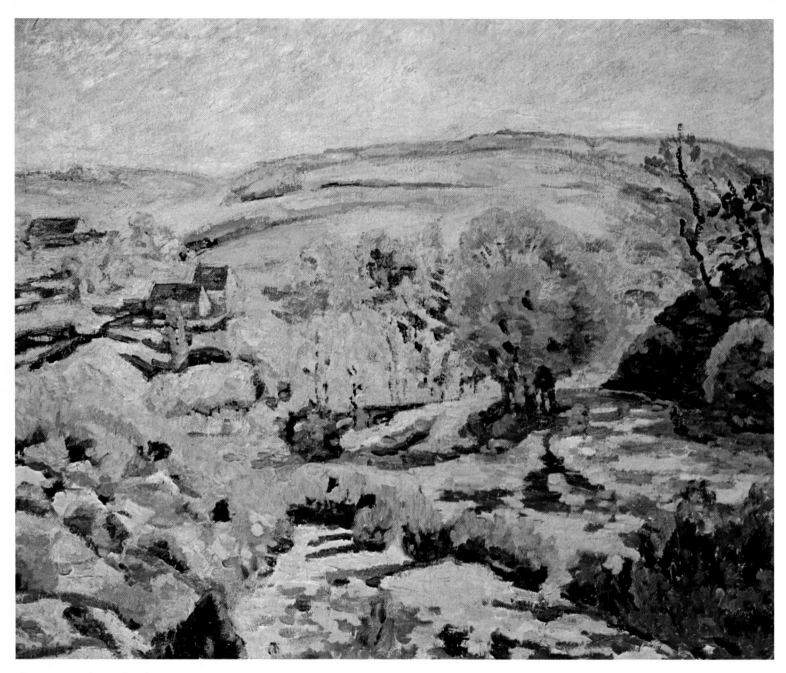

Pl. 48 *Pont Charraud*, February 1918

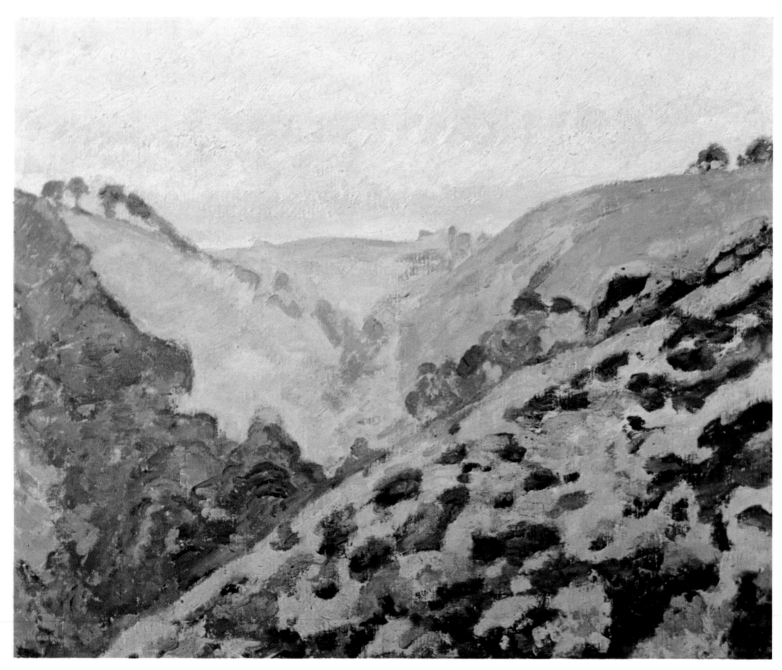

Pl. 49 *Valley of the Sédelle*, c. 1920

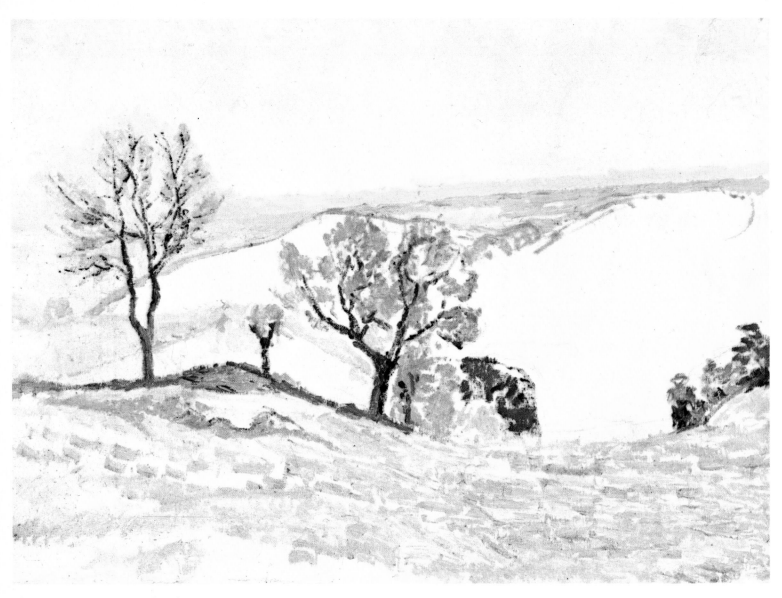

Pl. 50 *Puy Bariou – gelée blanche*, 1923

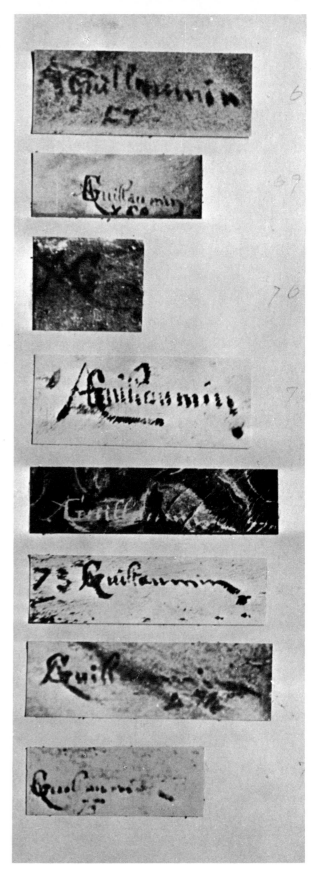

Pl. 51 *Signatures of Armand Guillaumin, 1867–1875*

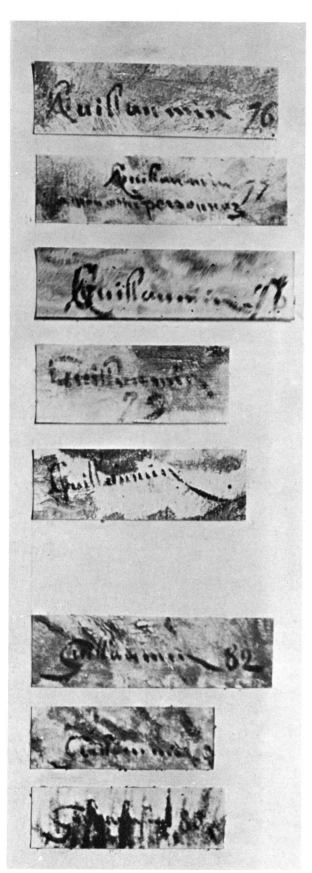

Pl. 52 *Signatures of Armand Guillaumin, 1876-1885*

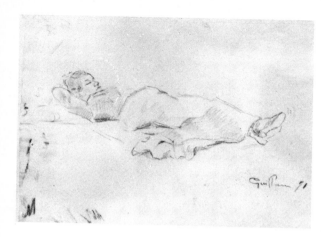

Pl. 58 Opposite: *Vallée de Chevreuse: Automne*, c. 1872

Pl. 56 *Sketch of reclining woman*, 1871

Pl. 57 *Vallée de Chevreuse*, 1872

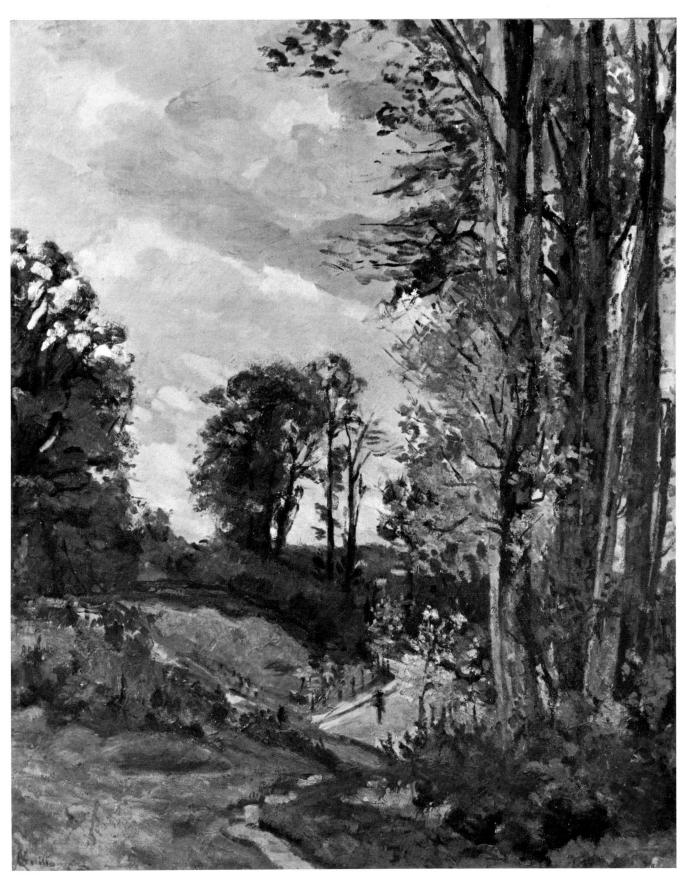

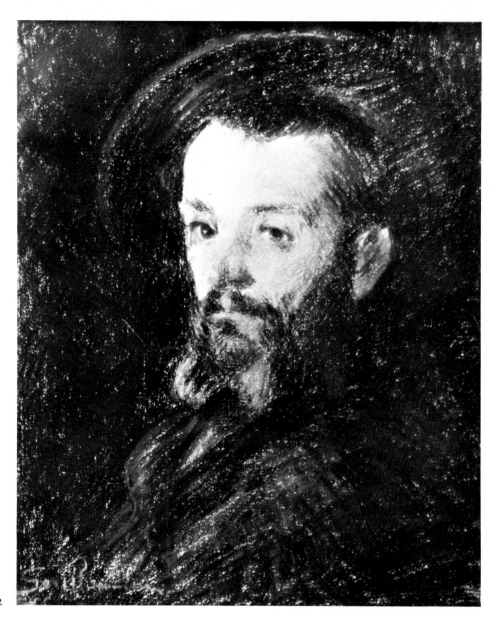

Pl. 59 *Portrait of the artist,* c. 1872

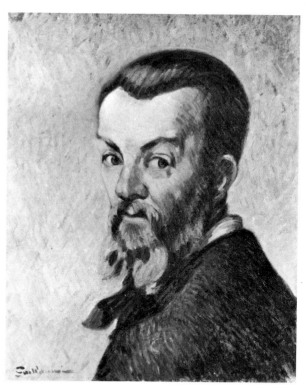

Pl. 60 *Self portrait*, c. 1872

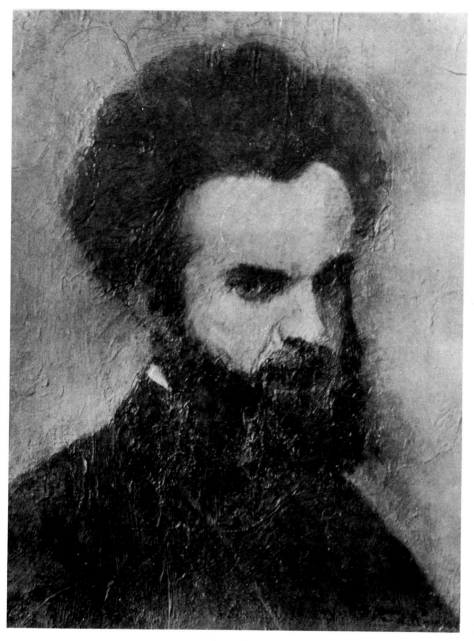

Pl. 61 *Self portrait*, c. 1872

Pl. 62 A. *Scene along the quais in Paris*, c. 1873
B. *Landscape*, c. 1873

Pl. 63 A. *La ruelle Barrault*, 1873
  B. *Chemin des Hautes-Bruyères*, 1873
  C. *Bicêtre et chemin des barons*, 1873
  D. *Unidentified*, 1873

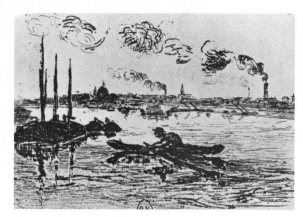

Pl. 64 *Charonton: les rameurs*, 1873

Pl. 65 *Le rameur*, c. 1873

Pl. 66 *Les forges à Ivry*, 1873

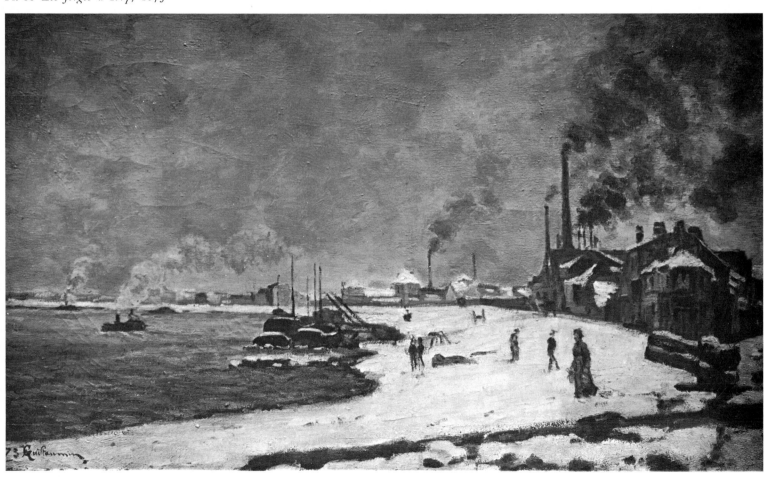

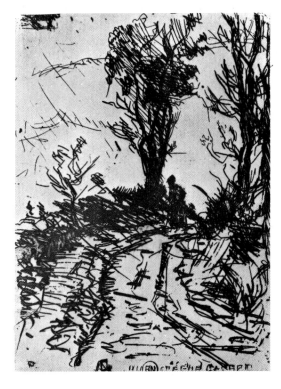

Pl. 67 *Chemin creux aux*
*Hautes-Bruyères, c. 1873*

Pl. 68 *La sablière sur la Seine,*
c. 1873

Pl. 69 *Quai de Bercy sous la neige,* 1870s

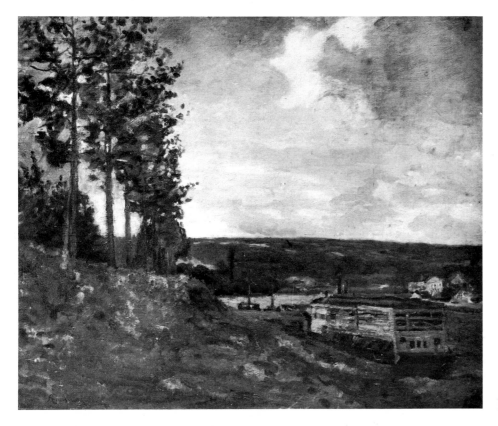

Pl. 70 *Bord de la Marne*, c. 1874

Pl. 71 *Le Pont Louis-Philippe*, 1875

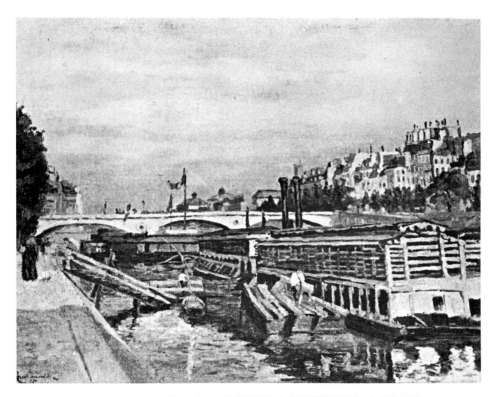

Pl. 72 *Paysage*, 1876

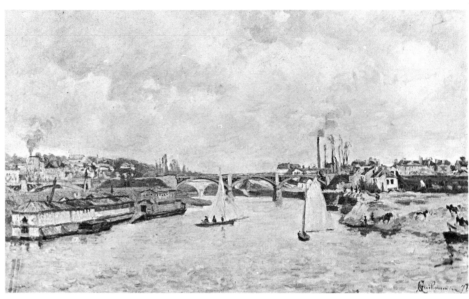

Pl. 73 *La Seine à Charonton*, 1878

Pl. 74 *La charrette*, c. 1878

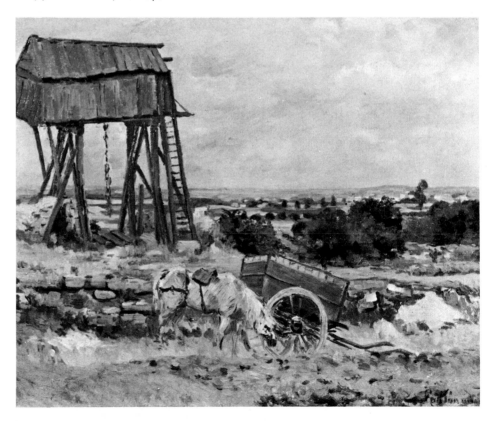

Pl. 75 *Robinson,*  c. 1878

Pl. 76 *Portrait of a young girl,* 1879

Pl. 77 *Portrait of a young man,* 1879

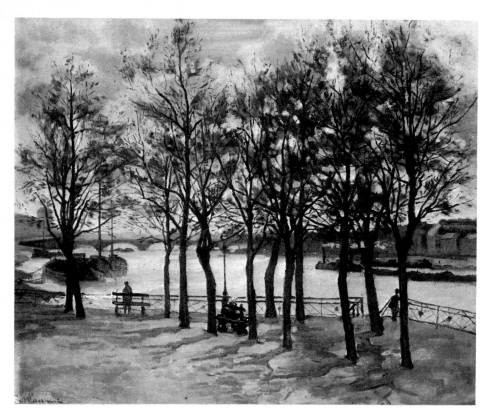

Pl. 78 *Quai de la Râpée*, c. 1879

Pl. 79 *Allée des Capucines*, 1880

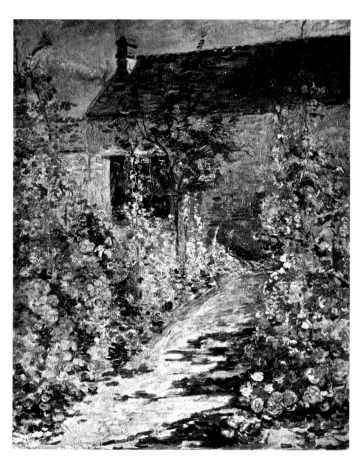

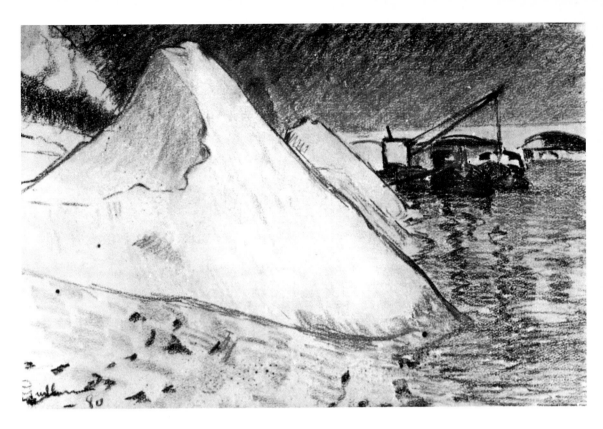

Pl. 80 *Tas de sable au bord de la Seine*, 1880

Pl. 81 *Cribleur du sable*, c. 1880

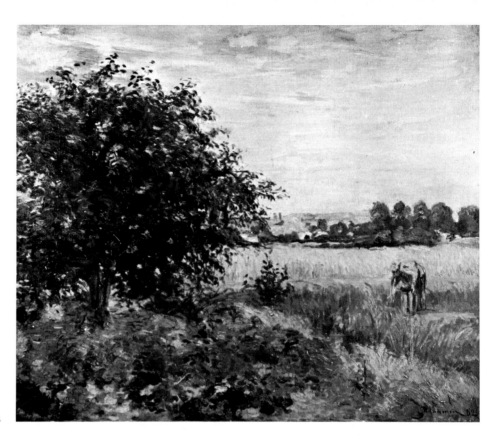

Pl. 82 *Le chemin de Damiette,* 1882

Pl. 83 *Ouvriers dormants dans l'ombre d'une charrette,*
1882

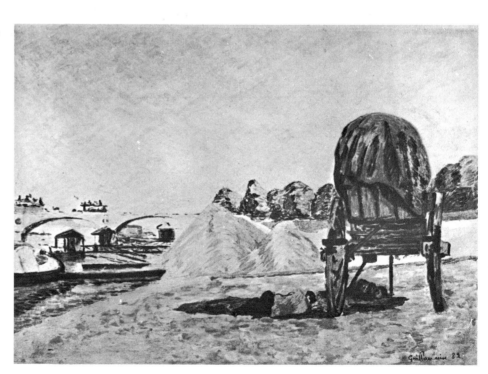

160 *Armand Guillaumin*

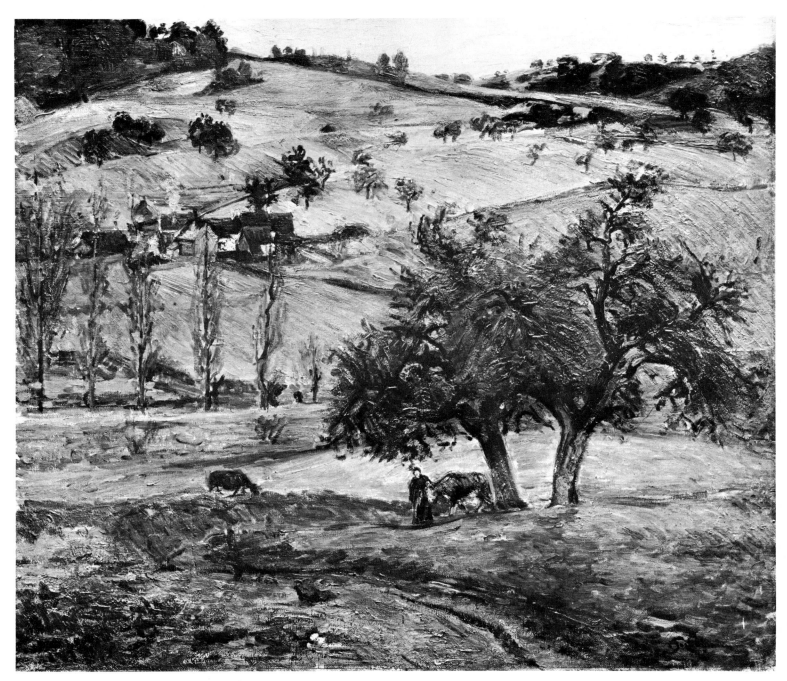

Pl. 84 *Les coteaux*, c. 1882

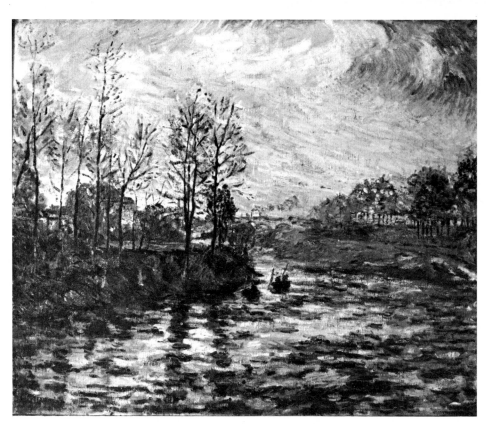

Pl. 85 *The Seine near Charonton*, c. 1882

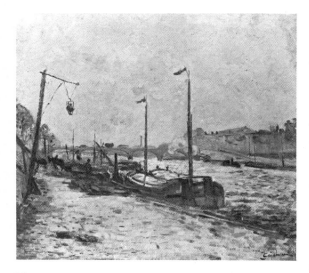

Pl. 86 *Quai Henri IV*, c. 1882

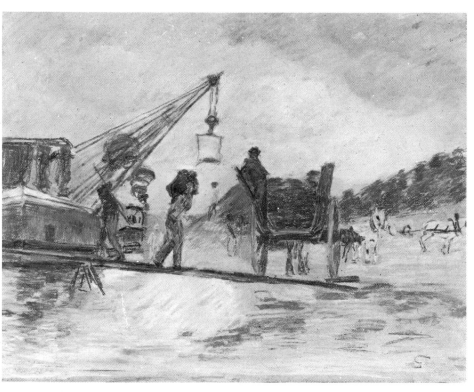

Pl. 87 *Les charrois au bord de la Seine*, 1882

162 *Armand Guillaumin*

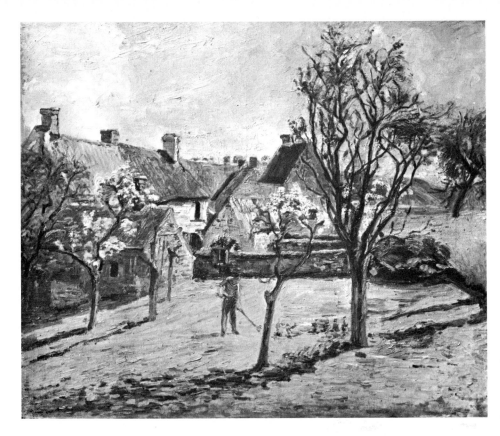

Pl. 88 *Jardin et vieilles maisons*, c. 1882

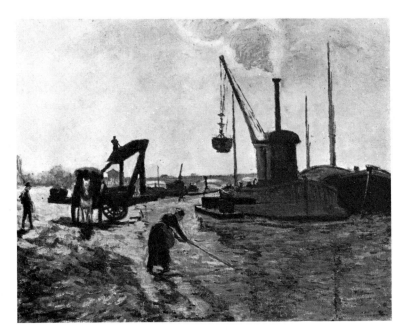

Pl. 89 *Le Pont National*, c. 1883

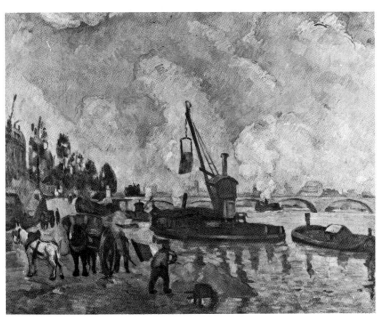

Pl. 90 *La Seine near Bercy*, 1873-1875, by Cézanne

Pl. 91 *Damiette*, 1882–1884

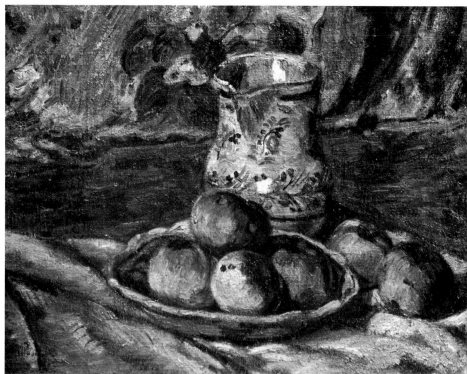

Pl. 92 *Pommes et cruchon*, c. 1884

Pl. 93 *Damiette*, September 1884

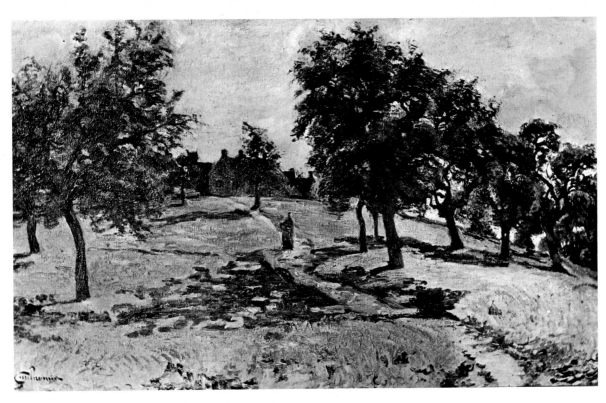

Pl. 94 *Damiette - les pommiers,*
c. 1884

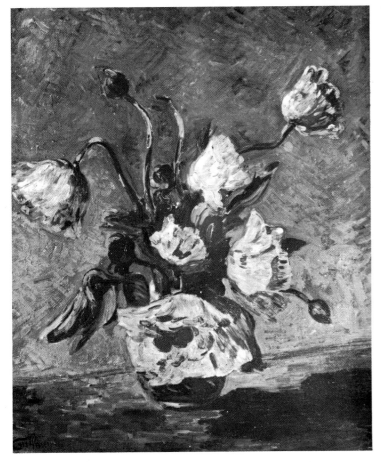

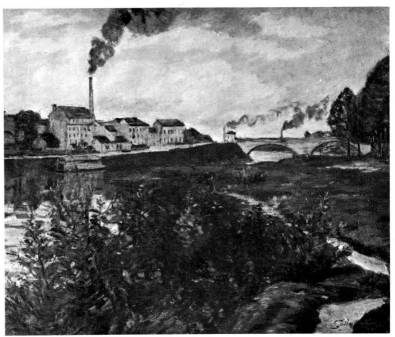

Pl. 95 (left) *Vase de coquelicots,* c. 1885

Pl. 96 (above) *Bords de la Marne,* 1885

Pl. 97 *Quai de Bercy*, 1885

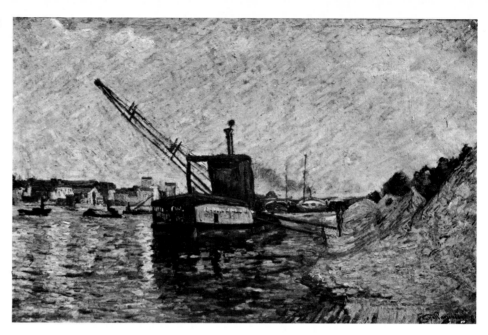

Pl. 98 *Baignade de cheval.*
*Quai de Bercy*, c. 1885

Pl. 99 *Quai de Bercy*, c. 1885

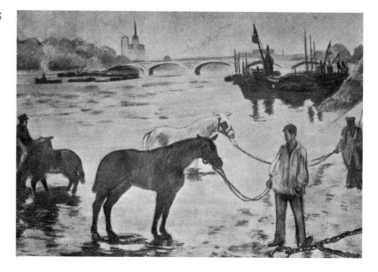

Pl. 100 *Petits voleurs de charbon*, c. 1885

Pl. 101 *Damiette*, 1886

Pl. 102 *Femmes pêchant*,
c. 1886

Pl. 103 *Cour à Janville*, August 1887

Pl. 104 *Vallée de Chevreuse, c. 1887*

Pl. 105 *Sand Hopper, Quai de Bercy, c. 1887*

Pl. 106 *Femme lisant dans un jardin, c. 1888*

Pl. 107 *Double portrait of "Mitou,"* February (?) 1888

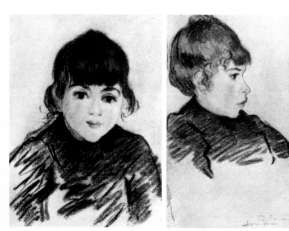

170   *Armand Guillaumin*

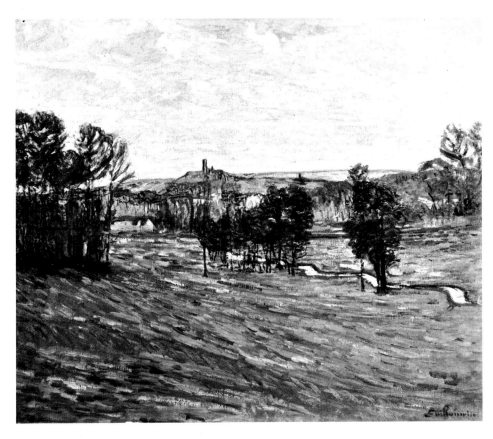

Pl. 108 *La tour de Monthéry vue d'Epinay sur Orge,*
1888 (April)

Pl. 109 *Vaches au pâturage,* c. 1888

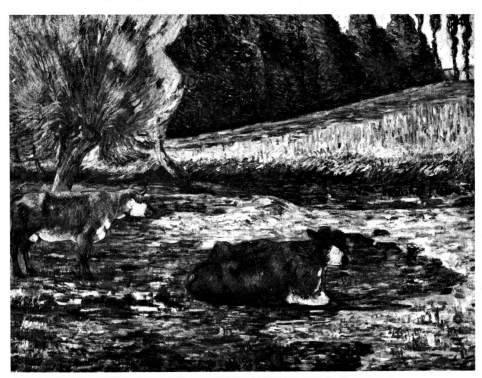

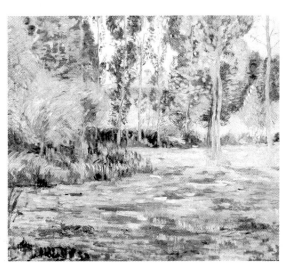

Pl. 110 *Prairie en soleil,* c. 1888

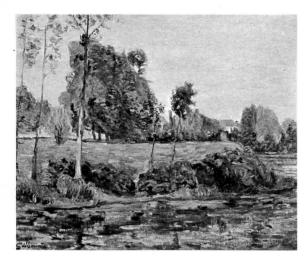

Pl. 111 *Bords de la Seine à Charonton*, c. 1888

Pl. 112 *Mme Guillaumin with daughter, Madeleine*, 1889

Pl. 113 *Mme Guillaumin reading*, 1889

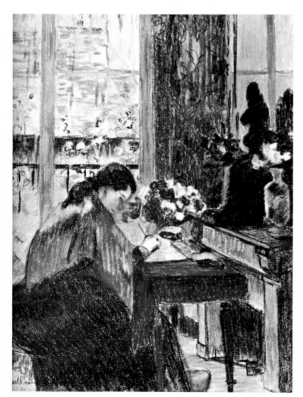

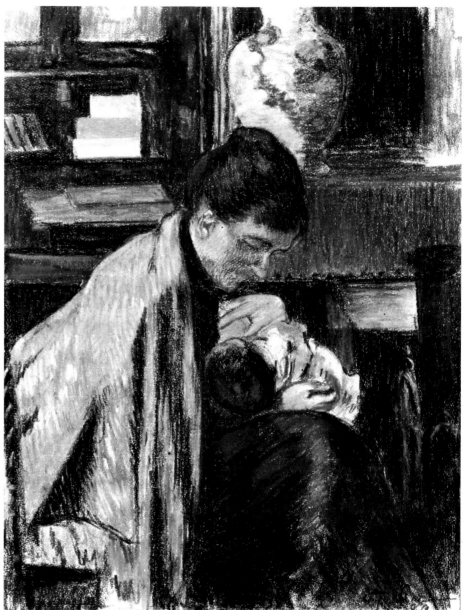

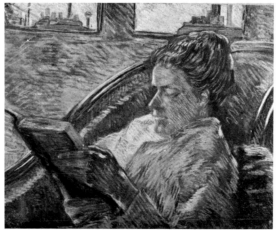

Pl. 114 *Mme Guillaumin reading*, 1889

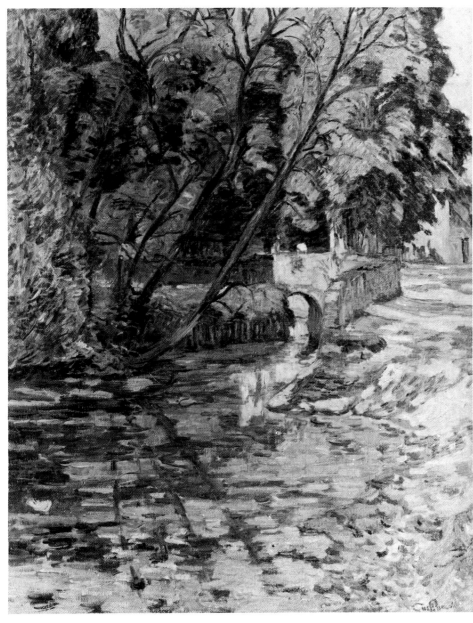

Pl. 115 *Abreuvoir à Epinay-le-Breuil*, June 1889

Pl. 116 *La Maison au vieux Thionnette*, c. 1889

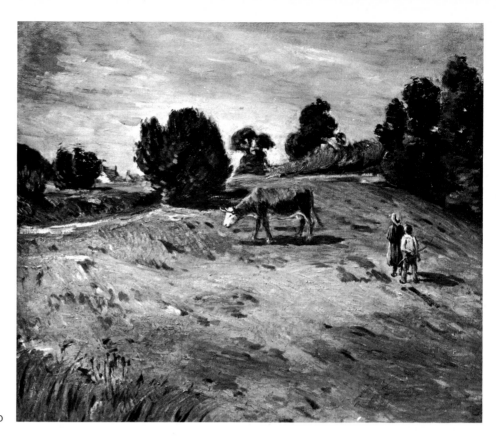

Pl. 117 *Paysage avec une vache*, c. 1890

Pl. 118 *Bords de la Seine*, c. 1890

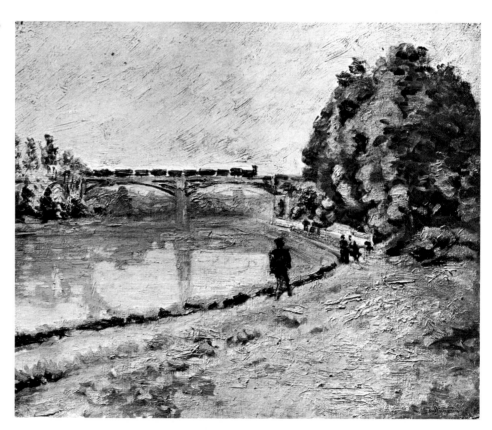

Pl. 119 *Déchargeurs du charbon*, January 1890 (?)

Pl. 120 *Breuillet*, 1890

Pl. 121 *Double portrait of Madeleine, c.* 1891

Pl. 122 *Les dunes de la Couarde, Ile de Ré,* February 1892

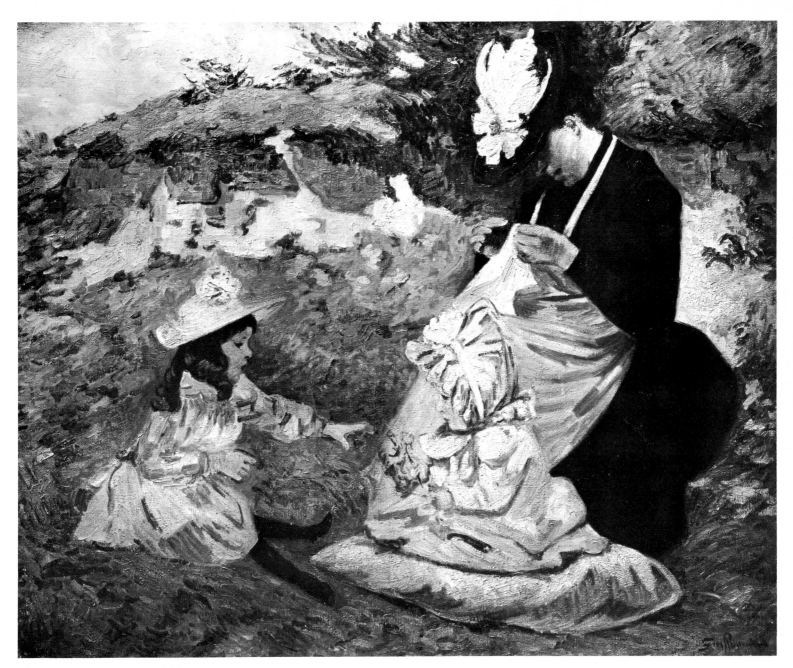

Pl. 123 *Woman with two children*, c. 1892

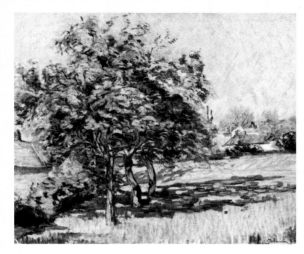

Pl. 124 *Verger à Miregaudin*, June 1892

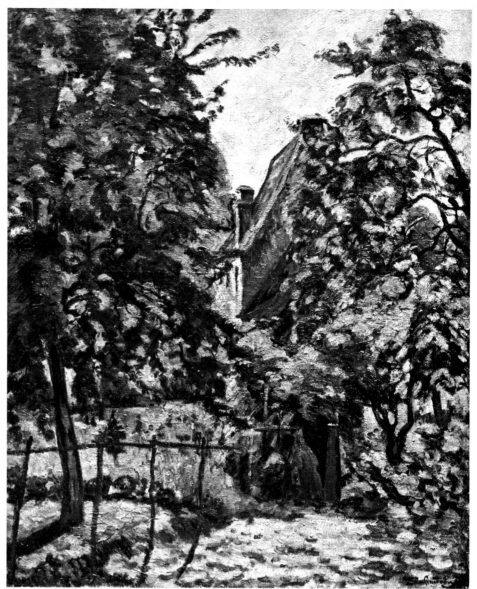

Pl. 125 *Verger à Miregaudin*, c. 1892

Pl. 126 *Agay*, December 1892 (?)

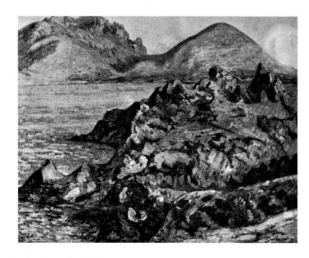

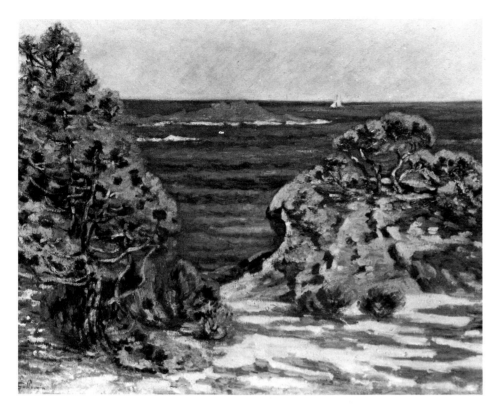

Pl. 127 *La mare, Agay,* 1893

Pl. 128 *La sablière,* February 1893

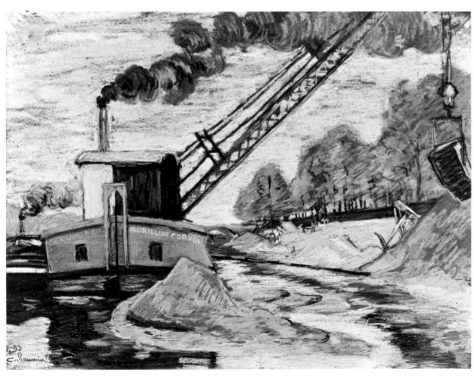

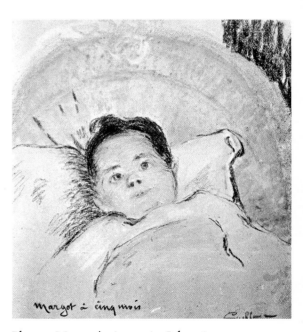

Pl. 129 *Margot à cinq mois,* July 1893

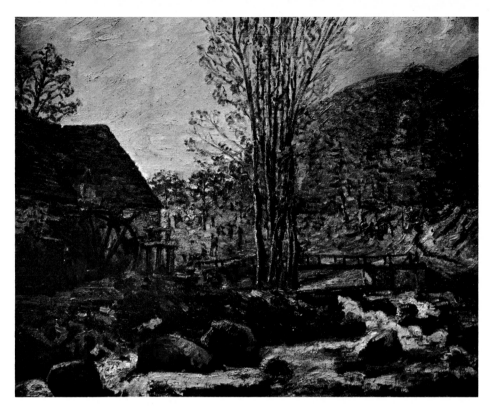

Pl. 130 *Le Moulin Brigand*, September 1893

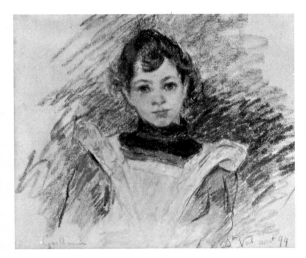

Pl. 131 *Portrait de Madeleine*, 1894

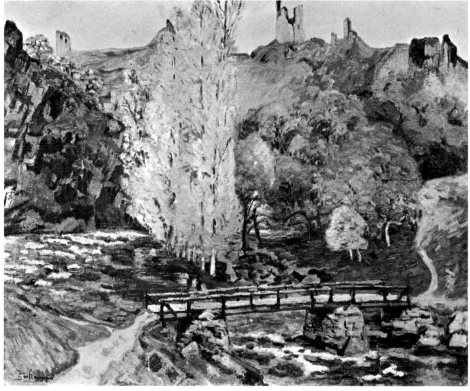

Pl. 132 *La passerelle sur la Sédelle*, c. 1894

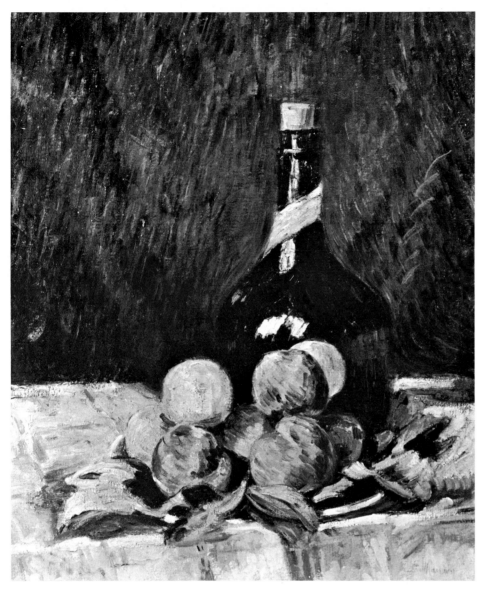

Pl. 133 *Still life*, c. 1894

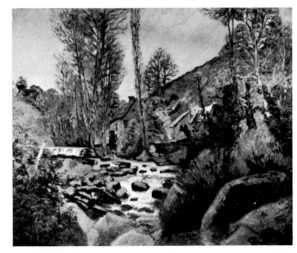

Pl. 134 *Le Moulin Bouchardon*, October 1894

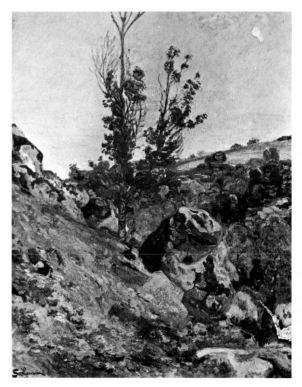

Pl. 135 *Boigneville-les-Carneaux*, June 1894

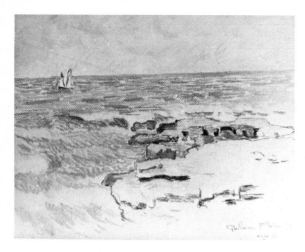

Pl. 136 *Saint-Palais*, 1894

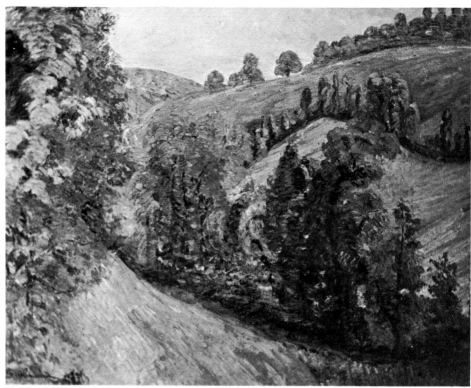

Pl. 137 *Paysage à Pontgibaud*, July 1895

Pl. 138 *Pontgibaud*, October 1895

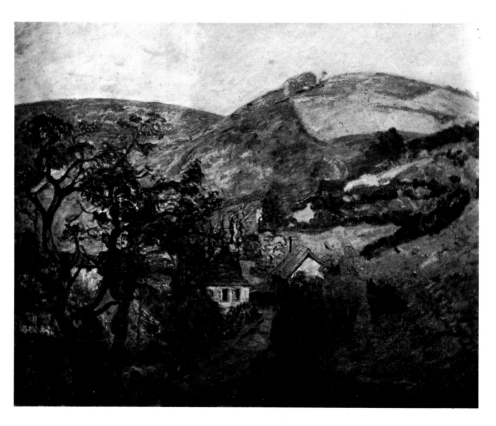

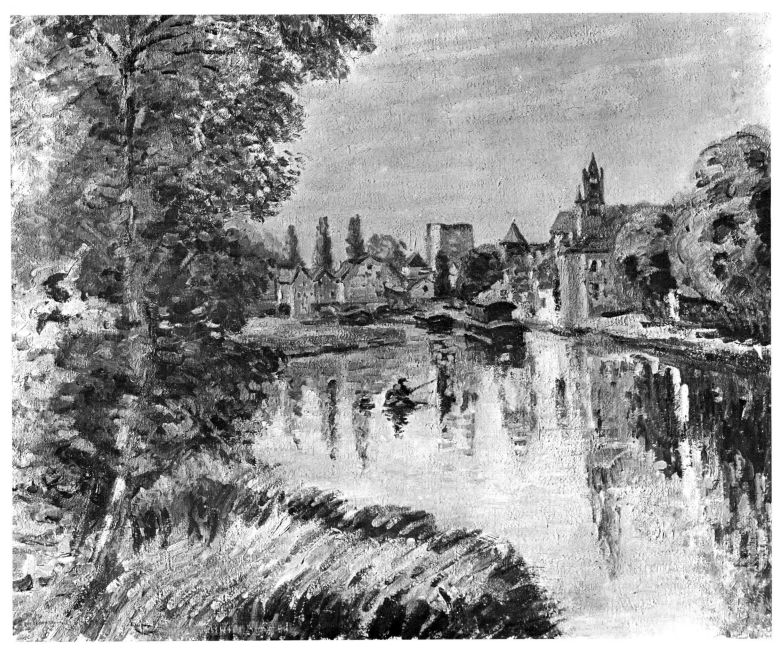

Pl. 139 *Moret*, c. 1896

Pl. 140 *Moret: le Loing et passerelle*, c. 1896

Pl. 141 *La Sédelle*, c. 1896

Pl. 142 *Pont Charraud*, c. 1896–1897

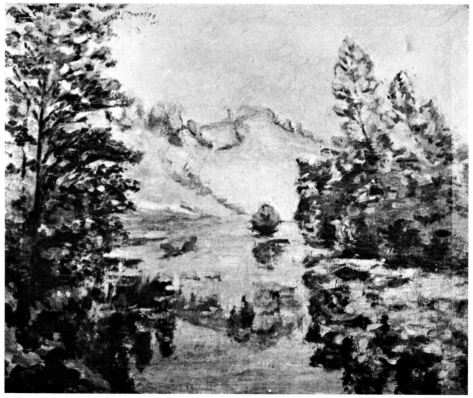

Pl. 144 *Paysage de la Creuse*, c. 1897

Pl. 143 *L'automne sur la Creuse (Puy Bariou)*, November 1896

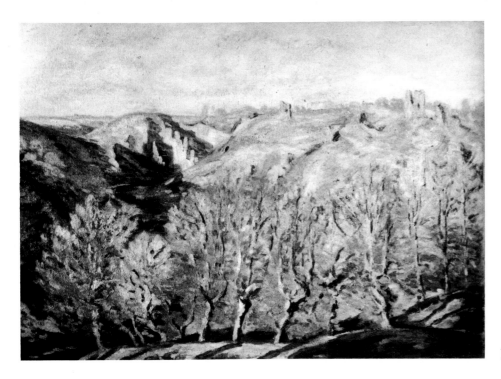

Pl. 145 *Les ruines à Crozant*, c. 1897

Pl. 146 *La Creuse à Génetin*, September 1897

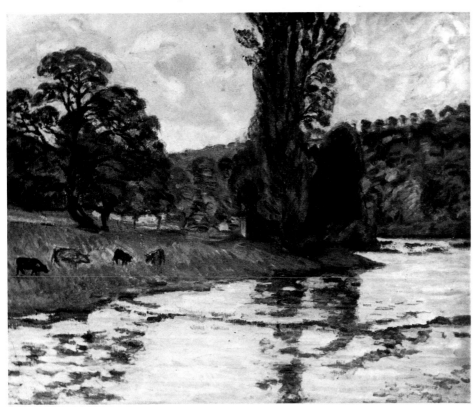

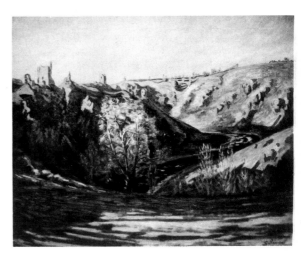

Pl. 147 *La vallée de la Creuse*, c. 1897

Pl. 148 *Portrait of Mme Guillaumin, c.* 1898

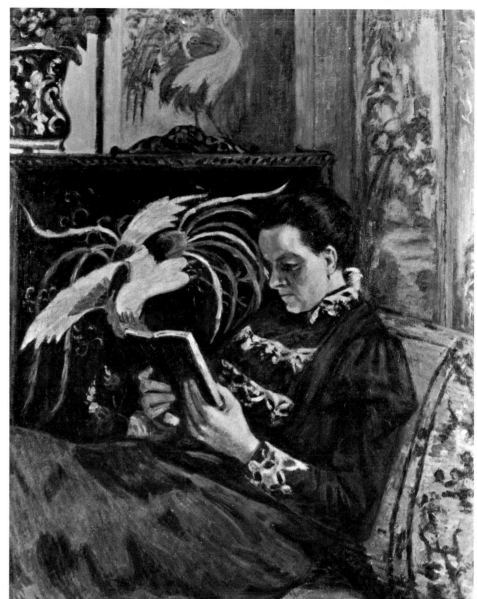

Pl. 149 *Chemin de Puy Bariou,* 1898

Pl. 150 *Les ruines,* October 1898

Pl. 151 *Neige à Crozant, c. 1898*

Pl. 152 *Le Cap Long et le Rastel d'Agay*, c. 1900

Pl. 153 *Les pâturages des Granges, Crozant*, c. 1900-1910

Pl. 154 *Pointe de la Baumette, Agay*, 1901

Pl. 155 *Mont Granies, Pontcharra*, July 1901

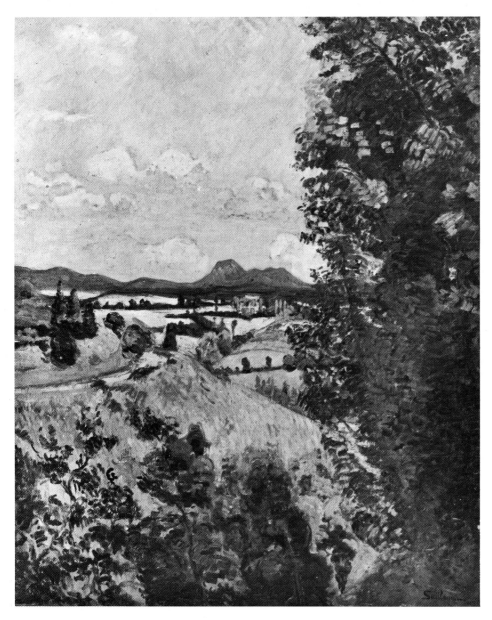

Pl. 156 *Pontcharra*, c. 1901

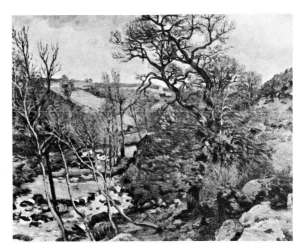

Pl. 157 *Clos des Bouchardons*, December 1901

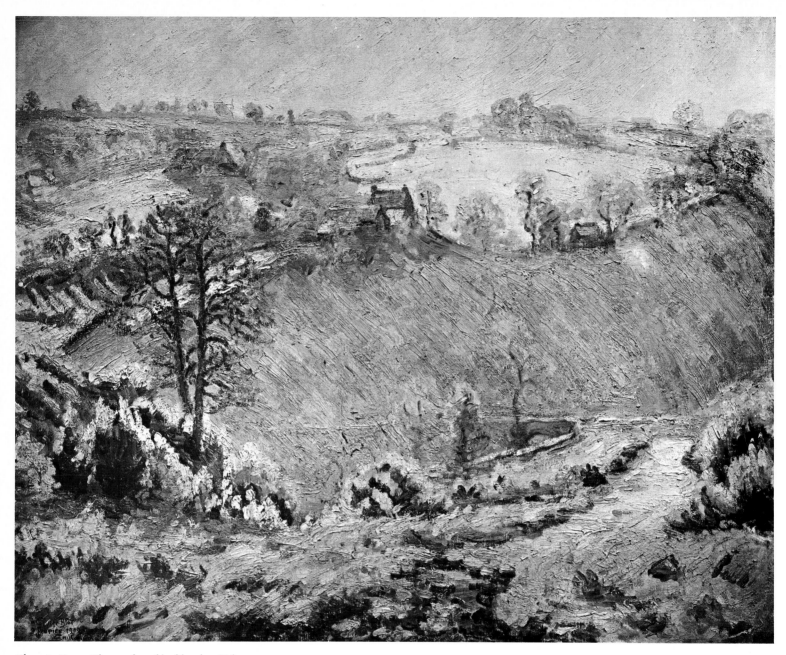

Pl. 158 *Pont Charraud, gelée blanche*, February 1902

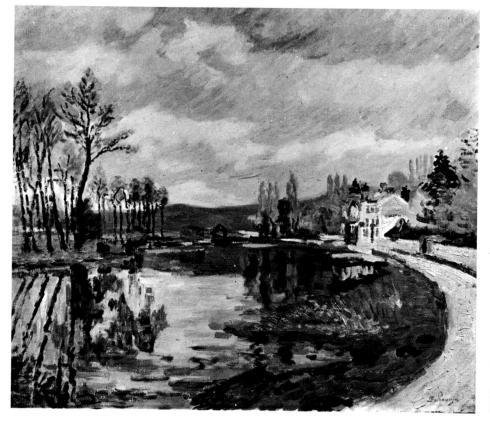

Pl. 159 *La Seine à Samois*, April 1902

Pl. 160 *Le Moulin Bouchardon*, c. 1902

Pl. 161 *Pont Charraud*, February 1903

Pl. 162 *Jeune fille cousant. Portrait de la fille de l'artiste,* c. 1903

Pl. 163 *Bords de l'Orne à Clecy,* August 1903

Pl. 164 *La Creuse en septembre,* September 1903 (?)

Pl. 165 *Vue de Zaandam,* 1904

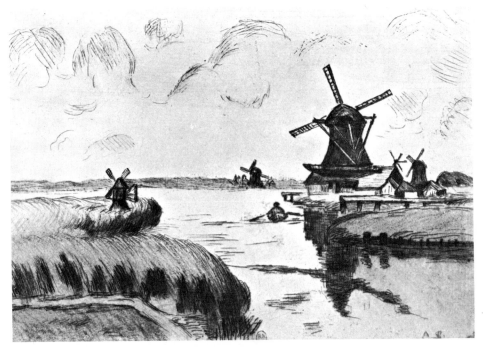

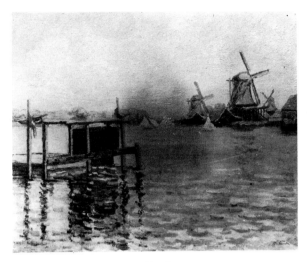

Pl. 166 *Windmills in Holland, 1903-1904*

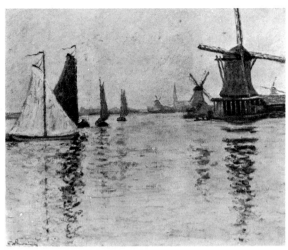

Pl. 167 *View of Holland, 1904*

Pl. 168 *Landscape near Saardam, 1904*

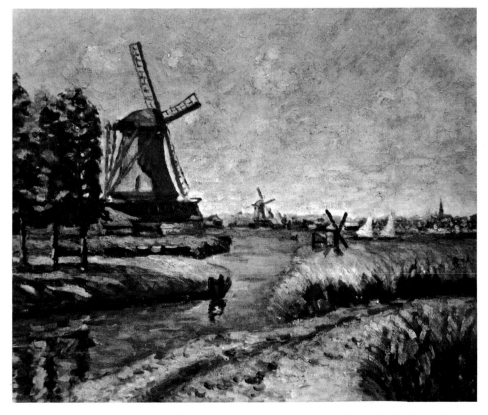

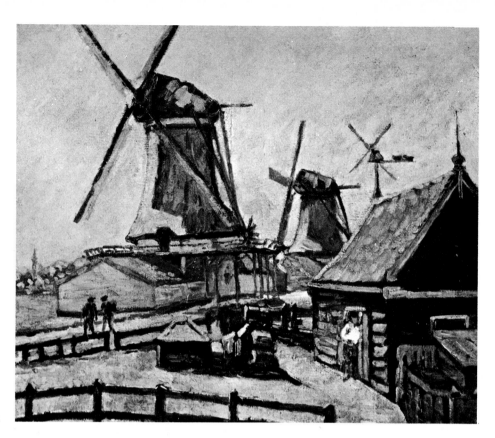

Pl. 169  *Wormeneer, Holland,* 1904

Pl. 170  *Rouen: la Seine le matin,* 1904

Pl. 171 *Quais at Rouen,* 1904-1905

Pl. 172 *Vue de Rouen, matin d'hiver,* 1904

*Armand Guillaumin* 195

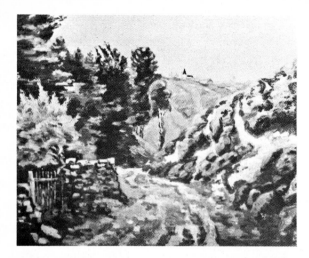

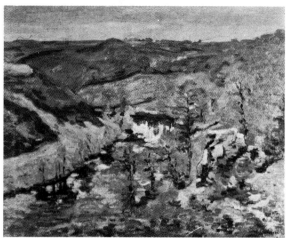

Pl. 173 *Chemin de Puy Bariou,*
c. 1905

Pl. 174 *Les Telles et Puy Bariou,*
c. 1905

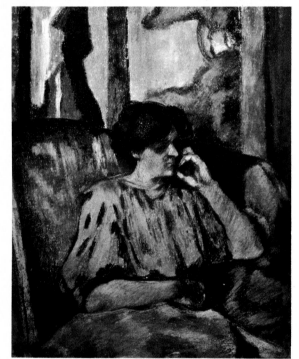

Pl. 175 *Madeleine listening to music,* c. 1905

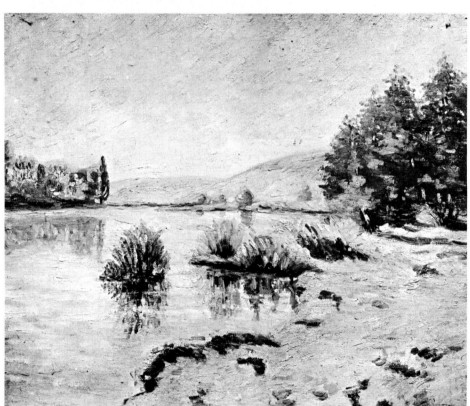

Pl. 176 *Villeneuve-sur-Yonne,* 1906

Pl. 177 *Le Moulin Jonon*, c. 1906

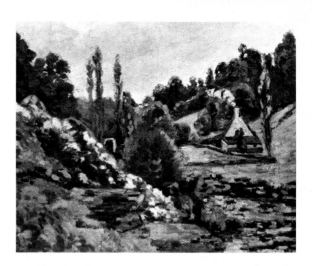

Pl. 178 *Agay*, 1907

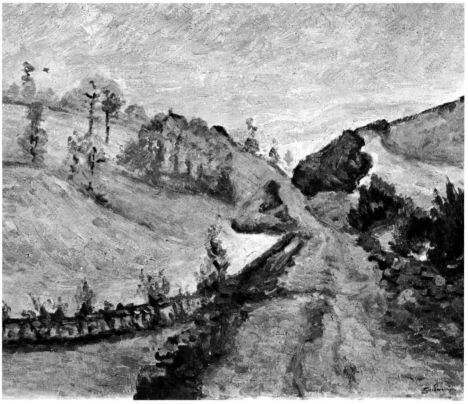

Pl. 179 *Le vieux chemin: brouillard du matin*, 1907

Pl. 180 *Le vieux chemin: effet de neige*, c. 1907

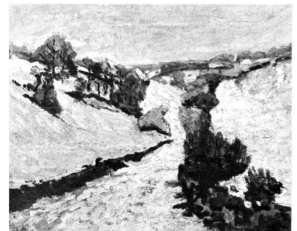

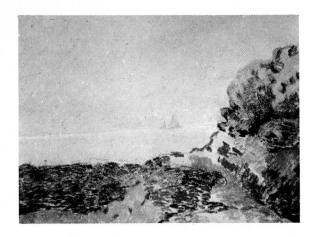

Pl. 181 *Pornic,* 1908

Pl. 182 *Saint-Palais: Embouchure de la Gironde,* 1909

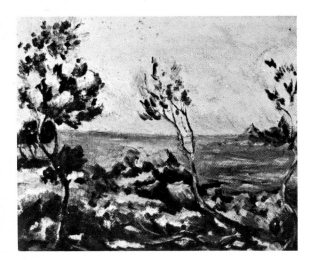

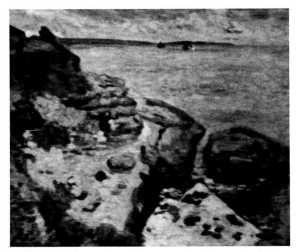

Pl. 183 *Agay: le rocher rouge, le mistral,* c. 1910.

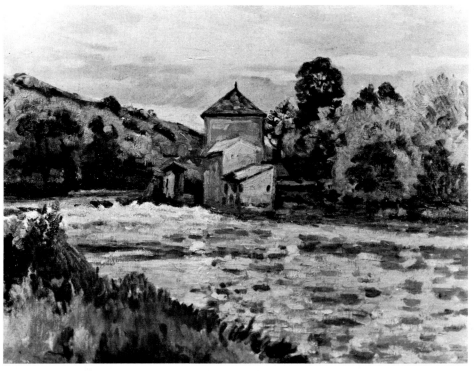

Pl. 184 *Poitiers,* 1910

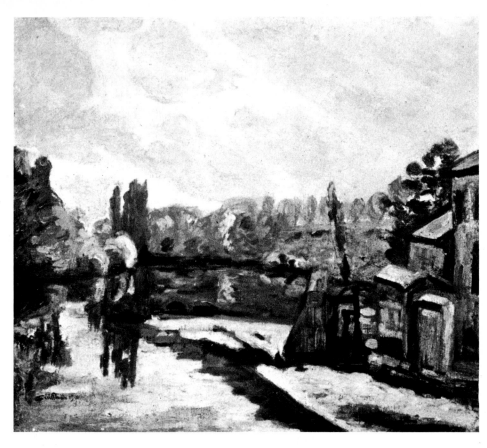

Pl. 185 *La Cabanne*, 1910

Pl. 186 *Pont Charraud*, 1910

Pl. 187 *Le Brusc*, 1911

Pl. 188 *Le port du Brusc,* April 1911

Pl. 189 *Le Moulin Bouchardon,* c. 1911

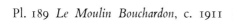

Pl. 190 *La Querlière,* August 1911

Pl. 191 *Pont Charraud: gelée blanche,* c. 1903-1911

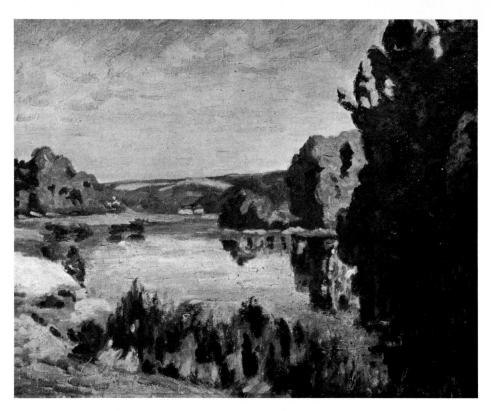

Pl. 192 *Nanteuil sur Marne*, 1911

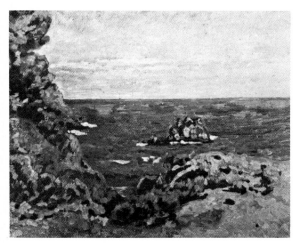

Pl. 193 *Agay: la Baumette*, 1912

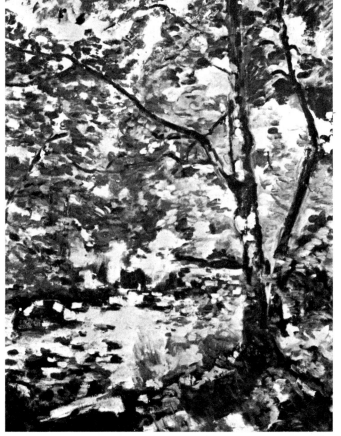

Pl. 194 *Bords de la Sédelle*, August 1912

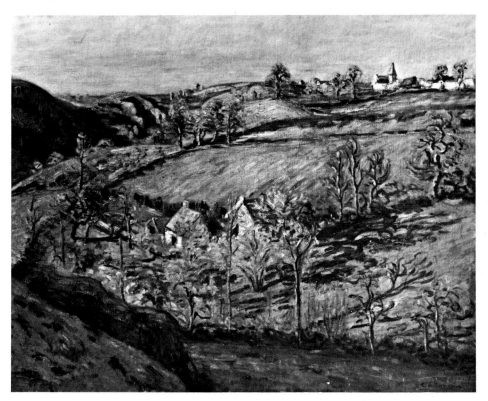

Pl. 195 *Les pâturages des Granges*, c. 1912

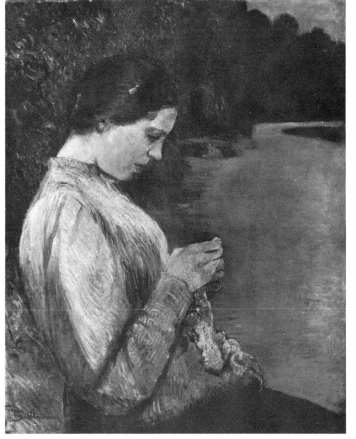

Pl. 196 *Pont Charraud*, c. 1913

Pl. 197 *Portrait of Marguerite*, c. 1913

Pl. 198 *Le Moulin Brigand et les ruines*, 1914

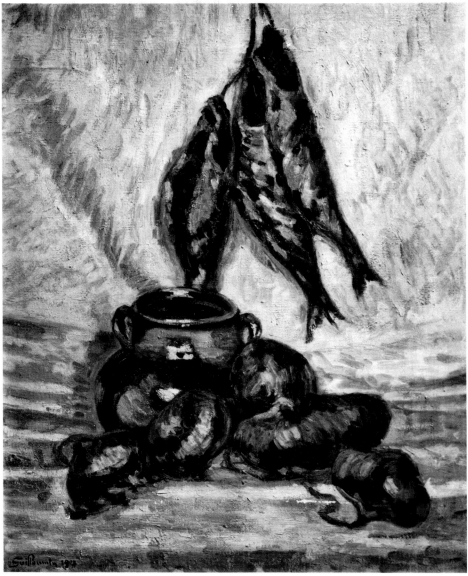

Pl. 199 *Still life with herrings, pot and onions*, 1914

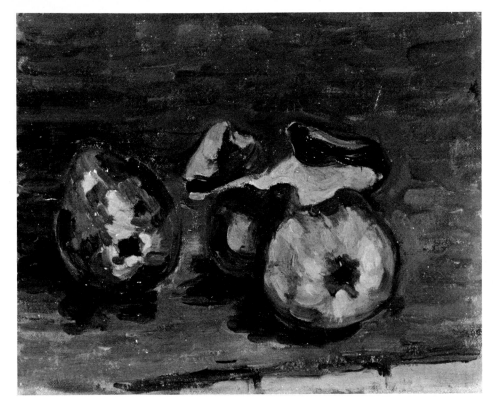

Pl. 200 *Nature morte avec pommes*, 1914

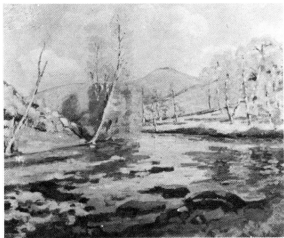

Pl. 201 *Les Telles*, March 1915

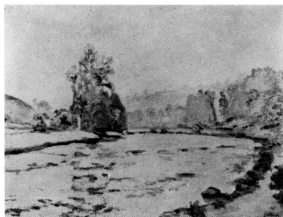

Pl. 202 *La Creuse à Génetin*, c. 1915

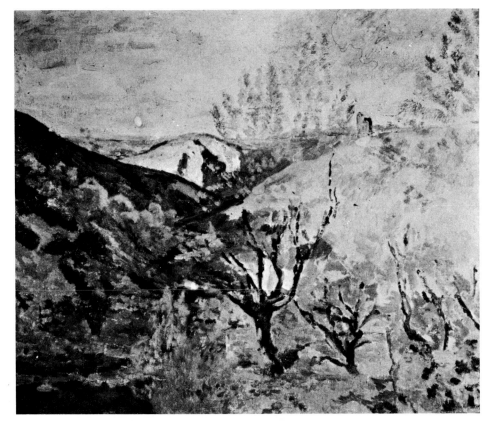

Pl. 203 *Rocher de la Fileuse*, 1915–1918

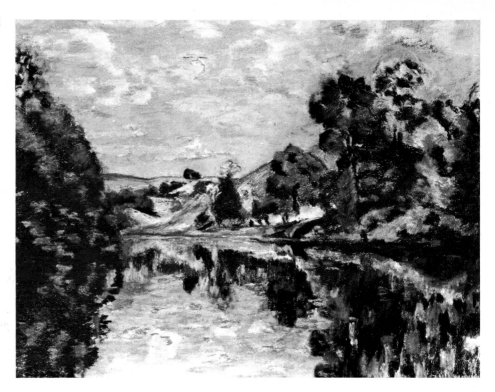

Pl. 204 *Bords de la Creuse*, c. 1916

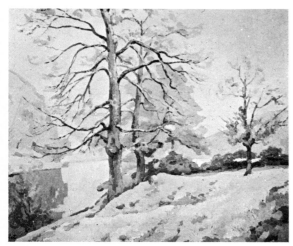

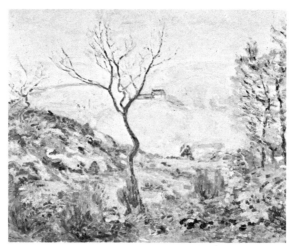

Pl. 205 Painting by Clémentine Ballot,
    *Rocher de l'Echo*, December 1916

Pl. 206 *Pont Charraud*, c. 1916

Pl. 207 *Pont Charraud*, c. 1916

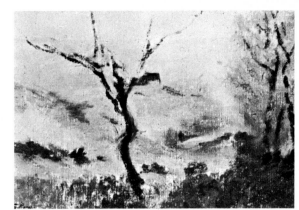

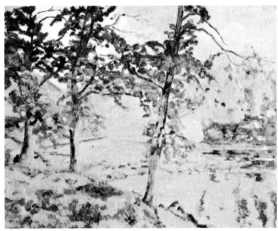

Pl. 208 *Le barrage à Génetin*, c. 1916

Pl. 209 *Rocher de l'Echo*, November 1917

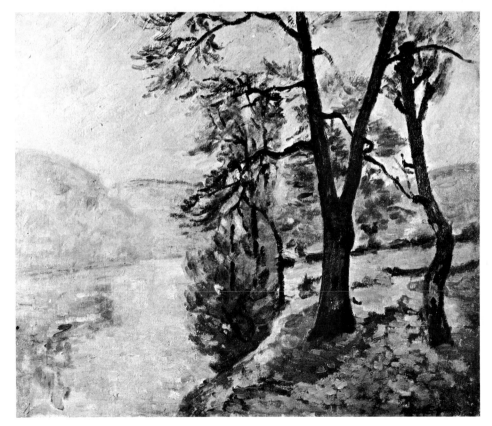

Pl. 210 *Pont Charraud*, c. 1918

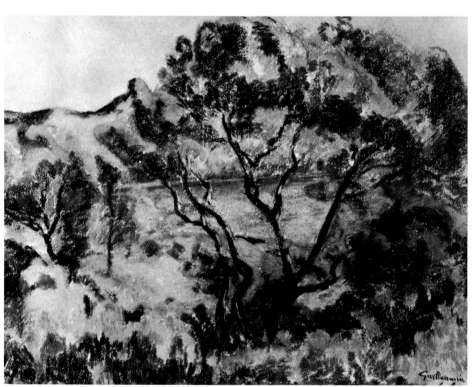

Pl. 211 *Agay*, 1919

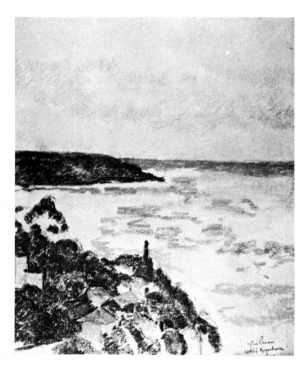

Pl. 212 *Cabbe - Roquebrune*, 1920

Pl. 213 *La Creuse à Génetin*, c. 1920

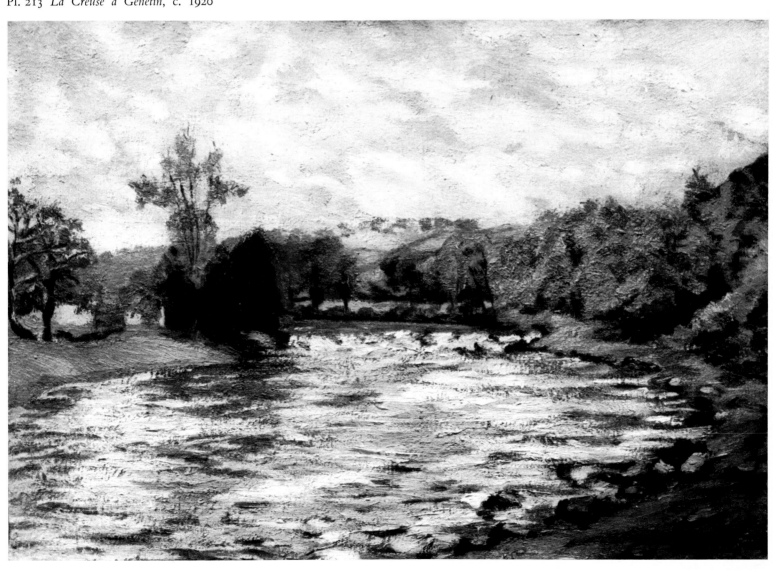

Pl. 214 *Paysage de la Creuse*, c. 1920

Pl. 215 *Rocher de l'Echo*, September 1921

Pl. 216 *Rocher de l'Echo*, 1921

Pl. 217 *Rocher de l'Echo*, c. 1921

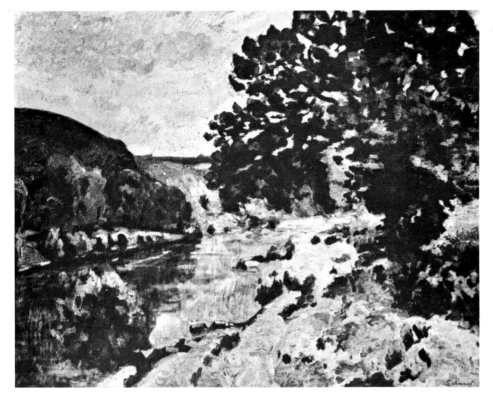

Pl. 218 *Rocher de l'Echo*, c. 1921

Pl. 219 *Agay - L'entrée de la rade prise de la villa des Falaises*, 1922

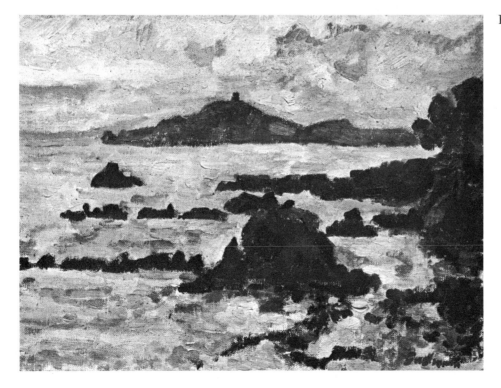

Pl. 220 *Vue de la baie d'Agay*, c. 1922

Pl. 221 *Agay – le matin*, February 1922

Pl. 222 *Valley of the Sédelle*, c. 1922

Pl. 224 *Le Rocher de l'Echo,*
c. 1922

Pl. 223 *Crozant,* May 1922 (?)

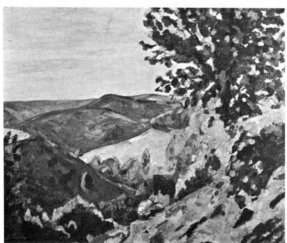

Pl. 225 *Puy Bariou,* July 1922

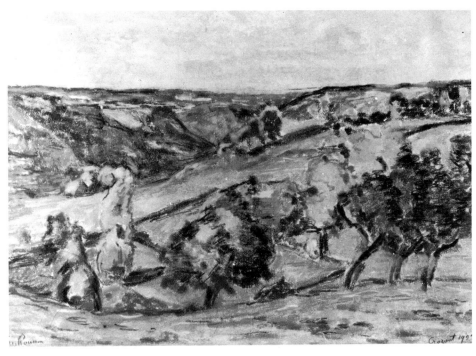

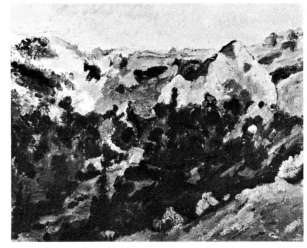

Pl. 226 *Puy Bariou*, November 1922

Pl. 227 *Le plateau de la Creuse*, 1922 (?)

Pl. 228 *Agay*, March 1923

*Books*

Baudelaire, Charles. *Œuvres complètes*. Paris, 1961.

Bergson, Henri. *Creative Evolution*, translated by Arthur Mitchell. New York, 1944.

Castagnary, J. A. *Salons*. Paris, 1892.

Cogniat, Raymond. *Louis Valtat*. Neuchâtel, Switzerland, 1963.

Des Courières, Edouard. *Armand Guillaumin*. Paris, 1926.

Dewhurst, Wynford. *Impressionist Painting, its Genesis and Development*. London, 1904.

Dorra, Henri, and Rewald, John. *Seurat*. Paris, 1959.

Duret, Théodore. *Critique d'avant-garde*. "Les Peintres Impressionnistes." Paris, 1885.

Fénéon, Félix. *Œuvres complètes*. "Les Impressionnistes en 1886." Paris, 1948.

Focillon, Henri. *La Peinture aux XIX^e et XX^e siècles*. Paris, 1928.

Fontainas, André. *Histoire de la peinture française aux XIX^e et XX^e siècles*. Paris, 1922.

Friedlaender, Walter F. *David to Delacroix*. Translated by Robert J. Goldwater. Cambridge, Mass., 1952.

Gachet, Paul. *Lettres impressionnistes au Dr. Gachet et à Murer*. Paris, 1957.

Gauguin, Paul. *Lettres à sa femme et à ses amis*. Edited by Maurice Malingue, Paris, 1946.

Gauthier, Maximilien. *Clémentine Ballot*. Paris, 1956.

Gilpin, William. *An Essay on Prints*. London, 1768.

Gogh, Vincent van. *Complete Letters*. 3 vols. Greenwich, Conn., 1958.

Herbert, R. L. *Barbizon Revisited*. New York, 1962.

Hume, David. *A Treatise of Human Nature*. Edited by L. A. Selby-Bigge. Oxford, 1958.

Hussey, Christopher. *The Picturesque: Studies in a Point of View*. Hamden, Conn., 1967.

Huyghe, René. *Delacroix*. New York, 1963.

Huysmans, Joris-Karl. *L'Art Moderne*. "L'Exposition des Indépendants." Paris, 1902.

Jourdain, Francis, and Rey, Robert. *Le Salon d'Automne*. Paris, 1926.

Knight, Richard Payne. *An Analytical Inquiry into the Principles of Taste*. 2d Edition. London, 1805.

Lecomte, Georges. *Guillaumin*. Paris, 1926.

Mack, Gerstle. *Gustave Courbet*. New York, 1951.

Mack, Gerstle. *Paul Cézanne*. New York, 1935.

Mallarmé, Stéphane. *Propos sur la poésie*. Monaco, 1946.

Mallarmé, Stéphane. *Vers et prose*. Paris, 1893.

Moore, George. *Confessions of a Young Man*. London, 1888.

Moreau-Nélaton, Etienne. *Daubigny raconté par lui-même*. Paris, 1910.

Perruchot, Henri. *La Vie de Cézanne*. Paris, 1961.

Perruchot, Henri. *La Vie de Gauguin*. Paris, 1961.

Pissarro, Camille. *Letters to Lucien*. Edited by John Rewald. New York, 1943.

Rewald, John. *Camille Pissarro*. New York, 1963.

Rewald, John. *Paul Cézanne*. Translated by Margaret A. Liebman. New York, 1948.

Rewald, John. *History of Impressionism*. 2d Edition. New York, 1961.

Rewald, John. *Post-Impressionism*. 2d Edition. New York, 1962.

Rey, Robert. *La Renaissance du sentiment classique dans la peinture française . . .* Paris, 1931.

Ribot, Th[éodule]. *La Philosophie de Schopenhauer*. 7th Edition. Paris, 1898. (1st Edition, 1874).

Rosca, D. D. *L'Influence de Hegel sur Taine, théoricien de la connaissance et de l'art*. Paris, 1928.

Schopenhauer, Arthur. *The World as Will and Idea*. Translated by R. B. Haldane and J. Kemp. London, 1883.

Sérullaz, Maurice. *The Impressionist Painters*. Translated by W. J. Strachan. New York, 1960.

Sérusier, Paul. *ABC de la Peinture*. Paris, 1942.

Taillandier, Yvon. *Claude Monet*. [Paris, 1963?]

Venturi, Lionello, *Les Archives de l'impressionnisme*. 2 vols. Paris, New York, 1939.

Venturi, Lionello. *Cézanne, son art, son œuvre*. 2 vols. Paris, 1936.

Villiers de l'Isle-Adam. *Axel*. Translated by W. B. Yeats. London, 1925.

Windelband, Wilhelm. *A History of Philosophy*. Authorized translation by James H. Tufts. Revised edition. New York, 1901.

*Periodicals*

Borgmeyer, C. L. "Armand Guillaumin," *Fine Arts Journal*, February 1914, pp. 50-75.

Dewhurst, Wynford. "Peinture impressionniste," *International Studio*, July 15, 1903.

*Messager de l'Assemblée*. March 7, 8, 11, 12, 1851.

Mirbeau, Octave. "Vincent van Gogh," *Echo de Paris*, March 31, reprinted in Mirbeau, *Des Artistes*, Paris, 1922.

Rivière, Georges. "Armand Guillaumin," *L'Art vivant*, July 15, 1927.

Tabarant, Adolphe. "Les Quatre-vingt ans de Guillaumin," *Bulletin de la vie artistique*, February 15, 1921.

Zola, Emile. "Le Naturalisme au Salon," *Le Voltaire*, June 19, 1880.

*Exhibition Catalogues*

Alexandre, Arsène. Preface to *Exposition Armand Guillaumin*, Galleries Durand-Ruel, Paris, 1894.

Bazin, Germain. Preface to *Van Gogh et les peintres d'Auvers sur Oise*, Musée de l'Orangerie. Paris, 1954.

The arrangement of material is as follows: *1. title and date; 2. material and dimensions (height × width); 3. signature; 4. inscription; 5. photograph credit; 6. collection, latest last; 7. figure or plate number; 8. notes.*

1. Landscape at Ivry, 1865
   Pencil sketch, approx. 32×48 cm
   Signed: Guillaumin '65
   Photographed by author
   Formerly Mlle Marguerite Guillaumin
   Fig. 1

2. Barges on the Seine, 1865
   Pastel, 32×65 cm
   Signed: Guillaumin '65
   Photographed by Bulloz
   Musée de la ville de Paris No. 1465
   Fig. 2

3. La Soupière or Marmite, 1867
   Heliogravure reworked with roulette,
     44½×55 cm
   Signed: A. Guillaumin/67
   Reproduced from Des Courières,
     *Guillaumin*, p. 47
   M. Eugène Blot
   Fig. 3

4. Landscape sketch, 1867
   Pencil sketch, approx. 36×46 cm
   Signed: Guillaumin '67
   Photographed by author
   Formerly Mlle M. Guillaumin
   Fig. 4

5. Horse, 1867
   Pencil sketch, approx. 32×48 cm
   Signed: Guillaumin '67
   Photographed by author
   Formerly Mlle M. Guillaumin
   Fig. 5

6. Quai de Béthune, 1868
   Pastel, 21×30 cm
   Signed: Guillaumin '68
   Photographed by Bulloz No. 70867
   Musée de la ville de Paris
   Fig. 8

7. Pissarro painting a blind, c. 1868
   Oil, 45×37 cm
   Photograph from Lecomte
   Fig. 6
   Ref.: Lecomte: Plate I

8. Péniches, 1868
   Pastel, 36×46 cm
   Signed: Guillaumin '68
   Photographed by author
   Mme M. Lacotte, Paris
   Fig. 7

9. Sketch, 1868
   Charcoal, 32×48 cm
   Signed: Guillaumin '68
   Photographed by author
   Formerly Mlle M. Guillaumin
   Fig. 9

10. Cribleurs du sable, c. 1869
    Charcoal, approx. 32×48 cm
    Signed: Guillaumin '69 (?)
    Photographed by author
    Formerly Mlle M. Guillaumin
    Pl. 54

11. La Bièvre, 1869
    Pastel
    Signed: Guillaumin 69/La Bievre
    Photographed by Bulloz
    Musée de la ville de Paris No. D 1400
    Fig. 14

12. Soleil couchant à Ivry, c. 1869
    Oil on canvas, 65×81 cm
    Signed: A. Guillaumin
    Photographed by author
    Dr. Paul Gachet, Auvers
    Jeu de Paume No. 165
    Gift of Paul Gachet, Auvers, 1951
    Fig. 10

13. Ivry, 1869
    Pencil on cross-section paper
    Signed: Guillaumin 69
    Photographed by Bulloz
    Musée de la ville de Paris No. D 1390
    Pl. 55
    This appears to be a preparatory study for
    *Soleil couchant à Ivry* (Cat. No. 12).

14. Chemin creux, effet de neige, 1869
    Oil on canvas, 66×55 cm
    Signed: A. Guillaumin 69

Photographed by author
Dr. Paul Gachet, Auvers
Gift to Jeu de Paume No. 163, 1954
Fig. 11

15. Bords de la Seine, 1869
Black crayon, 32×48 cm
Signed: Guillaumin 69
Photographed by Bulloz No. 70866
Musée de la ville de Paris No. D 1441
Fig. 12

16. Bords de la Seine, 1869
Black crayon, 32×48 cm
Signed: Guillaumin 69
Photographed by Bulloz No. 70864
Musée de la ville de Paris No. D 1433
Fig. 13

17. Drawing of artist's mother, 1870
Charcoal, approx. 32×48 cm
Signed: Guillaumin 70
Photographed by author
Formerly Mlle M. Guillaumin
Fig. 15

18. Drawing of artist's mother, 1870
Charcoal
Signed: Guillaumin 70
Photographed by Bulloz
Musée de la ville de Paris No. D 1389
Fig. 16

19. Drawing of artist's father, 1870
Pencil
Signed: Guillaumin 70/Siège de Paris
Photographed by author
Formerly Mlle M. Guillaumin
Fig. 17

20. Drawing of artist's father, 1870
Charcoal
Signed: Guillaumin '70/Siège de Paris
Photographed by Bulloz
Musée de la ville de Paris No. D 1388
Fig. 18

21. Portrait of Mlle Marie-Joséphine Gareton, 1871
Oil on canvas, 55×46 cm
Signed: monogram AG in upper left corner
Photographed by author
Formerly Mlle M. Guillaumin
Fig. 19 B
Also preliminary sketch in oil, Fig. 19 A

22. Sketch of reclining woman, 1871
Pencil, approx. 32×48 cm
Signed: Guillaumin 71
Photographed by author
Formerly Mlle M. Guillaumin
Pl. 56
Mlle Guillaumin thought that this might be a drawing of her mother's mother. Her mother was only thirteen years old in 1871.

23. Place Valhubert, c. 1871
Oil on canvas, 65×81 cm
Signed: A. Guillaumin
Photographed by Archives Photographiques No. BAP 324
Gift of Antonin Personnaz to Musée du Louvre, Paris
Fig. 21

24. La Seine à Paris (Quai de la Râpée), 1871
Oil on canvas, 1 m 26×1 m 80
Signed: A. Guillaumin 71
Photographed by Jay Oistad No. 1324
Mr. John Beck, Houston, Texas
Pl. 1

25. Péniches sur la Seine à Bercy, 1871
Oil on canvas, 51×73 cm
Signed: A. Guillaumin '71
Photographed by Bulloz
Jeu de Paume No. 164
Gift of Dr. Paul Gachet, 1954
Fig. 20

26. Vallée de Chevreuse, 1872
Pastel
Signed: G 72 (l.l.); Guillaumin (l.r.)
Photographed by Bulloz
Pl. 57
This pastel is evidently a study for the painting entitled Vallée de Chevreuse (Cat. No. 27).

27. Vallée de Chevreuse: Automne, c. 1872
Oil on canvas, 73×60 cm
Signed: A. Guillaumin
Photographed by Arthur Tooth and Son, London, No. 342236
Pl. 58
Another version of this picture has two figures instead of one in the middle ground. In a number of cases Guillaumin painted almost identical versions of pictures, and in many cases the major variation is in the

number of figures. One suspects that possibly the number of figures indicates the order in the series.

This picture is apparently based on a pastel study dated 1872 (Cat. No. 26).

28. Self portrait, 1872
Pastel, 37×30 cm
Signed: Guillaumin 72
Photographed by author
Formerly Mlle M. Guillaumin
Frontice

29. Portrait of the artist, c. 1872
Pastel, 46×38 cm
Signed: Guillaumin
Photographed by author
Mr. Blume, New York
Pl. 59

30. Self portrait, c. 1872
Oil on canvas, 46×36 cm
Signed: Guillaumin
Photographed by Maxwell Galleries, San Francisco, No. 7850
M. Oscar Solzer
Pl. 60
Cover piece portrait for Des Courières, Guillaumin

31. Self portrait, c. 1872
Oil on canvas, 43×37 cm
Signed: Guillaumin
Photographed by Hayashi Sale Catalogue, 1913
Pl. 61

32. Nature morte, 1872
Oil on canvas, 32.5×46 cm
Signed: A. Guillaumin 72
Photographed by author
Jeu de Paume No. 165
Gift of Paul Gachet, 1954
Fig. 22

33. Le Chemin des Hautes-Bruyères, 1873
Etching, 7.1×10.5 cm
Signed: monogram A.G.
Photographed by Bibliothèque Nationale No. 64 A 13671
Bibliothèque Nationale, Paris
Fig. 23

34. Proof sheet from a plate with two scenes, c. 1873

A. Scene along the quais in Paris, 15 × 15 cm
Signed: Guillaumin etched on plate in lower right corner. Cat in upper left corner. Also signed Guillaumin in pencil on border below signature on plate.
B. Landscape, 10.7 × 15 cm
Signed: monogram AG (reversed) in upper right corner. Signed Guillaumin in pencil on border below lower right corner of the etching.
Etching
Photographed by Bibliothèque Nationale No. 64 C 24253
Bibliothèque Nationale, Paris
Pl. 62

35. Proof sheet from a plate with four etchings, 1873
A. La ruelle Barrault, 9.3 × 17.5 cm
Signed: Guillaumin
Inscription: La ruelle Barrault
B. Chemin des Hautes-Bruyères, 7.3 × 10.3 cm
Signed: monogram AG
Inscription: Chemin des Hautes-Bruyères
C. Bicêtre et chemin des barons, 9.8 × 17.5 cm
Signed: Guillaumin
Inscription: Bicêtre & chemin des barons
D. Unidentified, 7.2 × 10 cm
Signed: monogram AG
Etching
Signed: Guillaumin in brown crayon, each etching signed on the plate
Photographed by Bibliothèque Nationale No. 64 C 24252
Bibliothèque Nationale, Paris, Collection Curtius No. 1672
Pl. 63

36. Charonton: les rameurs, 1873
Etching, 5.3 × 7.5 cm
Unsigned
Photographed by Bibliothèque Nationale No. 64 A 13670
Bibliothèque Nationale, Paris
Pl. 64

37. Le rameur, c. 1873
Pencil, approx. 32 × 48 cm
Unsigned
Photographed by author
Formerly Mlle M. Guillaumin

Pl. 65
This drawing apparently served as a basis for Guillaumin's etching *Charonton, les rameurs*, which he executed about 1873. The etching is, of course, reversed.

38. Les forges à Ivry, 1873
Oil on canvas, 60 × 100 cm
Signed: 73 A Guillaumin
Photographed by Durand-Ruel No. 10030
A. Caressa, Paris
Pl. 66
There is a smaller version of this picture (33 × 46 cm) which was offered at auction at the Galeries Charpentier, Paris, June 16, 1955 (No. 102).

39. Chemin creux aux Hautes-Bruyères, c. 1873
Etching, 13 × 9.5 cm
Signed: monogram AG
Inscription: Au docteeur (sic) Gachet
Photographed by Bibliothèque Nationale No. 64 C 24255
Bibliothèque Nationale, Paris
Pl. 67
The cat in the upper left corner was apparently used by Guillaumin as a form of signature. It appears on a number of etchings.

40. La sablière sur la Seine, c. 1873
Oil on canvas, 87.2 × 118 cm
Signed: Guillaumin
Photographed by Galleries Maurice Sternberg
Maurice Sternberg, Chicago, sold to private collector
Pl. 68
Mr. Maurice Sternberg dates this 1873.

41. Quai de Bercy - effet de neige, c. 1874
Oil on canvas, 50.5 × 61.2 cm
Signed: A Guillaumin
Photographed by author
Louvre Cat. No. 1041, Gift of A. Personnaz
Pl. 2

42. Quai de Bercy sous la neige, 1870s
Oil on canvas
Signed: Guillaumin
Photographed by Versailles No. 2767
Pl. 69

43. Bord de la Marne, c. 1874
Oil on canvas, 59 × 72 cm

Signed: A Guillaumin
Photographed by Versailles No. 40271*
Pl. 70
Parke-Bernet sale April 3, 1964, No. 103.
* Photographs credited to Versailles are included in the Musées Nationaux Photographs.

44. La péniche, 1874
Pastel, 40 × 51 cm
Signed: Guillaumin 74
Photographed by Modern Art Foundation
Mr. Maurice Sternberg, Chicago
Pl. 3

45. Viaduc de Fleury, April 1874
Oil on canvas, 50 × 64 cm
Signed: A. Guillaumin/4-7
Photographed by Galeries Serret-Fauveau, Paris
Fig. 24

46. Self portrait, c. 1875 (1870, according to the Louvre)
Oil on canvas, 73 × 60 cm
Unsigned
Photographed by author
Musée de Jeu de Paume No. 169. Gift of Mlle M. Gachet and M. Paul Gachet, 1949
Pl. 4
Des Courières, No. 206.

47. Le Pont Louis-Philippe, 1875
Oil on canvas, 46 × 60 cm
Signed: A Guillaumin 75
Reproduced from Rewald, *History of Impressionism*, p. 391
Chester Dale Collection, loaned to National Gallery, Washington, D.C.
Pl. 71

48. Vallée de la Châtillon sur Bagneux, c. 1875
Oil on canvas, 72 × 59 cm
Signed: A. Guillaumin
Inscription: on back of canvas, Vallée de la Châtillon sur Bagneux
Photographed by Galeries Serret-Fauveau
Galeries Serret-Fauveau, Paris
Fig. 26

49. Femme couchée, c. 1876
Oil on canvas, 49 × 65 cm
Signed: A. Guillaumin

Photographed by author
Musée de Jeu de Paume, Paris, No. 167
Gift of Paul Gachet, 1951
Fig. 25, Pl. 5 (See page 33)

50. Paysage, 1876
Oil on canvas, 55×46 cm
Signed: A Guillaumin
Photographed by Durand-Ruel
    No. Ph A 1387
Formerly in the collection of Mr. Kelekian,
    New York
Pl. 72

51. Issy-les-Moulineaux: le parc, 1877
Oil on canvas, 46×55 cm
Signed: A. Guillaumin 77
Inscription: A mon ami Personnaz
Photographed by author
Musée Bonnat, Bayonne, No. 14
Gift of A. Personnaz
Fig. 27

52. Paysage de la Plaine, c. 1877
Oil on canvas, 54×65.5 cm
Signed: A. Guillaumin
Photographed by author
Musée du Louvre, Paris, Cat. No. 1042
Gift of A. Personnaz
Fig. 28

53. La Seine à Charonton, 1878
Oil on canvas, 61×100 cm
Signed: A. Guillaumin 78
Photographed by Archives
    Photographiques No. BAP 321
Musée du Louvre, Paris, Cat. No. 1035
Gift of A. Personnaz
Pl. 73
This picture is not listed in Des Courières as
one among those in the Personnaz Col-
lection, though it is reproduced opposite
page 25. It is also reproduced in Rewald,
*History of Impressionism*, p. 356.

54. La charrette, c. 1878
Oil on canvas, 50×61 cm
Signed: A. Guillaumin
Photographed by Arthur Tooth and Son,
    London, No. 285360
Pl. 74
In a letter to his friend Eugène Murer, Guil-
laumin mentions a picture: " Une carrière
dans le parc d'Issy avec Paris au fond (10F). "

55. Robinson, c. 1878
Oil on canvas, 50×61 cm
Signed: Guillaumin
Photographed by Galeries Serret-Fauveau,
    Paris, 1957
Pl. 75

56. Pissarro's friend Martinez in Guillaumin's
    studio, 1878
Oil on canvas, 90×71 cm
Signed: A. Guillaumin 78
Reproduced from Rewald, *History of
    Impressionism*, p. 427
Mr. Hugo Perls, New York
Ailsa Mellon Bruce
Fig. 30

57. Self portrait, 1878
Oil on canvas, 60×50 cm
Reproduced from Rewald, *History of
    Impressionism*, p. 363
Mr. V. W. van Gogh, Laren
Fig. 29

58. Le Pont des Arts, c. 1878
Oil on canvas, 44×73 cm
Signed: A Guillaumin
Photographed by author
M. Nat Leeb, Paris
Pl. 6
The heavy impasto pigment seems to be
found toward the end of the seventies and
in the early years of the eighties.

59. Portrait of a young girl, 1879
Pastel, 38×30 cm
Signed: A Guillaumin 79
Photographed by Schweitzer Gallery,
    New York
Pl. 76
Ref.: Catalogue of the Hayashi Sale,
    New York, 1913 (ill.). Borgmeyer, C.L.,
    *The Master Impressionists*, p. 140 (ill.).
From the catalogues of the Impressionist ex-
hibitions it is known that Guillaumin ex-
ecuted a fairly large number of pastel por-
traits in the late seventies and early eighties.

60. Portrait of a young man, 1879
Pastel, 46×30.5 cm
Signed: A Guillaumin 79
Photographed by Ordrupgaard
    Sammlingen, Denmark
Ordrupgaard Sammlingen, Ordrup,
    Denmark, No. 61

Pl. 77
The suit and hat are blue-black. The back-
ground is green with orange flowers just
above eye level.

61. Quai de la Râpée, c. 1879
Oil on canvas
Signed: Guillaumin
Photographed by Versailles, No. 3854
Pl. 78
The signature is of an unusual form, occur-
ing on very few pictures.

62. Les Quais de la Seine, 1879
Oil on canvas, 69×93 cm
Signed: Guillaumin
Photographed by author
Galeries Serret-Fauveau, Paris
Pl. 7

63. Allée des Capucines, 1880
Oil on canvas, 79.5×63.5 cm
Signed: A. Guillaumin
Inscription: (on the stretchers) Paris, 1880
Photographed by Ny Carlsberg Museum
Ny Carlsberg Museum, Copenhagen,
    No. 915
Pl. 79

64. Tas de sable au bord de la Seine, 1880
Pastel, 33×47 cm
Signed: Guillaumin 80
Photographed by Bulloz
Musée de la ville de Paris
Pl. 80

65. Cribleur du sable, 1880
Charcoal and pastel, approx. 32×48 cm
Signed: Guillaumin 80
Photographed by author
Formerly Mlle M. Guillaumin
Fig. 32

66. Cribleur du sable, 1880
Charcoal and pastel, 29.5×35.5 cm
Signed: Guill.
Inscription: Cribbleur du sable
Photographed by author
Dr. Oscar Ghez, Modern Art Foundation,
    Geneva
Fig. 31

67. Cribleur du sable, c. 1880
Pastel, 47×40 cm

Signed: Guillaumin
Photographed by Bulloz No. 70.868
Musée de la ville de Paris, No. P.P.D. 1446
Gift of the artist
Pl. 81

68. Cribleurs du sable, 1880
Charcoal
Signed: Guillaumin
Photographed by author
Formerly Mlle M. Guillaumin
Fig. 33

69. Cribleurs du sable, c. 1880
Pastel
Signed: Guillaumin
Photographed by author
Formerly Mlle M. Guillaumin
Fig. 34

70. Cribleurs du sable, c. 1880
Charcoal drawing with gouache,
47×60.5 cm
Signed: Guillaumin
Photographed by author
Dr. Oscar Ghez, Modern Art Foundation,
Geneva
Fig. 35

71. Quai de Bercy, c. 1881
Oil on canvas, 55×71 cm
Signed: Guillaumin (l.r. in black)
Guillaumin (l.l. in red)
Photographed by Modern Art Foundation
Dr. Oscar Ghez, Modern Art Foundation,
Geneva, No. 8254
Pl. 8
The heavy dry impasto of the picture with
the small brushstrokes is unique in the work
of Guillaumin, as is the double signature.
The closest parallel is the *View of the Pont
des Arts* in the collection of M. Nat Leeb
(Cat. No. 58).
Note the similarity between this paint-
ing and that of Seurat five years later, *La
Grande Jatte*.

72. Vue de l'Ile Saint-Louis, c. 1881
Oil on ungrounded canvas, 79.5×45 cm
Signed: monogram
Photographed by Ny Carlsberg Museum
Ny Carlsberg Museum, Copenhagen,
Denmark, No. 916
Fig. 36

73. Le chemin de Damiette, 1882
Oil on canvas, 60×73 cm
Signed: Guillaumin 82
Photographed by Galeries Serret-Fauveau,
Paris
Pl. 82

74. Chaumières, c. 1882
Oil on canvas, 55×65 cm
Signed: Guillaumin
Inscription: A l'ami Portier (beneath the
signature)
Photographed by Arthur Tooth and Son,
London, A.C. Cooper
M. Alex Maguy
Pl. 9
Portier, to whom this picture was dedicated,
was a broker in painting, who sometimes
bought from Pissarro and his circle. The
style of the signature is that of 1882.

75. Ouvriers dormants dans l'ombre d'une
charrette, 1882
Signed: Guillaumin 82
Photographed by author
Exhibited: Galeries Serret-Fauveau,
Paris, 1954
Pl. 83
I know this picture only from a lithographic
reproduction. M. Serret states that the work
he exhibited was a watercolor. Mlle Guil-
laumin stated that it was a gouache. Yet
Guillaumin said that he only executed one
picture in a water medium (Des Courières,
p. 78).

76. Les coteaux, c. 1882
Oil on canvas, 50×60 cm
Signed: Guillaumin
Photograhed by Versailles No. 2554
Sold: Galeries Georges Petit, Paris,
May 30, 1927, No. 446
Pl. 84

77. The Seine near Charonton, c. 1882
Oil on canvas, 65×80.5 cm
Signed: Guillaumin
Photographed by Ordrupgaard
Sammlingen, Denmark
Ordrupgaard Sammlingen, Ordrup,
Denmark, No. 59
Pl. 85

78. Quai Henri IV, c. 1882
Oil on canvas, 54×65 cm

Signed: Guillaumin
Photographed by Ordrupgaard
Sammlingen, Denmark
Ordrupgaard Sammlingen, Ordrup,
Denmark, No. 60
Ancien coll. Viau
Pl. 86

79. Les charrois au bord de la Seine, 1882
Pastel, 48×63 cm
Signed: G
Photographed by Modern Art Foundation
Dr. Oscar Ghez, Modern Art Foundation,
Geneva, No. 9858
Pl. 87

80. Jardin et vieilles maisons, c. 1882
Oil on canvas, 58.5×72 cm
Photographed by Ny Carlsberg Museum
Ny Carlsberg Museum, Copenhagen,
Denmark, No. 917
Pl. 88

81. Le Pont National, c. 1883
Oil on canvas, 50.5×61.5 cm
Signed: Guillaumin
Photographed by Durand-Ruel No. 10043
Pl. 89
Ref.: *Impressionists & Their World* by
Basil Taylor, Phoenix House, London,
1953
There is an almost identical painting by Cé-
zanne, *The Seine near Bercy*, 1873-1875. It
is reproduced (Plate 90) from *Impressionists
& Their World* by Basil Taylor, plate 53.

82. Pont-Marie from the Quai d'Anjou, 1883
Oil on canvas, 48×66 cm
Signed: Guillaumin
Photographed by Modern Art Foundation
Dr. Oscar Ghez, Modern Art Foundation,
Geneva, No. 9643
Pl. 10
The locale of the scene is the Quai d'Anjou,
in front of Guillaumin's studio at number 13.

83. Damiette, 1882-1884
Oil on canvas, 74×100 cm
Signed: Guillaumin
Photographed by Arthur Tooth and Son,
London, No. 1989 D I
Pl. 91

84. Pommes et cruchon, c. 1884
Oil on canvas, 34×42 cm

Signed: Guillaumin
Photographed by Galeries Serret-Fauveau,
　Paris
Pl. 92
Des Courières, No. 484, mentions a still life,
*Pommes et cruchon*, 34×42 cm, in the col-
lection of M. Semenoff in Paris.
　　The *cruchon* is the same as that in *Vue de
l'Ile Saint-Louis* (Cat. No. 72).

85. Damiette, September 1884
　　Pastel, 50×65 cm
　　Signed: Guillaumin
　　Inscription: Damiette 7bre 84
　　Photographed by Hammer Galleries,
　　　N. Y. City
　　Sold by Trosby Galleries, Palm Beach,
　　　Florida, Feb. 1969, to Mr. Jacques
　　　Garvin, N. Y. City
　　Pl. 93

86. Damiette - les pommiers, c. 1884
　　Oil on canvas, 60×100 cm
　　Signed: Guillaumin
　　Photographed by Archives Photographiques
　　　No. BAP 317
　　Musée du Louvre, Paris, Cat. No. 1043
　　Gift of A. Personnaz
　　Pl. 94

87. Après la pluie, c. 1885
　　Oil on canvas, 50×73 cm
　　Signed: Guillaumin
　　Photographed by author
　　Musée du Louvre, Paris, Cat. No. 1040
　　Gift of A. Personnaz
　　Pl. 11

88. Cottage at Damiette, c. 1883-1885
　　Oil on canvas, 46×55 cm
　　Signed: Guillaumin
　　Photographed by author
　　Galeries Serret-Fauveau, Paris
　　Pl. 12

89. Crépuscule à Damiette, 1885
　　Oil on canvas, 72×139 cm
　　Signed: Guillaumin 85
　　Photographed by Modern Art Foundation
　　Dr. Oscar Ghez, Modern Art Foundation,
　　　Geneva
　　Pl. 13

90. Le chemin vers la vallée, 1885
　　Oil on canvas, 113×85 cm

Signed: Guillaumin 85
Photographed by Bulloz
Musée de la ville de Paris, Inv. 587
Fig. 37

91. Les pêcheurs, 1885
　　Oil on canvas, 81×66 cm
　　Signed: Guillaumin 85
　　Photographed by Archives Photographiques
　　　No. BAP 346
　　Musée du Louvre, Paris, Cat. No. 1037
　　Gift of A. Personnaz
　　Pl. 14 (See page 33)
　　Ref.: Des Courières No. 393. Des Courières
　　　gives the date of 1883, but the date on
　　　the canvas seems to be 85.

92. Vase de coquelicots, c. 1885
　　Oil on canvas, 61×50 cm
　　Signed: Guillaumin
　　Photograph courtesy of M. Nat Leeb
　　M. Nat Leeb, Paris
　　Pl. 95

93. Vase de chrysanthèmes, 1885
　　Oil on canvas, 60×73 cm
　　Signed: Guillaumin
　　Photographed by Raymond Asseo, Geneva
　　Dr. Oscar Ghez, Modern Art Foundation,
　　　Geneva
　　Fig. 38

94. Bords de la Marne, 1885
　　Oil on canvas, 50×61 cm
　　Signed: Guillaumin
　　Photographed by Durand-Ruel No. 11604
　　Pl. 96

95. Quai de Bercy, 1885
　　Oil on canvas, 60×92 cm
　　Signed: Guillaumin 85
　　Photographed by Ordrupgaard
　　　Sammlingen, Denmark
　　Ordrupgaard Sammlingen, Ordrup,
　　　Denmark, No. 62
　　Pl. 97

96. Baignade de cheval. Quai de Bercy, c. 1885
　　Charcoal on paper, approx. 32×48 cm
　　Signed: Guillaumin
　　Photographed by author
　　Formerly Mlle M. Guillaumin
　　Pl. 98

97. Le Quai de Bercy, c. 1885
　　Pastel
　　Signed: Guillaumin
　　Photograph from Lecomte, Plate VII
　　Lecomte, *Guillaumin*, 7th plate, shows the
　　completed picture for which Cat. No. 96
　　is apparently a preliminary study. Lecomte
　　dates the picture " vers 1885 ".
　　　A pastel of the same scene was offered at
　　auction at the Palais Galliera, Paris, on June
　　22, 1962: " No. 11 - Les berges de la Seine
　　au Quai de Bercy. Pastel signé et daté 85
　　en bas à droit 50×64 (*voir la reproduction*)."
　　Pl. 99

98. Petits voleurs de charbon, c. 1885
　　Oil on canvas, 73×92 cm
　　Signed: Guillaumin
　　Photographed by author
　　Dr. Oscar Ghez, Modern Art Foundation,
　　　Geneva, No. 8926
　　Pl. 100
　　Des Courières No. 177 " *Les petits voleurs de
　　charbon sur les berges de la Seine* - 30F. Galerie
　　Danthon, Paris ", Des Courières No. 177 is
　　listed as 30F - 73×92 cm, the same size
　　as the present picture. It is probably the
　　same.
　　　The style suggests the date of 1885.

99. Damiette, 1886
　　Pastel, 27×43 cm
　　Signed: G
　　Inscription: Damiette 86
　　Photographed by author
　　Dr. Oscar Ghez, Modern Art Foundation,
　　　Geneva, No. 1150
　　Pl. 101

100. Femmes pêchant, c. 1886
　　Pastel, Easel B
　　Signed: Guillaumin
　　Inscription: A E. Bernard (above signature)
　　Photographed by Versailles No. 44237
　　Pl. 102
　　Guillaumin probably met Emile Bernard
　　about 1886. In 1885 Guillaumin painted the
　　fishing scene in the Louvre (Cat. No. 91).
　　This may have been done at about the same
　　time.

101. Cour à Janville, August 1887
　　Oil on canvas, 65×82 cm
　　Signed: Guillaumin

Photographed by Durand-Ruel No. 12294
Hazard
Pl. 103
Ref.: Vente Hazard, Galeries Georges Petit,
Paris, 1, 2, 3, December 1919. No. 115.
This is one of the few paintings which can
be specifically dated in 1887.

102. Vallée de Chevreuse, c. 1887
Oil on canvas, 66 × 121 cm
Signed: Guillaumin
Photographed by Schweitzer Gallery,
New York
Mme E. Blot
Pl. 104
Ref.: Vente Charpentier, Paris, 11, 12,
June 1959. No. 42.
There are two versions of this picture, dif-
fering slightly in proportions and size. Ac-
cording to Mr. M. R. Schweitzer, this ver-
sion was offered by the artist to Mme Blot.
(Cf. Des Courières No. 86)

103. Sand Hopper, Quai de Bercy, c. 1887
Pastel, 45 × 63 cm
Signed: Guillaumin
Photographed by author
Mme Lacotte, Paris
Pl. 105
Another series of studies of the sand hopper
on the Quai de Bercy.

104. Sand Hopper, Quai de Bercy, December
1887
Pastel, 65 × 100 cm
Signed: Guillaumin 12 - 87
Photographed by author
Galeries Serret-Fauveau, Paris
Pl. 15
This unusually meticulously worked out
pastel, dated in December 1887, seems to
be the final version of the sand hopper
studies.

105. Femme lisant dans un jardin, c. 1888
Pastel, 46.5 × 30 cm
Signed: Guillaumin
Photographed by Ny Carlsberg Museum
Ny Carlsberg Museum, Copenhagen,
Denmark, No. 917a
Pl. 106
This is probably a portrait of Mme Guil-
laumin. The free sketchy technique of the
pastel suggests a date around 1888.

106. Double portrait of " Mitou, " February (?)
1888
Pastel, 33 × 26; 33 × 20
Signed: Guillaumin fevrier (?) 88
Photographed by author
Dr. Oscar Ghez, Modern Art Foundation,
Geneva, No. 8149, No. 8150.
Pl. 107
According to Mlle Guillaumin this is a
double portrait of " Mitou " the daughter
of their concierge. The two sketches were
made on a single sheet of paper, and were
probably separated by a dealer.

107. La tour de Monthéry vue d'Epinay sur
Orge, 1888 (April)
Oil on canvas, 60 × 73 cm
Signed: Guillaumin
Photographed by Durand-Ruel No. 10323
Pl. 108
The date is given by Durand-Ruel.

108. Vaches au pâturage, c. 1888
Oil on canvas, 73 × 100 cm
Signed: Guillaumin
Photographed by Barney Burstein, Boston,
No. 2-13-63-12
Art Museum, Jewett Art Center, Wellesley
College, Wellesley, Mass.
Pl. 109
On the basis of a preliminary charcoal sketch
dated 1888, that belonged to Mlle Guil-
laumin, this painting was probably done in
the summer of 1888. It has thin transparent
paint, with much green and pink.

109. Prairie en soleil, c. 1888
Oil on canvas, 54 × 65 cm
Signed: Guillaumin
Photographed by author
Mme Lacotte, Paris
Pl. 110

110. Bords de la Seine à Charonton, c. 1888
Oil on canvas, 65 × 82 cm
Signed: Guillaumin
Photographed by author
M. Jean Ache, Asnières
Pl. 111

111. Mme Guillaumin with daughter,
Madeleine, 1889
Pastel, 58.5 × 46 cm
Signed: Guillaumin/89

Photographed by Arthur Tooth and Son,
London, No. 283484
Pl. 112

112. Mme Guillaumin reading, 1889
Pastel
Signed: Guillaumin 89
Photographed by Agraci No. 25232
Cabinet des Dessins du Louvre, Paris
Pl. 113

113. Mme Guillaumin reading, 1889
Pastel, 50 × 67 cm
Signed: Guillaumin
Photographed by author
Formerly Mlle M. Guillaumin
Pl. 114

114. Abreuvoir à Epinay-le-Breuil, June 1889
Oil on canvas, 73.5 × 60.5 cm
Signed: Guillaumin
Inscription: (on back of canvas) Abreuvoir
à Epinay-le-Breuil, juin 1889
Photographed by Arthur Tooth and Son,
London, No. 238066
Pl. 115

115. Paysage, c. 1889
Oil on canvas, 54 × 65 cm
Signed: Guillaumin
Photographed by author
Dr. Oscar Ghez, Modern Art Foundation,
Geneva, No. 7992
Pl. 16
The painting is closely similar in color and
brushstroke to the works done at Epinay
in 1889. On the whole, the resemblance is
to the region around Epinay.
   This picture was sold at auction at the
Palais Galliera, Paris, June 23, 1961, No. 129:
*Paysage de la Creuse*. However, I know of
no region around Crozant similar to this, nor
does one find whitewashed houses with red
tile roofs in the region.

116. Pont dans les montagnes, August 1889
Oil on canvas, 65 × 80 cm
Signed: Guillaumin
Inscription: (on back) Mme. Vve
Besserac/Peschadoire p. Pontgibaud
Photographed by Boston Museum of
Fine Arts
Boston Museum of Fine Arts, Boston,
No. 48.560
Fig. 39

117. Pommiers en fleur, c. 1889
Oil on canvas, 58.5×74 cm
Signed: Guillaumin
Photographed by Kaplan Galleries, London
Private collection, London
Pl. 17
The scene is typical of a number done around Damiette.

118. La maison au vieux Thionnette, c. 1889
Oil on canvas, 60×73 cm
Signed: Guillaumin
Photographed by Arthur Tooth and Son, London, No. 227844
Mr. George Moore
Ms. Nancy Cunard
Pl. 116
Mr. G. Moore first became acquainted with the works of Guillaumin at the Impressionist exposition of 1886.

119. Paysage avec une vache, c. 1890
Oil on canvas, 60×73 cm
Photographed by Galeries Serret-Fauveau, Paris
Pl. 117

120. Bords de la Seine, c. 1890
Oil on canvas
Signed: Guillaumin 90 (?)
Photographed by Versailles No. 40283
Pl. 118

121. Déchargeurs du charbon, January 1890 (?)
Pastel
Signed: Guillaumin Jan 90 (?)
Photographed by Versailles No. 22133
Pl. 119

122. Agay, April 1890
Oil on canvas, 72.5×91.5 cm
Signed: Guillaumin
Inscription: Agay le cap long dans baie/ avril 90/ 8 h le matin
Not illustrated
Galerie de l'Institut, Paris
This is the earliest painting of Agay that I have seen. Unfortunately, I have not been able to obtain a photograph.

123. Breuillet, 1890
Pastel, 47×61 cm
Signed: Guillaumin 90
Inscription: Breuillet

Photographed by author
Dr. Oscar Ghez, Modern Art Foundation, Geneva, No. 1180
Pl. 120

124. Paysage à Pontcharra, c. 1890
Oil on canvas, 60×81 cm
Signed: Guillaumin
Photographed by Versailles No. 40298
Fig. 40

125. Double portrait of Madeleine, c. 1891
Pastel, approx. 32×48 cm
Signed: Guillaumin
Inscription: Madeleine (above signature)
Photographed by author
Formerly Mlle M. Guillaumin
Pl. 121

126. Quai de Bercy, April 1891
Oil on canvas, 79×112 cm
Signed: Guillaumin 4 - 91
Photographed by author
Dr. Oscar Ghez, Modern Art Foundation, Geneva, No. 7742
Pl. 18

127. Cribleur du sable, 1891
Oil on canvas, 54×65 cm
Signed: Guillaumin
Photographed by author
Dr. Oscar Ghez, Modern Art Foundation, Geneva, No. 7893
Fig. 41

128. Portrait of Mme Guillaumin, 1892
Pastel, 46×39 cm
Signed: Guillaumin
Photographed by author
Dr. Oscar Ghez, Modern Art Foundation, Geneva, No. 8148
Pl. 19

129. Les dunes de la Couarde, Ile de Ré, February 1892
Oil on canvas, 40×65 cm
Signed: Guillaumin
Photographed by author
Dr. Oscar Ghez, Modern Art Foundation, Geneva, No. 2548
Pl. 122
There is apparently another version of this picture represented in a Durand-Ruel photograph (No. 10032) with the information:

"Les Dunes de la Couarde, Ile de Ré, février 1892, 4 heures. (39×65). "

130. Woman with two children, c. 1892
Oil on canvas
Signed: Guillaumin
Photographed by Versailles No. 22829
Pl. 123
The figures seem to represent Mme Guillaumin with her children Madeleine and Armand, Jr.

131. Verger à Miregaudin, June 1892
Oil on canvas, 65×81 cm
Signed: Guillaumin 92
Inscription: Juin 4h du matin
Photographed by Arthur Tooth and Son, London, No. 322302A
A. Personnaz (Des Courières No. 396)
Pl. 124

132. Verger à Miregaudin, c. 1892
Oil on canvas, 81×65.5 cm
Signed: Guillaumin
Inscription: 4h soleil
Photographed by Ordrupgaard Sammlingen
Ordrupgaard Sammlingen, Ordrup, Denmark, No. 63
Pl. 125
Guillaumin was painting similar scenes at Miregaudin in 1892. (Cf. Des Courières No. 396)

133. La Querlière, August 8, 1892
Oil on canvas, 66×82 cm
Signed: Guillaumin
Inscription: Crozant 1892, la Querlière 8 août le matin (on back)
Photographed by author
M. Jean Ache, Asnières
Fig. 50

134. Les barques de pêche à Saint-Palais, September 1892
Oil on canvas, 60×73 cm
Signed: Guillaumin
Photographed by Schweitzer Gallery, New York
M. L. Cazalens, Paris
Fig. 51

135. Agay, December 1892 (?)
Oil on canvas
Signed: Guillaumin

Photographed by Archives Photographiques
No. BAP 318
Formerly A. Personnaz
Pl. 126
This may be Des Courières No. 398: " Agay. *La baie* - 25F. 1892. Le cap Long et les hauters du cap Roux. Matin de décembre. "

136. La mare, Agay, 1893
Oil on canvas, 71×92 cm
Signed: Guillaumin
Photographed by Schweitzer Gallery, New York
Pl. 127

137. La sablière, February 1893
Pastel, 58.5×79.5 cm
Signed: Guillaumin
Photographed by Modern Art Foundation
Dr. Oscar Ghez, Modern Art Foundation, Geneva, No. 9451
Pl. 128

138. Rochers à Agay, c. 1893
Oil on canvas, 54×69 cm
Signed: Guillaumin
Photographed by author
Mme Lacotte, Paris
Fig. 42

139. Ferme et arbres à Saint-Chéron, March 1893
Oil on canvas, 79×63 cm
Signed: Guillaumin
Inscription: (on stretchers) Mars 1893
Photographed by Galleries Maurice Sternberg
Galleries Maurice Sternberg, Chicago
Pl. 20

140. Prairie à Saint-Chéron, 1893
Oil on canvas, 60×73 cm
Signed: Guillaumin
Inscription: Prairie à Saint-Chéron 1893 (on back)
Photographed by author
M. Jean Ache, Asnières
Fig. 52

141. Margot à cinq mois, July 1893
Pastel, 44.5×43.5 cm
Signed: Guillaumin
Inscription: Margot à cinq mois

Photographed by author
Formerly Mlle M. Guillaumin
Pl. 129

142. Le Moulin Brigand, September 1893
Oil on canvas, 65×81 cm
Signed: Guillaumin
Photographed by Durand-Ruel No. Ph 10031
Pl. 130
Durand-Ruel gives the following information: " Crozant, le 9 septembre 1893. Le Moulin Brigand, 10 heures du matin. "

143. Landscape of the Creuse, France, c. 1893
Oil on canvas, 73.3×92.6 cm
Signed: Guillaumin
Photograph courtesy of Mrs. Lyndon B. Johnson
Mrs. Lyndon B. Johnson, Texas
Pl. 21

144. Saint-Palais: la mer, 1893
Oil on canvas, 65×81 cm
Signed: Guillaumin
Photographed by author
Musée Bonnat, Bayonne, No. 16
Gift of A. Personnaz
Fig. 45

145. Les rochers platins, Saint-Palais, August 1893
Oil on canvas, 62×93 cm
Signed: Guillaumin
Photographed by Durand-Ruel
Formerly Herr Rusterholz, Zurich
Fig. 46

146. Saint-Palais, c. 1894
Oil on canvas, 29×36.5 cm
Signed: Guillaumin
Photographed by author
Galeries Serret-Fauveau, Paris
Pl. 22

147. Saint-Palais: Pointe de la Perrière, c. 1893
Oil on canvas, 55×63.5 cm
Signed: Guillaumin
Photographed by Galleries Maurice Sternberg
Galleries Maurice Sternberg, Chicago
Fig. 47

148. Mme Guillaumin écrivant, 1894
Oil on canvas, 81×65 cm

Signed: Guillaumin 94
Photographed by author
Dr. Oscar Ghez, Modern Art Foundation, Geneva, No. 1200
Pl. 23

149. Portrait de Madeleine, 1894
Pastel
Signed: Guillaumin
Inscription: St. Val 94
Photographed by Agraci
Cabinet des Dessins, Louvre, Paris
Pl. 131
This pastel of Madeleine was the basis of one of the lithographs that Guillaumin executed for Vollard in 1896-97. (See Cat. No. 167)

150. Enfant mangeant la soupe, August 1894
Pastel, 47×43 cm
Signed: Guillaumin aout 94
Photographed by Galleries Maurice Sternberg
Galleries Maurice Sternberg, Chicago
Campbell Museum, Camden
Pl. 24
This pastel served as the basis of the lithograph (Cat. No. 168).

151. La passerelle sur la Sédelle, c. 1894
Oil on canvas
Signed: Guillaumin
Photographed by Versailles No. 40276
Pl. 132
Cf. Durand-Ruel No. Ph 2513 - Génetin 1897. The picture seems to have appeared in the Salon d'Automne about 1907-08.

152. Still life, c. 1894
Oil on canvas, 46×38 cm
Signed: Guillaumin
Photographed by Schweitzer Gallery, New York
M. Blot, Paris
Pl. 133

153. Le Moulin Bouchardon, October 1894
Oil on canvas, 73×92 cm
Signed: Guillaumin
Inscription: Crozant 1894/ le moulin du Pont Charrault 1er jours d'octobre (on the chassis)
Photographed by Galeries Serret-Fauveau, Paris
Sold, Hôtel Drouot, Paris, 27 avril 1933

Pl. 134
The mill of Pont Charraud is better known in Guillaumin's œuvre as the moulin Bouchardon.

154. Boigneville-les-Carneaux, June 1894
Oil on canvas, 81×65 cm
Signed: Guillaumin
Photographed by Durand-Ruel No. 2948
Galerie M. Bernheim, Paris
Pl. 135
Durand-Ruel furnishes the following information: " Boigneville les Carneaux, 1894. Juin 8 heures du matin. " The detail of the information suggests that there is an inscription on the back.

155. Saint-Palais, 1894
Pastel, 47×64 cm
Signed: Guillaumin Saint-Palais 94
Photographed by Bulloz No. 70.863
Musée de la ville de Paris No. 1426
Pl. 136

156. Agay, 1895
Charcoal, approx. 32×48 cm
Signed: Agay 95/Guillaumin
Photographed by author
Formerly Mlle M. Guillaumin
Fig. 53

157. Vallée d'Agay, 1895
Oil on canvas, 65×81 cm
Signed: Guillaumin
Photographed by Archives Photographiques
No. BAP 322
Musée Bonnat, Bayonne, No. 21
Fig. 54

158. Le Lac, Agay, 1895 (Durand-Ruel)
Oil on canvas, 38×55 cm
Signed: Guillaumin
Photographed by Versailles No. 40309
Fig. 55

159. Agay, 1895
Charcoal, 48×64 cm
Signed: Guillaumin
Inscription: Agay 95
Photographed by Bulloz No. 70874
Musée de la ville de Paris No. D 1425
Fig. 56

160. Agay: la baie, May 1895
Oil on canvas, 73×92 cm

Signed: Guillaumin
Inscription: Mai 1895
Photographed by Archives Photographiques
No. BAP 320
Musée du Louvre, Paris, RF 37-28
Gift of A. Personnaz
Fig. 57

161. Agay: Pointe de la Maleraigue, May-June 1895
Oil on canvas, 80×112 cm
Inscription: Agay mai juin 95 Pointe de la Maleraigue (on stretchers)
Photographed by author
Dr. Oscar Ghez, Modern Art Foundation, Geneva
Fig. 58

162. Paysage à Pontgibaud, July 1895
Oil on canvas, 65×81 cm
Signed: Guillaumin
Photographed by Durand-Ruel
No. Ph 2425
Pl. 137
Durand-Ruel gives the following information: " Paysage à Pontgibaud, Juillet '95. "

163. Pontgibaud, October 1895
Oil on canvas, 65×81 cm
Signed: Guillaumin
Photographed by Durand-Ruel
No. Ph 2426
Pl. 138

164. Prairie à Pontcharra, August 1895
Oil on canvas, 60×73 cm
Signed: Guillaumin
Inscription: Pontchara août 95 4 pm Soir (on the back)
Photographed by author
M. Jean Ache, Asnières
Pl. 25

165. La mer à la Beaumette, c. 1895
Oil on canvas, 61×94 cm
Signed: Guillaumin
Photographed by Hickey & Robertson
Formerly Galleries Maurice Sternberg, Chicago
Fig. 43

166. Les Roches au bord de la mer, 1896
Lithograph, 45×61 cm (?)
Signed: 96 Guillaumin

Photographed by Bibliothèque Nationale
No. 64 C 24254
Bibliothèque Nationale, Paris, Portfolio AA3
Fig. 67

167. Madeleine, 1896
Color lithograph
Unsigned
Photographed by Bibliothèque Nationale
No. 64 C 24250
Bibliothèque Nationale, Paris
Fig. 63

168. La Soupe, 1896
Lithograph, 62×48 cm
Signed: Guillaumin
Inscription: Epreuve d'essai
Photographed by author
Dr. Oscar Ghez, Modern Art Foundation, Geneva, No. 7036
Fig. 64

169. Les meules or Haystacks in Winter, 1896
Lithograph, 45×61 cm
Signed: Au General Lacotte/ très amicalement/ Guillaumin
Photographed by author
Mme Renée Lacotte, Paris
Fig. 66

170. Moret, c. 1896
Oil on canvas, 51×61 cm
Signed: Guillaumin
Photographed by Versailles No. 3802
Pl. 139
Ref.: *Apollo*, Nov. 1964: reproduced in color with the title "Le vieux Sannois." Guillaumin seems to have been in Moret twice, once in 1896 and again in 1902. The scene represented at Moret was a favorite one of Sisley (Cf. Daulte, *Sisley*, Cat. No. 671.)
Another painting of the same scene was sold at the Vente Henri Viau, Galeries Georges Petit, Paris 27 November 1914: *Moret, le matin* 54×65.

171. Moret: le Loing et passerelle, c. 1896
Oil on canvas, 38×45 cm
Signed: Guillaumin
Photographed by Versailles No. 41512
Pl. 140
Des Courières No. 223, *Le Loing et Passerelle* 1896 (Coll. Th. Gaillard) 38×45.

172. Portrait of André, 1896
Pastel, 50×48 cm
Signed: Guillaumin
Photographed by author
Dr. Oscar Ghez, Modern Art Foundation,
Geneva, No. 1151
Fig. 65

173. La Sédelle, c. 1896
Oil on canvas, 60×74 cm
Signed: Guillaumin
Photographed by author
Mme Renée Lacotte, Paris
Pl. 141

174. Ravin de la Sédelle à la Folie, June 1896
Oil on canvas, 61×74 cm
Signed: Guillaumin
Inscription: Ravin de la Sédelle à la Folie -
Juin 1896 (on back)
Photographed by Galeries Serret-Fauveau,
Paris
Fig. 59

175. Le pâturage des Granges, c. 1896
Oil on canvas, 53×66 cm
Signed: Guillaumin
Photographed by Kaplan Gallery, London
Pl. 26
Guillaumin first started renting *La Ferme* at
*Les Granges* in 1895, and continued to stay
there for eighteen years. On the basis of
style and use of color, this painting would
be dated about 1896-1898.

176. Ecluse des Bouchardonnes, c. 1896
Oil on canvas, 65×81 cm
Signed: Guillaumin
Inscription: La Creuse - écluse des
Bouchardonnes
Photographed by author
Galeries Serret-Fauveau, Paris
Pl. 27
The rather thin, delicate application of paint
is characteristic of the period of about 1896-
1897.

177. Pont Charraud, c. 1896-1897
Oil on canvas, 65×92 cm
Signed: Guillaumin
Photographed by author
Mr. and Mrs. John Bass
Pl. 142

Catalogue of the John and Joanna Bass Col-
lection No. 123 - " Crozant, the Valley of
the Sédelle. Painted about 1897. "

178. L'automne sur la Creuse (Puy Bariou),
November 1896
Oil on canvas, 65×73 cm
Signed: Guillaumin
Inscription: Crozant 9bre 96/ l'automne
sur la Creuse (on stretchers)
Photographed by author
Mme Lacotte, Paris
Pl. 143

179. Paysage de la Creuse, c. 1897
Oil on canvas, 65×81 cm
Photographed by author
Dr. Oscar Ghez, Modern Art Foundation,
Geneva, No. 447
Pl. 144

180. Les ruines à Crozant, c. 1897
Oil on canvas, 81×100 cm
Photographed by author
Dr. Oscar Ghez, Modern Art Foundation,
Geneva, No. 2222
Pl. 145

181. La Creuse à Génetin, September 1897
Oil on canvas, 54×65 cm
Signed: Guillaumin
Photographed by Durand-Ruel
No. Ph 2513
Pl. 146
Durand-Ruel gives the following informa-
tion: " Génetin, septembre 1897, 7 heures
du matin. "

182. La vallée de la Creuse, c. 1897
Oil on canvas, 94×115 cm
Signed: Guillaumin
Photographed by author
Dr. Oscar Ghez, Modern Art Foundation,
Geneva
Pl. 147

183. Portrait of Mme Guillaumin, c. 1898
Oil on canvas, 81×66 cm
Photographed by Arthur Tooth and Son,
London, No. 246995
Friends of Guillaumin, Geneva
Pl. 148
Ref.: *Burlington Magazine*, June, 1969,
p. XIII. Illustration and sale notice.

A view of Mme Guillaumin in her house
in Paris. In the background are a number
of oriental screens of the type that Guil-
laumin received from Hayashi in exchange
for his paintings. Like most of his generation,
Guillaumin was fascinated by far eastern
decorative arts.

184. Chemin de Puy Bariou, 1898
Oil on canvas, 65×81 cm
Signed: Guillaumin
Photographed by author
Dr. Oscar Ghez, Modern Art Foundation,
Geneva, No. 8858
Pl. 149
Mlle M. Guillaumin dated this work
as 1898.

185. Les ruines, October 1898
Oil on canvas, 72×98 cm
Signed: Guillaumin
Inscription: 8bre 1898
Photographed by Durand-Ruel
No. 10284
Pl. 150

186. Neige à Crozant, c. 1898
Oil on canvas, 60×81 cm
Signed: Guillaumin
Photographed by author
Dr. Oscar Ghez, Modern Art Foundation,
Geneva, No. 8019
Fig. 48

187. Neige à Crozant, c. 1898
Oil on canvas, 60×81 cm (?)
Signed: Guillaumin
Photographed by Versailles No. 3823
Pl. 151
No. 186, Fig. 48 is an almost identical
picture, which is tentatively dated 1898.
The scene, a favorite with Guillaumin, is
the view across the fields from his house at
Les Granges toward Crozant.

188. Route de Crozant: petit brouillard et gelée
blanche, November 1899
Oil on canvas, 55×65 cm
Signed: Guillaumin
Inscription: The title and the date are
inscribed on the back.
Photographed by author
Galeries Serret-Fauveau, Paris
Pl. 28

189. Le Cap Long et le Rastel d'Agay, c. 1900
Oil on canvas, 72×94 cm
Signed: Guillaumin
Photographed by author
Galeries Serret-Fauveau, Paris
Pl. 152
Mlle Guillaumin suggested that this painting was executed between 1898 and 1902.

190. Jouy - les chaumières, 1900
Oil on canvas, 46×55 cm
Signed: Guillaumin
Photographed by author
M. Jean Ache, Asnières
Pl. 29

191. Les pâturages des Granges, Crozant,
c. 1900-1910
Oil on canvas, 73×92 cm
Signed: Guillaumin
Photographed by Galeries Serret-Fauveau,
Paris
Pl. 153
A view from Guillaumin's house at Les Granges toward the village of Crozant on the right and the valley of the Sédelle on the left. In the distance, left corner, can be seen *Les Ruines* and the *Rocher de la Fileuse*.

192. Barrage de Génetin, c. 1900
Oil on canvas, 65×80 cm
Signed: Guillaumin
Photographed by author
Galeries Serret-Fauveau, Paris
Pl. 30
M. Serret has dated this work " vers 1900. "

193. Dinard, September 1900
Oil on canvas, 60×73 cm
Signed: Guillaumin
Photographed by Durand-Ruel No. 10311
Fig. 68

194. Saint-Sauves sous la neige, 1900
Oil on canvas, 65×81 cm
Signed: Guillaumin
Inscription: Premiers j de (2? - illegible)
Photographed by author
Dr. Oscar Ghez, Modern Art Foundation,
Geneva, No. 8019
Pl. 31
Durand-Ruel photograph No. 9900, a close variant of the same scene, identifies the site as Saint-Sauves (Puy-de-Dôme). Des Cou-

rières: No. 45 " Saint-Sauves (Puy-de-Dôme) - *Effet de neige* - Février 1900 (55×66), " is apparently the same scene but with different dimensions. Des Courières No. 179 has the same title, but is a picture of 30F without a date.

195. Saint-Servan, September 1900
Oil on canvas, 60×73 cm
Photographed by Durand-Ruel No. 10035
Fig. 69

196. Agay, May 1901
Oil on canvas, 65×92 cm
Signed: Guillaumin
Inscription: Agay mai 1901 (on back)
Photographed by author
Galeries Serret-Fauveau, Paris
Pl. 32

197. Agay - les roches rouges, c. 1901
Oil on canvas, 66.7×82 cm
Signed: not visible, vestiges l.l.
Photographed by Galleries Maurice
Sternberg
Formerly Danthon, Paris
Galleries Maurice Sternberg, Chicago
Pl. 33

198. La Maleraigue au temps du mistral, 1901
Oil on canvas, 73×92 cm
Signed: Guillaumin
Inscription: Agay 1901
Photographed by Raymond Asseo, Geneva
Dr. Oscar Ghez, Modern Art Foundation,
Geneva, No. 2010
Fig. 44

199. Pointe de la Baumette, Agay, 1901
Oil on canvas, 60×73 cm
Signed: Guillaumin
Photographed by Ordrupgaard
Sammlingen
Ordrupgaard Sammlingen, Ordrup,
Denmark, No. 65
Pl. 154

200. Boigneville-les-Carneaux, June 1901
Oil on canvas, 81×65 cm
Signed: Guillaumin
Inscription: Boigneville, juin 1901 (on back)
Photographed by author
Dr. Oscar Ghez, Modern Art Foundation,
Geneva, No. D 167
Fig. 62

201. Portrait of Madeleine, 1901
Oil on canvas, 73×60 cm
Signed: Guillaumin 1901
Photographed by author
Dr. Oscar Ghez, Modern Art Foundation,
Geneva, No. 1912
Fig. 61

202. Rue de Villard Benoit, Pontcharra,
July 1901
Oil on canvas, 64×55 cm
Signed: Guillaumin
Inscription: Pontcharra juillet 1901/
rue de Villard Benoit
Photographed by author
Dr. Oscar Ghez, Modern Art Foundation,
Geneva, No. 7039
Fig. 71

203. Mont Granies, Pontcharra, July 1901
Oil on canvas, 59×72 cm
Signed: Guillaumin
Inscription: Pontcharra juillet 1901.
Mont Granies
Photographed by Schweitzer Gallery,
New York
Formerly Schweitzer Gallery, New York
Pl. 155

204. Pontcharra, c. 1901
Oil on canvas, 82×65 cm
Signed: Guillaumin
Photographed by Ny Carlsberg Museum
Ny Carlsberg Museum, Copenhagen,
N. 917b
Pl. 156
As Guillaumin visited Pontcharra in 1890 and 1901, the latter date is surely the correct one for this picture.

205. Clos des Bouchardons, December 1901
Oil on canvas, 65×81 cm
Signed: Guillaumin
Photographed by Archives Photographiques
No. MNPL 9186
Formerly A. Personnaz, Bayonne
Musée Bonnat, Bayonne, No. 15
Pl. 157
Des Courières gives the title of " Clos des Bourdonnes, " but as it is the view from the Moulin Bouchardon toward Pont Charraud, this is probably a misprint.

206. Agay: marine, c. 1901
Oil on canvas, 60×73 cm

Signed: Guillaumin
Inscription: Agay Marine
Photographed by author
Dr. Oscar Ghez, Modern Art Foundation,
Geneva, No. 61
Fig. 70

207. Pont Charraud, gelée blanche, February
1902
Oil on canvas, 65×81 cm
Signed: Guillaumin
Inscription: A Clair Blot/ 9 fevrier 1902
(above signature)
Photographed by Versailles No. 2651
M. Clair Blot, Paris
Pl. 158
Ref.: Des Courières, p. 48 (illustrated in
color)

208. Crozant: les Grandes Gouttes, March 1902
Oil on canvas, 60×73 cm
Signed: Guillaumin
Inscription: Crozant: les Grandes Gouttes
le soir. Mars 1902
Photographed by author
Galeries Serret-Fauveau, Paris
Pl. 34

209. La Seine à Samois, April 1902
Oil on canvas, 38×46 cm
Signed: Guillaumin
Photographed by Durand-Ruel
No. Ph 10041
Pl. 159
Des Courières, No. 43, places Guillaumin
in Samois in 1919. The date used is given
by Durand-Ruel.

210. Moret, c. 1902
Oil on canvas, 55×66 cm
Signed: Guillaumin
Inscription: Moret mai 1902 matin
(on back)
Photographed by author
M. Jean Ache, Asnières
Pl. 35

211. Le Moulin Bouchardon, c. 1902
Oil on canvas, 73×92 cm
Signed: Guillaumin
Photographed by author
M. Jean Ache, Asnières
Pl. 160

Mlle Guillaumin dated this c. 1902. The
houses of Pont Charraud can be seen in the
left distance.

212. Moulin de la Folie, c. 1902
Oil on canvas, 92×73 cm
Signed: Guillaumin
Photographed by author
Musée Municipale, Limoges
Pl. 36
This painting, formerly in the Musée du
Luxembourg, Paris, has now been depos-
ited by the state in the Musée Municipale,
Limoges.

213. Pont Charraud, February 1903
Oil on canvas, 65×81 cm
Signed: Guillaumin
Photographed by Schweitzer Gallery,
New York
Sold from Galeries Charpentier, Paris,
June 8-9, 1969
Pl. 161
Note the presence of two figures on the
road. Otherwise, except for the color, the
scene is identical with that of 1902 (Cat.
No. 207). There are many other paintings
very similar in composition. Galeries Serret-
Fauveau, Paris, showed one (38.5×46.5)
with the inscription, Crozant 1903. Kaplan
Gallery, London, had one (66×81) with
three figures on the road. Des Courières,
p. 41, illustrated another version with a
single figure in the collection of L. Bernard
without additional data.

214. Jeune fille cousant. Portrait de la fille de
l'artiste, c. 1903
Oil on canvas, 58×72 cm
Signed: Guillaumin
Photographed by Schweitzer Gallery,
New York
M. F. Chapuis, Paris
Pl. 162
A pastel of the same scene is signed and
dated 1903 (Cf. Des Courières, p. 35).

215. Bords de l'Orne à Clecy, August 1903
Oil on canvas, 54×65 cm
Photographed by Durand-Ruel
No. Ph 9177
M. M. Bernheim
Sold, Palais Galliera, March 27, 1962, No. 54
Pl. 163

216. La Creuse en septembre, September 1903 (?)
Oil on canvas, 60×73 cm
Signed: Guillaumin
Inscription: La Creuse en septembre 1903 (?)
(on back)
Photographed by author
Galeries Serret-Fauveau, Paris
Pl. 164

217. Moulins en Hollande, c. 1904
Etching, 12×17.3 cm
Unsigned
Photographed by Bibliothèque Nationale
No. 64 B 35001
Bibliothèque Nationale, Paris
Fig. 72

218. Vue de Zaandam, 1904
Etching and lithograph (?), 13.5×19.5 cm
Signed: AG
Photographed by Bibliothèque Nationale
No. AC1675-1676
Bibliothèque Nationale, Paris
Pl. 165
This etching seems to have been overprinted
on a lithographic stone. The Bibliothèque
Nationale has two examples. In one the
overprinting is black. On the other it is
green with accents of red. The Baltimore
Museum of Art has a third example in which
the overprint color is basically red.

219. Windmills in Holland, 1903-1904
Oil on canvas
Signed: Guillaumin
Photographed by Versailles No. 40264
Pl. 166

220. View of Holland, 1904
Pastel, 45×60 cm
Signed: Guillaumin 1904
Photographed by author
Mme Lacotte, Paris
Pl. 37

221. View of Holland, 1904
Oil on canvas, 60×73 cm
Signed: Guillaumin
Photographed by Archives Photographiques
No. BAP 323
Musée du Louvre, Paris, No. 1044
Pl. 167
According to Des Courières, there are three
versions of this painting (Des Courières

No. 409, 410, 411) done under differing weather conditions. The one in the Louvre is done under a luminous grey sky. Of the two others (Musée Bonnat No. 10 and No. 11), one is done in full sunshine, and the other in evening light. The paintings in the Musée Bonnat are smaller, both measuring 24×33 cm.

222. Landscape near Saardam, 1904
Oil on canvas, 61×73 cm
Signed: Guillaumin
Photographed by Knoedler & Co.,
New York, No. CA 5911
Advertised by Galerie Barbizon, Paris,
May 1969
Pl. 168

223. Wormeneer, Holland, 1904
Oil on canvas, 54×65 cm
Photographed by Schweitzer Gallery,
New York
M. G. Pautet, Limoges (cited by Des
Courières No. 372)
Pl. 169

224. Rouen: la Seine le matin, 1904
Oil on canvas, 54×65 cm
Signed: Guillaumin
Photographed by Archives Photographiques
No. BAP 327
Musée Bonnat, Bayonne, No. 13
Gift of A. Personnaz
Pl. 170

225. Quais at Rouen, 1904-1905
Oil on canvas, Easel A
Signed: Guillaumin
Photographed by Versailles No. 40269
Pl. 171

226. Vue de Rouen, matin d'hiver, 1904
Oil on canvas, 63×92.5 cm
Signed: Guillaumin
Photographed by Ordrupgaard
Sammlingen, Denmark
Ordrupgaard Sammlingen, Ordrup,
Denmark, No. 66
Pl. 172
This scene exists in several versions, differing mainly in the number of hansom cabs shown in the foreground.

227. Chemin de Puy Bariou, c. 1905
Oil on canvas, 65×81 cm

Signed: Guillaumin
Inscription: Chemin du... (illegible)
Crozant
Photographed by author
M. Jean Ache, Asnières
Pl. 173
Mlle Guillaumin dated this picture about 1905.

228. Vallée de la Sédelle et les ruines, c. 1905
Oil on canvas, 65×81 cm
Photographed by author
Galeries Serret-Fauveau, Paris
Pl. 38
The dating of this picture is a problem. Mlle Guillaumin dated it c. 1890. M. Serret believes that it was executed about 1900. I feel that it belongs to a somewhat later period on the basis of the brushwork and the quality of the color, perhaps in 1905.

229. Les Telles et Puy Bariou, c. 1905
Oil on canvas, 50×62 cm
Signed: Guillaumin
Photographed by author
Galeries Serret-Fauveau, Paris
Pl. 174
Mlle Guillaumin believed that it was done in 1905.

230. Madeleine listening to music, c. 1905
Pastel, 61×46 cm (?)
Signed: Guillaumin
Photographed by Galeries Serret-Fauveau,
Paris
Formerly in collection of Georges Haviland,
Limoges
Pl. 175
Mlle Guillaumin believed this portrait of her sister was executed about 1906. However, it may well be the picture cited by Des Courières: No. 293 - *Portrait de sa fille Madeleine*, 1905, 61×46.

231. Villeneuve-sur-Yonne, 1906
Oil on canvas, 54×65 cm
Signed: Guillaumin
Photographed by Versailles No. 40266
Sold, Galeries Charpentier, March 18, 1959
No. 50
Pl. 176
There are two versions of this painting, the present one, and one in which a boat appears in the left distance.

Guillaumin's only recorded stay at Ville-neuve-sur-Yonne was in 1906.

232. Le Moulin Jonon, c. 1906
Oil on canvas, 54×65 cm
Signed: Guillaumin
Photographed by Galeries Serret-Fauveau,
Paris
Pl. 177

233. Agay, 1907
Pastel
Signed: Guillaumin 1907
Photographed by Galeries Schmit, Paris
Pl. 178

234. Mademoiselle Guillaumin lisant, 1907
Oil on canvas, 65×54 cm
Signed: Guillaumin/ 1907
Photographed by Modern Art Foundation
Dr. Oscar Ghez, Modern Art Foundation,
Geneva, No. 9400
Pl. 39
This is probably a portrait of Marguerite Guillaumin.

235. Le vieux chemin: brouillard du matin, 1907
Oil on canvas, 54×67 cm
Signed: Guillaumin
Inscription: Vieux chemin brouillard du
matin 1907
Photographed by Galeries Schmit, Paris
Pl. 179

236. Le vieux chemin: effet de neige, c. 1907
Oil on canvas, 48×58 cm
Signed: Guillaumin
Inscription: Le vieux chemin; effet de neige
(on back)
Photograph courtesy of Galeries Urbain,
Paris
Offered for sale, Palais Galliera, December
8, 1966, No. 38
Pl. 180
The canvas has been relined, covering the inscription. Information courtesy of M. Urbain.

237. Pornic, 1908
Pastel, 45×60 cm
Signed: Guillaumin
Inscription: Pornic 1908
Photographed by author
M. André Ballot, Paris
Pl. 181

238. Chemin creux: gelée blanche, 1909
Oil on canvas, 50×60 cm
Signed: Guillaumin
Inscription: Crozant 1909 Chemin creux, gelée blanche (on stretchers)
Photographed by author
Mme Lacotte, Paris
Pl. 40
The houses of Pont Charraud can be seen in the distance.

239. Saint-Palais: Embouchure de la Gironde, 1909
Oil on canvas, 54×65 cm
Signed: Guillaumin
Photographed by Mr. Kurt W. Ury, Great Neck, New York
Mr. and Mrs. Kurt W. Ury, Great Neck, N. Y.
Pl. 182
This may have been painted during Guillaumin's last stay at Saint-Palais. The foreground scene is the Pointe de la Perrière, in the neighborhood of which Guillaumin usually painted at Saint-Palais. Another view of the same point was painted by Guillaumin in 1893. Though certain elements of technique have changed, the treatment of the soft colors of the *Côte d'Argent* remains essentially the same.

240. Agay: le rocher rouge, le mistral, c. 1910
Oil on canvas, 32×40 cm
Signed: Guillaumin
Photographed by author
Formerly Mlle M. Guillaumin
Pl. 183
Mlle M. Guillaumin dated this painting 1905-1910.

241. Poitiers, 1910
Oil on canvas, 60×81 cm
Signed: Guillaumin
Photographed by Galeries Serret-Fauveau, Paris
Pl. 184
Guillaumin was in Poitiers in 1910, in the spring.

242. L'Abreuvoir à Poitiers, 1910
Oil on canvas, 53.5×64 cm
Signed: Guillaumin
Inscription: signed and titled on reverse in artist's hand
Photographed by Galleries Maurice Sternberg, Chicago
Mr. Nathan Smooke, Beverly Hills
Pl. 41

243. La Cabanne, 1910
Oil on canvas, 43×51 cm
Signed: Guillaumin 1910
Inscription: La Cabanne (on back)
Photographed by author
Mme Lacotte, Paris
Pl. 185
The picture appears to belong to the series that Guillaumin executed at Poitiers in 1910.

244. Pont Charraud, 1910
Pastel, 45×60 cm
Signed: Guillaumin
Photographed by author
Dr. Oscar Ghez, Modern Art Foundation, Geneva, No. 8152
Pl. 186
This pastel in apparently unfinished. As a result it furnishes an interesting insight into Guillaumin's manner of working by establishing the main compositional accents through the picture before working up any particular area. The same method was used by Cézanne.

245. Le Brusc: le pin parasol, March 1911
Oil on canvas, 73×92 cm
Signed: Guillaumin
Inscription: Mars 1911 (on back)
Photographed by Geneviève Allemand, Paris
Musée de St.-Etienne, Inv. D. 63.2.1
(Dépôt de l'Etat, 1953)
Fig. 73

246. Le Brusc, 1911
Oil on canvas, 73×93 cm
Signed: Guillaumin
Photographed by Schweitzer Gallery, New York
M. L. Clerc, Paris
Pl. 187
Schweitzer gives the date of 1901. Des Courières (p. 51) gives the title *Le Brusc*. Guillaumin was only in Le Brusc in 1911. However, the picture looks very much more like the Maleraigue at Agay than it does a scene at Le Brusc. If it is Agay, the date 1901 is possible.

247. Le port du Brusc, April 1911
Oil on canvas, 60×81 cm
Signed: Guillaumin
Photographed by Durand-Ruel No. Ph 10135
Pl. 188
The information given by Durand-Ruel: "Le port du Brusc avril 1911 le matin."

248. Pointe des Embiers, 1911
Oil on canvas, 65×81 cm
Signed: Guillaumin
Inscription: Point des Embiers, matin vers l'est
Photographed by M. Nat Leeb, Paris
M. Nat Leeb, Paris
Fig. 74

249. Le Moulin Bouchardon, c. 1911
Oil on canvas, 65×81 cm
Signed: Guillaumin
Photographed by Arthur Tooth and Son, London, No. 321410
Pl. 189
Tooth gives the title as " Bords de la Creuse en printemps, " but the picture represents the Moulin Bouchardon with a view of the houses of Pont Charraud in the left distance.
On the basis of the loose handling of the paint, this picture belongs in the period around 1911.

250. La Querlière, August 1911
Oil on canvas, 55×65 cm
Signed: Guillaumin
Inscription: Crozant août 1911, la Querlière, Matin (on back)
Photographed by author
M. Victor Russe, Limoges
Galeries Serret-Fauveau, Paris
Pl. 190
This is one of several paintings of the same scene under differing conditions of light executed by Guillaumin in 1911. The Modern Art Foundation, Geneva, has a similar scene in pastel, 47×62 cm.

251. La Querlière, September 1911
Oil on canvas, 54×65 cm
Signed: Guillaumin
Inscription: Crozant (14?) 7bre la...
Photographed by author
Mme Lacotte, Paris
Fig. 60

252. Pont Charraud: gelée blanche, c. 1903-1911
Oil on canvas, 73 × 100 cm
Signed: Guillaumin
Photographed by Versailles No. 2806
Pl. 191
Among others, Mr. and Mrs. R. Tucker, Great Neck, New York, have a similar scene (61 × 74 cm).

253. Nanteuil sur Marne, 1911 (Durand-Ruel)
Oil on canvas, 54 × 65 cm
Photographed by Durand-Ruel No. 12292
Pl. 192

254. Still life with pewter pitcher, apples and *biscuits champagnes*, c. 1911
Oil on canvas, 38 × 47 cm
Signed: Guillaumin
Photographed by author
Galeries Serret-Fauveau, Paris
Pl. 42
Both M. Serret and Mlle Guillaumin agreed in dating this work about 1911.

255. Agay: la Baumette, 1912
Oil on canvas, 65 × 81 cm
Signed: Guillaumin
Inscription: Agay - La Baumette - Juin (?) 1912 (on back)
Photographed by author
Galeries Serret-Fauveau, Paris
Pl. 193

256. Bords de la Sédelle, August 1912
Oil on canvas, 65 × 55 cm
Signed: Guillaumin
Inscription: Crozant au bords de la Sédelle, août 1912 (on back)
Photographed by author
Mme Lacotte, Paris
Pl. 194

257. Rocher de l'Echo, c. 1912
Oil on canvas, 60.5 × 73.5 cm
Signed: Guillaumin
Photographed by Ny Carlsberg Museum
Ny Carlsberg Museum, Copenhagen, No. 918
Fig. 49

258. Les pâturages des Granges, c. 1912
Oil on canvas, 73 × 92 cm
Signed: Guillaumin
Photographed by Arthur Tooth and Son, London, No. 224110
Pl. 195
The view from Guillaumin's house, la Ferme, at Les Granges toward the village of Crozant (far right).

259. Pont Charraud, c. 1913
Oil on canvas
Signed: Guillaumin
Photographed by Blume, New York
Mr. Blume, New York
Pl. 196
I feel that this picture could not have been painted much before 1911, nor after 1918.

260. Portrait of Marguerite, c. 1913
Oil on canvas, 46 × 38.4 cm
Signed: Guillaumin
Photographed by Schweitzer Gallery, New York
Pl. 197
The technique recalls that of the *Portrait of Madeleine* of 1901 (Cat. No. 201) in the use of linear brushstrokes.

261. Le Moulin Bouchardon, October 1913
Oil on canvas, 65 × 81 cm
Signed: Guillaumin
Inscription: Crozant 1913 soir octobre Moulin des Bouchardons (on back)
Photographed by author
Mme Lacotte, Paris
Pl. 43

262. Le Moulin Brigand et les ruines, 1914
Oil on canvas, 50 × 61 cm
Signed: Guillaumin
Inscription: Moulin Brigand 1914 (on back)
Photographed by author
Galeries Serret-Fauveau, Paris
Pl. 198

263. Still life with marmite, c. 1914
Oil on canvas
Signed: Guillaumin
Photographed by Galeries Serret-Fauveau, Paris
Fig. 75

264. Still life with herrings, pot and onions, 1914
Oil on canvas, 55 × 46 cm
Signed: Guillaumin 1914
Photographed by author
Galeries Serret-Fauveau, Paris
Pl. 199
Des Courières lists (No. 189) a still life in the collection of the Galeries Danthon, Paris: "Pastel: *Nature morte - Harings, oignons et pot vert. 1914* (62 × 48)."

265. Nature morte avec pommes, 1914
Oil on canvas, 19 × 24 cm
Signed: Guillaumin
Photographed by Schweitzer Gallery, New York
M. Eugène Alluaud, Limoges
Pl. 200
Des Courières No. 9

266. Portrait of Marguerite Guillaumin reading, c. 1914
Oil on canvas, 60 × 73 cm
Signed: Guillaumin
Photographed by author
Dr. Oscar Ghez, Modern Art Foundation, Geneva, No. 1201
Pl. 44
The Modern Art Foundation gives the date as 1914. Mlle Guillaumin felt that it should be dated about 1917.

267. Les Telles, March 1915
Oil on canvas, 60 × 73 cm
Signed: Guillaumin
Inscription: 23 - 25 mars 1915 - soir (on back)
Photographed by author
Mme Lacotte, Paris
Pl. 201

268. La Creuse à Génetin, c. 1915
Oil on canvas, 61 × 81 cm
Signed: Guillaumin
Inscription: Avril 1 (...) (illegible) (on back)
Photographed by author
Mme Clémentine Ballot, Paris
M. André Ballot, Paris
Pl. 202

269. Rocher de la Fileuse, 1915-1918
Oil on canvas, 60 × 74 cm
Signed: A Yvonne son viel ami Guillaumin
Photographed by author
Mlle Yvonne Coste, Paris
Pl. 203
The picture is unfinished. Areas of the white ground show around the branches of the middle, as well as in other places.

270. Bords de la Creuse, c. 1916
Pastel, 47×65 cm
Signed: Guillaumin
Photographed by Schweitzer Gallery,
New York
Pl. 204
This work represents the same site as a pastel
from Arthur Tooth and Son (47×63) and
is similar in technique, suggesting that they
were executed at about the same time.

271. Moulin de la Folie, November 1916
Oil on canvas, 65×81 cm
Signed: Guillaumin
Inscription: 9bre 1916 matin (on back of
canvas)
Photographed by author
Mme Clémentine Ballot, Paris
M. André Ballot, Paris
Pl. 45
The paint is applied with extraordinary thin-
ness, allowing the white ground to add lu-
minosity to the colors, giving, except for
the brushstroke, an effect similar to that of
a watercolor.

272. Painting by Clémentine Ballot:
Rocher de l'Echo, December 1916
Oil on canvas, 65×82 cm
Signed: C. Ballot
Inscription: Gelée blanche aux Telles,
Crozant décembre 1916
Photographed by author
M. André Ballot, Paris
Pl. 205
This picture by Clémentine Ballot is of a
site that Guillaumin painted a number of
times during the first World War.

273. Pont Charraud, c. 1916
Oil on canvas, 60×73 cm
Signed: Guillaumin
Photographed by author
Mme Clémentine Ballot, Paris
M. André Ballot, Paris
Pl. 206
This painting of *Pont Charraud*, dated about
1916, is one of the most ethereal of all his
*gelées blanches*. At this period of the artist's
activity there is an almost mirage-like qual-
ity to his works.

274. Pont Charraud, c. 1916
Oil on canvas, 25×33 cm
Signed: Guillaumin

Photographed by author
Mlle Yvonne Coste, Paris
Pl. 207
This sketch was made from the same view-
point as the previous entry. It is a fine
example of the virtuosity of the seventy-
five-year old artist's hand.

275. Le barrage à Génetin, c. 1916
Oil on canvas, 59×72 cm
Signed: Guillaumin
Photographed by author
Mme Clémentine Ballot, Paris
M. André Ballot, Paris
Pl. 208

276. Crozant sous la neige, c. 1916
Oil on canvas, 54×65 cm
Signed: Guillaumin
Photographed by author
Mme Clémentine Ballot, Paris
M. André Ballot, Paris
Pl. 46

277. Rocher de l'Echo, November 1917
Oil on canvas, 54×65 cm
Signed: Guillaumin
Photographed by Durand-Ruel No. 10472
Pl. 209
Durand-Ruel gives the following infor-
mation: " Arbres au bord de l'eau. Premiers
jours de novembre 1917. " The precision of
this information almost surely indicates that
it was derived from an inscription on the
back of the canvas.
    Des Courières, p. 60, illustrates an almost
identical scene bearing the inscription: " A
ma fille Marguerite (?) Guillaumin. "

278. Rocher de l'Echo, c. 1917
Oil on canvas, 65×81 cm
Signed: Guillaumin
Photographed by author
Mme Clémentine Ballot, Paris
M. André Ballot, Paris
Pl. 47
Another ethereal painting, probably ex-
ecuted about 1916-1918.

279. Pont Charraud, February 1918
Oil on canvas, 60×73 cm
Signed: Guillaumin
Inscription: 10 février 1918
Photographed by author

Musée Municipale, Limoges
Pl. 48
This picture, with its high chromatic inten-
sity and boldness of brushwork, marks the
end of the " ethereal " Guillaumins.

280. Pont Charraud, c. 1918
Oil on canvas, 60×73 cm
Signed: Guillaumin
Photographed by author
Mme Renée Lacotte, Paris
Pl. 210

281. Agay, 1919
Pastel
Signed: Guillaumin
Inscription: Agay 1919
Photographed by Giraudon No. LA 22619
Musée d'Agen
Pl. 211

282. Cabbe - Roquebrune, 1920
Pastel, 56×48 cm
Signed: Guillaumin/ Cabbe Roquebrune
Photographed by Bulloz
Musée de la ville de Paris No. 1424
Pl. 212
Guillaumin was in Cabbe - Roquebrune in
the spring of 1920

283. Valley of the Sédelle, c. 1920
Oil on canvas, 38×46 cm
Signed: Guillaumin
Photographed by author
Mlle Yvonne Coste, Paris
Pl. 49
From 1918 on, Guillaumin's brushwork be-
comes bolder and bolder. The fact that the
heather is in full bloom would place this
work in August.

284. La Creuse à Génetin, c. 1920
Oil on canvas, 38×55 cm
Signed: Guillaumin
Photographed by author
M. Nat Leeb, Paris
Pl. 213

285. Paysage de la Creuse, c. 1920
Oil on cardboard, postcard size
Signed: Guillaumin (left margin)
Inscription: Hommage en souvenir d'un
aimable visite
Photographed by Versailles No. 43194

Pl. 214
At least one painted postcard also existed in the collection of Mlle Marguerite Guillaumin.

286. Rocher de l'Echo, September 1921
Oil on canvas, 73 × 92 cm
Signed: Guillaumin
Photographed by Durand-Ruel No. 9774
Pl. 215
Durand-Ruel gives the following information: "Crozant, les bords de la Creuse, le matin. Septembre 1921."

287. Rocher de l'Echo, 1921
Charcoal, approx. 32 × 48 cm
Signed: Guillaumin/ 1921
Photographed by author
Formerly Mlle M. Guillaumin
Pl. 216
A beautifully delicate drawing of one of Guillaumin's favorite *motifs* by the hand of the eighty-year-old artist.

288. Rocher de l'Echo, c. 1921
Pastel, 46 × 21 cm
Signed: Guillaumin
Photographed by author
Mlle Yvonne Coste, Paris
Pl. 217
On the basis of the close similarity with the preceding drawing, this pastel should probably be dated around 1921 (See Cat. No. 287).

289. Rocher de l'Echo, c. 1921
Oil on canvas, 73 × 92 cm
Signed: Guillaumin
Inscription: Crozant: les bords de la Creuse, matin septembre
Photographed by author
Galeries Serret-Fauveau, Paris
Pl. 218

290. Agay - L'entrée de la rade prise de la villa des Falaises, 1922
Oil on canvas, 24 × 33 cm
Signed: Guillaumin
Photographed by author
Dr. Oscar Ghez, Modern Art Foundation, Geneva, No. 3591
Pl. 219
For his winter visit to Agay in 1922 Guillaumin rented the villa Les Falaises, from

which this picture was painted. It is identically the same *motif* as a pastel offered at auction at the Parke-Bernet sale No. 2072 under No. 65. The pastel bears the inscription: "A Jean Bacque/ Guillaumin Agay 1922" (lower right). The size is given as 46 × 60 and it is probably the pastel listed by Des Courières under the Bacque Collection (Des Courières No. 32) with the information "matin de mars." In the same collection Des Courières lists a painting of the same *motif* (Des Courières No. 29) of the size 24 × 33 with the information that it was executed in the "soir de janvier." Probably this refers to the present painting.

291. Vue de la baie d'Agay, c. 1922
Pastel, 43 × 58 cm
Signed: G
Photographed by Modern Art Foundation
Dr. Oscar Ghez, Modern Art Foundation, Geneva, No. 9447
Pl. 220
Guillaumin was staying at the villa "La Falaise" on the Pointe de la Baumette in 1922. He executed a number of views of the bay of Agay at that time. Possibly this is one of them.

292. Agay - le matin, February 1922
Oil on canvas, 60 × 92 cm
Signed: Guillaumin
Photographed by Durand-Ruel No. 9775
Pl. 221
Ref.: Vauxcelles, Louis: "L'impressionisme," *Histoire générale de l'art français.* Paris, 1922, p. 171 (ill.).

293. Valley of the Sédelle, c. 1922
Oil on canvas, 32.5 × 40 cm
Signed: Guillaumin
Photographed by Arthur Tooth and Son, London, No. 293003
Musée des Beaux-Arts, Paris
Pl. 222
Since the spring of 1922 Guillaumin had been forced to have his wife write his letters for him, as his hand had begun to shake. Nevertheless he continued to paint until the fall of 1923, but the pictures painted in this year of his painting career show a blurred quality in the brushwork, though the color remains just as powerful as ever.

From the nature of this painting's brushwork, I should place it in 1922.

294. Crozant, May 1922 (?)
Oil on canvas, 65 × 81 cm
Signed: Guillaumin
Inscription: Crozant mai 19(?)2 matin
Photographed by author
Mme Renée Lacotte, Paris
Pl. 223
The third digit of the date is illegible, but the style conforms more closely to that of 1922 than that of either 1902 or 1912.

295. Le Rocher de l'Echo, c. 1922
Oil on canvas, 72 × 81 cm
Signed: Guillaumin
Photographed by author
Dr. Oscar Ghez, Modern Art Foundation, Geneva, No. 2558
Pl. 224

296. Puy Bariou, July 1922
Oil on canvas, 54 × 65 cm
Signed: Guillaumin
Inscription: Crozant juillet 1922
Photographed by author
Mme Lacotte, St.-Foy
Pl. 225

297. Puy Bariou, November 1922
Oil on canvas, 24 × 33 cm
Inscription: (on stretchers) Crozant 9bre 1922
Photographed by author
Mme M. Lacotte, Paris
Pl. 226

298. Le plateau de la Creuse, 1922 (?)
Pastel
Signed: Guillaumin
Inscription: Crozant 1922
Photographed by Giraudon
Musée d'Agen
Pl. 227

299. Agay, March 1923
Oil on canvas, 24 × 33 cm
Signed: Guillaumin (cachet)
Photographed by Durand-Ruel No. 19699
Pl. 228
In 1923 Guillaumin again spent the first part of the year at Agay, probably again renting the villa Les Falaises, from which he painted this picture across the harbor of Agay with the Dramont in the background.

Durand-Ruel gives the following information: "Agay le matin mars 1923."

300. Puy Bariou - gelée blanche, 1923
Oil on canvas, 80 × 113 cm
Not signed
Photographed by author
M. Ernest Alluaud, Limoges
M. Jo Teillet, Crozant
Pl. 50
This is said to be the last painting that Guillaumin commenced. Though it is only begun, it is interesting in that it shows Guillaumin's manner of working with almost no preliminary sketch on the canvas. It also shows that he endeavored to establish the color harmonies from the first, setting the mood of the picture.

The abandoned picture was left in the studio of Guillaumin's friend Alluaud, from whose property he often painted the view of Puy Bariou.

# Acknowledgements

The research for the study of Armand Guillaumin was made possible by the materials and information of many collectors, galleries, museums and friends of the artist. Credit for photographs is given in each of the catalogue entries.

From the begining to the end, Dr. Oscar Ghez of Geneva, collector and connoisseur of Armand Guillaumin, has encouraged this work. Mr. Maurice Sternberg of Chicago helped gather Guillaumin paintings in the United States. From the manuscript materials of Christopher Gray, Elizabeth J. Cooper and her staff at Brush-Mill Books prepared *Armand Guillaumin* for printing. The high quality of the printing was made possible by prof. Ezio Gribaudo of Turin, Italy.

Gratitude is expressed to the art historians who read and criticized the manuscript:

Dr. Frank Trapp, Amherst College, Amherst, Mass.;
Dr. R.L. Herbert, Yale University, New Haven, Conn.;
Dr. Frederick B. Deknatel, Harvard University, Cambridge, Mass.

Many other colleagues of Christopher Gray in Baltimore, Md., and Washington, D.C. read the manuscript.

Editorial assistance was given by Mrs. Helene Feinman of New Haven, Conn., as well as Mrs. Lyle Boyd of Cambridge, Mass.

Mrs. Agie Gold of Baltimore translated the Guillaumin letters into English.

ALICE D. GRAY

*Production:*
Brush-Mill Books, Inc., Chester, Conn.

*Designer:*
Sarah P. Sullivan